Inclusion Through Media

Edited by Tony Dowmunt, Mark Dunford and Nicole van Hemert

Inclusion Through Media

This product has been part funded by the European Social Fund (ESF) under the Equal Community Initiative Programme. The contents do not necessarily reflect the opinion or position of the European Commission or the Department for Work and Pensions.

ISBN: 978-1-906496-00-5
First edition, November 2007

Goldsmiths, University of London
New Cross
London SE14 6NW

Printed in Great Britain with OpenMute Print On Demand (POD),
www.metamute.org.uk

Designed by Jonas Andersson and Li Jonsson

Contents

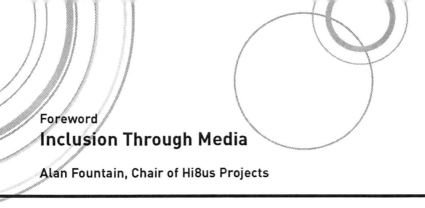

Foreword
Inclusion Through Media

Alan Fountain, Chair of Hi8us Projects

Inclusion Through Media is a project led by Hi8us Projects and funded by the European Social Fund (Equal). It has involved many imaginative and hugely productive collaborations between creative media professionals and excluded, often marginalised, people in various cities and regions of the UK and Europe over the past three years. This book offers some detailed first hand accounts of several of the projects and processes involved as well as looking at some of the wider issues the projects raise for contemporary society and especially, the role of media and cultural industries in modern Britain.

The idea of inclusion through media is deeply relevant both for community and individual creativity and for the centres of contemporary media power. The struggle of media activists for a voice for the disenfranchised and the powerless can be traced back to the workers' films of the 1930s when filmmakers and political and trades union activists collaborated to make films about poverty, unemployment, poor housing and fascism. Much later, in the 1970s, the Community Programme Unit at the BBC constituted another attempt to find corners of 'the system' in which the powerless, the minority, and the radical could make an appearance on television. During the 1980s Channel 4 all too briefly offered production budgets and distribution to programme makers and communities representing their experiences, histories and ideas about the world from hitherto unheard class, race and gender positions. In short, working class people, trades unionists, ethnic minorities, women, gays and lesbians, and artists of many shapes and sizes finally had a public voice and identity – a prerequisite to participation in a democracy.

As many of the articles in this book demonstrate, participation in media production projects by people who have been excluded can often transform peoples' self perception, building confidence and a sense of self worth, as well as new skills and a means of self expression, a social voice, educational breaks and, sometimes, a route to employment and new career prospects.

It is difficult to see what could be more important for thousands of people trapped in poverty and political, social and educational exclusion

in modern Britain than to simultaneously develop a voice and the skills and motivation to make new choices. The projects gathered under the Inclusion Through Media umbrella provide all the evidence a serious policy maker could require. This form of long term collaborative cultural production does make a difference to the lives of individuals and communities.

If participative media activities can make a significant impact on individual lives, they are equally as important to the health of the UK's political and media democracy. Arguably, the BBC and Channel 4, as the country's leading public service broadcasters, should by now have completely re-thought the very role of television within a modern, highly technological, digitalised, global world. At the centre of such re-evaluation should be how to harness contemporary and readily available technology to ensure that every community has a voice, as a matter of right, at the centre of publicly owned and financed communication systems. The history of Inclusion Through Media, including Hi8us' proud role in it, offers some indicators to media and political policy makers.

Even if today's major broadcasters, alongside the new global players dominating global digital media, do not take the democratic potential of media seriously, the really good news, of course, is the liberating potential of 'new media' for independent media makers throughout the world. There has never been a better moment in the history of media for independent voices to find distribution, to reach their intended audience, and to establish communication and dialogue.

As you will see from the following pages, the Inclusion Through Media project has effected hundreds of participants' lives in very positive ways, and has demonstrated the positive value of pan-European collaboration. It has stimulated innovative thinking about how to evaluate and understand these new communication processes, and points the way towards new social and media policy.

Chapter 1
Introduction

Tony Dowmunt

This book is about the current use of media as a means of working with, and empowering young and marginalised people in their communities. Despite having at least a thirty year history (see Chapter 5), this practice has emerged more strongly and visibly in recent years, nurtured in part by a number of technological factors:

- the extraordinary growth and increasing availability of digital media technologies, from Web 2.0[1] to iPods, camcorders to mobile phones;
- the opportunities for 'user-generated content' that these media facilitate (recognised and fostered by many mainstream organisations, including the BBC and other broadcasters);
- the growth in less formal distribution and 'uploading' opportunities facilitated by video sharing sites such as YouTube and MySpace.

These developments have enabled a more participatory culture, (particularly online), one in which young people are now more able to represent themselves and their concerns through digital media (to some extent – we will explore the limits to this potential later).

Alongside these developments, we have also seen growing concerns within Government and society (and a flurry of 'moral panics' in the media) focusing on young people. There are many groups of youth who are seen as dangerously alienated or particularly in danger of 'social exclusion', including those from the Black and Afro-Caribbean community, white working class boys, and (especially since 9/11 and 7/7) Muslim youth. More generally there are ongoing attempts both to increase the number of young people going to university, and to develop a strategy for enabling less academically inclined 14-19 year olds to become economically productive. Alongside the expansion of digital media, we have also seen the identification and promotion of the 'creative economy', and of 'creativity' more generally (particularly among young people), as a key site for economic regeneration in the UK. However, at the same time there is also a growing problem (cited by Nick Couldry below, p. 254) of 'voter apathy' among the young (18-34 year olds), less than 50% of whom voted in the 2000 and 2005 General Elections.

It is in response to these increasing concerns and anxieties about young

peoples' behaviour, attitudes and aspirations, particularly those seen as 'socially excluded', that government agencies, NGOs and charities at local and national levels, have been funding an expanding number of participatory media projects, including those featured in this book. Younger people are clearly those who feel the most relaxed about the new digital technologies outlined above, becoming their 'earliest adopters', so it is not surprising that funders should seize on digital media as a way of addressing their anxieties about young people.

A word about *social inclusion/exclusion*: we are using these terms because they are part of the current (particularly governmental) discourse about youth and participation, and we acknowledge that they mask as much as they reveal about why different groups of young people are or are not being 'included'. As the authors of a number of the chapters that follow make clear, young people are 'excluded' by and from the media because of the ways in which their class background, gender, ethnicity or (dis)ability has impacted on their economic, social and cultural capital: put crudely, the media are for the most part run by corporations of older, white middle-class people who therefore have the power to define how the world is represented, and who should be empowered to do the representing. In other words, social inclusion and exclusion (in the media and elsewhere) are caused by, and reflect the distribution of power and resources in our society, and as such will not be fundamentally challenged or changed except by their re-distribution. The work of 'including' young people through media, as described in this book, is one (inevitably limited and particular) strategy for achieving this re-distribution. (See Chapter 17 for an extension of this argument.)

Inclusion Through Media is an attempt to describe, and begin to analyse, this work from the perspectives of the youth workers, media workers and the young people themselves who do it. These perspectives are sometimes at variance with those of the organisations that fund them – to give just one example here, in relation to the issue of evaluation. These projects are often assessed in the crudest, most quantitative ways (for instance by 'measuring' the numbers of young people who find some sort of employment after the project). *Inclusion Through Media* will take a more 'qualitative' approach, seeking to understand this work as part of the wider social, cultural and economic circumstances in which young people operate. Most of the case study material in the following chapters (though not all of it) is based on work undertaken by the Inclusion Through Media Partnership, led by Hi8us Projects and funded through Equal (the European Social Fund).[2] A central principle that runs through the book is that projects should be driven by the needs and aspirations of young people

themselves, and should foster their autonomy and control over their own work.

Technology, media and the arts

Digital technologies – especially those associated with the expansion of the Internet – are often seen as inherently liberating – 'a new space of freedom, a Digitopia promising a transcendence of the restrictions of earthly law' (Claude 2007). And this utopian hope has infected some of our thinking about youth media. However, it will be clear from many of the chapters in this book that the availability of the technology by itself does not guarantee that (particularly socially excluded) young people will be able to get access to, or make use of it in productive ways.

For a start, it seems that there is much less participation on the Internet than some of the hype would have us believe:

> Web 2.0, a catchphrase for the latest generation of websites where users contribute their own text, pictures and video content, is far less participatory than commonly assumed […] A tiny 0.16 per cent of visits to Google's top video-sharing site, YouTube, are by users seeking to upload video for others to watch, according to a study of online surfing data by Bill Tancer, an analyst with web audience measurement firm Hitwise. Similarly, only two-tenths of one percent of visits to Flickr, a popular photo-editing site owned by Yahoo Inc., are to upload new photos, the Hitwise study found. The vast majority of visitors are the Internet equivalent of the television generation's couch potatoes – voyeurs who like to watch rather than create. (Auchard 2007)

Henry Jenkins is an American theorist who passionately believes that what he calls 'convergence culture' is ushering in a new era of participatory media, yet even he concedes:

> not all consumers have access to the skills and resources to be full participants in the cultural practices I am describing. Increasingly, the digital divide is giving way to concern about the participation gap. (Jenkins 2006: 23)

Most of the people he describes as full participants in convergence culture 'are early adopters. In this country they are disproportionately white, male middle class and college educated' (ibid).

There's no reason to believe this 'participation gap' isn't prevalent in the UK as well. In a recent study of amateur spoofs on YouTube, Rebekah Willet found that:

> A large majority of the authors of the spoofs surveyed are young white men, aged approximately 12-25, and we can assume they have access to camcorders, editing equipment and broadband Internet access. Only 3 out of the 68 producers were women, though occasionally women were included as actors. (Willet, forthcoming)

So, unsurprisingly, the use different people make of the Internet and digital media continues to reflect gender, class and other differences, and it remains a central aim of youth media work to close this 'participation gap'. However this is not to minimise the extraordinary potential for immersive involvement by young people that the Web offers, and often delivers, when the circumstances are right. To give one example, David Buckingham writes about the Skate Perception site (www.skateperception.com) which 'provides extensive resources for skateboarding video-makers':

> at the time of this research (spring 2007), it had over 1.2 million post-ings and over 11,000 registered members: its leading posters had more than 4,000 individual postings. The site features its own selec-tion of streaming videos, while individual postings also contain links to other videos available on generic sites such as YouTube as well as individually-run and company sites. (Buckingham, forthcoming)

Skateboarding is of course a lively and relatively autonomous youth sub-culture, and the website is consequently highly participatory and directed by its members. For instance there are

> advice pages and discussion threads providing detailed information on topics ranging from fitting lenses and file compression to "vignet-ting" and other post-production effects (at the time of this research, there were over 3000 sub-topics relating to fisheye lenses alone). Skate Perception also runs competitive "assignments," mostly fo-cused on the evaluation of specific shots – "best handrail shot," "best fisheye stairset shot," "best rolling longlens handrail shot," and so on. However, perhaps the most interesting area in terms of learning is the critiques, where members submit their work for frank but gen-erally supportive commentary by "SP's panel of video judges". The advice here is partly of a technical nature (to do with issues such as lenses, colour balancing or eliminating camera shake), but much of it is also focused on aesthetic issues. Video-makers are encouraged to "get creative" and to go beyond "point and shoot". (Buckingham, forthcoming)

Skate Perception is therefore a remarkable example of a use of Web 2.0 technology by young people, in that it is not only self-directed and highly participatory, but also is evolving its own aesthetic, its own distinctive and independent video-making vision.

The excitement around 'user-generated content' by young people, ex-emplified by Skate Perception, has attracted the attention of some broad-casters – particularly those with a 'public service' remit, who see it as a way of re-engaging with a section of the audience that is deserting main-stream TV for the Web. BBC News run two projects in this vein: School Report and Teen 24. School Report (news.bbc.co.uk/1/hi/school_report)

offers a way for young people in schools to make TV, radio and online news items, helped by BBC journalists, leading to a UK wide News Day. Teen 24 is a linked scheme based in BBC News 24. Another scheme, Blast (www.bbc.co.uk/blast/joinblast/about/), 'inspires and supports 13 to 19 year olds to get creative'. Channel 4 uses its Four Docs site (www.channel4.com/fourdocs/) as a way of getting in touch with, and soliciting material from, younger filmmakers, and Current TV (uk.current.com) is a US/UK based interactive cable channel aimed at younger people, where viewers send in video stories they've created to be aired on the network, voted on by other viewers. At best, these broadcasters' and cable company initiatives represent a genuine opportunity for young people to represent themselves and their interests on screen. Viewed more cynically, they can be seen as a clever way to generate innovative and cheap new content for these channels, without their having to invest much in training or developing new talent. However the potential for partnership and collaboration between them and the kinds of projects described in this book is enormous, and could contribute to the new definition of 'public service' broadcasting explored at the end of Chapter 5.

YouTube (www.youtube.com) and MySpace (www.myspace.com) represent more open and less regulated ways for young people to disseminate and share their digital content. However they both remain at heart competitive businesses (owned by Google and Rupert Murdoch respectively), so are not really likely to see their core business as nurturing participatory youth work! Converge (www.converge.org.uk) is a UK-based organisation, initiated by the Inclusion Through Media, that assists in the publishing of alternative video on the Web. They have produced a handbook and workshop programme to enable young people to make use of existing sites like YouTube, but also to publish video on their own sites, under their own control.

Despite all of these possibilities opened up the technology, we should also be wary of over-hyping the economic or employment benefits that young people working with digital media can earn:

> it is important to avoid an easy optimism here. While the industries are undeniably changing and fragmenting, not least with the impact of new technologies, the chances for relatively "unskilled" young people to find employment there remain minimal. There is a yawning gap between the work that may be done on these kinds of courses and the "real" world of the media industries. (Buckingham, Grahame & Sefton-Green 1995: 102)

This was written twelve years ago, at the beginning of the current period of media transformation which has to some extent closed the technical gap between the equipment available to young people and that used in the 'real' world; and some of the chapters below (3, 6, 8, and 9) do indi-

cate ways in which projects can help include 'excluded' young people in mainstream media work. Nevertheless entry to the media industries is highly competitive, and increasingly relies on prospective entrants being able to work voluntarily in the early stages of finding work, which clearly discriminates against poorer young people. The other danger in over-emphasising this employment-creating potential of the work returns us to the issue of evaluation. If projects are to be valued solely in terms of their 'hard outcomes' (for instance the number of young people who find employment after a project) then we lose sight of some of the major benefits of involvement in media and the arts – an argument made in more detail in Chapter 3.

The last few years has seen a debate raging about the 'instrumental' versus the 'intrinsic' value of the arts (Belfiore & Bennett, 2006: 9 & 177). In the recent past, governmental and funding organisations have found it more expedient and easier to measure and value the arts for what they can do (for instance, create employment or assist urban regeneration) than for what they are. 'We have lost a vocabulary and an area of permitted discourse where values are valued rather than costed,' John Tusa complained in the year 2000 when he was director of the Barbican Arts Centre in London, adding that we now have a debate 'where the public good is dismissed as a chimera so long as it cannot be quantified on a balance sheet' (29).

The arguments against 'instrumentalism' have found some favour in Governmental circles. In a personal essay in 2004 Tessa Jowell[3] asked : 'How, in going beyond targets, can we best capture the value of culture?' (18) and conceded that

> Too often politicians have been forced to debate culture in terms only
> of its instrumental benefits to other agendas – education, the reduc-
> tion of crime, improvements in wellbeing [...] we have avoided the
> more difficult approach of investigating, questioning and celebrating
> what culture actually does in and of itself. (8)

It is the aim of this book to investigate, question and celebrate young peoples' use of digital media, as much in its own terms as in relation to its instrumental benefits.

Aiming High(er) for Young People

Having said that, it remains true and demonstrable that participatory media work with young people does offer many social benefits. In fact, media projects are well suited to address a range of issues that have been recently identified as 'problems' with young people. The main conclusion of *Reach* ('an independent report to Government on raising the aspirations and attainment of Black boys and young Black men') was that there is a 'need for more Black male role models and more positive images of

Black men' because

> the image of Black boys and young Black men portrayed through the media is not a positive one. More and more research suggests that where children are without positive role models, they will seek them from the world of fantasy and the media. (Reach Group 2007: 6)

By 2010 the authors of the Reach report want to see:

> Positive images, portrayals and stories about Black boys and young Black men in the broadcast and print media, at national and local levels, accompanied by a move away the negative stereotyping. (9)

However Reach's main conclusion was to call for 'a structured national role model programme for Black boys and young Black men' (20), and surprisingly (given the focus in the report on the inadequacies of mainstream media) they say nothing about the value of young Black people making their own media about themselves, as a way of countering stereotyping. The conclusion of this book is that this work would also go some way towards fulfilling another of the report's targets for 2010, to see a

> significant improvement in self-image, self-confidence and self-esteem of Black boys and young Black men, alongside higher aspirations and expectations for themselves. (10)

These 'softer outcomes' (self-confidence, self-esteem) are the focus of another recent Government report – *Aiming High for Young People: a ten year strategy for positive activities* – which stresses the importance of

> social and emotional skills [...] young people's self awareness; their ability to manage their feelings; their motivation; their level of empathy with others; and their social skills. (Treasury 2007: 6)

These are precisely the areas in which creative arts and media work with young people deliver (see Chapter 3). In a recent evaluation of 'what works in stimulating creativity amongst socially excluded young people', among the range of impacts reported were:

- improved self-esteem and self worth;
- understanding yourself better and confidence in your abilities;
- greater maturity;
- improved social skills. (Halsey et al 2006: 84-85)

The *Aiming High* report cites a number of media projects that fulfil their idea of 'positive activities'. They describe how a group of young Travellers in Nottingham made a short video on a 'day in the life' of a young Traveller, to show to an audience of local decision makers, and then went on to organise a consultation event that 'identified strategies to improve the relationships between young Travellers and non-Travellers in Nottingham' (Treasury 2007: 40). The report also mentions the Media Box funding ini-

tiative (56) and Bus Buddies – a group of young people from the North East travelling 'the length and breadth of the region on public transport making a DVD to present to a Regional Bus Forum (59).

Aiming High identifies 'empowerment' as the first of three 'themes and principles for reform' (Treasury 2007: 14) and asserts that

> Successful provision includes young people in its design and development, its running and its decision-making processes. This gives them a sense of empowerment. (23)

The conclusion of this book is also that this 'sense of empowerment' is key to successful participatory media work with young people, but that achieving it involves often complex – and sometimes compromised – processes of negotiation between the young people, youth workers and the institutions that support the work[4]. A recent complicating factor in some work has been a growing insistence by Government that funding for youth work has to be tied to various accreditation schemes[5] as a part of the more general spread of 'target culture' under New Labour. While some of these schemes may offer some young people a feeling of empowerment and achievement, they are more often – particularly with 'excluded' or 'hard to reach' groups – experienced as barriers to involvement and so, effectively disempowering.

The conviction that underlies this book is that the bedrock of successful youth media projects is 'old-fashioned', 'young person centred' youth work that allows, as far as possible for the genuine empowerment and autonomy of the young people concerned. As a young interviewee in the NFER/NESTA report said:

> It's about making targets for yourself rather than someone else making targets [...] it's helped me to focus on me and not on what others want for me. (Halsey et al 2006: 76)

The book

This book mixes detailed case studies of projects with more analytical contributions to produce a varied, multi-vocal picture of the current 'state of the art' of youth media work. Some of the chapters (for instance 5, 6, 9b, 13, and 14) have a personal or (auto-)biographical flavour. We think this tone – alongside the more measured, objective contribution of other chapters – is an essential strategy for getting at what (in Jowell's phrase) the work 'actually does in and of itself'(8). In media arts work with excluded young people (dealing with the 'hidden injuries' that Couldry discusses in Chapter 17), the subjective and the personal are an essential component of the work – for both the young people and those who work with them. We hope this book will stimulate more discussion in this area.

Contributions to the book fall into four sections. Section 1 ('Evaluation')

gives a detailed account of the Inclusion Through Media Partnership as a whole and how its work has been assessed. Section 2 ('Projects') contains descriptions of work – mostly from the point of view of the youth media workers and filmmakers involved in it. Section 3 ('Participation') analyses the issue of young peoples' involvement in – and power over – their use of media, and Section 4 ('Regeneration') discusses some of the implications of this work for wider issues of social and cultural policy. The Afterword brings together some of the strands in earlier chapters, to present an argument about the relationship of this work to citizenship and democracy.

The DVD

The accompanying DVD contains clips from some of the work featured or described in individual chapters. The DVD menu uses the same lay-out as the Contents section for this book (though not every chapter has an accompanying clip). Readers will be alerted in the text (for example **DVD clip / section 2 / 5.1**) when a relevant clip can be viewed on the DVD. All clips are between 30 seconds and 7 minutes long.

Endnotes

[1] Web 2.0 is the name given to the second generation of web-based communities and hosted services – such as social-networking sites and wikis – which aim to facilitate collaboration and sharing between users. See en.wikipedia.org/wiki/Web_2.

[2] See Chapter 2 for a detailed description of the Inclusion Through Media Partnership.

[3] Minister for Culture Media and Sport, 2001-2007.

[4] For more on this theme see Jackie Shaw's discussion of the issues around participation and empowerment in her Chapter 12.

[5] See Flint 2005 and National Youth Agency 2007 for information about these schemes.

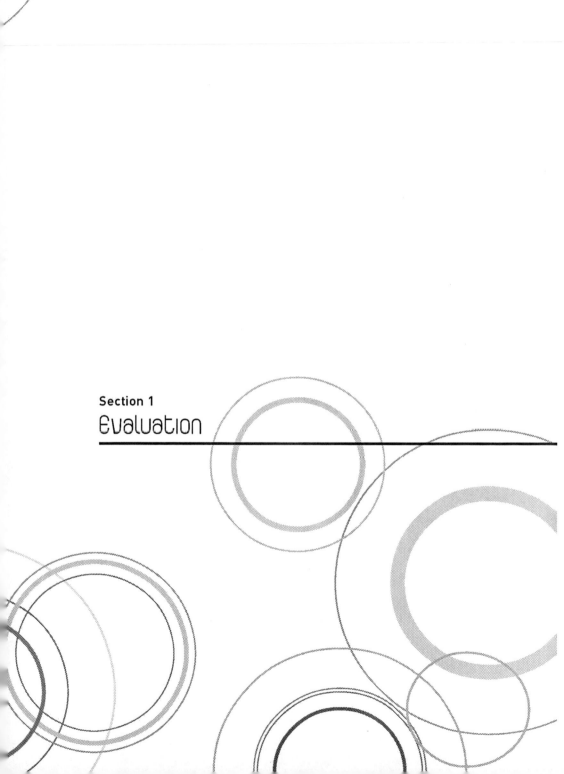

Section 1
Evaluation

Section 1: Evaluation

In the first chapter of this section Mark Dunford sets the policy context for the Inclusion Through Media programme and describes the quality, range and amount of work that took place between 2004 and 2007. The subsequent chapters describe issues around the evaluation of creative programmes, like Inclusion Through Media, which address different social, cultural and economic policy drivers. Ben Gidley draws on preliminary findings from the Beyond The Numbers Game project, a research project within the Inclusion Through Media programme looking at the efficacy of performance measures, and sets out some of the key elements in participatory media, focusing on the use of digital media to engage marginalised people and their communities. Robert Smith reflects on his experience as an evaluator and discusses the conceptual difficulties in using narrative as an evaluation tool.

Chapter 2
About Inclusion Through Media

Mark Dunford

This chapter provides an overview of the Equal Development Partnership called Inclusion Through Media (ITM). Most of our projects are represented in this book, and the intention here is to give a flavour of the work that took place across the full programme. In doing this it describes the ethos of Hi8us, the lead partner in ITM, and the policy context in which we operate. Other chapters throughout the book examine particular projects in greater depth. It is simply an overview and isn't intended to be evaluative or definitive. A full project list is included in Appendix 2.

Our publicity material describes ITM as precisely as possible.

What will ITM do?
ITM's key ambition is to demonstrate that participatory media work with excluded and disadvantaged people actively helps to combat social exclusion by giving them a chance to make their voices heard, whilst enabling some of our most creative young people to access the industry through 'non-traditional' routes, enriching the talent pool of the UK's world-class audio-visual industry. We want to showcase this evidence to convince policy-makers and employers that our model works, and that the social and economic benefits go hand-in-hand.[1]

What is ITM?
We are producing innovative, creative film, video and digital media work made by talented young people from a wide range of backgrounds, who have not necessarily achieved their potential through mainstream education and training. Uniquely, our participants are able to work side-by-side with experienced professionals, resulting in high quality, diverse stories,

25

created by those best placed to tell them (DVD **clip** / **section 1 / 2**).

The ITM programme runs from September 2004 until the end of December 2007. The total budget for ITM exceeded £6.5m.

About Hi8us

Hi8us provides young people across the UK with the opportunity to gain first hand media production experience and to collaborate with media professionals to ensure their own stories and experiences reach the mainstream media.

Our charitable work has three core aims:

- To reach young people at risk of social exclusion to enable them to articulate their experiences;
- To enable young people to use the experience of creating media as a catalyst for change in their own lives and in their communities;
- To create ground-breaking television, film and new media through a collaboration between professional filmmakers, web-designers and non-professional participants.

Hi8us is now well established as the UK's leading practitioner in collaborative professional media with young people. We have also built strong links with the varied sectors relevant to young people and the media. As an organisation working across the country, and now internationally in partnership with locally based entities, Hi8us has pulled together local projects with media access and outreach organisations, colleges of further education, local authority youth services and regeneration departments, schools and funding organisations, as well as key media players. The differing creative aspirations of excluded young people have been turned into television programmes, short films, websites and DVDs.

The origins of Hi8us go back to 1994 when key personnel from APT and Maverick TV, two independent television production companies, decided to take advantage of the opportunities offered by affordable video equipment to work together to make drama with marginalised young people using Hi8 camcorders. With support from the newly established National Lottery Hi8us was established as a special company, a registered charity and a vehicle to take this work forward. Television dramas, including six films for Channel 4 and one for ITV, pioneered a new style of television fiction made with a wide range of communities with something to express: Protestant East Belfast, Afro Caribbean Coventry, young offenders on Hull Prison's D Wing, homeless people in Manchester and young Asians in Birmingham. Produced through processes of improvisation, shot with people on the streets where they live and performed by new young talent, they are all distinguished by a sense of place, of unheard voices and first hand experiences. The contribution of high level professional involvement enabled marginalised young people to get their voices

heard, and set a benchmark of quality which attracted critical acclaim, audiences and industry prizes. Channel 4 transmitted *Nightshift* (**DVD clip / section 2 / 5.3**) in February 2000 and it was awarded joint best drama in the CRE's[2] Race in Media Awards. This followed the Royal Television Society Awards for Best Dramas for *Blazed* in 1996 and *The Visit* (**DVD clip / section 3 / 13.2**) in 1998.

Policy changes introduced by the New Labour Government after 1997 had a profound effect on Hi8us. Hi8us has always been committed to working collaboratively with community groups and an emphasis on a bottom up approach to renewal meant that the company needed to structure itself to operate at a local and national level. Added to this was an emphasis on building skills, knowledge and enterprise to increase employability across various sectors of the economy, including the creative industries. This differed markedly from an earlier use of large-scale capital investment as a means of attracting major employers to 'deprived' regions. Regional policy flowed from recognition that regions have different needs, and that most are characterised by uneven patterns of growth. Newly established Regional Development Agencies became the focal point for the implementation of locally derived policies addressing social and economic needs at a local level. New Labour aimed to use 'localism' to build economic performance across all regions[3]. There is strength and synergy in the unity provided by a simple structure but we had to restructure so Hi8us could operate in this tiered environment. A number of key funding agencies also responded in a similar fashion and the period saw the establishment of a number of regional agencies. We created a network of linked companies based in different regions, overseen by the central charity. This enabled Hi8us to build projects through community based partnerships at a local level, and establish a presence on a national and international stage. A number of high profile multimedia projects like *L8R* and *EDRAMA* started at this time, and they quickly became the creative bedrock of a newly focused Hi8us network.

In February 2000, after a competitive tender, the Film Council[4] awarded Hi8us the right to manage national investment in young people's filmmaking. Hi8us established Hi8us First Light, a subsidiary company to manage the annual £1,000,000 budget to support filmmaking by 8-18 year olds, and this became the first fully operational delegated Lottery scheme in the UK. Hi8us managed the First Light programme for five years, and in 2006 First Light was floated off to become First Light Movies, an independent grant making trust.

About ITM
By the start of 2004 Hi8us had a successful portfolio embracing production based activity running through the regional companies, grant giving

via First Light and developmental activity overseen by the main charity. Though the individual projects operated successfully, it was still a relatively small company with some fifteen workers and a number of successful partnerships.

Hi8us had looked at the potential offered by the EC's Equal programme[5] during Round One of Equal, and had worked as a delivery partner in iCI Equal, a scheme managed by Birmingham City Council. The advent of a second round of Equal, with an emphasis on building local partnerships led by third sector organisations to undertake experimental work intended to influence policy, fell squarely into the charitable objectives of Hi8us.

After careful consideration, Hi8us decided to pull together a partnership of like-minded organisations to deliver a collection of projects with a shared ambition to explore new creative opportunities with marginalised people. In doing this we were able to attract the support of ten 'producing partners[6]' and a group of related strategic partners[7]. All of these came together under the working title Inclusion Through Media. Like many working titles, it was there until someone came up with a better name but it ending up staying.

Although the various ITM projects covered different creative forms including film, music and graphic design, they shared a common ethos around the importance of a collaboration between creative professionals and excluded people. They all started with an acknowledgement that collaborative work guided by talented professionals provided people with a unique opportunity to acquire skills which could enable them to access the labour market or re-enter education. Just as important was recognition that creative work empowered people by giving them an opportunity to express themselves. These concerns are central to Hi8us, and all the producing partners and the funding providing through the Equal programme meant we could explore them over three years through our own 'action research programme'. The timescale meant that all the partners were able to address the ambition to influence policy that underpinned the Equal programme. Our programme was considered long enough to stand the test of time, and most importantly we had space to fail. This unusual combination of ambition and freedom fitted perfectly with the concerns of the ITM partners.

Policy context

Inclusion Through Media operated in a diverse sector of the economy, where growth often takes the form of innovation, spin-offs, start-ups, new partnerships and diversification. The media industry is structured around a very small number of very large companies and a very large number of very small companies, an 'hourglass' effect replicated across Europe.[8] In

the South East of England 56% of all Creative and Cultural industry businesses turnover less than £100,000 while 73% of turnover is generated by only 2% of businesses[9].

It is a dynamic, fluid world. Young, highly skilled and enterprising people move across *and* between traditional work and technology boundaries. Creative businesses need to be hooked directly into a global market place and yet are dominated by self-employment, micro and small businesses. Part time, flexible and contract working are the norm and the network is the organisational form most suited to the creative economy. Spaces to meet, network, discuss and exhibit new work are an essential motor of the media economy. This has significant implications on public policy interventions and on the ability of the industry to organise itself. It is an exclusive world dependent on who you know as much as what you know.

Success usually depends on having particular skills and a high level of education. This sector has particularly high levels of degree-level education; in the South East of England circa 40% of those working in Content Origination hold at least a degree level or equivalent qualification (compared to 19.7% in the South East workforce as a whole). Specialist skills need to be matched with the highly valuable 'social skills' (contacts, networking etc.) and, although driven by the demand for high skilled workers, the sector could be seen as having the flexibility to attract people of talent and ambition without traditional qualifications and can offer a way out of exclusion. This potential is unfulfilled.

In his seminal study of the rise of the 'creative class' Richard Florida (2002) argues that creative industries are a key driver of economic growth. He highlights the importance of diversity to success, and argues that fostering diversity builds creativity and is consequently a better route to long term regeneration than large-scale capital projects, such as shopping centres. His influential Creativity Index has been widely used as a tool to demonstrate that the most successful urban economies are those which encouraged and supported creativity in a given location. A comparable methodology was adopted by DEMOS for a 2003 conference entitled *Boho Britain*, which identified Manchester as the creative capital of the UK. Florida's work is primarily concerned with urban regeneration, and has been adopted by policy makers across the globe. Projects like ITM, which are designed to encourage creativity and diversity within regions and specific economic sectors, have attracted widespread political favour.

A lack of diversity in the media industry is a recognised problem and UK policy makers have committed themselves to taking strategic action to address this[10]. At one level this flows directly from the complex structure of the media and the related creative industries, and is reflected in various programmes designed to improve the representation of particular

groups across the industry. However diversity needs to be understood in the broadest possible way, and not simply in terms of ethnicity, gender or sexuality. In a key report The Work Foundation argue that the long-term strength of the UK's Creative Industries depend on 'cognitive diversity', 'the capacity of different sets of knowledge when interacting to produce better decisions and outcomes' (Work Foundation 2007). Developing the means to build and sustain such diversity is therefore an important policy driver. It is the *type* as well as the *range* of people which matters. ITM adopted a grassroots approach to this by providing long-term support so individuals could develop the networks needed to gain access to this complex world, and the depth of experience required to operate successfully in it. In this way we sought to combine social and economic outcomes with cultural benefits to the UK's creative industries.

Equal provided ITM with the resources to develop and support unconventional collaborative training. We recognise this is simply a start as the wider problems of access are part of larger social inequalities. Our programme is just a drop in the ocean.

Work and projects across ITM
Hi8us managed Inclusion Through Media using a 'hub and spoke' model, whereby a small central team worked in partnership with community based organisations in key regions. This built on the model developed and utilised by Hi8us in the years immediately preceding ITM.

By doing this we were able to establish a locally based partnership with direct links into excluded communities. Hi8us North provides an excellent example of this approach. Dave Tomalin worked diligently to establish close links with regeneration agencies and representative community groups across East Leeds. By doing this he was able to gain access to a range of different people and work with them to create a remarkable body of work.

When I Was a Kid I Used To Dream was the first film completed as part of the ITM programme in Leeds, and it simply contrasted the original dreams of twelve young people on ASBOs[11] with their current situations. The film was made as a collaboration between the young people, the regeneration agency Re'new, the youth service and filmmakers from Hi8us North. The production team faced a number of difficulties in working with young people with multiple problems. Under the complex terms of their ASBOs many of the young people were forbidden contact with other group members.

Policy makers were unaware of the terms and restrictions in individual ASBOs, or of the consequences if these were breached. The film had a profound impact on local youth policy within East Leeds. Councillors and local executives on a whistle stop tour of the city saw the film, which re-

sulted in a four hour discussion on youth policy and how this could be improved to enhance prospects for the young people involved in the film. A Youth Inclusion Strategy was devised in partnership with Re'new and this became part of a larger Safer, Stronger Communities Strategy. The film was also screened to policy makers at an Equal conference and at the annual Creative Clusters Conference. It was also shown in the Leeds International Film Festival and at Cannes. This combination of professional success, policy change and local empowerment sowed the seeds for subsequent work in Leeds, and established ITM as an active partner in a range of regeneration initiatives across Leeds. However the outcome was a shift in social policy, rather than the economic impact sought by Equal.

Hi8us' work in Birmingham and East London took a similar route. In each case we were able to build on established links to create new projects which strengthened the initial impetus behind the work. Much of this is described in greater detail throughout this book, and a full list of projects follows in Appendix 2. There are many strong projects, though two in particular can be used to illustrate new opportunities created in the Equal funded research laboratory. Firstly, Hi8us Midlands work in Stoke and secondly the development of a new strand of work in Cornwall.

Projecting Stoke is a film production initiative involving some 20 community groups from across Stoke working with professional filmmakers. Participants developed, organised, directed and shot a number of short films in collaboration with professional filmmakers. Through a series of workshops and bespoke mentoring sessions Projecting Stoke supported and encouraged community based filmmakers to gain skills and express their experiences through short films. Completed films have been screened in the local community and are available via the project website. Projecting Stoke was run by Hi8us Midlands and supported by Screen West Midlands and Stoke City Council, as well as ITM. It was originally developed by Hi8us as a response to a request from Screen West Midlands to look at ways of working in Stoke, a relatively underserved part of the region. This partnership met a number of strategic concerns, as well as the wider policy goals inherent in the Equal programme. Without the flexibility offered by the programme, this initiative would not have happened.

ITM also allowed Hi8us to work in Cornwall. Extending the Hi8us network had been a long-term ambition within Hi8us and Cornwall represented an exciting opportunity, especially as this was our first chance to work in a rural area. There was also pragmatism in the decision to work in Cornwall, as a number of us had connections in the area and were able to draw on links with Cornwall Film and Creative Partnerships. Working together as a partnership we recruited a Development Director to build and produce creative projects with young people across Cornwall. Denzil

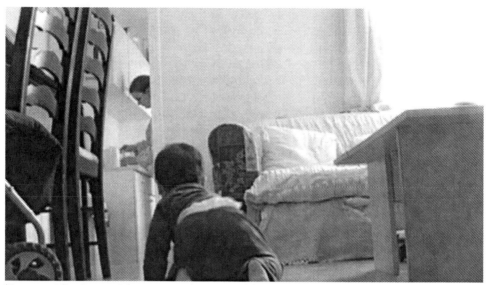

'Teens and Tots', one of the films made as part of Projecting Stoke

Projecting Stoke winners at the PS Film Awards 2007

Monk took on the role and quickly established a portfolio of projects, including a training scheme supporting ten trainees on two micro features.

A project that involves a national agency developing local work in a new environment needs to be taken forward with considerable sensitivity. Establishing local connections and appointing a locally based Development Director helped ITM establish local credibility which enabled creative work to take place. Parachuting a national team into a new area is a dangerous option which can easily lack credibility in local eyes. However it is also less of a risk. Equal funding allowed us to take a calculated risk, and this paid off in real benefits to the local economy to the point where Hi8us Cornwall is now able to broker local partnerships directly.

A number of ITM projects were led by partner organisations. Goldsmiths, University of London, produced Converge, a web-based project designed to enable young people to upload their own video material to websites such as You Tube. A series of workshops were held across the UK so that trainers and beneficiaries could acquire skills. Mental Health Media held responsibility for a number of initiatives, such as the extension of the Open Up Programme, a support programme for users and survivors of mental health services. ITM was also able to support the introduction of a new award at the annual Mental Health Media Awards. The Making a Difference Award recognised the contribution of a particular individual to the representation of mental health issues in the mainstream media. The annual Creative Clusters conference provided a forum where the issues addressed via ITM were discussed and debated in the presence of 400 policy makers. This was a key aspect of our 'mainstreaming' strategy.

Shared work
One of the most important strands within Inclusion Through Media related to work which went straight back to Hi8us' roots in participatory drama with young people, namely a programme of work designed to support the development and production of feature films made jointly by media professionals and marginalised people. This was particularly important, as it was one of the few elements of the overall programme which drew together partners from across ITM to create work together.

Development funding for feature films is notoriously hard to find, and often comes with a hefty premium. It is even harder for edgy low budget work made with people with no direct experience of production. However, changes in the market also meant that many of the entry barriers were coming down. The cost of production has fallen as the ability to access adaptable, digital equipment to make work of a cinematic standard was increasing all the time. Allied to this was the potential to exploit new revenue streams created by the expanding market for feature film material.

Above and left: Stills from Heavy Load. Images by Morgan White

ITM established a small Steering Group and appointed an Executive Producer to oversee the development of a slate of ideas from across the Development Partnership. All the elements of the partnership were invited to submit proposals to the Steering Group following discussions with the Executive Producer. A staged development process was carefully managed, and three markedly different projects were taken forward. The first of these was *Heavy Load*, a collaborative documentary feature shot by Jerry Rothwell from APT Films following the fortunes of a punk band including people with learning difficulties as they simultaneously campaign for recognition and attempt to break into the mainstream. The second project was lead by Hi8us South, and involved young people involved with two other ITM Projects – UK Sound TV and Beatz! Camera! Action! The story charts the rise and fall of people involved with the Grime music scene in East London. The final project came through the more conventional route followed by leading UK production company Parallax East. A series of developmental workshops were held with an established writer in Great Yarmouth, and these were used as the inspiration for a script about seaside deprivation.

A second project which established new links across the partnership was Beyond the Numbers Game. This is explored in greater detail in Chapter 3. However it is worth saying that the project initially arose from a frustration Hi8us experienced with the efficacy of the performance measures used by funding agencies in relation to production work with marginalised young people. We wanted to find a way to understand and evaluate the work which flowed from the activity rather than criteria imposed by policy makers. Our ambition was to undertake a project capable of making a straightforward policy intervention, and this ultimately crystallised into the development of digital tool for use by young people participating in media production work. The idea for the project came from Hi8us and the research was driven forward by a research team from Goldsmiths, University of London. The skills, expertise and knowledge provided by Goldsmiths mean all those involved in participatory media work with young people stand to benefit.

Transnational work
Hi8us had not had an opportunity to undertake any production work with like minded organisations in Europe before ITM. This was something new which we welcomed. One of the consequences of Hi8us' role as the lead partner in a European funding programme was to force us to undertake transnational work.

A specially organised Equal conference in Birmingham proposed two modes of transnational working. The first simpler model looked at the exchange of ideas and experiences through transnational seminars

conducted across a series of countries, while the second more complex model focused on a shared project or work programme taking place in a number of countries. Hi8us was keen to explore the second possibility and we identified a number of prospective partners responsible for art and media-related Equal projects in other European countries. Miramedia hosted our initial meeting in Amsterdam, and the partnership quickly decided to focus on digital storytelling. This simple yet effective means of storytelling embraced creative work and training; in many ways it was the archetypal Hi8us project. Completed films were hosted on a special website which evolved into a collage of personal stories from across the participating countries. DigiTales attracted attention from a number of different sources, and only a year after the project officially launched we received approaches from other projects wishing to contribute to the site. Juliette Dyke describes the ambitions and work of the DigiTales partnership in Chapter 7.

Fellow travellers

Work across the Inclusion Through Media partnership benefited from the active interest and involvement of a number of key strategic media organisations operating in the UK. The most important of these was undoubtedly the BBC. Staff from the BBC attended Development Partnership meetings and Lynne Connolly, a BBC volunteer and active member of the Hi8us Projects Board, played an important role in developing and evaluating the overall ITM programme. The BBC also contributed expertise and resources through their Corporate Social Responsibility programme, and this was particularly important in building the capacity of the partnership. In the longer term we are looking at ways in which we can use some of the work as a springboard so Hi8us and the BBC can work together on key projects.

Staff from the UK Film Council also participated in the development of ITM, specifically through contributions to Beyond the Numbers Game and by taking a wider interest in the quality, range and amount of work taking place during the life of the programme. The National Endowment for Science Technology and the Arts (NESTA) played a similar supportive role. Large government departments such as the Department of Health and the Department for Education and Skills also supported the work of specific elements of ITM.

The Regional Screen Agencies lent support to developments in the areas where Hi8us had been an active presence before 2004, and by the middle of 2007 Hi8us was in active discussions with South West Screen about the future of Hi8us Cornwall. We were also able to forge long-term partnerships with Higher Education, and our work with Goldsmiths, University of London, and University of Central England (Birmingham) en-

sures we are well placed to take forward key projects in partnership with larger organisations.

Policy implications

The Equal programme is promoted as a space for innovation and experimentation; somewhere that allows people to take risks through an 'action research' programme. The longer-term ambition is simply a desire to influence mainstream practice by allowing innovators to experiment, in the hope that policy makers will adopt this experimentation. The University Research Laboratory is offered as a point of comparison, and this leads directly to perhaps the most fundamental criticism of the programme. Universities often have years to undertake research and they do not ordinarily work with 'hard to reach' communities. The Equal ambition is laudable and the creative space is universally welcomed, however it is virtually impossible to deliver the desired change in the limited time available. Creative freedom is further diluted by the imposition of a stifling bureaucratic system, which although intended to provide accountability starts with an assumption that every missing bus ticket is evidence of a likely fraud.

The reality is that developing and sustaining creative projects takes time. Industry players may notice when something is adequately proven or acquires a sufficiently high profile, but the reality is that they almost certainly will not adopt an innovation from the public sector in the pilot phase. All the partners in Inclusion Through Media have tried to address this and a number of people have worked across different elements of the programme to provide them with the sustained practical experience needed in a world where you are as good as your CV. These people will hopefully have enough experience to build careers in the media sector. Policy makers and funding agencies need to recognise that this is a sensible practical outcome. It will marginally increase diversity in the media industry, though regrettably it will not make a sustained difference. The only way to achieve this is to provide programmes like ITM with the same degree of stability as a University Research Laboratory.

Endnotes

[1] See www.inclusionthroughmedia.org.
[2] Commission for Racial Equality.
[3] See Regional Studies Association 2001 for a complete description and exploration of New Labour's regional policy.
[4] Now know as the UK Film Council.
[5] See www.equal.ecotec.co.uk for detailed information about the full Equal programme. Round One ran from 2001 to 2004 and Round Two from 2004 to 2007.

[6] The producing partners are Hi8us Projects, Hi8us Cornwall, Hi8us South, Hi8us North, Hi8us Midlands, Creative Clusters, Musicians in Focus, Goldsmiths, University of London, Mental Health Media and Parallax East.

[7] See www.inclusionthroughmedia.org for a full list of all the partners in Inclusion Through Media.

[8] For a description of the Creative Industries sector across Europe see Hackett et al. 2000.

[9] For a detailed analysis see Powell 2003, op cit.

[10] For example, The Equalities Charter for Film (www.diversitytoolkit.org.uk/glossary/?term=equalities) is a public pledge, developed by the Leadership on Diversity forum, which is led by the UK Film Council and is made up of key companies, guilds, unions and trade associations in the film sector. The charter is a significant step towards an equality standard which will both help the industry realise the opportunities from diversity in film and provide a framework for action.

[11] Anti Social Behaviour Orders were introduced in the UK under the Crime and Disorder Act of 1998 as means to tackle anti social behaviour such as drunkenness, abusive behaviour and drug dealing. The orders place restrictions on an individual in an attempt to curb this behaviour. These restrictions affect a person's freedom without a custodial sentence.

Chapter 3
Beyond the Numbers Game
Understanding the value of participatory media

Ben Gidley

This chapter sets out some of the key elements in participatory media, focusing on the use of digital media to engage marginalised people (and in particular young people) and their communities. It draws on preliminary findings from the Beyond The Numbers Game project, a research project within the Inclusion Through Media (ITM) programme, and on a review of existing literature on participatory media.[1]

From 1994 onwards Hi8us regularly evaluated projects, but had grown increasingly frustrated at the efficacy of evaluative activity around young people's participatory media. The quality and scope of the different approaches to evaluation is variable and much of the evidence collected could be described as 'anecdotal'. Evaluations tended to end when media projects themselves ended, so it was difficult to answer questions about the longer-term impact of projects. Much of the work is completed at the request of funding agencies so questions posed reflected partial interests.

Over the years Hi8us has increasingly complied with funding bodies' conditions around certain 'hard outputs' (such as numbers completing a project, for example) but these criteria do not always adequately reflect the value or outcomes of participatory work. Hi8us concluded that this is true of the participatory film and media sector more generally and wanted to explore these questions through an action research project.

In recent years, there has been a growing recognition of the contribution of cultural activity to regeneration and policy interest in how culture can contribute towards social inclusion.[2] This has included debate about the impact of cultural projects or programmes on 'excluded' participants and communities. The heightened policy interest has resulted in this area

attracting more serious research attention and greater research funding. A number of broad-based literature reviews (e.g. Coalter, 2001; Jermyn, 2001; Reeves, 2002; Wavell et al, 2002) and more detailed policy-specific reviews (e.g. Staricoff, 2004; Evans and Shaw, 2004) have been published and cultural agencies such as the Department of Culture, Media & Sport (DCMS), Arts Council England and the Museums, Libraries and Archives Council have commissioned primary research in this field. There was a notable absence of interest in media activity.

For the reasons Hi8us took advantage of the opportunity afforded by the Inclusion Through Media programme to develop a programme of evaluation and research to explore the impact and effectiveness of participatory media as a tool for engaging young people in meaningful activity.

There are two separate but connected strands to Beyond the Numbers Game:

- Research to explore the short- and long-term impact of projects on participants;
- the development of an evaluation toolkit to help ITM partners evaluate work and its impact more effectively.

The chapter is divided into three sections. The first section, 'Lights!', sets out some of the key *ingredients* of a successful participatory media project, drawing on some of the models within the Inclusion Through Media programme. The second section, 'Camera!', examines more closely the *process* of engagement using media, identifying some of the central principles which must inform this work. The third section, 'Action!', looks at some of the *outcomes* of these sorts of projects, focusing in particular on outcomes for participants themselves.

Lights!

The Beyond The Numbers Game research team, based at the Centre for Urban and Community Research (CUCR) at Goldsmiths, University of London, has been looking at a dozen case study projects in participatory media. These projects have been part of the ESF-funded ITM programme or have been developed by ITM partners. All of these projects use media as a tool for participation, but in a wide range of ways. The projects are:

London
- Beatz! Camera! Action! – A youth music video project
- UK Sound TV– A youth broadband TV channel based in East London.
- Music for Screen and Drama – Using technology to enhance music education for visually impaired people
- *L8R* – Web-based interactive youth drama/education project
- *Be Roma or Die Tryin'* – Documentary DVD on Roma identity

Midlands
- StripSearchers – Comic art project
- Boost – Business development for digital enterprises.
- PCT Health / Beta – Breastfeeding Awareness DVD with young mothers
- Projecting Stoke – film-making project with various 'excluded' groups in Stoke

Cornwall
- Chew TV – youth broadband TV channel
- Liskeard Youth Group

National
- Converge – A project supporting community groups and young people to exhibit their video content on the Web
- Open Up – Anti-discrimination project

We have used a variety of qualitative research methods to investigate these projects, including interviews, focus groups, participant observation and analysis of media products. Where possible, we have used film and photography alongside the research.

We have identified a range of project types and a range of participant types – and this range reflects the flexibility of the participatory media model as understood within ITM. Projects seem to fall roughly into two categories:

1. Finite, distinct projects with already formed groups, in collaboration with youth or community workers. Examples include Be Roma, which worked with Roma youth who had been engaged by the Roma Support Group, or the PCT Health project, which worked with young parents already engaged by the Primary Care Trust.
2. New, longer-term projects with participants, who have often been recruited through projects of the first type or via existing youth or community provision, focused around an interest in and aptitude for a particular media form. Examples include UK Sound TV and Strip-Searchers, both of which built groups or 'crews' around a specific media form.

These kinds of media intervention projects therefore serve different people in different ways. The first category might include people who come from the most 'hard to reach' sections of the community, but have always been already reached by existing community or youth projects, so collaboration with these workers is a key ingredient of success. Here, the emphasis is on *enhancing* youth and community provision through media, in the ways which will be discussed in the course of this article: enhancing soft skills, giving voice, opening up new pathways.

In the second category, participants have generally shown some skills or motivation for a media form – perhaps a skill that has not been valued in formal educational settings, a motivation that has not been ful-

filled through mainstream provision. Again, if participants come from the 'hardest to reach' sections of the population, they have nonetheless already been engaged in some way. This means that the value of participatory media may not be as a tool of *initial* engagement with the 'excluded,' but rather as a tool for relationship-building and development.

In both cases, media acts as a 'hook' for engagement, in the way that the arts or sport can also act as hook for other sorts of engagement projects.[3] ITM uses a range of media (including film, music, web design, graphic art, digital photography) in its work with participants. Such media forms – particularly new media forms and media forms with strong resonance in popular culture, such as the Web or music video – have a glamour or kudos that is extremely helpful in building engagement. At the same time, media work offers something to participants with a wide range of interests and skills – from the creative to the technical, from the 'behind the scenes' to the on-stage performance – and does not require formal literacy.

More specifically, ITM takes a quality-led, professional approach to the use of media. In the production process and, crucially, in the product, ITM projects have aimed at achieving industry standard. For example, the comics produced by StripSearchers have had as good production values as any comics in the commercial market. Young participants, in particular, appear able to recognise this quality – as they are often already highly media literate – which contributes to the allure of the projects for them. For example, the fact that the film-maker who worked with the Roma youth on the Be Roma project had a track record with the BBC was a mark of quality for the participants. At the same time key audiences, such as potential employers in the industry, are also able to recognise this quality, which opens up new pathways into the industry. Consequently, we believe that the use of media alone is not a key ingredient of a successful participatory media project, but that *quality-led media* is essential. (We will explore this further below, in looking at how quality-led media work affects the *process* of participatory media.)

In both cases, a youth work or community work approach is also an essential ingredient. In the case of projects like Be Roma or the Breastfeeding Awareness DVD, support from youth or community workers already in place with the participants was essential for maintaining the group's involvement through the project. In the case of projects like UK Sound TV, media workers take on the role of youth or community workers to support the participants. We characterise this as a *developmental and non-authoritarian approach to participant engagement*. By 'developmental,' we mean a *holistic* focus on the participant as a whole person (i.e. not solely in terms of their media skills), a focus on the participants' *own* needs and desires (i.e. not just in terms of labour market outcomes), and support for

the developmental pathways that will best fulfil these needs and desires. By 'non-authoritarian,' we mean approaching the participants respectfully and allowing their own motivation and enthusiasm (rather than an injunction to complete a course) to set the pace.

Connected to this non-authoritarian approach is a range of possible styles of engagement that make workers appealing to participants. For example, one participant we interviewed from the Breastfeeding Awareness project spoke of Hi8us workers as 'down to earth' and 'even though they were older, they were fun and with it'; another said, 'I felt my opinions counted'; another said, 'they were on our level, they made us talk, listened and supported us and were not bossy'; another said they were 'cool' and 'proper'. These features can be especially true if staff are of similar age and/or come from similar backgrounds to the participants, if they work in spaces that participants can have some sense of ownership over and if the work focuses on things relevant in the young people's own lives.[4]

When the media workers, or youth workers or community workers in partnership with the media project, take this sort of approach, it is possible for them to become embedded in an area. As an example of this, one former Hi8us South participant we interviewed (who later became a worker) spoke of a chance encounter in a local chicken takeaway with a worker he had met briefly on an earlier project; this chance encounter brought him back into contact with the project and ultimately changed the course of his life. If the worker had been a media professional brought in from elsewhere, rather than a local resident himself, then this encounter may never have happened.

As well as the importance of this approach and of media as a 'hook,' the final point that emerges from looking at the range of projects and participants is *flexibility*. It is clear, given the variety of types of project and participant, that participatory media is a flexible tool. It is appropriate for working with all sorts of people (for example, with those with physical disabilities and impairments, with young people, with 'excluded' adults and with those with mental health issues) and in all sorts of settings (rural and urban, school- or youth club-based and community-based).

Camera!
Examining the process of participatory media, as exemplified by ITM projects, we are convinced that the use of media and a developmental approach can each be demonstrated to add value when used side by side; for example in terms of the added intensity and enchantment generated by high quality media products, the quality of craft skills, soft skills and creative skills generated in the media apprenticeship experience when these are delivered in the context of a developmental and holistic approach,

and the ability of high quality media products to give voice to participants and communicate their stories to audiences when the participants are properly supported.

A developmental and holistic approach

In an account of a long-term study of six youth engagement projects, Tim Crabbe et al. (2006) identify a series of characteristics in workers that are central to what we are calling here a developmental and holistic approach to engagement. First, there are the characteristics present in friendships:

- Interest in participants' wellbeing
- Concern over their future plans
- Co-receptive trust and respect
- Familiarity and knowledge of personality traits
- Warmth, joviality and humour

But, crucially, there also 'additional characteristics which relocate their relationship with the young people from that of a pure "buddy" to one of "buddy/mentor/coach"':

- Consistency and reliability
- Setting of appropriate boundaries relating to language and behaviour
- Written or unwritten codes of conduct
- Purposeful and developmental aims to the relationship

These characteristics are also present in the participatory media projects we researched. For example, during our observations we saw relaxed and convivial interactions between workers and participants, but also challenges to inappropriate behaviour. Similarly, in interviews participants reported feeling supported and trusted by the workers – for example responding positively to being trusted with expensive equipment):

> 'And then one day I said to M—, "how about this music show my friend's doing? I wanna film it." I said, "do you think I could take a camera? I'll leave money or something down, I'll write seven addresses down. You don't know me, and I'm asking to take a 3.5 grand camera." And they were like, you know, some of the guys said, "that's fine you can take it. You can use the equipment, that's fine it's what it's there for..." I was like, "are you sure? Come on man, I can't take this." They were like, "no no no"... That was really nice to have someone trust you with their equipment and stuff. That was really cool... It's weird but once somebody trusts you, you just think, you know what, I got respect for you. I'm not gonna let you down. I'm gonna try to be a good person you know.'

From these characteristics, Crabbe et al. develop a three-step model of engagement, which we find useful in thinking about using media as an engagement strategy:

Step 1: Initial engagement and relationship building phase
- Use of activity as a 'hook'
- Use of initial relationship building tools including humour and conviviality
- Allowing 'risky' language/behaviour to go unchallenged to avoid 'distance'

Step 2: Maintaining engagement / Developmental phase
- Development of a mutual bond with each young person
- Distinguishing young person's needs and interests
- Signposting to appropriate schemes of work

Step 3: Purposeful & tailored engagement
- Maintenance of a consistent level of engagement and familiarity
- Challenging inappropriate behaviour
- Accreditation of activities
- Person-specific advice and signposting to specialist agencies

A key point here is that this process, getting from step 1 to step 3, does not follow a fixed timetable: with some young people, it can happen incredibly quickly; with others it can be a long, drawn-out, intensive process. As the really important work – supporting individual career pathways, challenging difficult behaviour – does not occur until the third stage, which means it is important (and this is a key point for funding) that projects are allowed the time and space to reach this third stage. As an example, a Hi8us South project, Beatz! Camera! Action!, worked with the Bomb Squad, a crew of young people based in E14, but was using a studio in E3 (Bow). The Bomb Squad had in the past had run-ins with the local crew in E3 and felt the need for weapons for protection. When the worker realised they had a weapon, the session was stopped. There ensued a long discussion about the need to carry a weapon or not. The majority took it on board and stopped bringing weapons for protection. Reaching this decision was based on the worker having built up a strong relationship of trust with the participants, trust which cannot be built up overnight.

Intensity and glamour
The study by Crabbe et al. focused primarily on sport-based inclusion projects, where the sport was identified as having provided added value to this engagement strategy. We believe that media itself similarly adds something significant. Central to this is the *intensity* that can be generated by media: its glamour, buzz or kudos. This can be seen at a number of levels. We have already noted the glamour of media (and especially digital media, music and film) serving as a hook for engagement; it continues to serve in this way to *maintain* engagement as projects move into steps 2-3 of their engagement strategies, which is crucial when working with 'excluded' communities.

Central to this glamour is the concept of *brand*. The power of branding within participatory media can be seen at a number of levels. Cen-

45

tral to the success of Hi8us projects has been the build up of significant 'brand equity,' both in terms of 'family branding' (the Hi8us brand) and 'individual branding' (the brands of projects, like UK Sound TV, Beatz! Camera! Action! or StripSearchers). In youth culture contexts such as in the East London neighbourhoods where Hi8us South works, this brand equity can be built up through word of mouth exchanges amongst young people – an alternative form of 'viral marketing' typical of contemporary youth culture.[5] Thus former Hi8us South participants we interviewed, when asked about how they knew about the project, said they heard about it from friends.

With locality-based participatory media projects – with UK Sound TV or Projecting Stoke, for example – this sort of viral branding dovetails well with the territorialism that is very much part of contemporary youth culture.[6] Thus, for the young people, 'representing' their project and its products can become closely tied up with 'representing' their 'ends' or neighbourhood. For example, Hi8us South has developed projects around the Grime music scene that is strongly identified with inner East London. For instance, as already noted, the crew of young people involved in the Beatz! Camera! Action! project, the Bomb Squad, has a very strong territorial identity, defined by their location in area code E14.

From our interviews and observations, when young people actively participate in these sorts of projects – particularly, as we will discuss later, as part of a *collectivity* or 'crew' focusing on *producing* some sort of media product – then they can build up high levels of ownership of the brand, so that 'representing' the project becomes a source of pride and empowerment. An example of this would be when project participants are involved by the project in screenings, such as the film festivals where *Be Roma or Die Tryin'* has been shown, and participants in its making have presented it.

A corollary of this point, however, is that this sort of work loses value if participants are unable to build up ownership of the project (and its brand) because of limits set by funders or commissioners of the work. We saw this in two of our case studies. In one, the commissioners of the work set the topic of a short film made by young people, a topic to which the young people found it difficult to relate, and hence did not establish a sense of ownership over the film. In another, the funders set the topic, and the young people related to it, but the version they came out with did not conform to the values of the funders, so they had a sense of ownership over the film, but not of the project, as the film was never screened. In both cases, the sense of empowerment that we have seen in most of the case studies was not visible; instead, the participants felt disillusioned and disempowered. Although the participants have certainly come out of these projects with something they didn't have before, they have not had the sense of completion that participants in other projects get, which leaves

them feeling let down. This underlines the importance of developing alternative platforms for communities' and young people's media content, as will be discussed below.

The production process

If glamour and kudos represent one facet of the intensity of participatory media, the production process represents another. Although the details vary from medium to medium (for instance, there is a significant difference between those media which tend to promote individual working, such as comic art, and those which tend to promote collaborative working, such as film production), in general media production is often an extremely intense process. The pressurised time schedules of production – deadlines before screening or publication, limited time windows due to the high cost of renting equipment or to the availability of the right light, the complications of assembling the crew and cast at the same place and the same time – are significant components in a sense of intensity and excitement that gives media work a particular buzz for participants. As one interviewee, a former Hi8us South participant, put it, 'I felt when I came out you know yeah I could actually do something… I could actually work on a film. I was excited.'

The production process tends to require the co-ordination and synchronisation of several elements, such as the different talents of the producing participants and the different pieces of hardware or kit needed. The evaluation literature emphasises the value of the collaborative nature of media work, suggesting that, as media production is a mostly collaborative affair, participatory media projects offer their participants a unique opportunity for not only developing their creative but also their social potential. For example, Madzey-Akale (2005) explains in her evaluation of Phillips Community Television, a not-for-profit youth media education organisation, that because media production is a team-work activity with a number of roles to play, it can effectively engage with a wide range of youth: 'Most [youth] are able to "find a niche" in the media and technology processes and are encouraged to flourish' (6).[7]

A key aspect of this collaborative dimension that we have witnessed is that *different participants' individual creativity makes a significant difference to the endeavour*. In the production crew, each individual participant brings unique qualities and thus makes a unique difference – their presence is not interchangeable with that of any other person. This is what the theorists Deleuze and Guattari (1988), drawing on the anthropologist Elias Canetti (1973), called the 'pack' as opposed to the crowd or mass. In the pack (such as the youth crews Hi8us South work with – the Wolf Pack and the Bomb Squad), the difference members make is *qualitative* rather than quantitative – new members do not simply contribute additional *mass*,

but unique *qualities* that make a difference to the product. Thus pack collectivities – and relationships *within* them – tend to mutate over time, and the difference between individual and collective actions tends to blur. The difference between the pack and the crowd can be summed up in the difference between a crew member and an extra: the crew member's function may or may not be clearly defined and may not be equal to that of other crew members, but makes a crucial difference in the production, whereas the extra can be substituted by any other extra without making a difference. As Canetti writes, every pack member is 'a distinct, substantial and indispensable addition... The position he occupied would be clear to all; he would really count in the economy of the group, in a way that scarcely any of us count today... they are a few, and have to make up in intensity what they lack in actual numbers' (109).

This pack dimension of crew membership – as with youth gang membership – generates an intensity that impacts directly on the participant; the participant changes with the process.[8] This intensity and its impact is captured in this passage from an interview with a former Hi8us South participant: 'They were like come in, stand up, now you're part of the team, working with film. So I was excited man, and then you had to shoot.' Similarly, in our observational study with Projecting Stoke, such moments, for example when participants were told 'Now you're the camera man,' were visibly transformative for them.

This point leads us back to the issue of *quality* in media work. There is already anecdotal evidence from arts workers that a sense of pride in work and the quality of the product relate to the sense of success that participants and artists feel when the project is complete. 'There was a belief among artists that the better the final result, the greater participants' sense of achievement' (Jermyn 2004:47) In most of our case studies, either participants have articulated or we have been able to witness the *moment* when participants transcend a 'youth club' ethos and start to view themselves as professionals, often spoken about in interviews as when they feel that they have achieved a certain 'sharpness' in their game, a certain level of quality. In UK Sound TV, for example, we can see this in the moment when one young woman 'stepped up' to an interview with a particular MC she was previously intimidated by. This feature underlies the importance of giving participants formal roles – Youth Producer, for example, or Production Trainee.

Key to this sense of quality has been the catalysing encounter with media professionals, rather than just trained youth or community workers or trainers, as mentioned by several interviewees. For example, a participant in the Breastfeeding Awareness DVD spoke of 'a once in a lifetime experience working with professionals,' and the participants in StripSearchers spoke about working with professional comic artists

Breastfeeding Awareness DVD group in Birmingham (Hi8us Midlands)

Hunt Emerson and John McCrea. Similarly, participants in Musicians in Focus commented on the 'privilege' of working with London Symphony Orchestra members: one participant said: 'mutual respect grew... being surrounded by such quality, the level was unreal. [It makes you] raise your game'. This echoes Halsey et al.'s finding, in their study of NESTA-funded arts education projects, of the value of working with staff who are professionals in their field and thus exude expertise and authenticity (2006).

Connected to this is the element of *challenge* in the sense of giving participants challenges to overcome – interviewing stars who you were intimidated by, taking on the role of director or camera operator – which can be enormously empowering. Facing up to challenges, and the transformative moment at which a professional role is taken on, has added value too in that it enables the sort challenging behaviour mentioned by Crabbe et al. When participants are facing the challenges thrown up as part of the media work, they become more open to challenges to their outlook in general – and thus confronting weapons culture or sexist language, for example, is made easier for workers.

Finally, in terms of the production process, there is the value of the mo-

ment at which the process generates a finished product, a tangible sign of the work the participants have done.[9] This is important in terms of participants (particularly those who lack formal accreditation from their previous educational experiences) having something to show for themselves, for example as a portfolio that can be taken to potential employers. But as well as this 'hard' outcome, there are 'soft' outcomes around the final product that are valuable too. The moment of the final production – for example of performance or of screening – is one of the most intense moments in the production process. One former Hi8us South participant illustrated this in an interview:

'When we finished the short film, it was like yeah yeah yeah, we're gonna show it at Genesis. You know… nothing prepared me for that. I'd never seen anything that people had done that I'd been close to, especially on the big screen. So then they showed it and it was like, I think about 600 people came down in the end. There were four screens, 150 seater cinema, and they had four sessions. And they were all packed. I had to stand in the back. All my family came down… It was very emotional. I couldn't sit down watching so I was like walking around at the back, and people started laughing. I was like I couldn't believe it. That was one of the most amazing feelings I've ever had. And afterwards, they had drinks afterwards, and they were yeah, you're really cool yeah. It was just a stupid little short film, crazy and stupid. It's you know, a lot of people were like, yeah, you know you've never done this kind of thing before, well done, cool, what you're going to do next? I was like, yeah I was excited, I was buzzing. And so it was good, and after that I started doing editing.'

A Musicians in Focus participant also used the word 'buzz' about the performance, noting the importance both of getting feedback, and on seeing what you created: 'We gave birth to a piece of music entirely our own'.

In this section, we have seen that the *intensity* and *quality* of participatory media is central to the value it brings to engaging the socially 'excluded'. This intensity, however, comes with a risk that, if expectations are not managed well, then the intensity can be followed by a coming down. Thus, with one of our case studies, a strong sense of excitement that built up was followed by disillusionment and disempowerment when lack of further funding brought the participants' engagement to a premature close.

Action!
As the previous section looked at the production process, focusing on intensity and quality, the next section looks at the outcomes and impacts of participatory media, looking at both 'hard' and 'soft' outcomes and impacts. While 'hard' outcomes are widely accepted in monitoring and

evaluation models for social inclusion and media work, the 'soft' outcomes and impacts need to be particularly stressed, as they are so often neglected.

Engagement pathways

As already suggested in this chapter, the model used by many ITM projects, especially the Hi8us projects, is one which emphasises the creation of alternative pathways into the media industry, building on an initial engagement using media as a hook, through a developmental or holistic approach to the participants. This is best exemplified in the life stories of some of the individuals we interviewed, such as Asia Alfasi, the young graphic artist discussed in Chapter 9b of this book, or the group of young men we interviewed at Hi8us South who have progressed through their engagement in Hi8us. These young men have graduated from being users of projects to being volunteers to being trainees, and finally, in some cases, either freelancers employed by Hi8us while developing their own enterprises, or employees of Hi8us. In many cases, in both Hi8us South and Hi8us Midlands, individuals have been referred from one project to another, as they develop new aptitudes and new aspirations. In other words, the range of projects Hi8us has developed in its regional hubs has enabled it to provide 'bespoke' pathways appropriate to individuals' unique trajectories.

Many of these participants *either* had no routes to take this forward *or* were not being fulfilled by (or have been disengaged from) formal routes. For example, one had become disengaged at school and left with few qualifications despite obvious talent; another had struggled to find something that interested them after school and had dropped out of further education. These individuals serve as examples of how participatory media can provide alternative pathways outside mainstream education or labour market institutions for young people with passion and talent.[10]

Their stories highlight the fact that individual pathways rarely follow linear progression routes, but instead are characterised by dramatic ups and downs, periods of intensity and periods of disengagement. Often, former participants spoke to us of periods in which they 'lost touch' with the projects, before chance encounters or targeted outreach re-engaged them. Working with 'excluded' residents, and especially 'excluded' young people, therefore requires the non-prescriptive, non-authoritarian and developmental approach described above. There is no single 'one size fits all' model of progression into the media industry that can be prescribed for all participants.

As these alternative pathways are developed within the projects, the possibility is opened up of formal and informal mentoring, and of role models.[11] One former participant told us:

'I see other people, I see people like S—, I see people like L—, you know they do sometimes inspire me to do things. I see people around me like, definitely M—. Cos M— he's just like, he's been with Hi8us, now he's got his own established company. They've won an award, they've been in The Guardian and various things. They've done a lot for themselves, and that's something I see myself much later in life establishing. Definitely. When you see people like that, you think it is possible. It's not just a dream. It is a possibility. There is a reality within that, which is very important to me.'

So far, within Hi8us, this model has been conceived in terms of apprenticeship – a model appropriate to the intense, learning-by-doing ethos of media production. The Hi8us apprenticeship model is not the hierarchal master-apprentice relationship of some tradition craft training, but a collaborative process. Only more recently have possibilities around accreditation been explored, for example through the Arts Award. Accreditation is positive, because it gives formal recognition to the sense of achievement participants get from the media work. But it is worth stressing that this sense of achievement is recognised and valued in other ways in the work of ITM projects, such as in the final products the participants produce (for example published comics, films that are screened publicly, a website that is visited by users across the planet). It is also recognised in the personal recommendations and contacts opened up for participants in the media industry.

In many cases, the projects act as an interface between participants' local informal / territorialised networks and previously inaccessible industry networks. This is illustrated by StripSeachers, which enabled participants to access events and meet other artists and publishers, in an industry that is based around informal networks. It is illustrated by the Midlands Comic Collective, the collective created by StripSearchers graduates to support each other in accessing these networks. It is illustrated by many of the stories we were told by former Hi8us South participants who had been given opportunities to work in the industry after professionals saw their work on projects.[12]

There are a number of key lessons from the nature of media progression routes as we have seen them in the study. First, the simple existence of interaction between 'excluded' people and media networks is not enough; the *quality* of this interaction is crucial – media professionals working closely enough and at a high enough level with participants for them to be able to personally recommend the participants to employers, or portfolio products that are industry standard. Second, work with 'excluded' individuals and communities, and especially with young people, must unfold in a long-term, sustained way – doing justice to the uneven, non-linear stories of participants.[13]

Skills

Looking at our case studies, we have identified three types of skills that participants gain through engagement with media work: 'hard' craft skills, 'soft' life skills and creative skills.

'Hard' craft skills – using cameras, writing code, inking comics, editing and so on – are clearly valuable in social inclusion and employability terms, because they are most easily measured and accounted as human capital – as skills which are marketable to employers.[14] Sometimes (as with Strip-Searchers or many of the Hi8us South projects), participants already have (some) such skills, and the project is important for valuing and recognising this – especially if these skills are deployed in the context of non-mainstream youth culture, such as graffiti art, 'spitting' lyrics, or sample-based music. In other examples (as with the Breastfeeding Awareness DVD), the project brings skills to people who have little or no experience.[15] This is important because of the lag between media use in formal settings, notably schools, and in the wider youth culture:

> Although students are sophisticated users and viewers of video, multimedia computing, interactive gaming, and text messaging in the real world, predigital definitions of school success require young people to park their media skills and cultures at the schoolhouse door. Youth media programs bridge the gap between students' use of advanced technologies at home and in social settings and their dismal integration into the formal school curriculum. (Tyner 2003:6)

However, accounting for these skills in ways that make sense in social policy terms can sometimes be in tension with the intensity of the production process where participants learn by doing, and with the developmental approach discussed above. Formal accreditation models are often very linear: typically, in such models, trainees graduate progressively from more basic skills and knowledges to more advanced skills and knowledges in clear, defined stages. In the production process, however, learners often have to 'run before they can walk,' doing things they don't yet fully understand and only later come to an understanding of.[16] The pressurised time schedules of production often make this even more so, as learners may not have time to learn things in the prescribed order.

Formal accreditation models are also by definition very individualised in that they focus on an individual trainee building up a corpus of skills and knowledges. The production process, however, is often very collaborative, and skills and knowledges can be built up in a team rather than in an individual and, crucially, can often best be evidenced by collective work rather than an individual's portfolio, which makes it harder to calibrate with a formal accreditation model. The intensity, the non-linear unfolding and the collaborative nature of media might, therefore, fit better with the relatively informal pedagogical models which have been more

typical of participatory media. Consequently, a shift to an accreditation model needs to be managed very carefully.

Furthermore, the media industry itself has traditionally worked on the basis of an informal apprenticeship model and through networks: formal accreditation has not been significant in getting employment and progressing in the industry. Thus, if there is a shift towards an accreditation-based model in participatory media and youth media, following the Skillset agenda, it is vital that the apprenticeship model built into many of our case studies is enhanced not sacrificed, and, above all, that the industry networking dimension discussed above is not sacrificed.

A final point to be noted about the craft skills is that their value is not just in terms of labour market outcomes, and certainly not just in terms of the media industry. Media literacy has become a crucial part of everyday life (Goodman 2000; Potter 2005; Aufderheide 1993). We found it interesting that some of the former project participants we interviewed talked about helping their friends with IT issues – this kind of outcome (ripple effect) is unlikely to be recorded for funders and yet is beneficial in wider informal ways, especially in 'excluded' communities.

'Soft' life skills are fundamental to the value of participatory media, and increasingly regarded as important, but currently poorly defined.[17] We have taken the following as examples of soft skills we saw in our case studies:

- Confidence
- Time keeping
- Social development
- Teamwork
- Successfully dealing with changes and challenges
- Sense of direction
- Organisational skills
- Personal development
- Decision making
- Communication

Additionally, one former participant suggested to us that learning itself was a skill that had to be learnt – he had had a poor experience with school and it took him some time to 'learn how to learn'.

Developing any of these soft skills is useful both in life and for employability. And they also help with the development of qualities like self-esteem and motivation – which are again also valuable both in life and for employability. Because of the 'soft' qualitative nature of these skills, they are most often missed by formal, quantitative methods of evaluating and accrediting projects. Participants in the Breastfeeding Awareness project that we interviewed spoke of some of the benefits they gained from the project. One said it gave her 'confidence – I'd been through a difficult time

and this helped me find my feet again'. Another said it made her feel 'proud of myself'. Another said she learnt respect, how to express herself, to justify her views and to communicate well; 'it makes you realise that you can do things'. Participants in Musicians in Focus reported enlarged social networks. They also reported raised aspirations: many had not thought of themselves as university material or of composition as a career option, and were now pursuing these.

These things are less tangible and measurable than 'hard' craft skills, but no less valuable. As Halsey et al. write, 'Increased confidence, improved self-esteem, capacity for self-expression, enhanced social skills and raised motivation, were all documented in the literature as contributing towards reducing social exclusion' (2006: iii). This is particularly the case as many participants do not move into the media industry (none of the young mothers involved in the Breastfeeding Awareness DVD had aspirations to work in the media industry). For those that don't, in particular, these soft skills are valuable because they are *transferable*; they can be used in other sorts of employment and in other parts of the participants' lives (Jermyn 2004: 16-17). This was explicitly noted by one former Hi8us South participant in an interview, when asked what he'd gained from his involvement: 'just like, [how to] approach people, talk whatever, if I need to. I've learnt like general skills that you would need in life really, which I find quite important.'[18]

It is worth noting that the developmental, non-authoritarian youth and community work approach we advocated in the previous two sections – rather than a more straightforward pedagogical approach focused solely on media craft skills – is the approach most likely to bring out these sorts of soft skills. For example, the young mother quoted above who said the project helped her find her feet spoke of the importance of feeling that the workers thought her 'opinions counted'.

The third set of skills is the *creative skills* that are not specific to particular media, but not as general as soft life skills. Examples of these are:[19]

- Developing ideas
- Experimentation
- Telling stories
- Imagination
- Reflection
- Expression
- Working to a brief
- Creating pieces of work
- Reciprocity: exchange and feedback

The importance of these skills has been emphasised by the NACCE Report (1999), which posited an urgent need to develop creativity, and subsequently in the work of Creative Partnerships in building up the country's

'creative wealth'.[20] More recently, research for NESTA and the National Foundation for Education Research argued for the importance of 'creative outcomes such as developments in imagination, thinking skills, or capacities to invent or innovate' (Halsey et al. 2006:iii).

A key point in this literature is that creative skills are transferable to other aspects of life, including the development of enterprising behaviour, and also have a value in themselves. The very novelty of 'new' media encourages 'thinking outside the box' (Halsey et al. 2006); developing creativity through media enables participants to see new possibilities in technologies and in the world (Halsey et al. 2006; NAMAC 2003); and the ability to give and take reflective criticism facilitates both civic and enterprising behaviour.[21]

The combination or interaction of the three sorts of skills is vital, as Jermyn has noted, arguing that the way in which new skills interact creates a sense of internal transformation. This in turn relates back to the issue of media work *challenging* participants, which was referred to earlier in this chapter (for instance, in terms of challenging the Bomb Squad's territorialism and weapons culture). Facing the challenge of developing craft skills, building the soft skills that enable people to move into new worlds, and the creative skills that enable people to reflect on their situation, imagine other situations, and take risks to get there – these are all ways in which participatory media helps address social exclusion, without necessarily translating in the short term into labour market outcomes. This is summed up well in the words of one former project participant, of Bengali origin: 'I mean like coming to Hi8us I've learnt like, there is another world out there. Because... the area I'm from, the school that I went to was full of Bengali people. College: mainly Bengali... I come to Hi8us you meet people from like different ages and different backgrounds, you know. It was really interesting to see that... there's a whole world out there you know, gotta go out to explore.'

Telling stories

A final aspect of participatory media is that of performance and exhibition. Here again, the concept of intensity explored above is useful in demonstrating the value of this aspect. (This is illustrated by positive examples from Be Roma, but also a negative example, where the product was never released, thus disempowering the participants.) Performance and exhibition are also as valuable as way of *giving voice* to the participants, or allowing them to see the importance of their voice, enabling them to challenge their situations (NAMAC 2003). Thus, while the production process is challenging for the participants, the product can be challenging for audiences.

This dimension of giving voice and telling stories is well documented

in the literature. Shaw and Robertson (1997) argue that the value of media art is tied up with its ability to link the creative process to a clear and powerful means of communication. According to the literature, participatory media may allow youth to present and represent their own image or that of their community (Shaw and Robertson, 1997; Goodman, 2003; NAMAC, 2003), to engage them with the social issues of their community (Harvey et al, 2002), to want to 'give back' to their community – in short, to develop what Madzey-Akale (2005) calls 'public-mindedness,' developing a sense of agency around issues that effect them, and what Goodman (2003) calls 'civic literacy,' representing those issues to others. Goodman (2003) writes that

> Taking a video camera into the community as a regular method for teaching and learning gives kids a critical lens through which they can explore the world around them. It helps de-familiarize the familiar taken-for-granted conditions of life. (3)

An essential prerequisite of media production is learning to think critically about existing media forms. Media education 'enables young people to interpret and make informed judgements as consumers of media; but it also enables them to become producers of media in their own right, and thereby to become more powerful participants in society' (Buckingham, 2001; cf. NAMAC 2003). Stereotyped and misrepresented by mainstream media, participatory media enables its young participants to re-invent their media image (Goodman, 2003).[22]

A very clear example of this from our case studies is the *Be Roma or Die Tryin'* film, which explicitly set out to challenge stereotyped and racist notions of Roma people, and European Roma youth in particular. The DVD has since been used in educational settings, particularly schools, as a tool for educating young people about the reality of Roma life. Another clear example is the Breastfeeding Awareness project, where one participant we interviewed told us about the way she felt young mothers are not portrayed positively in general: she said that she didn't see others like her; the DVD experience gave her the opportunity to address this, providing real role models. Another spoke of the impact of 'seeing images of yourself and each other' and images she had been involved in creating – a very emotional experience. She felt strongly that the DVD was about their own experience and as such they were 'just telling the truth'.[23]

If giving voice to participants is a crucial aspect of participatory media, this in turn highlights the importance of building alternative platforms to exhibit participants' work – particularly given the points made above about the value of allowing participants to develop ownership of their products. Three of our case studies addressed this directly: the youth broadband channels UK Sound TV in East London and Chew TV in Cornwall and the on-line platforms opened up by Converge.[24] Chew TV

and UK Sound TV provide a platform for young people to exhibit work that would not get access to the mainstream media, creating a space over which young people can have a strong sense of ownership. Converge is a project that provides training to both media workers and participants in media projects in exhibiting their content on the Web, either through the main proprietary user-generated content platforms (YouTube and iTunes), using alternative non-proprietary platforms (Democracy Player), or by developing their own channels (using Broadcast Machine). Converge is based on open source and creative commons principles, and enables participants to facilitate open access to their content while protecting their rights over it.

Conclusion

Through this chapter, we have seen that the value of participatory media cannot be isolated in any of its components, but rather comes from the interaction between its different elements. A focus on high-quality professional media alone – or on participant-centred and developmental youth and community work alone – would miss the value added by the combination of these in participatory media. Participatory media must be seen as a *process*: starting with the 'hook' that media offers, going through the intensity of media production, to the buzz of seeing a finished product. This process can be uneven – like participants' own lives, it does not follow a set, linear pathway – but it almost always requires duration, a long-term investment. Similarly, an emphasis solely on measurable outcomes, whether in terms of hard skills or employability, would miss the point of the *impact* of the work on people's lives, including their soft and creative skills, their civic engagement, and the stories they can tell through media.

Endnotes

[1] The research team has been led by Ben Gidley, with Imogen Slater as the principal researcher. The team has also included Tony Dowmunt, Simon Rowe, India Court MacWeeney, Paulo Cardullo and Alison Rooke. The research has been very much a collective endeavour, and all of these people have contributed towards the writing of this chapter. The chapter also draws on case studies developed by Robert Smith for the Be Curious evaluation of Inclusion Through Media. We also want to thank the project workers and participants who gave their time to the research project.

[2] See, for example, *Policy Action Team 10: Report to the Social Exclusion Unit – Arts and Sport* (DCMS, 1999) and *Culture at the Heart of Regeneration* (DCMS, 2004).

[3] Compare the findings of the Positive Futures National Case Study Research Project for sport as a 'hook' for engagement (Crabbe et al. 2006). However,

Trainee producer mixes the UK Sound TV Show

clearly media has its own specific power as a hook; Shaw and Robertson write about the very presence of camera as a motivating factor for involvement and a stimulus for communication (1997).

[4] Halsey et al. (2006) and Lord et al. (2002) report similar findings, based on studies of NESTA- and EU-funded media education projects.

[5] Centre for Urban and Community Research and Crime Concern Trust UK (2006).

[6] Cohen (1997), Gidley (2007).

[7] These point s are more relevant for some media than others – e.g. Lord et al. found that video production training was most effective at building teamwork abilities (2002:66) – but our case studies found strong collaborative aspects in the Hi8us approach even to more 'solitary' media forms, such as graphic art.

[8] The importance of the collective in media has led some authors to focus on participatory media's value in terms of opening up alternative modes of learn-

ing: to learn socially (Lord et al., 2002). The collective dimension in creativity has been discussed by Chappell (2007b), who analyses a number of forms of 'collaborative' and 'communal' creativity", including 'controversial collaborations,' 'complementary collaborations,' 'integrative collaborations' and 'inclusive leadership' (36).

[9] Shaw and Robertson note that the media process enables participants to 'develop a recognition of their capacity to achieve results, and this can be the first step towards self-help in other areas' (1997:12). This is most apparent at the moment of screening, publication or exhibition.

[10] Cf Harvey et al. (2002) for similar arguments.

[11] For similar findings from the NAMAC youth media initiative in the US, see Tyner (2003:5) and from the Positive Futures youth engagement programme in the UK, see Crabbe et al. (2006). Tyner talks about the possibility of youth media 'modelling peer leadership activities' (cf NAMAC 2003).

[12] The interface between industry networks and local youth and community networks might also be of immense value to the industry itself, as user-generated content and narrowcasting become more important. As one former participant from East London told us: 'Every industry in the world wants to know what's going on in the street.'

[13] This point is sustained by the literature. Jermyn (2004) argues that in order to see long term 'hard' outcomes from arts programming in the areas of crime, education and employment, we need to carry out long term participatory arts projects and the longitudinal analysis of such projects. In turn, this points to the need for long-term research and evaluation: longitudinal tracking of participants as they move on from engagement in projects. This is a point that (see Harvey et al. (2002) and Jermyn (2004) have made too.

[14] For other literature evidencing the development of hard skills through participatory media, and its transferable/employability potential, see Shaw (2003), Lord et al. (2002), Harvey et al. (2002), Shaw and Robertson (1997), NAMAC (2003), Jermyn (2004).

[15] Harvey et al. (2002) similarly argue that an engagement in participatory youth media programmes might help fight social exclusion in the form of building on extant skills and resources in order to engage with the wider community both professionally and personally. Hence some studies emphasise the value of media work in feeding young peoples' interest in and significant knowledge of popular media cultures and forms (Goodman, 2003; Halsey et al. 2006).

[16] In the scholarly literature, this is often conceptualised in terms of 'cursive,' 'embodied' and 'practical' forms of knowledge (see Chappell 2007a). There is also an emphasis on the possibility of 'formulaic' forms of pedagogy 'dampening' the creative process involved in passing on such skills (Chappell 2007a).

[17] On soft skills in general, see Gale et al. (2002), Employability Skills for the Future (2002), Newton et al. (2005). On soft skills in participatory media, see Shaw (2003), Halsey et al. (2006), Lord et al. (2002), Harvey et al. (2002), NAMAC (2003), Madzey-Akale (2005).

[18] Other literature gives examples of the impact of media and arts work through soft skills. Matarasso's (1997) survey of 243 adults participating in arts pro-

grammes found 84% of participants felt more confident in their abilities after doing the programme. Hill and Moriarty's (2001) report on Merseyside ACME Access and Participation programme found that the increased confidence gained through arts programming could show itself as beneficial or as a stepping stone to vocational or educational advancement. They found that participation in arts activities kept participants moving forward and planning for the future – what's next. Dewson et al. (2000) also found that the increase in soft skills gained by arts programming is an important step forward and that it leads to other steps as well.

[19] A number of these skills were skills mentioned by participants and former participants we interviewed. We will give more examples of them in our final report.

[20] See the work of Chappell (2007a), drawing on Craft (2000), who in turn draws on Feldman, Csikszentmihalyi and Gardner (2004). This literature stresses attributes like 'possibility thinking – being imaginative, problem finding and solving,' the importance of play in creativity, the intertwining of appreciation and performance with creative skills, as well as reciprocity, openness to the unusual, and the importance of working through dilemmas and decisions as part of learning creativity (Chappell 2007a, 2007b).

[21] It should be noted that Lord et al. (2002) found that participants did not report a gain in these sorts of creative skills where the focus of a media project was exclusively on hard technical craft skills, but that nonetheless an increase in soft skills was reported by participants in these projects.

[22] Shaw and Robertson (1997) give a very thorough account of the different dimensions of this process.

[23] If story-telling is important in the projects, this has an implication for evaluation research; listening to young people's narratives must have a central place in such research.

[24] www.uksoundtv.com/, www.chewtv.com/, www.converge.org.uk.

On the Question of Story and Evaluation
A narrative verdict

Robert Smith

Introduction
This chapter looks at an attempt to employ the processes of storytelling to serve the purposes of evaluation, and explores ways that powerful stories could be used to enhance evaluation. It is a fish out of water story: a filmmaker entering the world of evaluation and drawing a general lesson from a particular experience.

I have been a fiction filmmaker for the last 35 years, and a consultant working on evaluating media projects for the last ten years. Recently I was part of an evaluation team on Inclusion Through Media (ITM) that proposed an evaluation approach based on the premise that human beings relate to each other through stories. We argued that evaluation could use powerful, compelling stories gathered across ITM projects to tell a larger story about the whole programme.

Early on in the process I began to question whether storytelling could survive the demands of evaluative research as I struggled to determine which methodological tools were appropriate at each stage or situation. Our approach to gathering stories revealed a distinction between an empirical process for collecting material (leading to objective stories delivering a broad overview of a community) and an intuitive, emotional method that led to more subjective personal stories that I thought were more powerful. Objective stories have clear resolution and closure, whilst more subjective stories reflect softer outcomes, personal experiences and more open endings. The effectiveness of a 'story' approach to evaluation is dependent on the quality of the stories and how they address audience expectations.

This led me to reflect on the difference between the dynamics of powerful and compelling stories, and the broader requirements of evaluative research. A methodological conflict emerged. A conventional evaluative analysis of the project gave a series of 'narratives' about beneficiaries, matched against the pillars of the funder, value for money and lessons learned. On the other hand, our preferred methodology was to create the space for free flowing, subjective and emotional stories to emerge. A complex matrix began to develop which combined a quantitative/qualitative evaluation axis set against gathering subjective/objective stories about individuals or the communities.

One potential narrative to represent the ITM project is of 25 media projects gathered under the umbrella of the Equal programme, working creatively with different groups of excluded people. It would be a sprawling narrative; a sort of tapestry pinned on the structures of the programme, the resulting stories revealed through the dissemination of the final media products, and project outcomes evaluated through the prism of Equal. This narrative could be presented as either a subjective story where the reader wanders through the tapestry until their eye catches something of interest or, as an objective story in which the reader is guided through the tapestry coming to rest on a series of focused conclusions.

Another narrative approach (and the one we favoured) would be to take a single beneficiary and track their journey of social inclusion as a triumphant journey to find a voice that speaks out. All of this is made possible by Inclusion Through Media: an objective story that carries a clear message of the power of the model (though subjective if the reader contests the values or the veracity of the story).

Our ambition to tell the 'larger story' of ITM through a series of compelling, smaller stories ran into the two challenges of how much time it takes to gather the original stories, and then of whether the demands of evaluation are compatible with the traditional functions of stories.

Story and the ITM model
The media world has a recurring mantra that precedes the allocation of money to a particular project: 'What's the story?'

Screenwriting guru Aronson goes back to the fairytale as the heart of story and each fairytale is founded on a story question that has to be answered (or the reader feels cheated).

> Once upon a time there was a (protagonist) who lived in (normality). One day when the (protagonist) was (doing something normal), there was (a... disturbance) which made (protagonist) decide to (a plan to cope with the disturbance-induced crisis). But suddenly without warning (surprise) happened, which created (an obstacle hindering the protagonist for the rest of the story). (protagonist) tried

many ways to overcome (the obstacle) and encountered (hindrances, complications, substories, more surprises and obstacles) until finally (protagonist) (climax), resolving the problem triggered initially by the (disturbance). (Aronson 2000: 45)

On the other hand the questions that an evaluator asks are more prosaic:

- What are the indicators of performance in relationship to the project objectives?
- What is the record of delivery?
- What lessons have been learned and how can they be disseminated as examples of best practice?
- What was the feedback from the users and delivery team?
- Is it good value for money?

It seemed to us to be a small step to introduce the elements that will elicit the evaluation objectives by refining the structure of the fairytale story question and layering in a series of focused evaluation story type questions that establish the themes of the stories.

- Consequences of the ITM project on participants
- Lessons Learned for the participants
- Personal moments
- Achievements
- Patterns within the project
- The Future (Simmons 2001)

I attempted to combine these elements of story and evaluation in the process of gathering stories from the UK Sound TV project, as follows: [1]

Moving On
Kyle's story takes him from security guard to film director. He is 21 years old. He came on to UK Sound TV as a security guard (and determinedly did not take part in the actual project). He then started to become a trainee, the project progressed, he was drawn in and asked what interested him. He was full of stories and had a particularly unique take on music and gun crime. This interest led to two documentaries. The first was about DIY music creation verses the mainstream music industry. The second film asked 'should the police carry guns?' When he first joined the project he was outspoken and could exhibit a temper. Through the processes of expressing his ideas through the media and confronting his prejudices on gun crime and music he started to change. The start of the story was getting the job of security on the project. His transformation began with the act of becoming a trainee. By the end he had moved up to taking charge, made two films and became a youth producer.

Personal Triumph

Dame Danielle was the only female youth producer on UK Sound TV. She went to film the Newham Generals at Newham Circus. She was an MC but was in awe of the artists who were there. 'Mayo' and 'Bengo' are legends of the Grime scene. On the day she stepped forward, took control of the situation, was composed and did a great interview. A personal triumph as she overcame her feelings of being nervous. She was elated at her triumph realising she had taken a huge step and was empowered to claim her place in the scene. She is not just the angry Danielle but Danielle of UK Sound TV who is an editor, MC and part of the production team. The experience has created huge avenues for her anger. She walks into the room and no longer tries to dominate the scene. Now she is empowered, has started production on a DVD and is doing it all as part of the team. The only female youth producer who now shows rather than shouts.

New World

The Sit Com boys are Dion and 'Femi. They started by working with comedian Ashley workshopping an idea called Flatmates. The characters have to find new flat mate. During the workshops Dion and 'Femi were a couple of the participants who emerged as confident actors. They were tough guys who learned to let go and reveal their inner feelings. From that process of them acting out stuff Ashley wrote it up into a film script. During the production process they all gained a real insight into the amount of work and costs in takes to make a film. They clicked on the complexities of the processes of casting, extras and production. The Sit Com boys Dion and 'Femi were changed from tough guys into professional actors and production people. The three day shoot in ten hour days to create the drama/narrative is a huge process. It appears they are raring to go again.

Patterns within the project

A key pattern to emerge from UK Sound TV is the journey from the 'street' to the world of the 'professional.' The Hard Boys to Comedians story started with high expectations and ideas of huge record deals and fame as MC's. Then they face the reality that UK Sound TV does not necessarily meet these expectations. The next stage is to put into practice the processes of making things and making connections. They are transformed from angry, ignored people into people who are listened to, full of self esteem, chilled out and comfortable with a creative processes that are supported by new found communication skills. They have come from the street with claims for respect and full of anger. They become humbled but engaged with live skills and they have learned how to work together moving from Hard Boys to Comedians. This follows the classic story arc.

These individual stories are unquestionably a celebration of the triumph of the ITM's UK Sound TV project. The themes of consequences for beneficiaries, lessons learned, personal moments, achievements and patterns are clearly evident. The strength of Aronson's (2000) story question is the reader being invited into the world of the story, to engage emotionally in the events, desires and conflicts but above all to empathise. The stories from Kyle, Danielle and The Sit Com Boys address some of the structural points from Aronson's story question but the problem is they are presented in the past tense, they are being retold by third parties, we are distanced from the characters and they are not audio-visual representations of the events and the triumphs. They are merely reports.

The nature of stories

Aronson's story about (fairy-)story telling is only one of many models, which fall for me into two broad categories: objective and subjective. An 'objective' approach to story could be characterised as reducing it to a key set of standard elements: character, theme, story, plot (Parker 1998; Mckee 1997; Aristotle in Tierno 2002) that have a premise, beats of action, key turns, genre conventions, suspense, mystery and dramatic irony that lead to emotional engagement, a revelation of what the story is about, and resolution.

A 'subjective' story takes a different starting point which is rooted in the act of telling, with a more open approach to the nature of character and the unfolding of events. This still needs the dramatic beats of narrative structure but provokes active participation by the reader and leads to a less directed but deeper truth in the resolution. Proponents of this more 'open' text characterise it as more like the experience of listening to music (Dwoskin 1976) than travelling the narrow route of the linear narrative.

An important objective of the evaluation is what it could offer to the 'mainstreaming' required by the funding agency. Mainstreaming is defined as the ability of the 'action research' pioneered by Equal to be adopted by policy makers, funders or other practitioners. Creating an impact in this way is the ultimate aim of the Equal programme; it looks to pioneer change so that new ideas are taken up into future policy and practice. This is done by identifying the value of each of the projects, encouraging 'others' to use the experiences gained to achieve similar outcomes and repeat them on a bigger scale. It is through mainstreaming that the ITM project aims to influence 'others' (policy makers, decision-makers and other practitioners) to adopt good practice, making sure that innovations are integrated more widely into mainstream programmes and that positive change is achieved. So the question was, which configurations of story will work best for these 'others' who are the apparent audience?

A paradox began to emerge for me. Current debates about the role of

the reader in the consumption of stories favour the open (subjective) text as the most appropriate and engaging form of address. In contrast, the evaluation story needs to have an impact on policy makers in a form that delivers a succinct 'message'; a closed 'objective' text that guides to clear, simple conclusions. The objective of the evaluation was a story that functioned as a symbol of the power of the ITM model that could be 'mainstreamed' – a beacon to take the project into the future.

The key question is who are gathering, creating and authoring the stories as they emerge from the project? How the stories are gathered, when, what forms are used to frame the stories and which formats are used to present? Is it a retelling or is it a gathering documentary style as it happens? It's also a question of the power and the quality of the evaluation stories that are constructed. The act of gathering and retelling stories is inevitably one of judgement and genuine access to the participants. The evaluator needs space and time to reflect on the events as they emerge and this process must move in along in parallel with the projects.

Evaluation – does it need stories?
Evaluation is inevitably a policy-orientated process. But our aim was to make a shift towards a more elastic process, using stories to expand the evaluation template. We wanted to use the personal story to influence the political process.

Without these stories the process would have been very similar to the traditional evaluation with methodologies, data and recommendations. However the application of the tools of storytelling, which have the notion of fiction implicitly embedded within them, could lead to evaluation narratives that tell a good story but are not necessarily about what actually happened. On one level this 'fact or fiction' concern is redundant because every analysis is selecting data to support, embellish or demolish a particular project – every analysis tells a story. Key to my concern is the function of evaluation.

The ITM programme is attempting to challenge a simple numbers game and demonstrate a much broader set of values, gains, outputs and outcomes. If evaluation stories are to emerge that are both true to the events and also have powerful dramatic impact on audiences then I would argue that it requires a large scale project for gathering and recording and retelling of these stories on screen and in print, larger than we were able to undertake.

Conclusion
I am left with a number of questions that emerge from this reflection on story and evaluation. Firstly whose story and which story to tell in what form and to which audience(s)? Should the stories be episodic narratives

that are contorted to hit key evaluation points or are they best presented as powerful stories that have strong dramatic turns, a major climax and a compelling resolution for the target audience/reader? And are the demands of evaluation compatible with the traditional functions of story: reflecting a culture, generating meaning, revealing deep truths and above all engaging and entertaining the target audience?

The methods of creating narratives and the processes of evaluation at times appeared to be compatible. At others, it seemed to be that story was a natural tool in the broader processes of evaluation. On one level all evaluations are a narrative. The 'characters' are the players in the project, and the themes come (in this case) from the pillars of the Equal programme. The events are the dramatic beats of each project and the resolutions are the measures of the outcomes and outputs of the scheme. It's a legitimate evaluation narrative that has been played out time and again and aimed at a very specific audience, usually funders and policy makers.

The use stories for evaluation remains a very strong idea, but as I've experienced (a landed fish gasping my last on the river bank), there are difficult practical problems with implementing the idea. It requires an understanding of the complexities and contradictions of using an empirical methodology to gather the stories. How will the evaluator know which person to film as the winning symbolic story unfolds? It raises the questions of impact, who the evaluation stories are for, whose stories to tell, in which form, at what scale and by whom as the author. Which assets should be gathered, which form(s) work best, what are the pathways for readers and are audience expectations satisfied? Has the story model addressed the issues of the performance of the project effectively replacing and confronting the more conventional simplistic cost benefit analysis? The challenge remains how to break free and use narrative to create and present the bigger ITM story. Dame Danielle's triumphant journey finding her true voice would be a great starting point.

Endnote

[1] The names of all UK Sound TV participants have been changed.

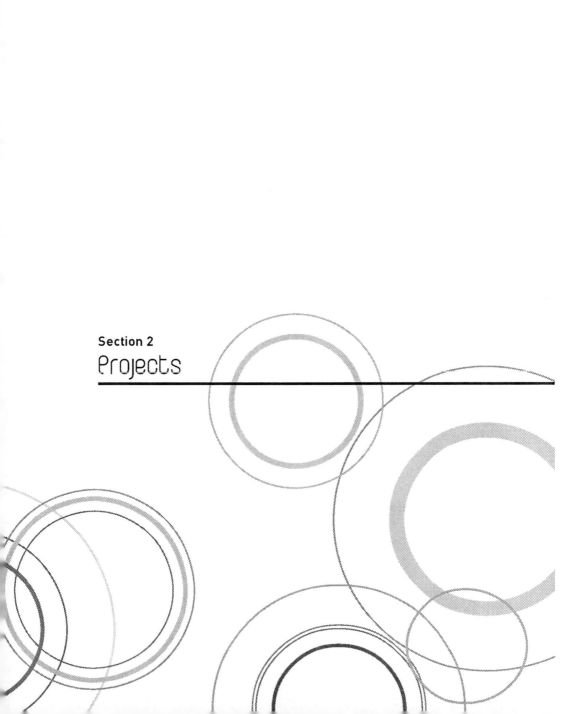

Section 2
Projects

Section 2: Projects

This section gives an idea of the range and diversity of participatory media work, in terms of both the media technologies employed (from black and white video to 35mm feature film, comic strips to a broadband TV channel), and of the participants (Roma youth in Slovakia, Grime artists in East London, blind musicians, Muslim communities in Bradford).

First, Andy Porter tells the stories of three key moments in his thirty year career in youth media, and makes suggestions about how this work might be sustained into the future. Then Sally Hibbin talks about how she has incorporated collaborative processes with the communities that have been the subjects of some of the feature films she has produced. In Chapter 7 Juliette Dyke describes the Digital Storytelling techniques that have been used across the European-wide DigiTales partnership, and in Chapter 8 Jacqueline Clifton and Tricia Jenkins outline how the organisation Musicians in Focus is working to include blind and partially sighted musicians into composing for the screen.

The section concludes with two linked contributions. In Chapter 9a Kulwant Dhaliwal outlines how Hi8us Midlands works developmentally with excluded young people to nurture their careers in the media. Chapter 9b follows on with an account of the work and progress of Asia Alfasi, a comic strip artist who was a participant in the Hi8us Midlands project, StripSearchers.

Chapter 5
IMAGEination in Power
The creative citizen

Andy Porter

In 1977 we took News at West 10 around the streets of North Kensington. It was a local TV news programme put together by young job creation trainees. Before the days of VHS and VHS players, it meant loading an open reel black and white mains player / recorder and monitor onto a pram and wheeling it to the local laundrette, old peoples' centres and adventure playgrounds. Narrowcasting at its most narrow. Unsurprisingly, we ended up wheeling the pram, whilst the young people followed at a discreet distance on the other side of the street.

In 2007 the young people are coming into UK Sound TV office in Bow in East London, grabbing the camera, shooting an interview with a local Grime[1] artist, editing and uploading footage onto their broadband web channel – UK Sound TV – and broadcasting it to a worldwide audience – which to date has had over 2.5 million unique visits.

Two snapshots, 30 years apart, from a working life in a field of work that has been variously described as alternative, community, tactical, underground, grassroots, independent, even radical media.

It has always been difficult to describe precisely the activity, what I do (particularly to my Mum who'd always respond to my attempted explanation with the query of 'couldn't you get a job as a BBC Cameraman?'). What do you call the work, how do you describe it in a way that makes sense beyond a small of coterie of practitioners and interested intellectuals/academics? It has always operated on the fringes, its scope rising and falling with shifting political climates and available funding opportunities. It is a sector that lacks institutional status, operates outside the mainstream culture, and tends to work with people who are themselves marginalised and lack the social and cultural, not to mention economic capital that would give them agency in the wider society.

The labels give an impressionistic account of the work:
/alternative – offering a different versions of reality and possible modes of production to the mainstream media **/community** – a sense of interrelated group of persons and interests, and the concept of a common good **/underground** – an activity starting beneath the radar of conventional society, or an activity deliberately suppressed **/grassroots** – from the bottom up, a notion of the power of ordinary people rather than that of leaders and elites **/streetlevel** – working with ordinary people **/tactical** – the need to adapt the production of media to the particular terrain and countervailing forces **/independent** – not part of the existing broadcasting and educational institutions **/experimental** – operating at the margins of the 'known', both in terms of cultural form itself and in the mode of cultural production **/radical** – proposing a fundamental re-consideration of the nature of the existing media.

An underlying assumption behind these descriptions is a belief in the importance of people being able to create and control the production of their own images and messages and get them seen and heard in the world.

A third snapshot:

It's spring 2006 and we are in the office in Bow working with the young people to put together their live Broadband TV show to launch the UK Sound TV web channel. They are in the editing suite and the excitement is palpable. This is good. I go in and look across at the screens, expecting to see an interview they have got with a local Grime artist. But no. It's one of them showing off his MySpace site featuring his tunes. What's this MySpace? I don't know about it. And he's done it all without our involvement? It's a rude awakening. The technology is moving faster than we are. Wasn't this what *we* were meant to be developing with them?

So how meaningful is this activity now, in a world that affords most people, at least in the developed world, the ability to create their own moving images on the ubiquitous mobile phone, and circulate them on MySpace, YouTube and the plethora of emerging video-sharing sites?

At one level it has been a story of increasingly accessible technology, in which the inaccessible has become accessible, as we have moved from an analogue to a digital world:

In *production*: the black and white (B&W) Portapak, with its separate tape recorder and camera, became the integrated VHS camera/recorder. This was followed by the lightweight Hi8 camcorder, with its superior image and broadcast possibilities. And then the digital camera, where the distinction between professional and domestic has finally become blurred. And now the camera on your mobile phone.

In *distribution*: the mains recorder on the pram was followed by the VHS recorder and tape distribution, and its child the DVD. Early community cable channels came and faltered on a lack of commitment and funding. Channel 4 launched in the early 1980s with its remit to access unheard and unrepresented voices, progressively diluted in competition with the proliferation of Satellite and TV channels since the early 1990s which offered only limited access to 'other' voices. But a whole new set of possibilities have opened up with the Internet and IPTV (Internet Protocol Television) and the likely convergence of the Web and traditional broadcasting on the domestic television set/computer and whatever handset device wins that particular war.

So if popular access to the technology is a problem near to solution, is it time to pack up and go home? I don't think so, and because I don't, I want go back and look at some of the work I have been involved in, to look at its practice and values to see how they might still be relevant to the contemporary media ecology.

I will look at three periods when I have been intensely involved in the work – at its beginning in the 1970s Notting Hill, with its origins in the B&W Portapak and community action, the second a period in the nineties when we were producing camcorder dramas for Channel 4, and the last six years of working with young people in East London on regeneration and cultural industries funding. It's my attempt to understand what it has all been about and what the future might hold. In many ways the fundamental vision has always been the same, but it has had to articulate itself in different ways in response to differing technologies, the prevailing social and political zeitgeist and funding strands. Perhaps lessons can be learnt from each period which can inform current thinking.

1975–1984: Community Video – Power to the People?

The word 'community' has been much used and abused over the last 30-40 years. It's hard to remember back to a time when its use meant something fresh and challenging, to a time before the meaning was wrung out of it by countless grant applications and funding policies.

Back then its meaning was small 'p' political, and was invariably linked to action – community action, and had arisen out of a movement mostly within the inner cities for people to take more control over their lives and the communities in which they lived. In Notting Hill it meant people sitting in the road to stop traffic and get a zebra crossing, squatting empty housing, disrupting property auctions to stop gentrification, pulling down fences on private squares to create public playspaces, marching against police victimisation of the Black community. It was the less recorded and less fashionable part of the 1968 'revolt', the grassroots version of 'power to the people'.

By necessity this movement developed its own means of communication, the first community owned printing press, a communal darkroom, silk screen printing facilities producing local news sheets, magazines, posters and photo exhibitions. Run by a mixture of local residents and activists who like myself had recently moved into the area.

And then there came video! There had been film, but it was expensive, time-consuming and required a level of skill that it was hard to access. Video offered immediacy, instantaneous playback, and cheap tape stock that allowed you to shoot as much as you wanted (and often too much!)

And it was TV – the nation's most popular and potent cultural form. The preserve of an Oxbridge elite, the gatekeepers of how we saw each other and the world. The Establishment. With the Portapak in our hands now we could, in the words of the video artist Nam June Paik, 'attack it back'[2]. Revolution was in the air. Rather a lot to put on a clumsy and clunky technology that came in two parts, a camera ever in danger of having its lens ruined by pointing at the sun, and a portable recorder that weighed four times the average modern laptop and required an intricate finger operation to insert the tape onto its spool. And it wasn't TV of course, which is as much defined by its distribution system – Broadcast – as by its means of production. Our pram wasn't about to compete with the Alexandra Palace TV mast (**DVD clip / section 2 / 5.1**).

It's hard to recapture the excitement of the time and not to be dismissive of the naivety of the expectations. For a generation brought up with the magic of the TV box in the corner, it seemed that we too could now

Guide to images: Housing conditions in North Kensington (**top left**); clips from video about occupation of Powis Square (**middle left, bottom left**); Tenant's Leader interviews Local Tenant (**top right**); Playleader interviews young people about what they want on their square (**middle right**); Local tenant speaks out (**bottom right**)

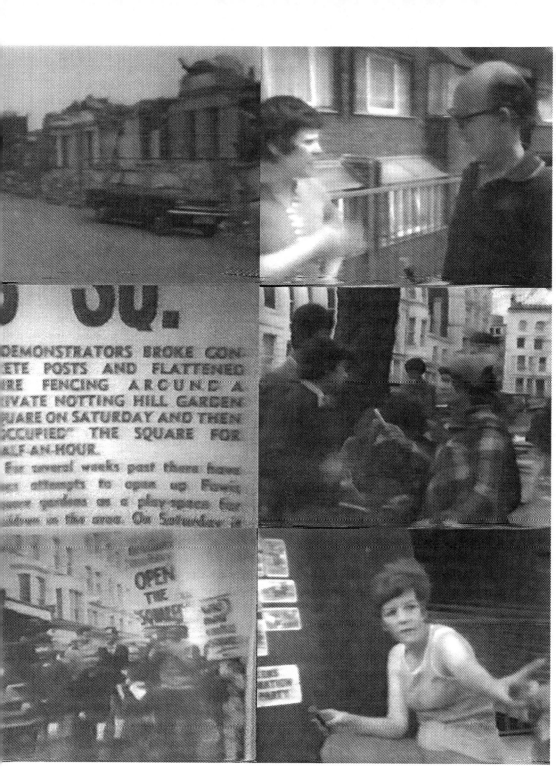

become magicians, and without having to join an exclusive magic circle.

And the *we* here is vital. The people didn't rise up and demand TV. It was an intervention. If I look at the people who were involved in community video projects across London, in the main they were college educated. And initially we didn't come from within the communities in which we were working. We were propelled there by a mixture of beliefs, hopes and aspirations for social and political change, and I am reckoning often a personal experience of exclusion, of not belonging to the system in which we had been nurtured. Of course this was what fuelled the generation of '68, from the Hippies to the Yippies, from the drop-outs to the political radicals, as it has fuelled activists throughout the ages. What's interesting is what we did with it.

A seminal document of the time was a report on the Challenge For Change programme set up by the National Film Board of Canada (Hopkins 1973). It described how activists in Canada had worked with video in a declining coal-mining community. We took this as a model for working with tenants in Notting Hill, creating programmes about the appalling local housing conditions. The tenants did the interviewing and told us how to put it together on the very crude editing system. The process was integral to getting people involved, and to public meetings where the films were screened to neighbours, fellow residents, and to the authorities who were confronted with their responsibilities for the housing conditions.

Our greatest 'success' was a housing issue being taken up by the local paper, which was then followed up by the BBC. They came into the area and virtually remade our programme, but this time with a kipper-tied young John Stapleton framing the reality of the slums. They de-focused the shot of the young girl's head wound – a wound that was refusing to heal in the damp conditions, and which in its stark in-focus reality had been so powerful in our original. It was broadcast on the BBC's teatime Nationwide news magazine and so reached a (for us) undreamt of audience. It revealed both the strength and weakness of the project. We could access and empower different voices, but we were limited to a very local audience, except in the rare instances where the material attracted the attention of the mainstream media, when it would be mediated by the body of the broadcast 'professionals' entrusted with presenting a balanced and impartial version of the world.

The News at W10 project referred to above was an attempt to explore the possibilities of developing audiences beyond the specific programmes/audiences. Funded by the Job Creation Programme (JCP), it was created with four trainees off the unemployment register. A magazine format, with a trainee acting as a presenter, it covered local issues, news and events. Necessarily grainy and roughly produced on the crude equipment available, it drew small audiences in old people's clubs, adventure

playgrounds and laundrettes – and was more a gesture toward community television than a realistic test of its potential.

At other times we were working on oral history programmes with pensioners, working with young people and covering local festivals and events in response to demand from the local community.

Are any of these programmes/processes of any more than historic interest? We learnt a lot about working in the community with media, much of which is now standard practice. A key issue was a mismatch between our 'vision' and the vision, or rather needs and requirements, of the funders. On the one hand we were being funded with small amounts from Arts/Film agencies, with their own particular brief, which at this point meant 'radical' film product – the Greater London Arts Association Film Officer was noticeably disappointed by the low key nature of the output – we were not living up to his fantasy of Russian Agit Prop film trains in Revolutionary Russia. On the other hand with barely adequate funds from the JCP, we were not set up to offer adequate training and support to the young trainees on the scheme, who we chose on the basis of perceived need rather than prospective talent. Our vision of the project was to develop an enabling community video resource that could offer local people the opportunity to represent themselves in their own terms, both vertically upwards to the authorities, reflectively back to themselves and also horizontally across to other members of their own and other communities. That we could sustain such a vision at all was because we were young, fired up on idealism, and able to fall back on part time work and the dole, which was almost possible to live on in those days.

There is no doubt that for us in West London Media Workshop, the 'vision' outstripped our ability to deliver. We were trying to make sense of the slogans – people power, information as power, imagination in power – without the technical means or experience to deliver on it. The primitive equipment, our own relatively low level of skills, the absence of any sensible method of distribution, and a lack of funding all militated against the project being much more than an experiment, a stab at the possible. But there were glimmers of how a genuinely community-based resource could offer any number of creative and communications opportunities, which together could play a vital role in empowering people and communities.

How much more possible is it then today, with the advances, miniaturisation and accessibility of technology, to develop a people's media as central to making sense of the current slogans of the democratic deficit and active citizenship?

1994–2001: Camcorder Dramas – He who Pays the Piper Calls the Tune

In the early 1990s camcorders came onto the market that recorded pictures that TV was finally prepared to broadcast on a regular basis. Much as lightweight 16mm cameras had opened up a whole new world of possibilities to filmmakers in the 1960s, the advent of the Hi8 camcorder and subsequently DV made it possible for filmmakers to get closer to their subjects, at an affordable cost. And to get their programmes broadcast.

With support from these new technologies and Channel 4's remit to get new voices and unrepresented communities on the screen, we set out to create collaborative dramas that would both provide entertaining and informative TV, and maintain a commitment to the participants' control over their own representation. And at a cost that broadcasters would find acceptable. It was an opportunity to make good on the project of getting people's voices out to a wider audience on the platform of terrestrial TV.

Snapshot 1, 1994
We are in the windy upstairs hall of a youth club in the heart of working class Protestant East Belfast. Beefy – ginger crew cut, stocky, sixteen years old – harangues Dave the drama worker, himself a product of the same East Belfast. Its a street battle between a drug dealer and the boy who hasn't paid his debts – a battle of wits with an undertone of potential violence that swirls from one side of the hall to another. The audience is electrified: the 6 kids from the neighbourhood who have come on board to make the drama, Marie the writer who lives two roads up, Stephen the youth worker who has got the group together; and Jonnie and me, the director and producer from 'across the water' – the outsiders, who have problems penetrating the accents, but a visceral sense of the drama. Beefy 'wins' – a fact the drama worker finds it hard to swallow, although it's not 'real'. And Beefy is another step forward in creating the character of Wingnut, and another scenario for Wingnut and the Sprog, the even-

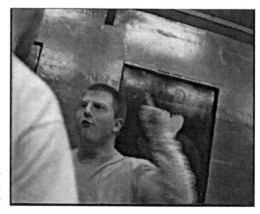

Beefy creates his
role as Wingnut in
the workshop

The film went on to become a minor hit of Channel 4's *Long War* season.
It was television's first Camcorder Drama, and it showed the reality of the
lives of young people in East Belfast, who weren't seen on TV except in
stereotypical images of loyalist marching bands and July 12th celebrations.
It was also a cracking good story.

And in Stephen's words, it was one of the best pieces of youth work
he'd ever done, in terms of its impact on both the individuals and the
wider community.

The process developed in *Wingnut and the Sprog* became the modus
operandi for the production of the films:

- a script developed with 'indigenous' writers and drama workers
 through improvisation with 'found ' groups of young people;
- the young people supported in developing their performances for
 the camera;
- a predominantly hand-held shooting style that utilised the flexibility
 of the new camcorder technologies, to accommodate the perform-
 ances of non professional actors.

And central to this process was a commitment to the participants to get
them on screen, and portray the reality of their lives as truthfully as pos-
sible. We gave them right of veto on the script, with the proviso (written
into our contracts with Channel 4) that the broadcaster had the final deci-
sion.

Wingnut
title sequence 2

Snapshot 2, 2000
We are in the cutting room of the film *Nightshift* we have made with a young Asian people from Birmingham. Scenes with two of the characters are progressively hitting the editing suite's digital waste bin. Their part in the drama is being almost completely removed, along with the comic element of the plot, as the director does what directors do, make the film their own, craft their own vision. When I meet these two people at the screening, I can't look them in the eye. I'm embarrassed by their lack of participation in the final film, after their commitment in the workshops, and our commitment to them, promising all the participants representation in the final piece. Of course it is what actors have to get used to, but they weren't actors.

(DVD clip / section / 5.2)

The film had become an auteur piece – a representation of the young Asian women director's vision of a particular experience of growing up as young and Muslim in contemporary Britain. A poetic film, using de-focused shots and contemplative camera work, it went on to win a Best Drama award at the Commission for Racial Equality (CRE) Race in the Media awards. But it was no longer shot on camcorders, and though still made with a non professional cast, they were hand-picked by the director after a series of rigorous workshops. In many ways less accessible than the other films, it still represented a largely unheard voice and experience. But it wasn't the same project we had set out on six years earlier. What had happened and did it matter?

What had happened was that the most recent commissioning editor at Channel 4 into whose hands the project had fallen, wanted to do it differently. Partly I think because the previous film, *Pure*, had been probably the least successful of the films in terms of final product, but also because the Channel 4's Independent Department was increasingly looking at its

Sophina plays the main
role in Nightshift

role as a developer of new talent. He wanted us to take on a young director of his choice – who was working at BBC Arts and who had recently made a highly acclaimed film about young underground Asian musicians for BBC – and a writer of his choice, a well established television writer of drama documentaries. If we agreed he promised to get behind the film.

Previously either Jonnie or I had directed the films or we had directed them together, but we agreed and from this decision an inevitable series of consequences flowed.

These have to be seen against the changing world of broadcast television. In making the dramas we had been attempting to combine two very different and often conflicting processes:

- The broadcast production process of television drama with its tight schedules, its military-style planning, and responsibilities to the higher power of the broadcaster and paymaster.
- A community development process necessarily organic, often slow and uncertain, with is responsibilities to the participants, their growth, development and power.

It was always going to be a difficult balancing act, a balancing act increasingly hard to maintain in a period of newly deregulated broadcasting. The proliferation of channels was increasing the competition for audience ratings, and putting the scheduler and marketing department in the driving seat. Once you had got your audience hooked, it was important to keep them hooked. It was a period of 'seasons' and 'zones', and the search for the 'new' and 'innovative'.

For a time we managed to surf these changes and maintain our vision, partly because annual 'seasons' were in vogue, the 'rawness' of camcorder drama was still 'new', and our particular 'one-off' programmes added a different, young people's feel to the season's output. They were also useful in fulfilling Channel 4's original remit for accessing new voices. The programmes went out late at night and got respectable but not great audience figures, but they were getting regional Royal Television Society (RTS) awards and valuable column inches in press coverage – as important to nervous commissioners as audience figures for 'marginal' programmes. But once the scheduler and marketing men are king, the producer is increasingly responding to the channel's definition of its output, rather than the channel responding to the vision or otherwise of the independent producers.

This began to impact on us after the third programme – *The Visit* (**DVD clip / section 3 / 13.2**), which we had made on D wing with young prisoners and prison officers in Hull Prison, and which people familiar with the prison system said was one of the most accurate dramatic portrayal of prison life to be seen on TV. It won an RTS award and got great reviews.

We proposed a series of six similar dramas from across the regions and

the commissioning editor at Channel 4 put his name to it. This enabled us to win a £500,000 Arts Council Lottery Arts for Everyone award for 50% of the budget. Young people from Newquay to Tynemouth, Hastings to Whitehaven who never saw themselves on TV were going to get the opportunity to create dramas that would tell the story of their lives to a national audience.

But when it came to it, the word from on high in Channel 4 was that they couldn't sell such a disparate strand of effectively 'one-offs', it would be impossible. But the newly installed director of programmes at Channel 4 would accept us to doing more of the same for an upcoming Channel 4 Drugs season. This was in November, and three programmes had to be delivered for screening the following April. An almost impossible schedule. Rightly or wrongly we agreed. Did we have a choice? I don't know. It didn't feel like it. The tightness of the schedule forced us first into doing three stories in one city, Manchester, and finally into compacting three stories into one 75 minute drama, *Pure*, made with homeless young people in city centre Manchester. It had to be devised, written, rehearsed and shot within a twelve week period, with probably the most vulnerable group of young people we had ever worked with. And it showed. Best described as a picaresque adventure through the underbelly of Manchester, it was very loosely plotted, with not always convincing performances.

It went down a storm when it was screened at a full Arena cinema in Manchester, complete with the limousine arrival of the cast in their best drag gear. It was featured in the Manchester News, but failed to excite much attention in the national press, and even less at Channel 4's programme review. It's an industry where you are only as good as your last job, and I think as far as they were concerned it wasn't good enough. It wasn't relevant to them how we were affected by the strictures imposed by the schedule, or the benefits that we ensured accrued to the cast, and the trainees on the training scheme we ran alongside the film – they were, after all, a TV company not a social work agency. In the event the season was postponed and didn't go out until the following November. We hadn't needed to work to such a tight schedule![3]

But it meant when we came to the next programme we were not in a strong position to do it our way.

So in *Nightshift*, with a director in place chosen by the Commissioning Editor, the process became very different. As with all filmmaking it was necessarily a collaborative process, but inevitably it was the director's vision that predominated. With a cast chosen from across the city, the kind of youth and community work that accompanied previous projects didn't exist. The young people who were chosen and represented were confident enough to get themselves to rehearsals, survive the improvisation process and were already potentially good performers. The writer found a story

that included all the characters, but where these characters didn't fit the vision, they were marginalised, first on the shoot and then in the edit suite. The camcorder became a professional video camera and stayed on the tripod. It had become a far more conventional production process. It had lost the sense of 'community' that had characterised the previous productions, with that sense of everybody being in it together, pulling together with its sense of building both individual and community strength. It did undoubtedly empower its two lead characters, and the training scheme that we ran along side of the film helped a number of young people into the industry. But outside of these two I doubt if the young people felt a particular ownership of the film, and certainly some of them were disappointed by their final presence on screen. Yet it was an interesting and different film, it portrayed an Asian experience rarely seen on TV, and a number of young people benefited from the process. So what's the problem? Is it sour grapes because we couldn't do it our way?

I can only answer this by proposing an alternative. We could have based ourselves in one of the poorer areas of Birmingham, and working through youth workers or community organisations, developed a script and story with a 'found' group of more marginalised young people – young people that were unlikely to respond to leaflets and find their way to an audition. It would have been more risky, the film might not have been so good or it might have been better, but it would have had far more potential for empowering both the individuals and community, and working within what is now called an inclusion agenda. Of course you should be able to do both. I guess it's a question of priorities and by this time it had become obvious that differing priorities of us and the broadcaster was too big a gap to bridge.

In terms of the commissioning editor getting behind it and it getting out to a national audience, it was a disappointment. With 'seasons' having gone out of fashion the Channel found it difficult to place the programme as a one-off, kept changing the date and timing of the transmission and didn't promote it. It went out after midnight seemingly lost in the schedules. Only when it won a CRE Best Drama award did the Channel sit up and notice it. They sent us fulsome letters of appreciation!

All the five films delivered on our initial project of getting young and unheard voices to a national audience. The audiences fluctuated at around half a million. The broadcast budgets – although modest in TV terms – allowed us to develop a new kind of work that enabled us to combine a small 'p' political community development process, impacting positively on both individuals and communities, with getting a 'quality' broadcast product from the process. It also not only paid us but the participants too. It enabled us to attract match funding that allowed us to introduce high quality hands-on training schemes alongside the films for young people

who may not have otherwise had access to the industry. And it gave us the kind of profile and kudos that enabled us to set up Hi8us which has gave birth to the Hi8us network of companies, First Light Movies and most recently the ITM partnership.

It was an excellent example of what one element of public service broadcasting could and should be in a democratic society. Only as the balance of power tipped towards the commissioners did the equation tip towards product over process, and the project became less viable. Perhaps we could have reinvented ourselves and the project for TV, but maybe our 'camcorder moment' had passed in that particular configuration of the broadcasting environment. There was also a nagging feeling that whilst these one-off interventions in communities across the country were beneficial to both individuals and communities, we weren't leaving behind a sustainable activity.

2002–2007: Inclusion Through Media

The advent of the New Labour government saw more money being put into economic and social regeneration. Arts and culture were understood as making a contribution to this process with the cultural industries and the creative economy often seen as main drivers. It was an opportunity to make good on the early attempts at developing a genuine community based resource, building on the processes we had learnt and developed in making the broadcast programmes. We were making an intervention – but, if we could sustain it over a period of time, what could it look like and how could it contribute to community empowerment?

Snapshot 1, 2002
The Lansbury Youth Centre is not much more than a hut on the Lansbury Estate in Poplar, East London, overlooked by the majesty of Canary Wharf. It's 8.30 and we are playing back a selection of Hi8us dramas to a group of mostly boys; 15, 16, 17, white and mixed race, who have trickled in over the last hour. They are sitting slouched across their chairs watching apparently disinterestedly, some of them with their hoodies still up and most of them stoned.

It's not a promising start. I give them the spiel about making their own drama, telling their stories etc. to little response. It's their project they can make it about what they want. But what they want to do is make a music track. And what they want in the club is decks. But that's not what we do. Eventually we make a deal. We'll help them make a music track if they also make a music video to go along with it. The next week I turn up with an ex-student of mine who is a now music video producer. She shows them stuff that she has made with Orbital and other dance music crews. Again it's hard work. They are not responding. The music means nothing to them. We might as well be from outer space. By now Stephen the youth

worker has got them the decks. We film them DJ'ing and MC'ing in the club handing the cameras over to them. The music is fast and furious. The mic is passed from hand to hand as one after the other they spit their lyrics over the top of the tracks. This is the most animated I have seen them, and is the most I've heard them say in all the time we've been there. The next weeks are a mutual learning curve. Its means a lot of hanging about, just being there and listening and allowing them to take charge of the process. We learn about the world of Grime music, and they begin to understand that what's on offer that can work to their benefit, and that they might be able to trust us. Eventually we get the video made – *The Endz*. It's performed on the streets of their neighbourhood and on their trail bikes out on Beckton Marshes. The edit goes back and forth with them until we find an editor to work with them that understands their aesthetic, turns it black and white, speeds it up, slows it down, to give it the 'street' feel they want. It's not that they have achieved something that they didn't imagine was possible. They have achieved something that they didn't even allow themselves to imagine.

The young people we are working with are from an area that hits all the multiple deprivation statistics. Many have dropped out of education, and feel failed by the system. They are not excluded from their own commu-

VHS cover for The Endz

nity, but they are excluded from the mainstream, or exclude themselves from the mainstream, by class and race. Grime music is their subculture, their voice. It is angry and defiant, often indecipherable to the outsider. At its worst it is egotistical posturing, sexist and homophobic. At its best it tells stories of the struggle for survival in a world that seems to offer few opportunities outside your street gang, music and drugs.

This was our first of our hands-on, participant-led Bow By Blow production – a project we had proposed to the local regeneration agency (Leaside Regeneration) for SRB funding for an eighteen month scheme developing digital media projects with young people in the area. We were not only on a strong learning curve about the work but also about the bureaucratic baggage that comes with such funding. When we were working for Channel 4 we were largely trusted to get on with the job, here we had signed up to outputs and outcomes that required vast amounts of form filling, record keeping, reporting and monitoring. It was a shock to the system! Worry about the commissioning editor's opinion was replaced with the fear of the auditor's arrival to discover that we had not dotted every 'i' and crossed every 't'. It was the same issue as with the broadcaster – people, especially young people, do not necessarily fit into tight timetables of training and development. We learnt to cope. The grant, along with other funding we managed to attract, was big enough to enable us to fulfil our remit across a whole variety of outputs: from training to community empowerment, from crime prevention to job creation. It allowed for a process that was organic, responsive and developmental at the same time as ticking the boxes. Crucial to this was the support and involvement of a small local production company Primal Pictures with its young producer, who came from the area and knew the streets and the world of the young people's music, and who had contacts with young filmmakers in the area who could work with the young people on the projects; and a network of local youth workers who were vital advocates for the young people.

The programmes were being made for an audience, and not as an educational exercise. The commitment to the young people's 'voice' and our 'hands-on' production-led approach was critical in being able to involve some of the most disaffected young people for whom 'education' or 'training' spelt school and failure.

Despite initial suspicions in the community that we were carpetbaggers, here to take the grant money and run, we were determined to stay in the area. We continued on a project by project basis, building up an extensive area of work with young people, and youth generated product much of it featuring music in one way or another. Yet the products stayed 'local' – screened to local audiences at youth and community centres, at local festivals and events, local cinemas and at the East London Film Festival.

Snapshot 2, 2006
The Jongleurs comedy club in Bow E3 is packed with people sitting around tables and standing at the back. The show is about to begin. But it's not the usual comedy crowd. Three young people bound onto the stage to get the show started – presenters for the launch of UK Sound TV (UKS), the UK's first youth led broadband channel. The three cameras and vision mixer are being crewed by young members of UKS, another is floor managing, others are responsible for the Green room and hospitality as the acts come and go. It's a 2 ½ hour live show of live music, dance and comedy with pre-recorded comedy clips, videos, documentary inserts that they have generated themselves. The performers are home grown talent from the neighbourhood and across East London. The audience is local, family and friends with a strong presence of crews from off the street. The show is also streamed on the Web to a worldwide audience. Local goes global.
(DVD clip / section 2 / 5.3)

The reality of course is that with our scant resources for promotion and publicity the show is only watched on the night on about sixty computers. The 'live' element is there because it creates the buzz and because we want to put a marker down for the possibilities of young people running their own live broadband show. In the next few days the show is sectioned up, encoded and is being screened along with stuff from a previous pilot show and new material generated by them for the UKS Channel.

Two things stood out more than others about the show and UK Sound TV: Firstly, it had absolutely been their show. The young people ran the whole thing themselves. They booked and organised the artists, scheduled the programme, shot and recorded both the inserts and the live show. And only *they* could have done it – because only they knew their people. To get there they had to struggle through team decision making, conflicts, loss of confidence and walkouts, until the common purpose brought them all back together again. Our role was as facilitators. We gave them creative, personal, and technical support, but not direction. It didn't happen overnight. It was built on the five years of working in the area, six months of UKS discussions and training around content production, and the relative freedom of the ITM funding which allowed us to experiment with and explore new ideas. It demonstrated to me the power of a live show to engage the participants and the community. There is nothing like the deadline of a 'live' show and the presence of a live audience to learn new skills and hone old ones, to sort out ego problems, and focus your energies. It's a buzz. And when you're a teenager the buzz is especially important.

Secondly the young people now had a means of distribution that was global in its reach. The project has developed alongside developments in

Left: Regal Players live at the UK Sound TV Show. **Right:** Rehearsing camera shots for the show

technology. *The Endz* was distributed on VHS. It was a struggle to get it properly screened at the local cinema. But then we had DVDs and digital cinema projection, and now we have broadband and the Internet. Every fortnight new material has been uploaded onto the UKS Channel – interviews with local MC's and crews, comedy sketches, locally made videos. There is a regularly updated music column covering the urban music scene. Within a nine month period there have been 2.5 million unique visits to the site, with an average download of five megabytes per person. At least half of these are from overseas. But nothing has quite animated the young people like the 'live' show and what they call the 'flagship' shows they created for it.

Young people have their MySpace sites (or is it Facebook now?), but it is an entirely different experience to the collective and collaborative process of generating and distributing material on UK Sound TV. Perhaps every online community needs an offline community, and vice-versa.

The Future: Creative Citizenship

The last five years have been for me personally the longest period of sustained (if erratic) funding. It has allowed us to re-imagine and put into practice the original intentions of the community communications project that we started out on 30 years ago.

It has meant sustaining the activity across a range of diverse funding sources with their multitude of acronyms – NRF, SRB, LDA, ERDF, ESF, ALG! – with the monies disbursed through any number of regeneration, local government, cultural industry and media agencies, each with their

own agendas. It has meant twisting and turning to meet each of their particular targets and requirements: from crime prevention to accredited training, from soft skills learning to craft skills training, from community empowerment to economic development, from recreational activities to job creation, from media literacy to basic skills learning.

It is an instrumental approach with its hard outputs and outcomes ironically often running counter to what it is avowedly supporting – the empowerment of individuals and communities. Growth and creativity are human processes, organic, unpredictable, often messy and often not susceptible to being corralled into time specific work patterns, or evaluated by tick boxes. This is not to reject elements of instrumentalism, and its corollary accountability, but it is a conundrum. Nothing is for free, and public spending in so far as it is an expression of the public will, needs to be accountable to that public.

I want to argue for a holistic understanding of all this media activity which both incorporates and transcends its various strands. At the heart of my understanding of the 'inclusion through media' agenda are the interrelated issues of voice and power, which together add up to democracy. Finding your voice is crucial to all of us, learning to speak is the first step to being able to control your world, to communicate with others, to assert your identity and independence at the same time as equipping you to negotiate, to resist and give way, to operate in a social and mutually dependent way. Language is crucial to our being able to control the world around us. Being able to name and describe your world is the prerequisite being able to understand it, to re-imagine it and change it. This is power. In an increasingly audio-visual age it is crucially important that all citizens have the opportunity to express themselves in the audio-visual media, and even more crucial for the disenfranchised and excluded, who for a myriad of reasons are outside of mainstream society.

This is not to deny that power in this society relates to money. Getting your hands on a video camera is not a substitute for getting a job and a wage/salary that buys you at a minimum survival, but often, and as importantly, status and freedom. Hence the attraction of drug dealing when the legal methods of acquiring decent money are perceived to be demeaning or nonexistent. However I do want to argue that a sense of powerlessness, in all its forms, deprives a person of the will to take up the opportunities that will enable him or her to engage actively in both the economic and social life of the wider society. One of the keys to such engagement and a sense of empowerment can come from developing the skills to express yourself and be heard.

How can this be delivered? It means re-imagining the notion of public broadcasting in an age of digital convergence.

Imagine for a moment in every town, city and community, an inter-

active broadband channel, a mini TV station with a small studio and a café attached. It is open and accessible, a 'studio without walls', run and controlled by local people. It is its own multi channel environment. Each Friday is 'live' band night for a local bands or music crews, some days schools are using it to create their own shows and deliver their 14-19 Skills diploma, on other days a group of pensioners deliver an oral history programme, there are talent shows, arts performances, films made on mobiles, local documentaries, global link-ups, local sports reports, online fanzines, user-generated content, a politics show where local politicians are subject to public scrutiny by the local public. All maximising the developing interactivity of digital media. The permutations are endless. It is also a centre for creative entrepreneurship and creative business support. It takes its shape from the particular locality, culture(s) and community in which it is situated. All content for the channel is available on your soon-to-be-converged TV at home, your laptop or on whatever mobile device you are currently using, and to anyone else on the World Wide Web. A physical and virtual public space, a 21st century town square. Active citizenship in practice.

Utopian? Perhaps. If it was possible with libraries in the age of the 19th century industrial revolution, why not in the age of information revolution? (Maybe the library system could be part of it?) Who will pay for it? Taxation? The government and the BBC are squabbling over the licence fee and the digital switchover. The fact is that the licence fee is a levy on the whole population for a service used by only by a percentage. It can only be justified with an argument about the beneficial role of public broadcasting spaces within a democratic society. We need to extend our vision of the public broadcasting beyond the walls of White City and its regional counterparts, beyond the attempts to take the BBC to the people in the Blast⁴ bus or the Radio One Roadshow, to embrace a wider concept of broadcasting that recognises that the consumer can equally be a producer. Not a provider of cheap user-generated content for other people's television programmes, but a producer who genuinely has some control over the context and the dissemination of their output.

It wouldn't be as expensive as it sounds. It is not an alternative to a properly funded BBC, but an exciting extension of the concept of public service broadcasting in a democratic society. It might mean top slicing some of the licence fee and some BBC economies, but it would build on current resources in the community and education services, and on current and new funding sources. Its precise configuration and structure is for another time – except to say that it would be a different (and additional) concept of public service broadcasting requiring a different skill-set and management to conventional broadcasting institutions to ensure that it is both inclusive and builds social cohesion, where the emphasis would be

on facilitation on the ground rather than delivery from above.

That's my dream, shaped by a particular experience over 30 years and a response to the question I posed at the beginning: with the advent of the new technologies is it job done and time to go home? There will be many others. But do we need any of it in an age of niche channels, social networking, blogging and lateral communications across the Web? Why don't we all just make our own television stations? It's possible – you could almost say that is how MySpace functions. But *MySpace* it not *Our-Space*, it reflects the individualism and atomisation of late capitalism, a world where there is 'no such thing as society'. I believe it is vital to maintain the concept of a 'public' space in the developing communications and information ecology – a space alive and responsive to the potential of the evolving technologies for increasing an active, pluralistic and creative democracy.

Endnotes

[1] The UK's latest and homegrown version of Hip-Hop originating in East London.

[2] 'Television has been attacking us all our lives, now we can attack it back.' (Quoted in Elwes 2005: 5).

[3] As an aside it would have been interesting if instead of the Channel 4 'drugs' brief we had approached the young people with an open brief. Drugs were so much a part of their life that they weren't really an issue for them. We would have surely come up with a more interesting and to the young people a more relevant programme, perhaps superficially about sex, money, rent boys and prostitution on the streets of Manchester, but more meaningfully about the complexities of sexuality and abuse, gender and masculinity. A programme which would have been more challenging to its audience and as a process more challenging to the participants.

[4] See www.bbc.co.uk/blast/.

Chapter 6
A Conversation with Sally Hibbin

Sally Hibbin has produced numerous films under the Parallax Pictures umbrella and is well known as one of the UK's most prolific feature film producers. She collaborated for several years with Ken Loach, producing such highly acclaimed and award winning films as *Carla's Song*, *Ladybird Ladybird* and *Riff Raff*. Sally also produced the BAFTA and EMMY winning *A Very British Coup* and BAFTA nominated Channel 4 drama *Dockers*.

When Parallax Pictures dissolved in early 2002 Sally set up Parallax Independent and has now moved this company to Colchester in the East of England and founded Parallax East in recognition of the re-location.

Parallax's most recent productions have received considerable critical acclaim and extensive festival and audience success. The first of these was *BlindFlight*, the story of the kidnap and incarceration of Brian Keenan and John McCarthy starring Ian Hart and Linus Roache and directed by John Furse, a first-time director. *Yasmin*, directed by Kenneth Glenaan, is set in Keighley, West Yorkshire and is the story of a young British Muslim woman played by Archie Panjabi and the effect on her life of 9/11. The film found a strong audience both at home and abroad, achieving high profile festival recognition throughout the world. *Yasmin* achieved good viewing figures on its UK television premiere on Channel 4.

Most recently, Sally completed the film *Almost Adult*, written by Rona Munro and directed by Yousaf Ali Khan, another first-time feature director. Yousaf's first short film was *Skin Deep*, produced by Andy Porter and made by Hi8us South. *Almost Adult* is a UK/German co-production shot on location in Birmingham and it will be shown on Channel 4 in 2008.

This chapter is based on a masterclass with Sally which took place at National Film Board of Canada in February 2007. The question and answer session explored her work as a producer making films, and working interactively with socially excluded communities. It addressed questions around collaboration, authorship, community empowerment and support for new talent, and drew primarily on her recent work with *Yasmin* and *Almost Adult*.

Yasmin

A story of a young Pakistani woman torn between her work for the local council and her life in a traditional Pakistani family set against the rise of Islamophobia after Sept 11th.

 Director: Kenny Glenaan
 Writer: Simon Beaufoy
 Yasmin: Archie Panjabi

Almost Adult

Two underage asylum seekers get lost in the system and find themselves on the streets of Birmingham.

 Director: Yousaf Ali Khan
 Writer: Rona Munro **(DVD clip / section 2 / 6)**

Q: Where did the idea for Yasmin come from? Did you begin with a pre-conceived story?

Sally: No, we started with a completely blank canvas – the question being: could there ever be a British suicide bomber? We didn't articulate that out loud because you couldn't really say it. We said we were looking to do a film about the Pakistani community, an underrepresented area. You have to understand that the first workshop we held happened literally the week we went to war in Iraq so the world was changing around us: the rise of Islamaphobia became what the film was about.

Think back to before the Iraq war which is when we started this. I'd been to Palestine, I'd been wanting to make a film there with a Palestinian filmmaker. I'd come back quite profoundly shocked by the camps and by the total exclusion that the Palestinians have from any kind of political process and I came back not condoning but to a certain extent understanding why someone would suicide bomb. I wanted to know whether that was possible within our own country and that question led us into the Pakistani community because they clearly were (one of) the most excluded communities in Britain. Its not just one community, it's several across the M62 (a motorway that runs across the North of England) – quite large enclaves who mainly come from Kashmir and they are all living in effectively the same villages as they did back home. So it is very ghettoised and nobody has a job. The local Pakistani newsletter in Keighley would headline 'Congratulations to so and so – he's got three days work experience!' I thought this is really interesting – this is where you could get that kind of reaction and lo and behold! – it was where, when it happened, the suicide bombers came from.

Were you working with a writer at that time?

No, we didn't have a writer at that time – we naïvely thought that we could manage without a writer – we had a director, editor, researcher at

the workshops. It was only later we realised that we really did need a writer!

How did the story emerge?
Well, what happened to us – and it was quite bizarre – was that we thought we were telling one story which was the story of one strong woman. There had been riots in Bradford and Blackburn a couple of years earlier and in a lot of the Pakistani families the fathers had turned their sons in to the police basically thinking that British justice would hold sway – and the whole community was completely shocked when the Pakistani kids got custodial sentences and not a single white person was prosecuted. And the woman that we met whose story we thought we were telling had in fact spoken to the Guardian about this and had lost her job at the Council as a result, and had got very depressed – her whole life and family had fallen apart as a result. So we thought we were telling the story of the next Bradford riots – the film was always called *Spark* because it was about the spark that would ignite the next riots and it was only during the workshops, the fact that we were going to war in Iraq, that changed it. Islamaphobia just changed everything we were doing.

There was no lack of stories. The workshop participants were all performers, the kids who were rappers were desperate to get on to tell their story. We eventually had three stories – we had this girl who had been sacked because she supported her brother in prison. We had the story of a young lad who was going on what I would call a personal Jihad. We were interested in that notion of Jihad, not as a violent thing, but as finding your relationship with your religion and faith. And we still had 'suicide bombers', and we just couldn't work out how to tell all these stories.

As it was we bumped into Simon Beaufoy, the writer of *The Full Monty* who happened to have been brought up in Keighley (which has a large Pakistani community) and he said 'Yes, alright' and he came in and pulled it together.

So how do the workshops actually work?
It really varies from film to film – it depends on what you are doing and where you are. Take the film we're developing at the moment in Great Yarmouth where we've just run the first workshops – we're about to go back and run another set. Great Yarmouth is a seaside town in Britain and we have been working there with a local group called Seachange, permanently based in Yarmouth, who make videos with socially excluded kids. The film is centred on the notion of something called 'respect' because it came out of how young people and other people have different notions of respect and how that translates and how you occupy territory and space in a community. So we put out the idea that we wanted to do workshops

with young offenders, single mums, pensioners. Seachange brought these people together, and we did different workshops with them and out of these came a story about two young people. In Yarmouth we may make the film with some of the people who are involved in some of the stories. On *Almost Adult* that wasn't really possible for all sorts of reasons – not least being you can't actually employ someone who is an asylum seeker.

On *Yasmin*, we didn't hold the workshops in Keighley – we only moved there later. We actually held them in Oldham – we'd recruited from Manchester, Bradford, Oldham etc. and got a mixture of kids, youth club workers, a couple of aspiring actors, a couple of rappers. Because we found it hard to get older Pakistanis anywhere near the workshops we brought in a couple of actors from the older generation. We also couldn't get any girls or women near the workshops. So we found two or three really strong women – all of whom had different to stories to tell (Yasmin herself is actually a mixture of the three of them) – and we did 1:1 sessions with the three women and one of them in particular read the script for us and corrected a number of things for us. So we involved people in that way.

When it came to filming we moved from Bradford and Oldham where we had been researching because the temperature on the streets was still pretty high and we didn't fancy being on the streets. Keighley was a much more enclosed community and much easier to get to know everyone in it. Amar (local actor on *Yasmin*) came from there and was deeply rooted there and helped us to all be part of Keighley.

We liked Keighley because it was a typical Yorkshire town with views of the hills – the houses were obviously built for dour Yorkshire families to keep warm and snug inside, but the Pakistani community lives on the streets – so it is immediately obvious as an immigrant community. It is very ghettoised. There is a main road and one side is where the Pakistani community is and, literally across the street, is the white side of town, So our hotel was five minutes walk away from the community but a whole different world. The only time anyone from that community came into the hotel was on the one occasion when they were running away from a gang of youths with knives.

Amar helped us settle in. The first time we went there he told us to meet him by the swing park at 6pm so we were waiting there in the main street of the community and it was getting dark and drug dealers were cruising around in fast cars. Everyone was on their mobiles and eventually one car was detailed to come and check us out. They asked if we were coppers and we explained that we were here to make a film. I don't think for a moment they believed us and it was beginning to concern us that Amar was nowhere in sight. Eventually he rang and said: 'Oh, no. Not that swing park. I'll be there immediately.' He arrived and the upshot was that from then on everyone knew who we were. We didn't have trouble

again with the fast car crowd until we were filming and they tried to put us off. But after a tactful approach from our Asian art director they all became extras and things went back to being peaceful. The older generation took Kenny (the director) to their hearts. He doesn't sleep well when he is planning a shoot and was often prowling the streets looking for angles late at night. Soon he was being invited in and fed curry and tea – and he soon knew everyone in the quarter. When we filmed during Ramadam, the community were great to our Islamic actors and often included them in the break of fast in the evening.

How long does the process take?
Yasmin was probably over a year of work-shopping and *Almost Adult* somewhat less. Because you go back to the participants – you don't just do it for a three-week workshop and leave – you go back and test things out, although you may not actually show them the script. What we're doing in Yarmouth now, we've got our first draft of the script and what I want to do is cast three young girls and three young boys and get them to workshop around the roles that have been written so that it becomes even more real, so that even the dialogue becomes totally rooted in the way they think and speak and act.

So does the script change through this process?
The scripts on these films continually change. Even at the end of the first week's filming (on *Yasmin*) we were changing things. The local Keighley lads got a look in on the script. We had an open house policy when we were filming. At one point a youth club worker came in with a whole gang and half the crew sat round and we talked about the story. They were very worried about some specific things. There was an issue in Keighley at the time – the difference between forced marriage and arranged marriage – and we had a long debate about that. In the end you can see it in the film that we never actually refer to it as a forced marriage – it was definitely an arranged marriage – so they were very pleased that we had taken that discussion on board.

There's a scene we wrote which we tried to film and we couldn't film it because people kept stopping us – so we actually kept in what happened for reality. This is the scene in the market place where the kids are throwing milk at the women in the Burka. We film very discreetly, the camera's always hidden and nobody realises you're filming – and every time we filmed it someone would intervene. Some old bloke came up and told the kids off, and the old woman who says 'are you alright?' in the film is for real. We thought the public have proved us wrong so we have to go with what actually happened. So that's another way the script does change – reality hits every now and again. I thought it was great, and made you

proud of Keighley for a moment because it is an area where there is a lot of BNP support, but the fact is that people intervene and it's lovely.

I think, in the end, the important thing is that people feel they have ownership of the film. *Dockers* was written by Jimmy McGovern and Irvine Welsh and fifteen Liverpool Dockers and their wives. The Liverpool Dockers – all 400 of them – had been sacked overnight and the sacked Dockers and Jimmy and Irvine were going to write a drama together and they did it through workshops over the course of a year. Different people would write different scenes and they'd come together and act them and criticise them and go away and write other scenes. There came a point where I had to tell Jimmy to go away and write the script and he did and he came back, and he had performed an extraordinary feat, I think, which is that the script is pure Jimmy and yet there wasn't a person in the workshop who didn't think they wrote it. That's the trick you're trying to perform: there is an author there somewhere, but everyone feels that they've participated and their voice is in it.

Do you feel a responsibility to the people in the workshop to cast them?
Yes, obviously there is that responsibility but I think it's about honesty – we've always tried to be honest and explain that in the end they may not be in the film. On *Yasmin*, Syed and Shah who play the husband and brother were actually in the workshops, as was Amar who plays the preacher.

John Richards, Trainee on Almost Adult, Camera Unit

Actually it was Amar who introduced us to Keighley. We auditioned by improvisation – I think most good directors audition by improvisation and not reading as you are looking for the qualities that you want.

And then we just had a terrible problem looking for the girl. Most of the Pakistani actors we saw were Pakistani babes – they came in tight short black leather and high heeled boots – they're either presenting on the Asia Channel or trying to be rock stars and they live a million miles from ghettoised Keighley. You can appreciate that in the Pakistani community there isn't a tradition of acting, certainly among the girls. Even Archie expressed discomfort about the idea of sex, undressing, kissing. Simon, Kenny and I had one of our all day rows – on this one it was Simon and Kenny against me. I really wanted them to cast this young Pakistani lass who I thought was great, who lived locally, who was an actress and had done a bit. I thought there was something about her and I just couldn't see (and I admit I was wrong) how Archie would ever get the roughness of the character.

Do you take the film back to show to the community?
Yes we premiered *(Yasmin)* in Bradford – Keighley is only about five miles from Bradford and they all came over to watch it.

I have heard you now run special training programmes during the production of your films – can you tell us about it?
On *Yasmin,* because I knew we wouldn't get very many ethnic minorities on the crew, we created a number of training posts which were financed by the local council and through Channel 4 schemes to take on trainees in the Asian community. We did it in a slightly haphazard way, with people working on the film in production, in camera, in editing and in the art department and probably in wardrobe – I think there were about six of them. It wasn't well organised but it was very good and even though the production person changed twice during the lifetime of the film and the camera assistant really didn't work out, most people got something out of it. One production person is still working within the industry.

On *Almost Adult* we did this in a much more structured way. We took on seven trainees who were (in a phrase that is popular in UK at the moment) 'in danger of social exclusion'. They weren't entry level trainees – they were people that had some experience of working on film and we did a whole course around it, where they had an induction week and we had a training mentor on the film. They had work programmes in each of their departments and actually they made a DVD of their own training process. Of these seven, six are still working in the industry and it was much more successful. On *Almost Adult*, it wasn't about involving the community in making the film, it was about finding a way that we could give something back to Birmingham.

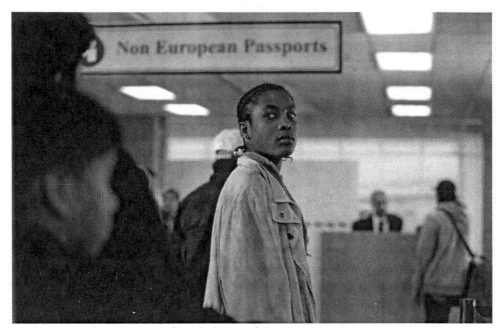

Still from Almost Adult: Mamie (Victoire Milandu) at passport control

Almost Adult: Director Yousaf Ali Khan with Victoire Milandu (Mamie)

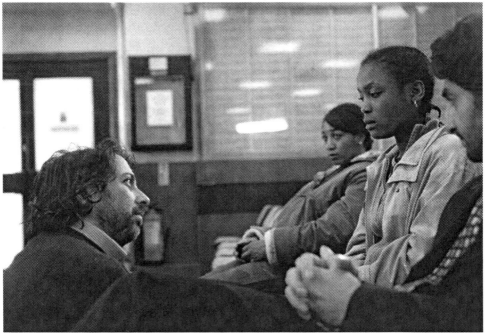

How was the film distributed and received?

Yasmin was offered theatrical distribution in the UK. Simon, Kenny and I had a long and serious chat about it and we thought we would spend 3-6 months of our lives promoting that film – if we were really lucky, *really* lucky, we'd get a box office of £500,000 – that means 80,000 people would go a see it. We would then have had to have wait six months to get it on TV. It was too topical to wait. So we took a very deep breath and rejected theatrical distribution on it. When it showed on Channel 4 it got an audience of 2.5 million, and after 7th July when they showed it again it got an audience of 2.5 million, which justified our decision.

The Daily Mail (which is our right wing trashy paper) gave an entire page to it and it was extraordinary – the critic said 'I'm embarrassed that I didn't know this was happening in our society. I want to thank the film makers for doing this.'

We did have some trouble from the London end of the Asian community since an all white team made this film. We did have a fair amount of resentment – particularly from writers in the Asian community who said 'why didn't you go with an Asian writer?' I deliberately didn't because I think most of Asian writers had an axe to grind and what we were looking for was to reflect the community's voice – not the writer's voice. Perhaps you can only do that by being outside of it.

I'm rather chuffed with *Yasmin* because it's been bought in Britain by an Asian Channel and they want to dub it. *Almost Adult* is much more interesting for me in the ways it gets used and seen. I don't think it will ever get distribution in Britain – there's no point in thinking about it – it's shown at the London Film Festival and various festivals. I don't think it's where Britain's marketing/sales distribution's head is at the moment but it has an extraordinary number of requests for screenings and it's nearly all for schools, charities – Red Cross, Save the Children, the Refugee Council, schools all over the place, any festival that has anything to do with ethnic minorities or refugees. I think what is happening with it is that people are using it to have a discussion. I think that's fantastic.

I feel quite privileged by the time I spent in Keighley. I think I had a window into a world that very few white people get – and a very rewarding way of working. The effect it's had on me is of a greater understanding of what's going on in the world – about Islam, about terrorism, Iraq. For me, however, the most rewarding thing that happened was the British Council sent me to Palestine for two weeks to tour (with *Yasmin*) on the West Bank and I just thought that was absolutely fantastic. The women adored it and the Islamicists were attempting to boycott it and it became this huge row about what was going on in Palestine. It was as if the film had come full circle.

Chapter 7
DigiTales
A European perspective

Juliette Dyke

'The age-old borderline between producers and consumers is beginning to blur; it's interesting times we're living in.'
(Daniel Rihák, film director and trainer on the Living Together project, Slovakia)

In the village of Krížová Ves at the foot of the Tatra mountains in Slovakia, Daniel Rihák meets with a group of Roma people to run a DigiTales workshop. The project is called *Living Together* and seeks to challenge the prevailing stereotypical images of Romani people in Slovakian society. Their community centre does not contain even one computer but by the end of the workshop, each of them will have produced and narrated a short story. With the help of scanners, cameras, laptop computers and storytelling games, Daniel guides them through the process of producing a personal two minute film which will eventually form part of a Europe-wide collection of DigiTales,

'It was a wonderful opportunity to see their creative side and how they react when they saw the work progressing. It is so unlike their daily routine, which is full of desperation and little hope of change.'

This is just one example of how a DigiTales project has changed the lives of excluded and disadvantaged people. It provides an opportunity for groups from across Europe to make short films about some aspect of their lives, and for those keen to pursue a career in the audio-visual industry an opportunity to learn techniques. DigiTales is the transnational arm of Inclusion Through Media (ITM), the Equal funded partnership led by Hi8us Projects Limited. The ITM programme has been running since September 2004 and in March 2005 Hi8us began to look for international partners.

Equal's database of over 1000 groups was trawled for suitable candidates who operated with a similar ethos, particularly in Eastern Europe where the European Union is turning its attention.

In January 2006, Outi Vellacott arrived fresh from the BBC to take up her new role as Transnational Producer for DigiTales and to forge the European links that exist today. Potential partners were identified in Slovakia, Finland and Holland, who in turn introduced partners from Germany and Greece. Then began the process of ensuring that facilities and equipment were in place, and training provided. Links were made between organisations who could contribute to the project, and where possible, independent professional filmmakers were involved to bring authenticity and expert knowledge to the process. The partners would meet every six months to plan the trainers' workshop schedule, held in each country in English. Then would follow the roll out of DigiTales courses within each project, in their own language. Various exchanges between trainers were organised, and each attended the others' seminars and screenings where possible. The regular meetings helped to keep up momentum, to share ideas and experiences and to find inspiration.

Since then Hi8us Projects have worked closely with these partners, running DigiTales workshops with participants from an extraordinarily diverse range of backgrounds. Using the DigiTales method, people develop story ideas through story circles, drama, photography, drawing, music, video clips and narrative. They learn how to write a script, edit photos and drawings, and make them into a two minute film, which with their permission is then posted onto the DigiTales website (www.digi-tales. org). Personal stories across nations are exhibited and exchanged and as the website grows, a patchwork-quilt of personal moments builds to create an evolving picture of Europe's diverse populations.

The aim of the website and the training that ITM provides is to leave a DigiTales legacy beyond the life of the Equal funding which stands to run out in December 2007. New partners in Poland and Lithuania have recently joined the programme, and the wheels have been set in motion to find new sources of funding to ensure that DigiTales has a lasting future.

The origins of Digital Storytelling

Sometime during the mid-1990s, an academic called Daniel Meadows at Cardiff University was researching the digital world and the future of online journalism. At the same time, a three strong team of activists, producers and writers in California were pioneering a unique computer training and arts programme called the Digital Storytelling workshop. Daniel came across their work and flew out to meet Joe Lambert, Nina Mullen and Dana Atchley who helped him produce his first digital story. He was impressed by how democratic the method was, as it enabled

105

audiences to participate in the media in a way that had not previously been possible or perhaps more accurately, encouraged. Daniel believed that audiences were demanding to play a greater part in modern communications and this could be a way for them to do just that. Back in Wales, he pitched the idea immediately to the BBC who took it on under the title *Welsh Lives*. Joe, Nina and Dana flew over to Cardiff the following year to run a pilot workshop at the BBC, where Daniel took their therapeutic workshop model and adapted it to suit for use in communities. Five years passed and the project grew, changing its name to *Capture Wales* and winning countless awards including a Welsh BAFTA. Groups all over Wales were and still are running their own regular Digital Storytelling workshops in miners' institutes, welfare halls, colleges and village halls. The films that are produced are adapted for broadcast and shown on terrestrial and interactive television channels such as BBC2W, played on the radio and broadcast on the Internet. In May 2005, Hi8us Projects approached the BBC to discuss a collaboration and DigiTales was born. What Daniel Meadows believes has made the project so successful is its accessibility,

> 'The problem with open access media used to be that there was no form. It's like trying to teach children poetry without first using a haiku or some template for them to learn with. The digital storytelling form gives people a voice.'

He is thrilled that the idea has spread so far and empowered so many people,

> 'Today, instead of being represented in the media by professionals, if given a bit of assistance we can all – even those of us who are computer novices – represent ourselves with a considered and elegant, broadcast-ready, narrative. A workshop gives its participants courage, for making a digital story isn't easy. It can though, be remarkably therapeutic. It's certainly empowering and when imagined as a tool of democratised media it has – I believe – the potential to change for ever the way we engage in our communities. Back then, seeing the workshops in California just gave me the courage to believe such a thing was possible.'

The journey from page to screen

Myriam Sahraoui is a programme maker for Dutch local television and a Policy Consultant. She runs DigiTales workshops for Muslim women as part of the *Zina* project in Amsterdam, which draws connections and stimulates dialogue between the Western and the non-Western world. The project encourages women to take part in activities outside of their homes and give them a sense of empowerment. However, Myriam found that many women were reluctant to have their films shown outside of the

group for personal or cultural reasons, and so were unable to complete the workshop in the conventional way.

> 'It took a lot of patience and effort to get them on board the workshop, and finally only half of the participants produced a DigiTale. Whilst the process of sharing stories was wholly successful, the production process was only half so. In the future, we should be able to include women who want to make a film without necessarily sharing it. These women are often the most excluded and their participation in the workshops is a first step in developing a voice. I feel very grateful to have had the chance to help people tell their beautiful, touching, intimate, funny, brave, strong stories.'
>
> (DVD clip / section 2 / 7.1)

Malika Mehdaoui who works at a women's centre in Amsterdam, took part in the *Zina* project.

> 'I was selected by the women's centre to join the workshop and had very little experience of using computers before I took part. The most rewarding aspect was listening to others, telling a story that was burning in my heart and reducing it to a powerful short text, all in Dutch. I would like to assist with running the workshop in our centre next time, and could help to create an intimate safe ambience for women to open up in the group and not to be afraid to join in. A lot of women – especially those from an Islamic background – are afraid to join in activities where media (video, photos) has a role.'

One of the greatest challenges a trainer faces when running a workshop is encouraging participants to overcome their fears and inhibitions in order to access their creativity. Daniel Rihák of the *Living Together* project in Krížová Ves, spoke about his experience of the early stages,

> 'The warming up part is always a bit difficult, but that's normal – you can't expect people who don't know each other to just get together and immediately be relaxed and creative. So I really appreciated the games we played – they did the job and once we crossed a certain threshold everyone was very creative. It's a common superstition that Roma people are lazy, but the truth is that they hardly ever experience what satisfaction feels like. The vision of the finished films made them try twice as hard and once we had one or two finished films, more suddenly volunteered and wanted to take part as well.'

Rudolf Karafiát ran the Slovakian *Living Together* project and felt the positive impact of the workshop in his Roma community,

> 'At the Krížová Ves Workshop, 50 children were shouting outside the cultural centre, wanting a camera and wanting to be a star. They watched the movies together with their parents at home under the Tatras, and then in the Slovak state radio broadcasting company building in Bratislava. These films were a big influence in the com-

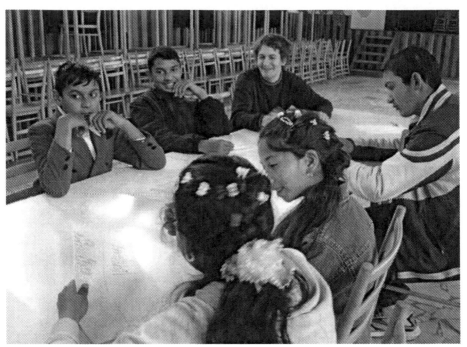
A group of Roma children share their stories with Daniel Rihak in Slovakia

munities; talking is always the beginning. Culture, arts and entertainment are as important as good healthcare, education and the participation of Romas in the local governments of places where they live.'

Another training challenge during the production period was guiding participants whilst they struggled with real, life-changing decisions. Szilvia Simon from the *Choose for Your Life* project (*Kiezen voor je Leven*) in the Netherlands found herself working with young people who were wrestling with issues ranging from heart disease, pregnancy, adoption, rape, addiction and low self esteem to being an asylum seeker.

'We took special care that these students' films addressed not just certain events but also how they dealt with those events. In the course of the weeks I saw students really thinking about their lives, events, choices and actions, we spent a lot of time talking about it. For example, one of the students Nannette, was born with a serious heart condition. The first version of her film focused on this aspect; the operations, the insecurity. It was very heartbreaking and when we first saw her film, all of us were knocked out. Nannette herself became very sad for days. Then we decided to start over and make a take two about her life now and how she deals with her illness. She has created a website about it and raises funds for heart foundations. All this made her film a bit longer than the rest but she is very proud of it!'

Choose for Your Life was run in various schools and colleges, and proved so effective that it is already being incorporated into a new project with young people in the province of Brabant, as an effective instrument for expressing cultural identity.

Technology: lock or key?

While the key to the success of the DigiTales method lies in its focus on the story rather than technology, the computers, cameras and scanners are still essential for its delivery. Nevertheless, software can vary, computers can be unreliable, and sometimes there are simply not enough trainers with the required knowledge to go around, as Giovanni Massaro (Project Manager of multicultural information projects at Mira Media) explained,

> 'The most challenging parts for me were the failing computers. Not all computers were working the same way and some of the participants lacked self-confidence. Next time, I would spend more time preparing the technical part (testing the computers and the uniformity of the equipment) and have a technical assistant.'

As an alternative to this reliance on technology, some groups have begun to experiment with other methods of illustration, such as clay animation in Holland and stop-gap animation in Cornwall. However, the tales remain *Digi*Tales and will continue to present challenges for trainers who are delivering workshop in areas with more limited resources.

Despite these difficulties, the majority of participants have found mastering the technology very empowering. The DigiTales project in Finland is run by Mundo, a media education and work training project aimed at immigrants and ethnic minorities. Its objective is to help with the process of social integration in Finland and promote multicultural understanding among employers, offering education, tailor-made individual study plans and work training in different media fields. Twenty one students participated in DigiTales and five of them in turn became trainers, teaching young people in schools (**DVD clip / section 2 / 7.2**). The original trainer, Michael Hutchinson-Reis from YLE (the Finnish Broadcasting Company who run the Mundo project) in Helsinki described his experience,

> 'The DigiTales method worked as an effective training, motivating and creative tool for the students, which included media teaching professionals as well as young people. The initiative empowered them by demonstrating that they themselves can use creative and innovative methods to make things happen. As relatively new and young immigrants, it has also helped their understanding of Finnish culture. DigiTales trainers must have the vision, commitment and an awareness of the potential impact of this new media tool. Otherwise, this could possibly result in an interesting "one off" not to be continued. New Media needs to utilise modern pedagogical methods to

A trainer edits her film in Athens

maximise students' learning. The technology is available to us; we just have to use it and try to make some positive impact.'

Perhaps the most challenging of all the groups were some young Roma asylum seekers from Berlin. They had little or no school education and as asylum seekers they are not allowed to work or enter any in-depth, long-term vocational education scheme. Prior to the workshop, they had been informed that they may get deported with very short notice – many of their friends and families had had to leave the country already. One young participant commented, 'I want to tell people about our situation. So many people think that we don't want to work. I would like to be a mechanic or a waiter, but I am not allowed to.'

With these kinds of pressures, their trainer Michaela Goetsch had to stretch and adapt her resources to meet their needs, emphasising the necessity to build trust between the participants and trainers.

'The meetings took place in familiar premises where the participants felt at home. The high number of trainers proved necessary as the participants only managed to concentrate with a one-to-one tutor to pupil ratio. These young Roma people had very few photos for their stories so it was necessary to produce new pictures, but they enjoyed

taking and selecting the photos and thinking about how to represent themselves and each other. A lot of different creative materials and cameras were needed, but once provided it they were keen to learn. Some started to work with Photoshop independently whilst others got interested in recording the voiceovers. The films were presented on a large screen with about fifty people present to celebrate the launch, and I could see how proud the young filmmakers were and how confidently they spoke about their contributions.'

So we can see that DigiTales has been successfully used in a variety of contexts, in some cases to help participants develop on a professional as well as personal level. In Greece, the *Community Net* Project aims to improve the training opportunities of unemployed expatriate journalists from the former Soviet Union, Europe, Australia and Africa. One of their partners is ARSIS (Association for the Social Support of Youth), which aims to prevent the marginalisation of vulnerable people and improve their social integration. They used DigiTales in a 'Youth in the Media' workshop with a group of young people from a rural area in Thessaloniki from different ethnic backgrounds, including Greek, Greek Roma, Albanian and Albanian Roma. They were encouraged to choose the theme of their videos; one of which was a string of interviews filmed during the street events in Thessaloniki for the World Day Against Child Labour. The experience led two of the teenagers to become trainers in editing, providing them with new professional opportunities.

Closer to home
In the UK, DigiTales are also reaching out successfully to different communities by adapting to meet the needs of individual groups. Lansbury Voices in Poplar, East London is a group interested in all things multimedia and with support from Ii8us, DigiTales teamed up with them to run a workshop. The participants, mainly single mothers from different ethnic minority backgrounds, were able to take the time out to complete the workshop as it was split into five 'bite-size' half day sessions. Patricia Evans, a single mother herself, was a participant.

'It was fun learning all these new things and I never knew that I had so much patience. The people running it were very helpful and informative and I'd love to do another project like this. The whole thing was brilliant, and the atmosphere was great. I would like to do a presentation of all the things we have done as a group, so that the people in the community could see what we are all about and possibly join us.'

Elsewhere, the Liskeard Youth project in Cornwall has also been working with young mothers, exploring their lives and loves. A trainers' course was run in a skate park in Truro with a team of filmmakers and trainers

from Hi8us in February this year and since then, workshops have been held all around Cornwall in partnership with local groups.

In the North of England, the latest DigiTales workshop ran for students at Liverpool Community College with Toxteth TV; an innovative space that combines professional film production companies with facilities for young people to access further education in the media. The group spent their half-term turning the camera on themselves and sharing their stories about Liverpool. And in Leeds, DigiTales worked with the *My World, Your World* creative arts network which provides a forum for refugee artists to access opportunities in all aspects of the arts.

In more conventional educational surroundings, teachers are beginning to express an interest in using the method in classrooms. Plans are already underway to deliver a workshop through the Children's Services in Liverpool, and a pilot scheme is being developed to offer 'Digital Essays' in universities with Birmingham University lined up as the first potential user.

Reaching a larger audience
The DigiTales legacy has reached far and wide since its humble beginnings in Cardiff in January 2006. The workshops have produced over eighty films (71 are currently available on the website), hosted countless screenings in communities and provided material for mainstream television channels from BBCi to YLE, the Finnish national public broadcaster. DigiTales have also been exhibited in a variety of public spaces from the major international policy conference *Creative Clusters* in Newcastle to DigiTales at de Balie, a major cultural institute in Amsterdam. A series of films were also screened on the Berlin underground trains in June 2006 during the football World Cup, as part of a scriptwriting competition based around the theme of Integration, organised by BGZ (Berlin International Cooperation Agency).

As the transnational partners begin to complete their projects, various events have been held to celebrate and share the content. One such event was the DigiTales conference *DigiTales – I tell you my story: Empowerment and Diversity in the Media*, held in Berlin in March 2007 as part of the European Week of Media and Diversity.

This year the week was kicked off with the DigiTales conference, organised by BZG-Berlin.

Partners from Germany, Finland, the Netherlands and the UK came together to celebrate and share the DigiTales method with members of the media industry, practitioners and broadcasters including Radio Multikulti from Berlin who specialise in producing radio programmes for immigrants in their own language.

Outi Vellacott, the Hi8us transnational producer, introduced the project

and the successful work completed over the last year. She highlighted the versatility of the method and diversity of groups reached through the work, as would be seen in the films showcased through the day. Participants from the Mundo media training project, *Zina* project and the German Roma asylum seeker project were all present to show their films and share their experiences with the audience. Different workshops were held by Outi and other trainers in the partnership to present the method and to discuss new ideas for improvement. These short workshops were held in both English and German, and dealt with the practicalities of running a DigiTales workshop. Rosemary Richards from BBC Video Nation held a complementary session about different stylistic approaches to personal storytelling, and all were invited to take part in a brainstorming session finding ways for NGO's to cooperate with mainstream media.

ITM also had a stand at the conference where Nicole van Hemert (Communications Manager Hi8us) and Julia Dunlop (Hi8us Administrator) were able to hand out leaflets and DVDs, and showcase the websites to people interested in learning more. The presence of the Hi8us team also helped to input and plan for the DigiTales conference which took place in Liverpool in June 2007.

The Liverpool conference saw the grand unveiling of the DigiTales website at the cinema and gallery venue FACT (Foundation for Art & Creative Technology). Completed stories were shown throughout the summer on the BBC Big Screen in the centre of Liverpool. The website has provided a platform for all the projects to come together in one place and be made available to the public. Overall, participants have been enthusiastic about showcasing their work via the Internet, but this approach was not always suitable for every group as was seen with the *Zina* project in Amsterdam.

The Liverpool event provided another opportunity for the European partners to meet with local film makers and members of the media industry. One such organisation was SeaChange Arts, an arts development organisation based in Great Yarmouth, Norfolk run by Joe Macintosh. They work across many art forms and social contexts and their activities are designed primarily to contribute to social, economic and cultural regeneration with a strong focus on young people. Joe commented on seeing the DigiTales method in action,

> 'It struck a chord with me. The method is a simple, powerful way to get to the heart of people, and what's good about it is that it can be taught to all staff members, not just filmmaking experts. It would provide a good starting point for our work which tends to be more in depth, and also focuses on cross-cultural collaboration.'

Other organisations involved in media education and inclusion were also able to showcase their work at the conference including Education TV

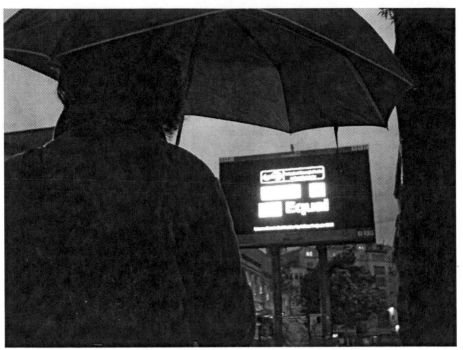
DigiTales films shown on the BBC Big Screen in Liverpool

and ROC (Central Netherlands Regional Education and Training Centre). It is these new relationships which will play a key role in the future of the DigiTales projects.

The day was hosted by BBC reporter Polly Billington from the flagship Radio 4 news programme *Today*, and she summed up with what she felt was at the heart of the DigiTales programme,

> 'This work gives us a chance to look differently at what makes up Europe. Not all of the participants who have made digital stories are here, but their voices are here. This project provides a real opportunity to look at how Europe is changing, how it is evolving.'

The future

If these positive reactions from participants, trainers and collaborators show anything, it is that DigiTales is a powerful model for transcultural cooperation and for giving people a voice and empowering people. The project intends to provide a fuller and fairer representation of minority groups in the media, and contributes towards a greater understanding between different cultures and communities.

Seeing stories from such diverse groups and in different formats (animation, video, stills) proves that the method is adaptable and suitable for

a whole range of groups, projects and cultural contexts – with the use of simple media technology and Internet tools. As part of a broad range of project activities, Hi8us and its partners have functioned as agents of change by providing specialised training through this innovative outreach tool. More time, resources and reliable equipment will make the initiative even more effective, but for now the goal of Hi8us is to secure the future of the project. New partners in Poland and Lithuania have been signed, and all members of the enlarged team are assisting with the search for new and sustained funding. DigiTales workshops continue to run successfully across the UK and Europe, experimenting with new creative avenues such as animation and illustration. Their aim is to branch out in new directions and diversify, ensuring that the projects continue to work at a local and transeuropean level.

Inclusion Through Music
Shifting perceptions

Jacqueline Clifton & Tricia Jenkins

Blind composers can't write film music!
WHY NOT?
A perspective from Jacqueline Clifton, Director of Musicians in Focus

Musicians in Focus

This is probably true for many blind people, but how do you define 'blind'? Is it really necessary to see the film to be able to compose the music?

Can't is a word that rarely enters the vocabulary of those who work with Musicians in Focus (MIF). The development of technology in recent years has meant that visually impaired people can easily access computers with the use of specialist software. Screen readers and magnification have opened up the world of word processing, email, the Internet and, most importantly for musicians, sequencing, recording and editing software. Consequently, visually impaired people are able to access any number of courses at colleges and universities around the country and the world.

About Musicians in Focus
Musicians in Focus has established a reputation for being amongst the leaders in promoting access to and development of technology for visually impaired musicians. Running courses and workshops to demonstrate

equipment and aids, not only for the visually impaired user but also for teachers, parents, support workers and employers forms a significant part of MIF's work. Research, in collaboration with a number of other organisations including key players from the music industry, the Musicians' Union, the London Symphony Orchestra and the Royal College of Music, one of the foremost music conservatoires in the world, seeks to develop further access and assistance for talented young people with visual impairment in the future.

Increasingly, research into social issues has become important and Musicians in Focus has developed a range of workshops to teach and apply presentation skills, investigate social attitudes towards blind and visually impaired musicians and to develop a network of teachers and trainers with relevant skills to work with visually impaired students and musicians.

Musicians in Focus and Inclusion Through Media (ITM)
Musicians in Focus joined the ITM Development Partnership in 2004 to take forward some ideas that emerged from participation in an Equal Round One Development Partnership: Creative Renewal. MIF joined a transnational meeting in Lisbon in 2003 to run workshops to train two visually impaired musicians in composition and music technology using Cakewalk, a music sequencing and recording programme and the Sibelius music notation software accessing the computer with the screen-reading programme JAWS. MIF then worked with a group of young people from Lisbon and London who had collaborated over three days to make four short films, to create the soundtracks. When this activity was first proposed, the reaction was one of disbelief – how can blind composers write for a visual medium? The project was great success and, with a different approach to briefing the composers and clarity in describing the look and feel of the films, excellent soundtracks were composed.

This led MIF to wanting to explore the possibilities of opening up other potential future employment possibilities to talented visually impaired musicians – *and* to starting to change the perceptions of employers, sighted music professionals, music teachers and, possibly most importantly, the visually impaired young musicians themselves.

Musicians In Focus' ITM Project – Music for Screen and Drama
MIF 's approach to this project has been to build upon what was learned through earlier projects and develop a programme of work that was firmly underpinned by research.

The real work began with research looking at access to education in Music and Media Studies for visually impaired students. It also involved exploring a wider range of social barriers through in-depth interviews

117

with visually impaired young people and their parents, which were captured in a report entitled *Conversation Pieces*[1].

Secondly, Music for Screen and Drama comprised an ongoing range of programmes created for visually impaired musicians in collaboration with the London Symphony Orchestra, the Royal College of Music and the Musicians' Union.

Lastly, Music for Screen and Drama encompassed a range of presentations, seminars, conferences, professional development and training that has been informed by an in-depth programme of evaluation of music hardware and software for visually impaired users. This has been undertaken with a view to influencing the music industry to improve access for visually impaired users.

1. Research: Exploring the barriers – the obvious and the not-so-obvious…

75% of blind and partially sighted people of working age are unemployed. (Action for Blind People website, 27 June 2004; RNIB website 19 September 2007)

Extract – Conversation Pieces interview with a young person, just under 16 years old, who has been visually impaired since birth, has been educated in mainstream school and uses a long cane to assist mobility.
Question: Were you the only blind student at your schools?
Answer: Yes.
Do you find that the support teacher does too much for you, is a bit of a barrier?
It is a bit annoying that you are always sitting with another adult in classes… you feel a bit cut off.
Did you feel that you were isolated, having someone with you all the time?
They were very protective when I was younger. One day my support teacher was not in and I was banned from going into the playground!
Do you feel that your support teacher was well enough trained then? For example, do you think that their training prepares them to work with you as blind students or encourages them to be too protective and wrap you up in cotton wool, making you dependent on them?
Everyone I have spoken to so far has said they would rather have been allowed to go and play with the other children and if they get into a bit of rough and tumble, well… that's all part of growing up really. […] because you both lose your skills to socialise and also you aren't used to getting hurt and you are more scared to go out when you are older and you become more isolated. It's much harder to learn that when you are older.

In the process of evaluating the workshops that MIF has been delivering, more pressing problems emerged around two fundamental exclusion issues: the inconsistent levels of education available for visually impaired people and, as a consequence of this and general perceptions about the capabilities of visually impaired people, a lack of access to social and life skills.

Research Themes:
- Existing learning and teaching resources
- Access to equipment used in the music industry
- Historical and social status of visually impaired musicians

Two key themes emerged through the research process: literacy and mobility.

Literacy
In terms of literacy, access to reading is dependent upon alternative formats, such as Braille, large print and screen reading technology. With Braille, there is an issue around the availability of sufficient publications; and with Braille music, the availability of scores is very limited indeed, especially for contemporary pieces. Braille reading and writing is introduced often at too late an age, which means that visually impaired children are likely to be lagging behind in their literacy skills, which has a knock-on effect to their access to the rest of the curriculum.

Partially sighted children are often only offered the option of reading large print, when perhaps Braille would be a better pathway because

a) if their sight deteriorates further, then they would have no access to reading and writing; and

b) reading large print slows down reading speed and impairs comprehension, simply because of the number of words you can get on a page.

Imagine trying to read a textbook or novel in 22 point text size. Research shows that the average adult reading speed is 250 words per minute but those who tend to say words in their heads as they read slow down to 200 wpm. Students with dyslexia usually read at around 130-160 wpm – some are even down to 85wpm which makes comprehension extremely difficult as words drop out of the memory and all connections within the sentence are lost. The average Braille reading speed is about 125 words per minute, but greater speeds of up to 200-300 words per minute are possible.

Many students in higher education can read at faster rates and skim at around 300-350 wpm. This clearly demonstrates the disadvantage a visually impaired student faces.

Recent developments in screen reading technology have opened up amazing possibilities in terms of accessing information from the Internet,

however this is reliant upon access to technology, and many schools are insufficiently equipped and not trained in using, or teaching how to use the hardware or software.

Mobility

> *Extract* – Conversation Pieces interview 2 with a young person, just under 16 years old, who has been visually impaired since birth, has been educated in mainstream school and uses a long cane to assist mobility.
>
> *Question: Of course, the other problem is with mobility. People trying to help you and panicking because they think you are going to walk into things. Well, what is a cane for except to bang into things so that we don't. The worst thing is when they grab you. You are more likely to have an accident falling off balance. It's hard not to snap at people... how do you manage with that? Do you say thanks I can manage or do you give in and let them help you?*
>
> Answer: I know my way around school really well but people are always saying 'Oh, I'll take you there'. I try, but it happens so often that in the end you give in.
>
> *What is the situation at school doing sports, school trips, etc?*
>
> I used to have really good teachers but now, well, they don't have the training. They send me to the corner with another student that does not do sports. They think it's enough to give me a ball to play around with for a bit in a corner.

Formal mobility training is incredibly important for visually impaired children to learn early. Most of our interviewees felt that mobility training was left too late and was too limited in terms of its expectations of the capabilities of visually impaired people. Without adequate literacy or mobility skills, the world of employment is almost impossible to access.

Changing Perceptions

Changing people's perceptions and expectations of what a blind person is and what they are capable of doing has become a central driver for what on the surface might seem to be a highly specialised and specific project around music composition. The advisory organisations are predominantly constituted of sighted persons and their advice is predicated on their experience as a sighted person working with blind people, rather than consulting successful blind people or blind practitioners in the workplace. The advice to parents, teachers and young people has lifelong effects on the future prospects of visually impaired people. Our research showed that advice and information is poor or inaccessible around:

- Good quality secondary and tertiary education.
- Disabled Students' Allowances and other grants.

- Fast access to books and scores in their preferred format.
- Top-up courses to acquire skills that have been missed or forgotten.

This lack of advice, coupled with a lack of understanding by society in general has a huge impact on the skills that visually impaired people need to acquire to prepare for employment in any field, let alone music. The recurring themes that came through the research were:

- How do you change the average person's presumption that if you are blind you need to be wrapped up in cotton wool?
- If you are blind, people assume that the number of brain cells you have is relative to your level of sight.
- How do we break the consequent culture of dependency?

What does 'blindness' mean?

Extract – Conversation Pieces interview 2
Question: Is there anything that, if you had a magic wand, you would want to change?
Answer: Well there are students that aren't used to us. I have not got much of a social life. They don't understand. They go to the cinema and they don't think to invite me and I would like to go. They think that because I am blind I would not be interested in going but I like films.

Many legally registered blind people do have some visual cognition. Being blind does not necessarily mean seeing black. In fact, in most instances this is not the case. The Oxford English Dictionary's definition of blind is 'lacking the power of sight' – not 'lacking a brain'. Unfortunately the English language also uses the same word to mean lacking in judgement or reason, to deceive (lead up a blind alley or blind someone to the truth). It is used to mean baffling (blind with science), carelessness, recklessness, lack of consideration for others (care not a blind bit, turn a blind eye to). All of these sayings show deep-rooted perceptions in society about the condition of blindness.

> 'By the way – we do not have extraordinary powers of hearing and touch (supposedly to compensate us) – we have just learned to use our other senses more acutely and accurately'. (Jacqueline Clifton)

The legal definition of 'blind' in most of Europe and North America is vision of 20/200 (6/60) or less in the better eye with correction. This means that a legally blind person would have to stand 20 feet from an object to see it with the same degree of clarity as a normally sighted person could from 200 feet. Only approximately ten percent of those considered to be legally blind are completely blind. The rest have some vision, from light perception to reasonable acuity. Those who have serious visual impairments, but are not legally blind, are deemed to have low vision (partially sighted).

Working out music cues
at the Get Your Hands
on an Orchestra Radio
Plays Workshop. Image by
Rachel Burgess

So – why might a blind person enjoy going to see a film? Why would
we even contemplate the idea of composition for a visual medium as a
potential occupation for a visually impaired musician?

Most blind and partially sighted people may well be able to make out
something of what is going on in a film, even if it is only movement or
changing light and colour levels. In any case, not everyone who is blind
now has always been blind, so some will have a strong visual memory.
With detailed verbal descriptions, such as audio description, it is possible
to understand what is going on in the action. Visually impaired people can
read the director's script and notes on a computer. Modern synchronisa-
tion techniques enable a visually impaired musician to produce accurate
lengths of music cues: once given accurate timings, a composer, visually
impaired or not, can produce cues exactly to order. Access to computers
with assistive technology solves accessibility issues.

2. Individual strands across Music for Screen and Drama
Musicians in Focus' *Music for Screen and Drama*, was designed to address
confidence, mobility, transferable skills, as well as the specialist applica-
tion of technology to the teaching of music with visually impaired musi-
cians and students of music. Specifically, through joining forces with a pre-
dominantly media focused Development Partnership, Inclusion Through
Media, the project was to explore the potential for composition and sound
design for film, television, theatre, radio and audio books.

Get Your Hands on an Orchestra!

Get Your Hands on an Orchestra! was the first of a series of workshops undertaken in partnership with the London Symphony Orchestra, designed to provide an opportunity to explore the range and scope of orchestral instruments in an orchestra and to provide the foundation for further courses and workshops exploiting music technology to compose and produce music for screen and drama.

The London Symphony Orchestra (LSO) is a self-governing orchestra founded in 1904, based at the Barbican Centre in London. It is one of the most famous orchestras in the world and has had a long association with film, recording some of the most loved music to emerge from this medium, most notably perhaps the Richard Addinsell score for *Dangerous Moonlight* and, more recently, the *Star Wars* and *Harry Potter* scores. The LSO undertook the partnership as part of LSO Discovery, its music education and community programme that aims to make the Orchestra an accessible resource to the local community through participation in music-making. Highly experienced animateurs (workshop leaders) and LSO musicians work alongside people of all ages and abilities in a variety of creative music workshops, informal performances, masterclasses and training sessions.

Recording voice over at the Get Your Hands on an Orchestra Radio Plays Workshop. Image by Rachel Burgess

Collaboration between professionals and non-professionals

The collaboration between professionals and non-professionals, or students, is a principle that is shared between MIF's project and the rest of the Inclusion Through Media projects. The empowering principles of such collaboration forms one of the key themes of the Inclusion Through Media approach.

Get Your Hands on an Orchestra! enabled the project's visually impaired participants to work with professional players from the London Symphony Orchestra in small ensembles. Not only did the participants learn from the professionals, but also the LSO players learned about how to change their working practices to ensure that their visually impaired colleagues could engage and participate fully. For example, finding ways of communicating that would enable a player without sight to know physical cues and the like. Often, in orchestras, cues are managed through watching the conductor, or by eye contact with other players. The LSO players and the participants worked together to find alternative solutions – often these would be suggested by the participants themselves. Teaching the professionals these techniques was felt to be very empowering and motivating – and the LSO players also felt that some of the techniques would be useful alternatives even when not playing with visually impaired musicians. For example, using breathing to signal cues, or giving a slight stress in the bowing of a stringed instrument to enable visually impaired players to know when to come in were two solutions that proved to be successful.

Creating Resources

a) Textbooks

Underpinning the learning programme, Musicians in Focus developed two textbooks with tactile diagrams: one about music technology and one about orchestras and instruments. Although music technology has become a major part of teaching music, visually impaired students do not have access to a wide range of 'real' instruments to illustrate what is being taught.

b) Development of Audio Diagrams

Through Inclusion Through Media, MIF has undertaken preliminary work and testing on adapting the necessary hardware and diagrams for some orchestral instruments. From this research, MIF is intending to develop a series of innovative audio diagrams suitable for use from secondary to post graduate level education. These resources will include:

- Specially designed tactile diagrams with up to four levels of audio information
- Multi-format text relating the history and development of musical instruments

- Recordings for the comparison of live and synthesised sounds
- Demonstrations of a range of playing techniques and notations

These resources will be invaluable for:

- Study of the history and development of instruments
- Instrumental teaching
- Relationship of live and synthesised sounds
- Rare instruments difficult to obtain
- Old instruments too delicate to handle and play

The integral audio and tactile elements of these materials will ensure equal access for all and further encourage institutions and teachers to support sensory impaired students.

This project is being developed with the Royal College of Music Museum. MIF is currently fundraising to enable further prototype resources to be developed and tested.

How did the 'Get Your Hands on an Orchestra!' project work?

Early workshops started off with participants predominantly in an observation role: the LSO players would play a piece of repertoire, then take an extract and explore themes and sequences with participants, using them to begin to develop their compositional skills and explore the process of composition. As the workshops progressed, the emphasis shifted to being composition led, whilst simultaneously participants were being taught music technology through workshops at the Royal College of Music, using assistive technology. This was to enable the participants to begin to notate their work in a format that would be accessible both to them and to the LSO players.

This progressed to providing the participants with a small piece of text to form the basis of a song – a first assignment for the students. Armed with their first ideas, they worked with the LSO players to develop an arrangement of the song, which could then be notated and played by the ensemble together.

Shifting more towards the media, the participants progressed from creating a song to being given extracts from several classic novels, from which they could choose to develop as a radio play, so that they could learn how music could enhance a dramatic or narrative medium. This involved three workshop days with the LSO musicians, then twelve weeks to write the music and sound-effects, using their increasing skills in music technology. This exercise served to develop their visualisation skills – how do you represent moods, events, characters, through music and sound effects?

After the twelve weeks, participants presented their arrangement to the LSO players, who gave professional advice on, for example, whether they had written well for their instrument, how the ensemble worked,

musical and aesthetic balance, whether it worked with the narrative.

The final element of the project was to undertake a collaborative composition, working on the arrangement with the LSO players, which would develop the participants' skills in learning how to work as a team, with professionals, to a deadline and a performance goal.

The Princess' Tale

> The project animateur was internationally-known conductor Howard Moody, who described it as "a modern day fairy tale written by committee". He and narrator Colin Brown, a specialist workshop leader and facilitator, worked with nine young musicians and four instrumentalists from LSO to take the story of Stravinsky's "The Soldier's Tale" a stage further: imagining what happened to the princess the soldier fell in love with after he had returned to his village. (FORWARD Magazine, Sept. 2007)

It was decided to use the 125th anniversary of Stravinsky's birth to stimulate a composition and performance to mark the end of the workshops.

Taking the format of *The Soldier's Tale*, which has a strong narrative base, each participant was asked to propose an idea for a story that would form an episode to a longer piece. The group came up with *The Princess' Tale* (**DVD clip / section 2 / 8**).

The participants had to work together, in collaboration with LSO players, to pool all of their scenes and find a connecting thread both for the story and for the music and sound effects. As well as taking account of the musical and dramatic needs of the exercise, they had to learn how to communicate as a team, how to compromise, how to work in an age-diverse group and how to work professionally, with professionals. The participants also had to direct the LSO players in terms of how they wanted their sections performed and explain what their scene was about. Directing rehearsals of professionals is challenging enough if you are not a professional – but for a visually impaired young person, who is perhaps more used to being directed or having things done for them than taking the lead, this was a phenomenal task.

Problem-solving was central to the participants' success in delivering the end result and the evaluation data that has been collected following the project confirms that the confidence that has been gained by participants in undertaking the project, and by collaborating with professionals has been incredibly successful and empowering.

A mentoring group, comprising four of the older participants, has learnt about the importance of working with their groups to draw out ideas and help with communication skills, rather than taking the easier route of providing ready-made solutions.

The ultimate challenge was also to find ways to communicate their

Above: First read through of The Princess' Tale
Below: Rehearsal of The Princess' Tale
Images by Ray Hogan

composition to the LSO players. The group had varying music literacy skills and for many, their primary medium for writing music was Braille. Learning the music technology software was essential in enabling participants not only to compose, but to notate their music in a format that would be accessible to all players.

Underpinning the creative and communication aspects of the project was to learn about working in the music industry: students learned about contracts, copyright, accounting workshops and the commissioning process – all with a view to encouraging participants to use their experience of working in a professional context, with a professional orchestra, to feel confident and equipped to pursue a career in music.

The Princess' Tale culminated in a performance at LSO Discovery on June 10th 2007, at its state-of-the-art home at LSO St Luke's, the UBS and LSO Music Education Centre in the City, which was attended by over 100 people. That evening, students went to see a performance of the original Stravinsky *The Soldier's Tale* at The Barbican, with Sam West as the narrator, enabling them to compare their composition and performance with the original piece – again, a professional approach to understanding composition and learning about music within a dramatic format.

Performers, The Princess' Tale, 10 June 2007, LSO Discovery at St Luke's:

Young musicians:
Don Logie (trombone)
Abi Baker (violin)
Takashi Kikuchi (viola)
Ashar Smith (percussion)
Caitlin Hogan (cello)
Siham Ibnoujoubeir (celeste)
Kevin Satizabal (harpsichord)
Aaron DeAllie (piano)

Non-performing young musicians:
Daniel Rugman (script, composition and arranging)
Maya Haynes (composition)
Amy Hawkins (composition)

LSO musicians:
Shaun Thompson (clarinet)
Philip Nolte (violin)
Thomas Goodman (double bass)
Jeremy Wiles (percussion)
Howard Moody (piano)
Colin Brown (narrator)

'I can only describe that performance as wonderful. It has been tremendously exciting to see such talented young musicians working so well with professionals from the LSO.' Kathryn McDowell, Managing Director, London Symphony Orchestra.

A documentary of the making of *The Princess' Tale* and of the complete performance, by filmmaker Tristan Daws, premiered at the Inclusion Through Music Conference at the Royal College of Music, 24-25 October 2007 and is available on DVD from Musicians in Focus.

The Impact on the Young Musicians

The overwhelming feedback from the participants was the sense of confidence they gained from the experience of working with professionals. One of the biggest barriers for visually impaired young people is their own perception of their capabilities. The equality of the relationship between the LSO performers and the young musicians placed a real value on their input to the composition and performance process and without exception, the participants all want to continue to study music and many feel enabled to progress towards careers in music. One young musician, Daniel Rugman, was commissioned to compose the sound-track for the Inclusion Through Media show reel: a real acknowledgement of talent overcoming the barriers – perceived rather than real – of having a sight impairment.

3. Presentations, seminars and conferences designed to influence manufacturers and policymakers

a) Influencing the Manufacturers

Throughout the Music for Screen and Drama project, Musicians in Focus has been undertaking action research to evaluate a selected range of music hardware and software with manufacturers to assess how accessible those products are and to make recommendations to manufacturers on improving accessibility. MIF has also met with research and development officers of manufacturers so that emerging products can take account of accessibility issues.

Through events, such as the Inclusion Through Music 2007 conference at the Royal College of Music, MIF intends to focus on music technology and technical solutions for teaching and learning, aiming to engage both potential users of music technology (teachers, musicians, specialists in further and higher education) and to work towards an agreement with manufacturers that asks them to be willing to work to address accessibility from the ground-up in their product design, so that visually impaired users do not need to keep inventing customised solutions for each product.

b) Influencing Policymakers

Equal has enabled Musicians in Focus to explore in depth the value of interventions around accessibility, both in terms of accessibility of technology, and in terms of changing attitudes of professionals and teachers to the capabilities of visually impaired young musicians.

Many of the findings of the project are also pertinent to a wider range of teaching and learning issues not only for visually impaired young people, but also for other special needs students and for professional development for qualified musicians.

This kind of 'laboratory funding' is invaluable to enable longer-term solutions to removing barriers to learning and employment to be developed by those who are specialists in understanding what those barriers are. Musicians in Focus has moved debates and solutions on visually impaired access and learning forward through both rounds of Equal. It is a great pity that there will not be any further rounds of a programme that enables people to deliver against agendas that are defined by the user groups, rather than attempting to meet unrealistic outputs and outcomes that, in the longer term, do not really benefit those for whom the funding is meant to serve.

The last word

A selection of comments and recommendations from participants of Music for Screen and Drama:

- Equal access to all music for all people
- Equal access means equal independent access not someone else doing it for you
- Everyone keeps taking about equality but what does anyone really do about it?
- No literacy equals no education equals no job, where's the equality in that?
- Equality workshops and policies are all very well but long term and sustained skills training is the key
- Depriving a child of music literacy severely limits their choice of career paths in the future
- The government has spent millions on promoting literacy and numeracy in recent years and yet seems completely oblivious to the fact that whole sections of society have no ready access to books, newspapers and magazines
- Would you accept that your child has to wait a year for a text book at school?
- Literacy is a basic human right in a civilised society
- Your number of brain cells is not related to your level of vision
- Music is a language. It is generally accepted that the younger the better to learn a new language
- Most instrumental teachers would not dream of not teaching a student to read music
- Notating music does not necessarily mean using stave notation
- You don't have to learn everything at once
- You teach notation to the level appropriate at the time
- Pretty nearly all music courses require a minimum knowledge of notation and theory
- What exactly are we testing in conventional sight-reading tests
- I keep hearing Vera Lynn singing 'keep smiling through, just as you always do' but that just is not good enough in this day and age
- A recent news item stated that the creative arts sector (and music in

particular) is one of the biggest earners in the UK economy, if we don't improve music education where is the next generation of musicians going to come from?

- A twelve-week course of music workshops is a good idea but it takes more like twelve years to train a good, all round musician
- Severe low vision children should learn braille as well as print
- All visually impaired children should learn touch typing as young as possible
- Technology is vital in education especially for those with a disability

Endnote

[1] Conversation Pieces – Conversations with 15 visually impaired musicians about their experiences, September 2005, available from Musicians in Focus (www.musiciansinfocus.org). There are many more resources and publications available upon request.

Chapter 9a
Finding a Thread

Kulwant Dhaliwal

Where do projects ideas come from? We only have time to consider this with hindsight, when trying to understand the success of certain projects. However, we continually ask ourselves: What are young people interested in? What is the best way of engaging them? And what do they need in order to progress and succeed? We responded to these questions by evolving a developmental approach to projects and the people we work with, rather than delivering quick hits for large groups. As a result, at Hi8us Midlands (HM), nearly all the projects are organically grown from previous projects. It is difficult to see the thread between new media projects starting with *EDRAMA*[1] (**DVD clips / section 2 / 9a.1** and **9a.2**) and then running through Animatix[2] (**DVD clip / section 2 / 9a.3**), our business support scheme Boost[3] (**DVD clip / section 2 / 9a.5**) or, the print-based comic illustration scheme StripSearchers[4] (**DVD clip / section 2 / 9a.4**) they're linked by development and training needs. We have worked entrepreneurially to secure funds on a project-by-project basis so we can work with the same groups of people over time. If we hadn't worked this way, we might already have said 'good-bye' to the people we've worked with, such as Asia Alfasi[5]. But we duck and dive so we can retain contact, and when we can, we develop new projects and seek out new funding each time to help them progress further. One-off interventions inspire and help clients to develop confidence and skills in certain areas, though longer-term working relationships create the most work. We meet policy goals by allowing people to progress into further training or work. This happens by default rather than design.

Since 2000 HM has worked with hundreds of talented creative people, most of them young and nearly all have some identifiable need. In policy

Back page of Grab, the comic book produced to showcase participants' work from the first round of StripSearch. It provides a snapshot of what's contained inside, with each illustrators name written beneath each image.

terms, they are described as at risk of social exclusion, hard to reach or under-represented. Our work reaches them.

The developmental approach evolved naturally and relatively quickly when a core Hi8us team was established in the Midlands in 2000. From the start, it was clear that the end of a project, for many participants, marked a crucial point in their development, which required further support if they were to step on to a larger stage.

Unfortunately voluntary sector projects usually have a short life span. Some funders partly excuse the 'quick hit' nature of their support by ask-

ing applicants to provide suitable 'exit strategies', which we do to the best of our abilities. Once the strategies have been applied, and the funded projects have ended, the funder loses interest. It is worth asking who is concerned with the progress of those who have taken part in the projects.

When projects end we try to stay in touch with people to see how they progress and, where possible, we continue to give informal support while remaining informed of their own needs. Most often, it is the gaps in provision identified at this stage that have inspired the evolving series of projects at HM. These gaps are usually at the heart of new project ideas.

In the absence of a sustainable funding base, we respond creatively by building new projects, which meet the continuing needs of past participants, while extending the same opportunities to larger groups. Many of our projects are innovative, being small means we are ready to respond to ideas and needs far quicker than larger organisations like universities. The developmental approach to projects also means that inevitably, there is an already identified demand for what is on offer. Usually the greater challenge is trying to balance policy makers' criteria for outputs – 'bums on seats' or value for money – with our desire to provide personalised, quality support.

At project development stage we may undertake an audit of other support services and schemes available to ensure we are not replicating provision. Existing support for young people tends to be fragmented or not specialised. General business support services are available across the Creative Industries, but often these are not suitable for our target groups. They are either targeted at people who are quite far advanced, or they don't offer much in the way of specialist knowledge or support. There are youth services but anything with a creative industries focus is patchy and professionally-led, hands-on training is rarely on offer. The larger the service the less it is able to meet the very individual needs of our target groups. Many existing services offer little in the way of bespoke or responsive support. So if the needs of those who leave our projects do not fit the standard support available, at best, they are in danger of wasting their time pursuing objectives in the least efficient way, and at worst they may just give up.

This developmental approach inspired the highly successful Strip-Searchers comic illustration scheme, which focuses on print media. Strip-Searchers evolved from an online media, illustration and creative writing project known as Animatix, resulting in an animated graphic novel. Animatix itself was developed by HM to enable young people to share the stories developed in *EDRAMA* with a far wider audience, by turning them into animated graphic novels. Animatix allowed participants to dip their toes in a number of skill areas, by collaborating with their peers and professionals. However due to project design, participants in the Animatix

Screenshots of EDRAMA, 2006

project were not able to fully explore comic illustration even though four out of the 30 young people taking part showed real talent and potential in this area.

Animatix fuelled creative activity, and it was clear that Comic Illustration was a hook for a wide range of young people especially with the support of a world-class comic illustrator, John McCrea. Animatix also highlighted the huge gaps in provision for comic illustration training for anyone, regardless of age or education. Conversely it is one of the few art forms that appeal to the broadest range of people and it is particularly accessible to those who have been failed by traditional learning.

We were firmly committed to ensuring that the StripSearchers scheme prioritised those who needed the most help, based on their economic or social position, but we also wanted applicants to have some demonstrable talent or potential. Our intention in making it talent-based was that we did not want to set up anyone to fail. As a result we decided at the outset that participants would be selected based on nascent talent as well as need. With such specific criteria and no advertising budget our expectation of recruiting to the ten available places was quite low. But the response was overwhelming as we received over 90 applications all containing artwork produced specifically for the competition. Over 50% of the entries showed great talent and potential, with the bulk of the remaining entries not being that far off the mark. Pressured by demand we increased the available places to fifteen. In this first round we received just five applications from women and one was successful, Asia Alfasi. For an industry still dominated by men, to only have one woman included on the first round of StripSearchers was initially disappointing. Subsequent StripSearchers schemes addressed this, resulting in an equal balance of applications and course places for men and women.

StripSearch, the first round, John McCrea delivering a portfolio review with a participant.

Searching for the perfect strip

Hi8us Midlands collaborated with John McCrea to develop the Strip-Searchers scheme. John created the artistic programme of workshops, which included the involvement of several key professional comic illustrators for a ten-week course. Although the medium of Comic Publishing was new for Hi8us at the time, the process of enabling collaboration between professionals and non-professionals, particularly those in need was true to the ethos that had informed previous work. This approach marked the quality of all previous training programmes developed by Hi8us.

Our support for participants on StripSearchers continued beyond the project lifetime. Immediately at the end of the scheme we could see they needed more to help them to the next stage of their development. This was particularly true in Asia's case, a number of opportunities were opening up for her but she had little knowledge of how to work as a freelance illustrator. She needed support to enable her to secure contracts and protect her work.

At the end of StripSearchers we had many talented illustrators but, other than assisted trips to the only two comic festivals in the country (John made sure all their portfolios got looked at by Editors from Marvel, DC and other successful illustrators such as Dave Gibbons of Watchmen fame), there was no provision in the first funded project to support them into work, or get them to market. We signposted them to other schemes, but these proved to be lacking.

During the first round of StripSearchers, having attended the London and Bristol Comic Festivals, it was clear that the market for comics in the UK would not provide full employment for many aspirant comic illustrators. Many professional comic illustrators undertook commissions in other market sectors, or even had other part-time jobs, to make up a full wage. Informal discussions revealed that only the most established of comic illustrators could expect to earn 90% to 100% of their income from comic illustration work.

StripSearchers 2007, publicity material generated
for San Diego Comic Festival featuring work by Laura Howells, from round 2

StripSearchers 2007, exhibition flyer featuring work by Michiru Morikawa, from round 2

As a result we devised Creating Change, a programme to help the StripSearchers participants and others to learn about different ways of generating income. Aside from general business skills and important specialist knowledge around protecting IPR, a large emphasis was given to how comic illustration skills could be used by diverse sectors such as Advertising, Film, Book illustration and Education. Creating Change was a pilot programme and it certainly helped some young people to get to the next stage; by Asia's own account it came at just the right time for her. Again, due to limited funding, Creating Change had a short life-span.

Two further rounds of StripSearchers, and we had many more comic illustrators needing specific business support relating to their skill area. HM maintained contact with many young people from previous projects, including those from the three rounds of StripSearchers. To help them we continued to refer them to other agencies on a regular basis. Some would report back disappointed that the support was too general or too specific, thus not fitting their needs. Much of the support assumed that they would already know how to express their business needs. Those offering bespoke one-to-one support tended to favour graduates. Some required business plans to already be written or businesses to have a certain turnover. It became clear that the support needed to help previous participants to the next stage was not readily available. The young people we had worked with had talent but some still needed a helping hand to open the door into a professional world.

In 2006 we conducted research into existing business support programmes in the region to identify gaps. HM staff and workshop leaders had gained experience of mentoring provided as part of the schemes, and also informally on an ad hoc basis. Specialised mentoring was proving to be one of the most effective ways of helping individuals. However the support available from existing service providers tended to have an existing pool of people. Most had very limited experience of the creative industries, and if they had any it was difficult to match that to the needs of the young people.

To make the most of new funding opportunities, we proposed a new scheme, eventually entitled Boost, to offer a bespoke business support service to past participants and others trying to making it in the creative industries. For the most part the scheme has provided workshops, mentoring, office space, graphic design and a marketing service. However unlike the other schemes, the workshops are programmed with input from young people. Boost identifies and rectifies gaps in their knowledge and develops areas that are of particular interest to them. Participants are encouraged to identify mentors themselves and these are added to a database of possible mentors for the Boost scheme. In certain cases, Boost will recommend suitable mentors if they match the identified needs. How-

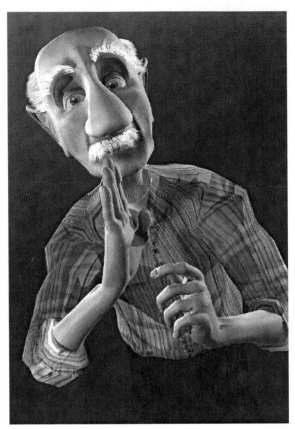

Screenshot from 3D animation by John Finn of Deadcreative, one of the companies supported by the Boost scheme. The animation showcases sign language generated using 3D animation, Deadcreative's speciality

ever, the participant makes the final decision about who they would like to work with. The scheme has had nearly 40 people who have received intensive bespoke business support, with many more benefiting from attending workshops open to all. There are more than 40 individuals still wishing to benefit from the intensive bespoke business support, we have put them on a waiting list for the future.

Asia has also benefited from Boost; it has become another stepping stone on her journey to establish herself as a professional illustrator and writer. The scheme has provided support for her to look at diversifying into the digital animation sector. Other StripSearchers' participants have also benefited attending the specialised, professionally-led, workshops on offer.

Beyond the life of funded projects, we have encouraged participants to use our office base to support their individual enterprises. Although not ideal, in the absence of follow-on funding, we know that the need for sup-

port at different stages of their development continues. With continued contact, we are in a better position to respond.

These projects, organically grown from need, offer vital continued support for some young people. Aside from responding to their needs, young people are able to be supported by individuals they already have a relationship with. For some, especially those still unemployed, under-employed or, under-represented in certain industries, it is reassuring and strengthens self-esteem by providing a place to go where aspirations are not only recognised but taken seriously.

The danger of providing intensive support with no follow-on, is that participants will not be in a position to fully capitalise on their poten-tial. Whatever they have gained from taking part in one-off projects could easily be undermined, without continued support. Also it is not always possible to know what the individual support needs are until a funded project has ended and the outcome becomes evident.

Some projects have resulted in young people setting up and running their own networks. MC2, initiated and managed by participants from our Comic Illustration schemes is one example. MC2 has successfully bid for their own project funding resulting in further comic publications, showcasing talent in the region. Alongside this, professionals employed by the scheme together with participants came together to stage the very first comic festival in Birmingham. These are fantastic legacies from our projects, resulting in community cohesion, which could be said to be the result of empowerment. However these independently inspired ventures didn't emerge overnight, much of this has been achieved at least four years after we ran our first comic illustration project.

We recently completed a third round of the StripSearchers scheme, the demand is still high with very little provision across the UK. To address this demand we have commissioned a feasibility study to explore the set-ting up of a Comic School or Comic Studio.

Much of the available funding is targeted to support specific projects that have a limited time span. While there are expectations to provide 'exit strategies,' once the funding has ended, there's no resource to ac-tually monitor the impact of the strategies. Exit strategies often involve linking participants with other services and networks available for them. However many of the existing services offer little bespoke or responsive support, so if an individual's needs do not quite fit they drop out of the system again.

Our own strategy has been to maintain as much contact with people we have worked with, assessing their needs on an ongoing basis and de-vising further programmes to support them to fill the gaps. As long as we have funding, we will continue to do this but, as a voluntary organisation with no guaranteed funding, the capacity available is never assured.

We provide consistency of support and this is what is needed to help young people find their way in the creative industries, especially those unlikely to benefit from existing services. Policy makers force us to operate in a world where we are asked to do this, while we stagger from project to project, where the only way to succeed is to devote a disproportionate amount of time and energy to fundraising for the next project.

As a small voluntary sector organisation we work hard to develop sustainable relationships, but it is hard to stay in touch with all the young people who need continuing support, and it is hard to find the thread that draws projects together. Disparate and shaky funding across our sector means that we have next to no resources available to undertake the development work needed to ensure our work continues. In the meantime, we continue using as much ingenuity and creativity, to respond to young peoples' needs. Our ability to continue working with young people like Asia Alfasi depends entirely on our success as fundraising entrepreneurs.

Endnotes

[1] *EDRAMA* is an online roleplay software tool that is currently used for creative writing and learning. All *EDRAMA* chat has a purpose and the software is used anonymously in different environments. Because of this *EDRAMA* has a powerful flexibility, which can be adapted for training or education. See www.edrama. co.uk.

[2] Animatix enabled a group of young people from rural Shropshire to collaborate with a peer group from inner city Birmingham to produce a graphic novel under the guidance of professional illustrators. See www.animatix.org.uk.

[3] Boost is business support programme run by HM in partnership with the University of Central England. See www.boostwm.co.uk.

[4] StripSearchers is a training and support programme for aspirant graphic illustrators. Training is led by professionals and trainees pcreate their own graphic publications and portfolio. Work has also been shown at exhibitions and trade fairs. See www.stripsearch.org.uk.

[5] Asia Alfasi describes her work in the second part of this chapter (9b).

Responsible Pictures[1]
Asia Alfasi and StripSearchers

Imogen Slater

A child is often the central character in Asia's stories. The child is a ubiquitous universal symbol and one that Asia believes is able to reach people across difference. It is also a key figure in Japanese Manga and Anime, which is Asia's strongest artistic influence. Sharon Kinsella writes that 'Kawaii style dominated Japanese popular culture in the 1980s. Kawaii meaning "cute" in English essentially means childlike, and by association: adorable, innocent, simple, gentle, and vulnerable'. A commonly known example of this is 'Hello Kitty'[2]. However for Asia instead of the child representing a sublimated challenge through escape from an adult made world, it becomes a tool for remonstrance with that world.

Asia herself is a young woman of 23, and being both unmarried and Muslim this means that she is still somewhere between childhood and full adulthood. It is a situation she seems to delight in. She draws (literally) from her experiences of growing up and from her maturer views (that are both intellectually and emotionally informed) of the world. In this she spans these two supposedly distinct ages, and in the way that Manga and Anime often do, speaks to cross generational audiences.

The desire to communicate, to tell stories is central to Asia's reasoning behind what she does. She wants to communicate despite and because of, cultural and religious difference, and refer to the common humanity that we share. For her the graphic narrative, and specifically Manga is both a personal passion and an ideal way of doing this. In finding mediums for the articulation of her voice, and arenas for the public sharing of this, Asia's experience of involvement with an Inclusion Through Media (ITM) project, is analogous with many other ITM participants,[3] thereby reinforcing one of the key arguments for the project's existence[4].

Jin Narration

Asia: 'A page from my first manga produced – a 50 page installment in an anthology book called The Mammoth Book of Best New Manga – which centers around a Muslim girl called Mai living in the UK and her Scottish friend who become involved in a convoluted series of adventures involving a Jinn trapped within Mai's keyring. Will hopefully be a continuing series and will find a separate publisher and continue it as a graphic novel series.'

Drawn in February 2006, released in October 2006

Asia's own story will soon be told by her, with the first two parts commissioned as graphic novels by Bloomsbury. Here, with Asia's consent I will try to tell a small part of this, focusing on how she arrived at this point as an increasingly acclaimed graphic illustrator.[5] Asia's story then, is clearly one of success, moving from her art as a personal passion, into the wider world where it has found public platforms and increasingly widespread acclaim. Of particular interest is what has been key to this; the inspirations, impetuses, and support that have carved out her path, and whether there are signposts in her story that may assist others like her.

Asia lived in Libya until the age of eight. She carries clear images that have become points of reflection from those years. She spoke of 'teatime' when family members would come together and watch Anime that was dubbed into Arabic. At school she loved drawing though she says wasn't very good. They were expected to simply copy other pictures. The teacher told her she needed a new sketch book and when she didn't have one the following week 'public humiliation' resulted. Asia said that the teacher slapped her, but that it was indignity that was the really painful thing. She said to herself at this moment 'I am going to pay you back and become a great artist'. With hindsight, Asia considered the way in which adversity can be turned around to become a motivator.

Asia moved with her family to Glasgow next, which contrasts as starkly as the black and white of cartoons, with her earlier Libyan years. There were things to be gained despite language difficulties, and always having a feeling of not fitting. She turned to the world of books and describes days spent in the library 'devouring' them. She would hide in the toilet to read as it was the only place she could find quiet uninterruption. Enid Blyton and the Famous Five helped her to grasp English, and Asia said her language and drawing 'evolved at a frantic rate'. More crucially she discovered Manga in book form, which meant she was able to study it closely for the first time.

The next move was to Birmingham aged 16 where she has settled, been happier and emerged from a timorous book shielded world into a wider multifarious one. She consciously recreated herself, using her personally wrought learning and passions as core resources. Illustrative of this, is the fact that at school (where she became known as 'the drawer') she set up and ran two Manga clubs, the first being oversubscribed.

Asia is unmistakably individual which meeting her further affirms. There is a danger here though, which can be equated with the reverence Asia herself felt meeting other artists; she said it made her doubt herself and feel 'lesser' in terms of talent. If we regard Asia as 'special' then we limit the possibilities and probabilities of other talents out there, waiting and incipient. Young people who haven't yet found their thing or pathway, and who haven't had the benefit of projects like those delivered by

Hi8us Midlands. We are interested in Asia's story for its particularity, but also for what it can tell us about the effects of the kind of positive interventions that inclusive media can have on young people's life choices.

After convincing her father that her chosen path was in the 'arts' rather than medicine, Asia began a degree course in Visual Communications at the University of Central England. Almost simultaneously she gained one of the 15 places offered on the StripSearchers programme:

> 'the StripSearchers competition run by Hi8us Midlands is what kick-started everything. I had just entered university when my brother forwarded me a link about a comic competition in Birmingham. The prize was a place on a comic course run by professionals in the field, such as John McCrea and Hunt Emerson and the deadline was in four days. There was no way I was going to pass it up, I was just desperate. I self-delivered my entry an hour and a half before the deadline.'[6]

Interestingly Asia describes this break as her career being 'kick-started in parallel'. She had finally got to university, yet she said that this course was often uninteresting or irrelevant, and at one point she even felt that it was hindering her development. By comparison, with StripSearchers she felt she was learning huge amounts, and that this was offered in different ways; pragmatically, theoretically and empirically. For example she was taught practical drawing techniques such as inking, while also being encouraged to build networks through attending comic conventions. Some of the skills that she acquired she believes would have taken her years to develop on her own, whilst building the confidence to talk to people and show her own work has been invaluable to her personal trajectory.

Asia talks about her first encounters with the comic world as entering into a unknown domain, of which she had very little knowledge or understanding. StripSearchers was vital to her, helping to negotiate these new experiences, and acting as an interface between the professional comic industry and newly fledged participants like Asia, keen to break into it.

Key to the Hi8us experience was 'the group;' the participants supported by the Hi8us staff and professionals. Asia described the Hi8us Midlands set up as being like one huge family, with herself as a child taking its first steps in terms of the assistance she was given, and significantly the space she was given in which to make mistakes. While this is undoubtedly critical to true learning, it is too often forgotten in the push for immediate and demonstrable results. The 'group' has evolved and transformed, but most importantly has continued, offering interaction and exchange for ex-StripSearchers[7], which is particularly valuable given the often solitary nature of this kind of creativity. They meet monthly, have formed a collective and are about to launch their second anthology. Their website acknowledges the integral part that StripSearchers has played for them as

individuals and a group:

> The Midlands Comics Collective is a group of established and aspiring comics creators based in Birmingham and the surrounding areas, most of whom met through Hi8usMidlands' highly successful Strip-Searchers project to identify and train exceptional local artists.[8]

Contacts made, continue informally, in keeping with the nature of the media industries generally. Asia mentions going to her course tutors if she has questions or difficulties, while they give her tips, promote her through their own established networks, and forward opportunities that arise. This ethos of mentoring works both ways – up and down. Asia has herself mentored participants on subsequent StripSearchers programmes, as well as going into schools and colleges to try to encourage more young women to consider graphics as an option. This peer mentoring approach is fundamental to the success of ITM projects like StripSearchers. There are examples across many projects of participants moving on to become professionals and in both formal and informal ways 'giving back', and passing on their own learning and experiences to others coming up through similar pathways. These mentors are ideal yet real role models, embodying what is potentially achievable, and offering personal accounts of the highs and lows along their routes.

While Asia is extremely positive about her dealings with Hi8us Midlands, it is pertinent to ask whether other participants feel similarly enthusiastic. I met with the most recent StripSearchers cohort and talked with them about their experiences of the programme. When I asked about 'other things' they got from the project (apart from skills and career benefits), they cited the following:

- Motivation
- Self confidence
- Self belief
- Confidence in what I'm doing
- Proper feedback

Research notes from this focus group include:

> It was recognised that the course was particularly useful in that graphic illustration is by nature a solitary occupation, and there is no support network. In some ways the project and each cohort therefore become this for each other. There was also strong feeling about the place or status that illustration has had traditionally. While it seems that barriers are beginning to come down, and their preferred art form is becoming more known and accepted, there was still the feeling that as artistic "outsiders," it really helped to become part of a group of other artists with similar interests. One person described the traditional view as being that "comic art is not art".

There were some criticisms, though these were contextualised within the

programme as a whole, and therefore stood alongside obvious benefits. For example some felt that there was an assumption about the participants knowledge, whereas they stressed the differences and variety of backgrounds that they came from in relation to their artistic skills, experiences and interests. Interestingly some participants would like to have been 'pushed harder' which corresponds with one of the tutors comments that 'attitudes need to be tightened up' in order for some of the participants to make the leap from their work as an absorbing interest, into it as a career which they need to be determined to pursue. Feedback like this has been integral to the programme; each time it has been run it has been tweaked and adapted responsively in order to maximise its efficacy.

Asia progressed through three Hi8us Midlands programmes; she began with StripSearchers, and is now on their Boost scheme which is pitched as delivering 'bespoke business support that responds to the needs identified by creatives in the digital industries'. Asia said that the business course came 'just at the right time' and offered workshops in copyright, charging, fees, invoicing, PR, illustrators associations, etc. She found this invaluable and described the delivery style and content as not 'scoobying[9] about,' which I guess can be interpreted as 'they knew what they were doing'. Each discrete project has been a stepping stone, and helped Asia develop a diversity of skills that range from the tangible and specific, to those rather elusive (yet arguably both more transferable and essential) so called 'soft skills', that include confidence, self esteem, communication

MYF Comics
Asia: 'Extract from an episode of Joseph & Jasmine – a series of comics centering around two main Muslim characters – Joseph, a half-Italian, half-English lad, and Jasmine, a Malaysian lass. The comics aim to tackle some misconceptions and introduce Islamic stances on various topics. It's hoped that they'll form part of the school curriculum in teaching Islam modules. This episode addresses the topic of boyfriends/girlfriends and marriage through an Islamic point of view. The episode was drawn and completed in July/August 2007, and the project was aimed to be launched three months thereafter.'

Underground

Asia: 'A 22-page story commissioned by Platform for Art as part of the "Thin Cities" exhibition – one meant to celebrate and commemorate 100 years since the launch of the Piccadilly Line. I was given free reign to produce whatever I wanted in a narrative sort of way of my choice. I decided to address, subtly, the topic of the negative atmosphere circulating around in London (and especially the Underground) after the 7/7 bombings. Through it, I tried to call for us all to put effort into reaching out to each other and understanding /appreciating each others' differences instead of tarring a whole group with the same brush and shunning them as one. It was a call for reconciliation and bridging of gaps.'

Produced in October-November 2006, was on exhibition 15/12 2006 to 20/4 2007

and team work. There is a clear recognition that for 'artists' to be able to successfully compete in their professions, they require utilitarian levels of business acumen.

The amount of media attention that Asia has already received raises questions, not about her undoubted talent as an award winning graphic illustrator, but 'why her?' and 'why now?': it maybe something to do with her being a rarity in the comic sphere, as a young Muslim woman. While some of her views could be considered radical, they are not angry but instead discursive. This makes her approachable, interviewable, and media friendly. Asia is inspirational, but this should not be something that puts people off. Instead if the Hi8us model holds, it will hopefully encourage other young people to think that maybe they can similarly conceive and pursue their own paths in creative media. When asked what advice she might offer to such aspirants, she said 'do something original that is from within yourself, your identity, your heart,' which she herself combines with a determination to learn[10] and to not be 'scared to approach people'. The question that this leaves is 'how many other Asia's are there out there?'

Asia Alfasi was also interviewed for the Inclusion Through Media show reel. See DVD clip / section 2 / 9b for an abstract.

Endnotes

[1] Manga is often translated as 'irresponsible pictures'.

[2] There are lots of other examples at www.animevisions.net/chibi.php.

[3] See Chapter 3 ('Beyond The Numbers Game' by Ben Gidley) for a fuller description of this project.

[4] ITM's key ambition is to demonstrate that participatory media work with excluded and disadvantaged people actively helps to combat social exclusion by giving them a chance to make their voices heard, whilst enabling some of our most creative young people to access the industry through 'non-traditional' routes, enriching the talent pool of the UK's world-class audio-visual industry.

[5] The last time I Googled Asia Alfasi there were hundreds of references, and there is a Wikipedia page about her: en.wikipedia.org/wiki/Asia_Alfasi.

[6] From an interview with Asia by Joshua-Pantalleresco. (Available from www.comicbloc.com, accessed 2/1 07).

[7] The Midlands Comic Collective involves ex-participants from all three Strip-Search programmes.

[8] www.comicscollective.co.uk.

[9] *Scooby* noun: inkling, clue. Rhyming slang from 'Scooby Doo' = 'Clue' Example: 'Naw ah don't know wherr yer purse is. Huvny a scooby' (See www.firstfoot.com/php/glossary/phpglossar_0.8/index.php?letter=s).

[10] She cited a Arabic proverb which she translated as 'be determined to learn even if you have to go to China to learn it'.

Useful websites:

www.apcartoon.com
www.asiansinmedia.org/news/article.php/events/943
www.maniacmuslim.com/index.php?option=com_content&task=view&id=130
www.comicscollective.co.uk
www.prospect-magazine.co.uk
www.alibhai-brown.com

Section 3
Participation

Section 3: Participation

The first two chapters in this section discuss how the interactivity offered by the Web can be used as a stimulus to participation by young people working with digital media. Rick Hall shows how engaging in theatre in education techniques on the Web can be both a powerful form of self-directed education, and a necessary antidote to the value-free zones of commercial digital games. Clodagh Miskelly, in her discussion of the *L8R* project, demonstrates how the Web can give young people a genuine sense of ownership of learning materials, and opportunities to imagine and consider a range of choices in relation to their own attitudes and values. However she also cautions that this involvement can be threatened by constraints imposed both by the technology, and by institutional practices and prejudices.

In the third chapter Jackie Shaw continues this latter train of thought in her discussion of a number of projects undertaken by Real Time, making a powerful case for clear and critical thinking about (and distinguishing between) the varying strategies that institutions who commission youth media work often lump together under the label of 'participation'. Finally Victor Jeleniewski Seidler deals with barriers to (and opportunites for) participation that are more psychic and emotional than technical or insti-tutional, in his analysis of Dave Tomalin's work with young men and their struggles with their particular masculinities. He discusses how media might be deployed to help young men (in particular) through processes of growth and transformation.

Chapter 10

Not So Troubled Waters

An exploration of the learning potential of virtual worlds through the medium of theatre in education

Rick Hall

The wisest of wise writers, Tove Jansson, knew a thing or two about the power of theatre. As she explained when the Moomin family found themselves flooded out of house and home and took refuge in an extraordinary floating playhouse.

> A theatre is the most important sort of house in the world, because that's where people are shown what they could be if they wanted, and what they'd like to be if they dared to and what they really are.
> (Tove Jansson, *Midsummer Madness*, Penguin Books, 1955)

So bearing in mind what theatre can be, I'd like to invite you to imagine a couple of scenarios.

There's an island; it's an island of someone's imagination but it could have a real latitude and longitude – say 60 degrees 27 minutes north and one degree 17 minutes west. The island might sit in the northern Gulf Stream, enjoy mild long summer evenings and dark damp winter days. The terrain might be rugged, let's agree that it is, and with a coastline

carved by incessant waves and winds, with cliffs that form the breeding platform for gannets and guillemots. But let's also agree that the seas surrounding the island are fast breeding grounds for crab, lobster, prawn, mackerel and herring. And the land though not fertile is covered with enough tussocky grass to sustain sheep and a few highland cattle. With me so far?

So, what of the inhabitants of this island – better give it a name. How about 'Brochvoe'? Yes, what of the 240 or so people who live at the three or so farms on Mickle Knowe and Fara Head, and in the fishing port of Scara Ness or around Mull Cove? As well as the traditional farming and fishing, there's a small quarry on the island employing 15 people, and a small distillery employing just six people. There's a primary school with 16 pupils (at the moment, though the McPherson twins are due to join the school in September, at the same time that Sandy Sanderson leaves to become a weekly border at Lerwick secondary school).

As I write, the Brochvoe community are preparing for their annual spring festival – the Scarra Song cycle and celebration. The festival is a major and ancient point in the traditional calendar and marks the time when the lambing is complete on the hillside farms, and the prawn, crab and lobster fishing season resumes.

At long last the days become longer than the nights, which in this latitude is a highly significant turn in the seasonal battle between the light and the dark. Scarra Festival is also often accompanied by spectacular displays of the aurora borealis and this is reflected in the costumes that the children wear for the evening entertainments on the Saturday at the end of the week of celebration.

As we can imagine (and we are still building this community in our imaginations are we not?) life on Brochvoe is steady, strong and in tune to nature's rhythms; but it is not backward or locked in tradition for tradition's sake. The Internet and satellite communications have added to the sense of connective informed education and opinion on the island, the ferry from Lerwick

BROCHVOE

every day brings a broad range of goods for the Scara Ness post office and general store, including the Daily Record, phone cards and frozen pizza. Each summer a steady trickle of tourists arrive to enjoy solitude and bird-watching, and evenings in the Broch Inn.

So is life on Brochvoe in a state of stable idyll? Far from it. The population of Brochvoe has oscillated and for nearly a decade in the early 20th century the island was abandoned after most of the male population perished in Flanders or the sea battles off Scapa Flow. In recent years the fluctuating shoals of fish and shellfish have seen a decline in the fleet of small boats putting out to sea each spring. Now the threat appears to come from rising sea levels and global warming.

However, the children and families of Brochvoe prepare for their annual festival with a customary optimism following their winter of tightly shuttered windows and peat fires.

Built a picture in your imagination? I've not laboured the point too heavily? Excellent.

Meanwhile, down the corridor, a second class of Year Six students have been immersing themselves in the oil industry, investigating its importance in the world economy, the geology of its formation and extraction, the range of products it supports. They have created an imaginary oil company – let's call it United Petroleum (UP) for the sake of discovery.

The UP management have recently instigated an extensive search for new fields and an overhaul of the company priorities and public profile. A new logo has been designed to reflect a new corporate approach to global energy, and policies of corporate responsibility now drive the progress of the company alongside the profit motive. Pupils in Year Six have even composed a new company song to reflect these new values and create a sense of corporate togetherness and shared vision.

An extensive training programme has been developed and implemented to ensure that teams are aware of the oil extraction, refining and delivery business and the impact these processes may have on countries, regions and localities where UP operate. Teams within UP have also been encouraged to explore alternative energy sources including renewable and sustainable forms of energy generation and conservation. The incentives for inventiveness are published on the UP corporate intranet, and teams in Year Six are about to celebrate their financial year end and the bonus scheme.

I guess you are ahead of me now.

The UP geologists are about to bring some exciting news to the end of year celebrations. A major new field has been confirmed in the North Sea at 62 degrees north and two degrees west. In these remote waters the nearest island where a terminal could be sited is, oh, let's just check the map, is that Brochvoe? How is that pronounced, colleagues?

A campaign will be required to ensure that the construction of the oil terminal is completed with the consensus of the local population, some of whom ('probably most of them, sir') will need to be relocated. Can we list the benefits in terms of employment, improvements to the quality of life, the boost to the local and regional economy etc; and then arrange a location visit? Let's do it, people.

Can you imagine the meeting and subsequent negotiations? (Oh, and for readers still wondering where and when web technology and learning come into this chapter, may I crave a further few hundred words of your patience?)

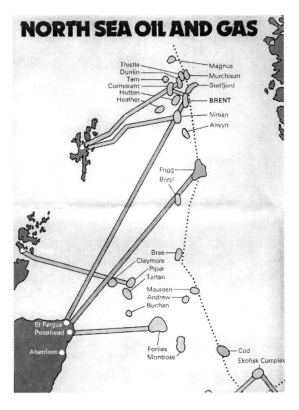

NORTH SEA OIL AND GAS

What I am describing is a Theatre in Education programme developed presciently in the 1970s and called appropriately enough, 'Troubled Waters'. It was first devised by Roundabout Theatre Company at Nottingham Playhouse, to whom I express thanks for allowing me to use it as reference here.

Almost miraculously the two classes, one developing their identification with families of Brochvoe islanders, and the other with teams of UP industrialists appear unaware of their overlapping dramatic destinies until the theatre company arrives, again as two teams of characters, to bring the 'conflict' of interests to a head in the school hall (or a.k.a. the community centre on Brochvoe).

Theatre in Education in action
An important component of the learning through theatre in the day is the presentation of key aspects of each class's culture and motivation. The Scarra celebrations are rehearsed for the oil representatives; the company song is performed and the corporate priorities are presented (probably on PowerPoint these days). Groups are created, Brochvoe families and UP teams, to discuss the issues, and the impact of various options. Values are

revealed and shared, emotions are aired and arguments deployed and indeed a consensus is sought through negotiations and debate.

The future development is celebrated through the participation of both classes in the Scarra Festival.

Troubled Waters is about values and what is valuable, and how communities and companies can embrace and influence their futures and maintain their values as well as their traditions or corporate priorities. The programme is not reactionary or anti-progress, nor in favour of one interest or another.

Let's compare two more scenarios.

This is from a new PSP game – *Chili Con Carnage* (from Eidos for £29.99) and I quote from the Observer review by Simon Lucas. There's a clue in the title.

> *Chili Con Carnage* is fantastically unsubtle, a rampage around Mexican scrub lands populated by homicidal farmers and single minded attack chickens. There's a spurious and borderline xenophobic plot involving murdered fathers, but that needn't detain you from getting stuck into the meat of the game: annihilating the local population with a selection of semi- and full-automatic weaponry, sometimes in a most attractive slo-mo, Matrix-style. Funny and brutal, *CCC* reserves the bulk of its bile for chickens, which can be dispatched in any number of inventively mean-spirited ways. (Observer Review, 2006)

Or how does *Crackdown* (£39.99 for Xbox 360) grab you?

> This is a free-roaming adventure set in a dystopian urban sprawl. Players assume the mantle of a genetically engineered super-cop tasked with putting an end to gangland activity... like Superman with a badge, you'll be able to dispense justice in the appropriate fashion.. while the soundtrack is the usual uninspired mish-mash of rock and hip-hop, the incidental sound effects (gunfire, explosions, dying screams) have a nice fat squelchy bass. Players are encouraged to crank up the volume. (ibid.)

And in the Observer too...

It is difficult to know where to enter the games world with any sense of critical judgment based on a desire to explore emotional intelligence or learning about values. Should we try and examine the racism of *Chili Con Carnage* in any objective sense? Or the notion of what comprises 'adventure' or 'justice' in *Crackdown*? Or do I simply accept that this is an alternative universe of entertainment and there is little point in getting fogyish about it?

Here is yet another alternative scenario:

I was at a seminar last year where a number of IT learning media designers were displaying their wares... and not all the wares struck me

as being particularly soft. This is the realm of developers who are seeking some kind of hybrid between games technology and learning programmes. But the absence of emotional intelligence or values left me in a state of incomprehension. In one programme on offer, the reward for acquiring certain language skills was more bigger lethal weapons and a higher level of interactive violence.

My difficulty here was that the scenario about the violence-rewarding literacy example involved a narrative described as character driven. Well, not in my book – the lack of understanding of narrative components only serves to undermine and diminish our respect for the term. The motivating 'why?' of character-motivated narrative is far more complex than a shoot 'em up confrontation between ciphers of good and evil.

In character-driven narrative I want to be invited to explore and understand the circumstances and personal beliefs and values that motivate the character to action. This is problematic and complex, appropriately so.

Don't get me wrong – I'm not seeking to rubbish 'shoot 'em up' games, but if we employ the narrative techniques of other media (novels, drama, film) in IT software (educational or recreational) we should at least start from an understanding of what constitutes 'good' narrative (appropriate to the form or medium) from 'bad' (otherwise better expressed in one of those other forms).

Which brings me on to learning, and useful and appropriate borrowings from other narrative media; but when we do so let's acknowledge that there is scope for the exercise of judgment.

If we pause to compare the complexity and rich learning potential of films like *Rashomon* with the cartoon simplicity of *Star Wars* we readily understand that learning demands complexity rather than simplicity. One more illustration – in Mark Haddon's brilliant *The Curious Incident of the Dog in the Night-time* there is a complex dynamic between the emotionally engaged reader and the emotionally detached (autistic) narrator. Emotional and intellectual truth in a fictional narrative offers real learning through exploration of motive and decision.

The arts and learning

The arts (and here I include the 'new' arts of digital media) have a fundamental part to play in the development of emotional intelligence. The latest developments in the interactivity of the Web – 'Web 2.0' – have much to offer in encouraging learning about one's own identity and the components of emotional well-being. Web 2.0 also has an important part to play in the development of a democratic and conflict-free society.

And this is what I want to explore further in this chapter; namely, how the Web can offer the kind of complexity of emotional truth and individual motivations and personal and social values which are then examined inter-actively in a genuine learning (co-authored) experience. I would like

to see web-based projects and learning programmes developed that, in the words of the Road Map for Arts Education, UNESCO Lisbon Conference in March 2006,

> cultivate in each individual a sense of creativity and initiative, a fertile imagination, emotional intelligence and a moral "compass," a capacity for critical reflection, a sense of autonomy, and freedom of thought and action. (UNESCO, Lisbon 2006)

There is a wider debate here about the value and nature of education, and I accept that this must remain the subject of a different conference. However, while the education system remains fixated by measurable outcomes and targets relating to cognitive abilities and its consequent focus on academic achievement and skills, emotional development will be neglected. (And at what cost to a cohesive society at ease with itself?) As an integral part of decision-making, the lack of emotional empathy means decisions based mainly on rational self-interest or appetite.

And by introducing the notion of 'empathy' I return to the idea of interactivity, participation and co-authorship of learning scenarios, narratives and environments.

The growth in learners of understanding through emotional engagement and empathy is key to the balance between cognitive and emotional personal development.

There is much good practice in other sectors and other forms and media that uses techniques of narrative in the creation of learning environments or challenges. For example, the interactivity of interpreting clues in the problem solving of a crime is already available in the Galleries of Justice, Nottingham; the Natural History Museum invites interactivity with the media presentation of its exhibits and the reading of clues about habitat, evolution or natural (or unnatural) selection. Other museums do the same.

But above all, theatre in education has evolved a series of interactive learning techniques within the dramatic form wherein young people are not merely spectators or audience, but participants in (and thereby co-authors of) the drama, the narrative. Couldn't, shouldn't interactive IT software, designed as learning media, do the same? That is, explore the complex and difficult choices faced by individuals in social contexts?

No Longer Kids
When I was director of Roundabout Theatre in Education company, we devised a programme about what motivated young people to take direct action against oppression and injustice. We were interested in the complex issues of personal and political self interest in a context of violence and denial of hope and aspiration.

ROUNDABOUT THEATRE COMPANY

No Longer Kids poster

We took South Africa under the apartheid regime as our context and research (this was 1987) though clearly and sadly, were we to devise a programme now we could explore scenarios in Palestine, Sierra Leone, Darfur, Rwanda, Sada City, or even Newham, Peckham or Beeston (Leeds). The question remains the same and has even nearly been articulated by Jenny Tongue and Cherie Booth; what leads (drives) young people to take up direct (violent, possibly self-destructive) action in pursuit of their goals?

No Longer Kids was our version and comprised a play at its heart involving a young black student who is picked up by a white police officer. In a brutal interrogation the young man is beaten and abused; the consequences of this encounter are played out to a tragic conclusion.

After the play, the young people watching and waiting, shocked, sur-

prised, apprehended by the powerful story they had just witnessed, seeking comprehension and a deeper connection with their own experience of making up their minds about what to do were able to interview the characters in a learning technique called hot-seating. The young people have the opportunity and in their own terms and language to dig deeper, to explore the 'back story' as we would now describe it of the characters. Little by little the young people reveal, not only the motivations and deep seated cultural complexities of the black student and the policeman, but also their own emotional responses to what they hear and see. The actor remains in character, and responds in character, but is able to retain a simultaneous watchfulness for opportunities to provoke and encourage the interrogators to examine their own responses and feelings.

When we presented the programme to an audience of adults, the frustration on their part at being unable to gain any ground on the white policeman was palpable. And whilst the policeman generally had the harder time of it, the black student was also often offered alternative scenarios or options to avoid the terrors of violent opposition. Invariably, emotional engagement (despair, frustration, anger, sympathy, sadness, concern) provoked the deepest levels of comprehension and understanding.

What is significant is that the technique rarely provokes questions like 'how did you become an actor?' or 'who wrote the play?' but focuses on the complexity of the narrative interactivity and the consequences of realising your motivation in a dangerous oppressive environment.

So how could these varied techniques be applied in the design of interactive media? It would be an interesting but not difficult challenge to 'programme' the dilemmas into an online scenario, using genuine character complexity to motivate the action.

Developing scenarios feels to me to be far more productive and pregnant with learning potential than interactive programmes that invite young people to follow yet another blond nubile heroine in a crop top to promote literacy, or load themselves with fantasy weaponry to overcome 'evil' opponents. The opportunity is there for young learners to share in the design of their personal curricula. And as we also now know, personalisation of learning is the new national curriculum.

What have we got already? At one level we have numerous chatrooms, message boards and blogs where we can consider and discuss the latest soap developments – 'is Kris the worst Hollyoaks character ever?' is currently on offer at lowculture messageboard. Live Q and A is available with members of the panel of Question Time after the broadcast programme. And online conversation is a regular feature of many websites.

But we can and should go further and should use the parameters of the form of theatre to provide the framework of 'what if' – where empathy operates in a safe world of imagination and fiction.

Webplay is currently a programme for schools that uses the resources of the Web to expand on the issues around a number of theatre productions for learning, including theatre in education. A current example explores issues of identity and culture by examining the impact of the partition of India on a family of Muslims and an adopted child. Schools are able to download resources about the history of India, a glossary of words in the play, information about Hinduism and Islam.

Webplay has also linked up with think.com – an interactive web resource where students and schools can post articles and exchange information opinion and comment via their own hosted webpages. The facility also allows for co-creation between students and schools, and the whole site is password protected and moderated.

Futurelab has developed a number of programmes designed to bring drama scenario building into a learning context. One such is Adventure Author – to quote from the Futurelab description:

> By modifying existing game engine technology, Adventure Author has been developed as a means to guide the young people (10-14 year-olds) through a series of steps, via "wizards," which are aimed at supporting thinking about character and storyline development on a scene-by-scene basis. In addition, an overall map easily allows users to arrange and link scenes to support non-linear storytelling. Having authored their own game, the young people can then play this and share it with others. Through this process of play and critical feedback from peers, young people are offered the opportunity to improve their game design and storytelling techniques.

Such initiatives are very welcome; they introduce young people to a deeper level of understanding of narrative, storytelling and character motivation. What we should encourage in my view are more opportunities to explore the back stories of contemporary and historical events, and the perpetrators of significant actions. It is through making and feeling that we enter these narratives, through surprise and delight. Later, through reflection, we make the connections that build our comprehension.

But let's go back to Troubled Waters. The island of Brochvoe that we constructed collectively in our minds' eye earlier, and which 1970s school students adopted as their 'home' for the half term leading up to the arrival of the United Petroleum representatives from down the corridor (and the catalytic visit of the theatre in education team) would now be constructed in Second Life (would it not?).

The island format lends itself to Second Life particularly in its under 18 protected dimension. The work of several weeks that in the 1970s version was created in the classroom studying the economy of islands and oil companies, the identification with families and teams, the science of energy and resources, the deeper understanding of climate and ecology

and conservation, the nature of celebrations and festivals in community and corporate life would now be translated into a web dimension (as well as continuing to provide fascinating classroom displays).

The interaction that would then be available to the participants would take place in real time but in virtual locations. Having designed and built the features of Brochvoe in Second Life (or an equivalent), more resonantly the meeting with the representatives of UP could take place in the virtual community centre and in real time.

And with regard to *No Longer Kids*, the real time interviewing of the white policeman and the black student could be facilitated using the avatars of Second Life.

Forum Theatre

There is a further theatre in education technique that I should like to explore briefly in the context of the opportunities for learning available from the new generation of Internet inter-activity, frequently referred to for shorthand as Web 2.0. Forum Theatre, also known as the theatre of the oppressed, was founded by Brazilian director Augusto Boal and developed in the UK by a number of directors and educationalists notably Chris Vine, Adrian Jackson and the Cardboard Citizens theatre company. In Forum Theatre Boal developed the notion of simultaneous dramaturgy whereby the spectators can intervene in the action before them and attempt to improvise a different consequence to the outcome presented. The form invites the learners to try out what they would do in the circumstances.

Boal first developed the form in the car factories of Brazil, where the notion of workers engaging in any kind of democratic influence to improve their conditions was anathema. Nevertheless audience members would attempt to resolve the complex power relationships that appeared to hamper the road to success or well-being of a central character with whom they identified, by placing themselves in their shoes.

The learning available from forum theatre is powerful because the participants are directly 'thinking on their feet' within a fictional but nonetheless realistic scenario. The engagement of their emotions in the building of the improvisation is also powerful, and as we have seen in earlier examples, this in turn generates deeper comprehension. The participants are co-authors of their dramatic playing out of cause and effect, of symptom and consequence.

Such a scenario and simultaneous dramaturgy could be attempted within the framework of Web 2.0, and virtual reality environments such as Second Life. Alternative points of view, approaches, creative problem solving can be presented, tested and refined in such a learning environment. The Web could thereby become a virtual creativity lab for addressing

problems, concerns and issues of relevance to the learning community.

The virtual worlds of the Web are also now proliferating, and the platforms for their development are also growing exponentially. The BBC has used Second Life to present an edition of the Money Programme. A University of the Arts degree show has been displayed (and assessed) in Second Life; the Tutors, having challenged their students to come up with an original way of presenting their work, then quickly had to learn how to acquire avatar identities and access the virtual galleries. Never underestimate the ingenuity of your students.

Proliferation

A choice of virtual worlds is available to us; now we observe from afar or engage as users as entropia universe wins a banking auction for real money exchange; HiPiHi grows out of China (the first Second Life millionaire was Chinese); kaneva has extended social networks into a virtual world; whyville is the virtual world of choice for the Getty Museum; there.com is now allowing its users to customise the weather over their individual plots (choose from rain, thunder or automatic change. There.com users will also be able to set environmental moods, including new dawns, high noon, romantic sunsets or moonlit nights). There are more on the horizon.

Virtual learning

In all these examples there is a question that remains unanswered; namely whether the interaction available in live theatre in education, and the face to face encounters presented are diminished through the medium of the plasma screen, the web cam, keyboard or mouse. I do not have an answer because the programmes I have suggested have not been developed yet, and no comparison of impact is available. I suspect that the learning experience will be radically different.

What I do offer as a hypothesis, however, is that the learning for individuals and groups and school or other communities, by engaging in theatre in education techniques on the Web is a powerful form of self directed education, and a necessary antidote to the value-free zones of digital games.

Which brings me back to the whole question of values. Difficult not to sound po-faced of course; but the values that underpin the choices of designers of interactive games media are reflected on the screen. It has been argued that the design choices merely reflect the manifestations of contemporary culture, and is in turn simply a temporary fascination with laddishness, ladetteness, TV reality game shows, or tabloid obsessions with nipples, but I really don't think the excuse of 'engaging' or 'motivating' hard to reach young men with poor basic skills is good enough.

As for more mainstream games, should we not be concerned that they are based on principles of entertainment that reinforce racist or sexist attitudes? The avatars that become our players in these games are invariably white muscle bound and powerful – indeed many rely on gaining further powers and attributes in order to overcome the enemy. Most of the avatars in Second Life at least start as similarly defined muscular body types. Choices that are 'value-free' are, in my view, valueless. And learning should be the most valuable opportunity we design.

We are at something of a moral crossroads in the way that the Web can be used for educational purposes. In this essay I have tried to suggest some ways in which older forms of learning through the arts, and notably through theatre in education can open up a democratic exploration of deep and complex dilemmas. Web technology is a wonderful learning resource; ICT and design can point us to a fascinating and exciting future for discovery and personal development; but reference to the arts, and the learning available through theatre in education in particular will provide us with a framework of values to guide us through the complexity of humane moral choices.

The young residents of Brochvoe, and more especially all young people on the 'mainland' deserve nothing less. And as Moomintroll also learned in the floating theatre, the world of the imagination is where people are shown what they could be if they wanted, and what they'd like to be if they dared to and what they really are.

Note: The views expressed by the author are his own and do not necessarily represent those of Inclusion Through Media or Hi8us Projects.

Chapter 11

Now or L8R
Online participatory drama

Clodagh Miskelly

L8R is an innovative multiplatform participatory drama for life skills learning aimed at teenagers, enabling them to reflect on issues and choices pertinent to their lives. Based on a series of short video dramas, it introduces new modes of participation via the Internet to create a safe space where young people can explore their own views and priorities, using actual and fictional experiences (**DVD clip / section 3 / 11**).

In this chapter I outline how this resource works, describing how young people can use the safety of drama to raise issues, possibilities and voice their own concerns. The fictional choices the stories throw up are used to help make sense of, or prepare for, actual choices in their lives, and for some young people this becomes a two way process where their own experiences help to develop the fictional lives in *L8R*.

However, the effectiveness of *L8R* is limited by constraints within the education and youth sectors, including limited technological resources, inadequate support for practitioners and by pressures to meet national and local targets in information delivery or reduction in teenage pregnancy. These constraints can limit the potential of the resource in practice and lead to a playing down of opportunities for participation and self-directed learning in favour of message delivery. This reduces young people's opportunities for developing confidence in their own attitudes and behaviour. I go on to discuss these constraints and how they may be overcome later in the chapter.

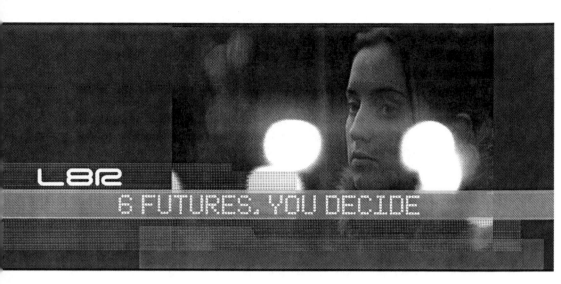

Above: tagline for L8R, featuring Katy, one of the leading characters
Below: Ben, the other leading character

How L8R works

A serial drama lies at the heart of *L8R*. Short live action episodes follow the relationships of six teenagers. Each episode ends with a dilemma for one character and viewers are directed to the website (www.l8r.uk.net) where they can:

- vote on what the character should do and thus determine the direction of a future episode;
- post messages to an online forum where the characters, improvised by young actors, reply and a group of peer moderators help to develop discussion;
- visit *L8Rworld*, a flash environment with animated versions of the characters where participants explore their bedrooms, to discover their private thoughts and family situations;
- visit the Advice Centre for links to support agencies for young people;
- visit the Showcase to see participants' video diaries and other work in response to *L8R*;
- take part in online chats hosted by trained peer mentors.

A practitioner-only section and a printed pack provide support and guidance for teachers and youth workers.

Online participation in the drama is complemented by situated group activities such as discussion or role play which draw on topics from *L8R* and support decisions on voting and advising the characters.

The drama about the lives of six characters deals primarily with sex and relationships. One storyline follows teenage parents, Katy and Ben, through the birth of baby Chanelle and how they deal with the realities of teenage parenthood. Katy struggles with post natal depression and abruptly leaves her baby when she can't cope and Ben has to balance being a parent with study and work. The story goes on to show how they negotiate care of Chanelle after Katy's return as well as the belated support and interference of Katy's mum.

Other storylines focus on the experiences and dilemmas of Misha, James, Danny and Tilly. Themes include peer pressure, risky behaviour, assertive behaviour, and grooming.

Who participates in L8R?

Since 2004 *L8R* has been used across England in a range of educational and youth work settings that register with the project. Episodes are shown on BBC Learning Zone, Teachers TV and distributed on DVD. In summer 2007 there were over 200 organisations using the project with approximately 1000 young people.

L8R is used flexibly in a range of formal and informal educational and youth work settings and to fit with different programmes including Personal Health and Social Education (PHSE), citizenship, drama and youth

sector curricula. It works particularly well with young people who are 'hard to reach' and with groups identified in government policy as being at high risk of unwanted early pregnancy and sexually transmitted infections (STI) (Dept for Education and Skills 2006: 9-13). From observing use of *L8R* in Pupil Referral Units (PRUs), other special units, and with looked after young people, it is clear that the resource engages a range of young people and that its is particularly successful in engaging young men in thinking about fatherhood (Miskelly 2004: 13).

L8R can assist in developing communication and confidence. Practitioners like the resource because it enables discussions on sensitive topics and encourages young people with challenging behaviour engaged in more subtle discussion than is the case with less participatory SRE (Sex and Relationships Education) resources (Miskelly 2006: 64-70). One teacher working with a group of young mothers and young women with emotional or psychological difficulties considers *L8R* as particularly relevant and appropriate because these young women can use the drama to safely address their own experiences, including teenage pregnancy and sexual assault.

> 'It's a really safe way of introducing those issues through the one person removed technique and a lot of work we do has to be using that method because then you're not discussing individual pupils, you're discussing somebody else who's got those issues and they're more likely to discuss things that relate to them by talking about somebody else, somebody else's experiences.'

A participatory web-based drama
Through its multi-platform format, *L8R* introduces different modes of involvement which have consequences for how young people learn and make sense of experience.

L8R is participatory in its use of drama and its use of the Internet. Emphasis is placed on young people's interaction with the drama and opportunities to influence subsequent storylines. This differs from interaction with quest type computer games and other educational resources which allow the user to explore a set of pre-authored routes through a story. The authorship of those kinds of resources is procedural, in that not only are the texts prewritten but so are the rules by which they appear to the viewer/player (Murray 1997: 152). They often involve forking paths which take the user on a particular journey following a predefined set of causes and consequences. This type of structure risks a didactic presentation of relationships which would be difficult to avoid in a pre-scripted interactive drama where characters' 'good' or 'bad' decisions may be used to promote particular behaviour (for example, Jagodzinski 1999).

L8R does have some predetermined and procedural elements, however

the way in which the story develops is not predetermined and requires participants to vote for the story to progress. Unlike a forking paths structure, *L8R* episodes follow a linear serial format. This maintains a dramatic coherence through the episodes and contributes to a *realness* and consistency in the characters which has proved important in maintaining young people's engagement. The forums, group discussion and improvisation are used to explore alternatives and this extends beyond the dilemma on which there is a vote, to exploring other storylines from the episodes and *L8Rworld*. Rather than being presented with pre-determined courses of action and their consequences, they are offered opportunities to imagine and consider a range of choices in relation to their own attitudes and values.

Although innovative in its integration of web-based elements, this approach to learning about life skills and decision-making has its roots in the well-established use of participatory drama and theatre in health and life skills education (Ball 1993; Jackson 1993). *L8R* draws on forum theatre, where spectators can intervene directly in the dramatic action, replacing an actor to improvise how they think the character should act in a given situation (Boal 1979; Vine 1993).

Katy's virtual room

A physically located process where the audience works with actors to recreate scenes and explore alternatives, is replaced in *L8R* by intervening through the vote and the forum. This different engagement of the audience in the drama still allows them to articulate and address different actions, choices and consequences, regarding both future and past actions but the emphasis is on advising and influencing the characters. The collective nature of this process is important both in the classroom and online. It is the sharing of perspectives through discussion, messaging and improvisation that 'deepens thought and broadens the issue' (Vine 1993: 123).

The following key features of *L8R* enable participation and reflection; '*realness*' and relevance of the drama; opportunities to influence the action; and the inclusion of both actual and fictional experience.

'Like true teenager life'
L8R storylines are fictional, but are informed by young actors' and participants' contributions which draw on their own experiences and concerns. Young people identify with the characters and do not feel patronised by the resource. They talk about *L8R* as '*real*' and '*like true teenager life*'. The drama is a fictional space for experimenting which is relevant to their lives while safely avoiding the specifics of their experience.

Still image from the
L8R interactive film

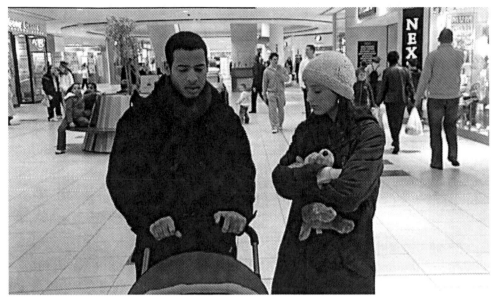
Ben and Katy

> 'Seeing how other people cope in difficult situations is a good thing
> to see because then you can copy in a difficult situation and see if you
> cope better or worse and I don't know, it could help if you cope, if you
> cope worse than them.' (Young mother aged 16)

Young people know (usually) that the characters are not 'real' and do not
always accept their actions as credible, but in the forum they 'speak' di-
rectly to them and are curious about other aspects of their lives. They care
enough to take the time to advise Ben about his responsibilities to the
baby.

> giv up
> u hav 2 ern money 2 look afta the baby, and 2 ern mony u hav 2 work.
> how will u work and look afta the baby at the sme tym? c it is beta if
> u put chanelle in a fosta home and wen ur redy 2 look afta her, u can
> get her bac.

Choices, consequences and opportunities to influence

Young people explore in depth the situations on which they can vote. In
their groups and online they approach and expand on the narrow voting
options in a whole range of ways. At the end of Episode Eight the partici-
pants are asked: *Should Katy tell her mum she wants Ben to share looking after
Chanelle?* A group of young mothers considered how Ben, Katy and Katy's

mother, who allows Katy to move home with Chanelle but on condition that she restricts Ben's access to the baby, could resolve their differences by establishing the rights and responsibilities of each character. This process involved a lengthy discussion about the role of parents and grandparents, access rights, and responsibilities to each other and to a baby. For example they addressed Katy's mum's responsibilities.

> She's got a responsibility not just to think of herself because that's what she seems to be doing and she doesn't seem to be thinking about her daughter and what's best for her daughter and if she's coping or how she feels.

Voting decisions resulting from such discussions are conditional; for example, some young people voted yes, Katy should tell her mum, because she should stand up to her mother to ensure Ben's involvement in Chanelle's life, but explained that she should try to negotiate to avoid losing her mother's support. Some talked through how Katy might achieve this. These conditions, nuances and alternative courses of action are presented to the characters via the forum. Both characters and moderators respond to and challenge different courses of action. For example, Ben replies to the suggestion (above) that he should '*giv up*'.

> Aint putting my kid in a foster home so people can say a nothing black baby father failed his duty. Don't care what I have to do to keep her at least she'll have one parent who loves and cares. You any experience of foster homes?

There is some confidence that the vote decides the general direction of the next episode. Although some sceptics assume (wrongly) that the episodes are already made and the vote is a bluff, most consider a vote with the majority as proof of influence and some participants think they influence the characters through the forums. But on the whole they are not naïve about the extent of their ability to influence, understanding that, ultimately, the production team decides the detail of what happens next and will introduce new dilemmas and twists. This is after all what keeps the drama suspenseful and interesting. While participants really want or expect to know about the characters' subsequent actions, they do not necessarily want the characters to do exactly as they advised. Some young people vote against their own advice or how they would act themselves precisely because they want to see what could happen if a character takes a risk that they would not want to take.

Fictional and actual experience
The dialogue between young people, characters and moderators in the forums moves between fictional and actual experiences. Participants introduce their own experiences and dilemmas into the forum whether

drawing on these experiences to advise and empathise with characters or asking for help and advice. For example, young mothers talk to Katy:

> i think that you can be any age to have a child as long as u can give the child love and support thats all that matters [...] well i suppose u need money and eveything but if ur unda 18 u will get benifits for ur child neway. [...] Im pregnant but i dunt want money or nething i just wanna give that child a great life ahead of it and all the love it can get. ...

Characters respond to young people's experiences improvising their responses and drawing on actual experience to develop the fiction. Katy replies

> i admire u for the way u think... i think its very nice of you 2 keep the baby and try ur best 2 do what is rite for him/her... i decided 2 keep my baby because i dont think i could live with myself if i had an abortion.. i would always be thinkin about how it would be if i did have her [...] but i do understand that some people really do not have conditions to keep a baby... some people have no one to support them... and i understand if they do not decide to keep their baby.

Moderators treat young people and characters in similar ways, for example, talking to Ben about how to deal with stress.

> i realise that sometimes situations such as urs, can often cause too much stress to a person... it sounds like u r stressed and being stressed isn't healthy – neither 4 u or Chanelle – so here's a website which basicly breaks down the symptoms of stress, the causes of stress and then how 2 deal with it......i hope it will help u somehow... it helped me! :)

Using the relative anonymity of a username, young people can discuss issues with others from across the country. This creates a space where views can be voiced which might not have been considered acceptable or comfortable face to face and perspectives heard from a wide range of experience and backgrounds.

The content and tone of the forum are shaped by the emphasis on life skills and choices, the context in which young people are introduced to the resource and the value placed on their own views and advice. Often, especially in school, young people's language changes in the forums where they write as they would when text messaging or in a chat room and sometimes imitate the characters. How they speak online is not how they speak in class, or necessarily how they speak to one another. Some participants adopt a role when online, taking on the style of the drama. There may well be shades of fiction or creative investment in the messages, from adopting a particular style of writing to creating fictional experiences presented as actual experiences in order to help develop the

debate and learn about topics of concern.

Young people actively collaborate in the drama as well as in a learning process about life skills and choices. They are not deluded. They can distinguish between the fiction and their own experiences and those of the other young people involved, but willingly collaborate in order to explore the issues. The inclusion of actual young people's experience is important too. For some young people it is the first time they have heard the views of a young parent and for them, these are experiences '*you wouldn't even dream of*'.

The interweaving and sometimes blurring of the fictional main drama, the improvised, and actual experience impacts on and appears to enable young people to think and learn about life skills and choices.

Barriers to access and participation

The potential and successful use of *L8R* is constrained by the everyday realities of the education and youth sectors. Institution, infrastructure and technology-related constraints place limitations on access and inclusion and can mitigate against or curtail participation both in terms of using the web-based resources and in terms of how life-skills issues are addressed.

Even enthusiastic practitioners mention limited access to audiovisual and computing resources as a barrier to full use of *L8R*. Some organisations, mainly in the youth sector, still have no or limited access to computers and/or the Internet. Even where there is the infrastructure, as is usual in schools, PHSE tends to be a low priority for a highly prized resource. Where there is access to the infrastructure, the website is frequently blocked or filtered either by the school or agency or by Internet service providers, because it is incorrectly considered an entertainment rather than educational site, or because of the streaming video content, live chat functions or the nature of the content.

L8R is increasingly delivered through partnerships with local authorities. Therefore uptake has shifted from the enthusiastic individual practitioner to practitioners for whom *L8R* is a recommended and free resource from the local authority. Although supported by bespoke in-service training, some practitioners lack the experience or support to adequately integrate the forum, *L8Rworld* or voting into group or classroom practice. This is more problematic in mainstream schools where student to teacher ratios are high and there is less specialism in PHSE compared to teaching in special units or youth projects.

Practitioners are the gatekeepers to young people's use of *L8R* and shape their engagement with the resource. For practitioners there are two areas of challenge – teaching sensitive material and using ICT. The technical and infrastructure barriers are sufficient to discourage busy practitioners and especially those for whom time and confidence are an issue.

Some argue that the episodes and resource pack are very rich so they do not need to use the online and interactive aspects, however this limits the autonomy and voice of young people and also their knowledge and understanding of the characters and can lead to a more prescriptive, controlled approach to the issues. Lack of support and training for practitioners both in their delivery of PHSE and in the use of interactive media and the Web impacts on the opportunities that young people have for using the resource. It limits differentiated learning and the ways in which young people can consider and voice their own views.

Shaped by policy and practice

Participation and practitioners' approaches to using the resource are shaped by wider issues at organisational, local authority and national levels where there may be pressure to demonstrate results or impact in relation to public policy initiatives and local or national targets.

L8R is operating in a context of public funding and local authority partnerships which is sympathetic and supportive of the project and welcomes the resource as a means to address key issues. However this is a context in which success is often measured in negative terms – the reduction in teenage pregnancies and STIs – or in terms of the delivery of information – the number of young people who learned how to use a condom. While these are important, this approach to evaluating is a *'deficit model'* (Wight, 2002). It focuses on the consequences of risky sexual behaviour and does not address the needs of young people to develop the skills to make informed and confident choices and to consider their own attitudes, nor does it address young people's own priorities. There is a great deal of difference between telling a young woman that condoms will protect her and supporting her in developing an informed and assertive attitude regarding when and how she has sex. As the Sex Education Forum suggests, it is a case of

> trying to measure what [sex education] prevents rather than what it enables. SRE is a lifelong process of learning about sex, sexuality, emotions, relationships and sexual health. It involves acquiring information, developing skills and forming positive beliefs, values and attitudes. (Wight 2002)

These aspects of learning and experience are more difficult to evidence. Online dialogue with young mothers acting as peer moderators or imagining the possible consequences of Misha going to her boyfriends house when his parents are out, may have no direct causal relationship with decreased numbers of STIs or unwanted pregnancies, but they do open up opportunities for young people to address the subtleties of those relationships and wider experiences that lead to risky behaviour.

Young people's own evaluation of their learning through L8R, the pos-

itive feedback from many practitioners and the quality of reflection and discussion observed during the evaluation of *L8R* all reflect the findings of wider studies which suggest that to achieve meaningful SRE requires a multi faceted approach and a long term view on evaluation. (Health Development Agency, 1999; Sawney, 2003). However funding is often dependent on meeting certain targets and, in the face of hard targets and with limited time and resources for SRE it is not surprising when resources like *L8R* are adapted to draw out particular messages about behaviour rather than enabling young people to develop confidence or reflect in depth.

Conclusion

L8R builds successfully on the use of participatory drama, using new communication platforms and technologies. These enable different ways for young people to participate through a closely interrelated set of online and offline activities and involving a spectrum of 'fictional' and 'actual' accounts and experiences.

Through this activity they have an opportunity to reflect on negotiation, choices and consequences and life-skills and also to gain information about a range of issues relating to sexual health, and personal safety.

However the potential for young people to engage in discussion and debate and differentiated learning is related to the degree to which they can participate or take some control of their use of the resource and their learning. This is undermined by institutional and policy-related barriers to do with limits in resources and pressures to meet narrow targets. *L8R* can be adapted or used in a reductive way to serve message delivery without dealing with young people's attitudes to or ability to act on those messages. Policy, funding, evaluation methods and technological infrastructure lag behind technological and creative potential for young people's opportunities for learning and participation. They also take insufficient account of young people's autonomous, creative uses of new communication technologies for their own purposes as well as their views on adequate life skills education. In spite of its success, a resource like *L8R* must continue to keep pace with young people's priorities and communication practices while also continuing to produce, and demonstrate the value of, creating opportunities for young people to address life-skills issues and their own attitudes and priorities. However the full potential of participatory web-based drama for learning about life skills cannot be realised without improvements in infrastructure and changes in policy.

The author would like to acknowledge the contribution of ideas from John White and Mandy Keene that helped shape this chapter.

Chapter 12

Including the Excluded
Collaborative knowledge production through participatory video

Jackie Shaw

In a rapidly changing and media-rich world the use of video as a participatory tool with socially excluded groups seems to offer much promise for community development agencies. One socially motivated application is in community consultation, which aims to include service recipients in the issues and decisions that affect them. Councils and other statutory agencies can use it as a way to research and communicate the views of those who are not normally heard.

Currently however there is limited understanding of the approach and contexts that are necessary to ensure disadvantaged groups lack of voice is adequately addressed. The process needs to facilitate participants to both develop as well as express their opinions. Otherwise the danger is that consultation merely provides people with the opportunity to ratify decision-makers plans. In some cases lack of clarity and skills as well as conflicting agendas leads to projects that can be detrimental to the group concerned.

In this chapter I discuss some of the projects undertaken by Real Time[1] with young people from the perspective of Participatory Action Research. Examples include a project with young people in-care, a project with homeless young people, a project with young council tenants as well as projects with black and ethnic minority pupils attending nine supplementary schools. I also draw on the results of recent reflective interviews with Real Time personnel (directors, trustees, practitioners and funders).

The aim is to explore some of the factors that need to be considered in setting up and running projects of this kind. My discussion centres on the importance of the working relationships developed between different project stakeholders throughout the process. In particular I emphasise the

need to address the degree to which funders, and indeed others involved in a project, are committed to a participatory process that genuinely empowers participants. I also discuss the factors that need to be considered if the process it is not to be subverted to serve the agendas of project stakeholders (For instance a council officer may want video evidence to support there own work plan, a community support worker may want a promotional video to help raise project funding, and a video worker may want a final video production to showcase there own technical and creative skills.)

Conceptualising the approach – Participatory Action Research

Participatory Action Research (PAR) involves participants in collaborative research activity with researchers in constructing their own perspectives of their world with a view to social improvement. PAR grew out of participatory research, which in turn developed from emancipation-focused projects in the developing world (Fals Borda 2001). Its defining characteristics are community participation in the analysis of needs and problems, and co-ownership of research and the facilitation of community based social change (Kemmis and McTaggart 2003).

Participatory Video can be perceived as a form of Participatory Action Research in its own right, and discussion of it as a research methodology seems to be increasing (e.g. Mayer 2000; Krogh 2001; Kindon 2003; Protz 2004; Ramella and Olmos 2005). Participatory Video can certainly be used as a tool to support communities in examining their own social realities and developing their own understanding of their experiences. It also involves them in communicating this knowledge to others through the production and screening of video material such as video stories, testimonies or documentaries. Participatory Video also shares with PAR a general focus on participants' empowerment as well as a reflective approach to development. It is with this understanding that Participatory Video's use as a tool for collaborative knowledge production with socially excluded groups is framed here within a PAR umbrella. It is also within this context that I explore some tensions that exist in practice.

One of the defining characteristics of an Action Research project is how much emphasis is placed on the action compared to the research. The importance of the research products compared to the project action determines the time and attention and priority that are given to each in the set up, facilitation, and output stages. In the same way these sorts of Participatory Video projects balance two main intentions:

1) A project process which aims to empower participants as individuals or as a group.
2) The production of video that communicates new knowledge that has been generated by the participants through the process.

Sometimes these two aims can be in conflict in terms of the practice on the ground, which is important for all stakeholders to recognise (see example discussed later at 4) Production of the video).

A linked question that needs to be addressed stems from different interpretations of 'participation'. Participation in this context can be framed as the active involvement of service recipients in the way a service develops, that takes account of their perspectives. The participation discourse dominated development literature through the 1980s and 90s. The concept inspired several 'people-centred', 'process-orientated' participatory methods that became increasingly influential in the development field. These approaches were influenced by the ideas Paulo Freire (1972) brought to teaching and learning work with marginalised people in Brazil. Most methods used visual techniques including maps and diagrams, and video has been suggested as a tool (e.g. Laney 1997; Chambers 2005).

'Participation' as well as 'empowerment' are buzz words that are often used positively by practitioners and academics without critical definition, and the concepts have been the subject of much recent critique (e.g. Cooke and Kothari 2001; Mosse 2001). Many writers (e.g. Braden 1999; Humphreys, Lorac and Ramella 2001) have asked whether manuals produced to encourage participation result in a rigid approach to local people, and whether participatory processes offer no more than the opportunity to participate in the decision-makers' programme. Fuzzy terms like 'participation' and 'empowerment' do get project stakeholders with different agendas round the table talking, without which many projects would not

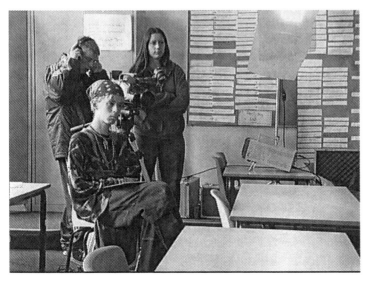

Time To Listen
project (Real Time)

get off the ground, but they are used to serve a wide range of purposes and politics (Hickey and Mohan 2004). Developing a clearer understanding of different stakeholders' approaches to 'participation' can help clarify some of the tensions that arise in project practice. The next section of this chapter will explore four project examples to illustrate these issues.

The Projects

All of the projects involved statutory service providers approaching Real Time with proposals to use Participatory Video. The purpose in each case was twofold:

1) To explore and develop the views of a defined target group in a particular policy area.
2) To facilitate the groups in making a video to communicate those views that could be used in planning, policy making or awareness-raising.

The projects were:

Time To Listen – The education department of Stoke and Staffordshire County Council commissioned Real time to run a Participatory Video process with looked-after (in care) young people to explore the difficulties they faced in accessing education.

Dee Park Project – Reading Borough Council asked Real Time to work with young people living in the Dee Park council estate to involve them in community consultation around the estates' regeneration.

Young Homeless and Housing – The housing department of a London Borough had funding for a research project using Participatory Video to explore young homeless people's housing needs.

Video Views – CfBT Education Trust funded Real Time to work with nine supplementary schools (schools additional to mainstream education, predominantly with black and ethnic minority pupils set up for cultural or religious reasons) in Bristol, Birmingham, London and Manchester. A Participatory Video process was used to facilitate pupils in representing their experiences of supplementary schools (**DVD clip / section 3 / 12**).

The projects each had their own particular challenges and problems, and in what follows I discuss issues that arose in different phases of their development and in the conduct of these kinds of project more generally.

1) Project aims

Practice issues during a project often arise from a lack of clarity of purpose at the start. Fraser (2005) has highlighted four different community participation approaches: conservative approaches using top-down decision making; managerialist approaches which result in community consultation with community 'stakeholders'; empowerment approaches which aim to address social needs and inequality, but may not reach socially

excluded groups and can be dominated by the agendas of established groups; and activist approaches which attempt to reach socially excluded groups and aim for completely bottom-up process with all the resultant difficulties.

Using Participatory Video to access the views of socially excluded groups could be approached from a managerialist, an empowerment or an activist perspective. Different project stakeholders may hold any of these views of participation and this causes the majority of problems in project implementation. One of the biggest challenges for project workers is managing the different beliefs about what the process is for. This is part of the project process, as a funder expressed:

> 'I suppose part of the role of Real Time is to manage the expectations of the funders, commissioners and the agencies that work with the groups, and still come out of it with a process that has some integrity, and a product that people will want to watch.'

Project clarity can improve by educating stakeholders about what Participatory Video can offer compared to other consultation processes. An open meeting, a survey or a video made by a professional crew are most likely to reach community members who already have a voice. A Participatory Video process has the potential to engage and motivate those that might not usually get involved. Improving clarity about this potential can aid agenda setting.

In Stoke Real Time was commissioned to run the project because council officers clearly understood the value of the approach in reaching an excluded target group. Consequently Real Time was given free rein to take a flexible approach to the project. The process was successful, working with sixteen young people who formed a core group. There was also enough funding to work with them for an adequate time to develop their views and transfer decision-making to them.

In Dee Park the arts department who involved Real Time understood what the process offered. However individuals in the housing department who funded the project had different perspectives on what the project was about which caused problems later down the line. The London Homeless project wanted to reach young people, but misunderstood the process that was necessary to reach them successfully.

2) Setting Up
Participatory Video is thought to be effective at involving socially excluded groups. It is an exciting medium, that all can learn to operate with the necessary support. It focuses very directly on the groups' lives. The themes explored therefore revolve around participants' experiences and ideas. This generates a sense of purpose and motivates them further.

184

Often the problem in engaging hard to reach groups is that it is not possible to simply set up a meeting and expect them to arrive. In the Dee Park project Real Time worked with youth and voluntary sector workers to identify participants. Video itself was also used to draw in those who might not otherwise participate by setting equipment up in various locations on the estate and encouraging young people to have a go. Generating interest in watching the material drew them into the community centre and a group was formed.

The Stoke project also had a flexible approach to group formation. Individuals and small groups (two to three young people) were initially contacted at the suggestion of care workers and other council providers. Work initially happened with these small groups in separate locations. Individuals were then brought together to form a core group. However project work continued predominantly with smaller groups, as well as incorporating further young people as the project progressed.

One of the problems in the London Homeless project was that the housing department prescribed a more traditional training course approach. They specified a number of groups of minimum ten young people. They wanted participants to commit to regular attendance at a fixed venue for 10 two-hour sessions (despite having had no experience of what they were committing to). Any setting not recruiting enough participants was deemed unviable and project work cancelled. Real Time advised that this approach was unlikely to be successful with young homeless people living unstructured and difficult lives (who may also have been failed by traditional teaching methods in school). These housing managers did not accept the guidance and Real Time was unprepared to sign a contract to deliver the project under these terms.

3) Project processes
Socially excluded groups may be unpractised in expressing their opinions. Recording material before they have had the opportunity to work out what they think is more likely to pay lip service to their involvement, and simply confirm what commissioning agencies expect to hear.

Real Time addresses this by taking participants through a process that builds confidence that they have something worth saying, facilitates them to develop their ideas through discussion and interaction, and encourages them to reflect and think critically together about their situation (Shaw and Robertson 1997). This proceeds through a series of structured video games and exercises. Group members operate the equipment for themselves from the very start. Recording the exercises and playing them back provides the opportunity to transfer video skills to the participants alongside the development of communication skills and critical awareness.

The interviews with practitioners indicate several key factors in suc-

cessfully running a process like this:

- *A structured approach* – Handing over equipment to groups to do what they like is likely to lead to disappointment and consequent lack of motivation. Structured games and exercise provide an incremental learning process through which participants can succeed.
- *Taking turns* – All group members participate in every role throughout the project. This helps to create a group dynamic where all can take part rather than one that is dominated by one or two. It also builds co-operation and shared ownership of the final material.
- *Equipment used to create space for all* – Participants report one of factors that has the biggest impact on them is the sense that they are being listened to. This is particularly so for excluded groups. The video equipment can be used to create space for all to speak. In early exercises each participant takes it in turn to hold a hand mic and have their say. Later all take turns at expressing their opinions and choosing shots.
- *All material recorded is played back* – Watching themselves on tape expressing their views seems to be an important factor in participants gaining confidence and developing a sense of individual and group identity. It also facilitates critical reflection.
- *Importance of the early sessions* – If early sessions are successful in building self-esteem and an inclusive working dynamic, the rest of the project work tends to go well.

To run projects like these facilitators need to have good group work skills as well as video production skills. Beyond this they need to approach a project as a 'collaboration' with participants as equal partners. Facilitators bring video production and group facilitation expertise, and the participants bring the knowledge about themselves that the process wishes to capture. Part of the facilitators' job is to bring out these views.

The facilitator needs a clear understanding of their own power in the process to either facilitate a transfer of decision-making and control to the group, or to manipulate them to their own and the funders ends. Nowhere does this become more apparent than in the production of the final video material.

4) Production of the video

The debate about Participatory Video has often centred on the question of emphasis on process, compared to product. This has arisen from the need to distinguish it from traditional production practice, where product is everything. However it is an artificial distinction. Recording video is a core activity within projects and working towards an end-product on tape gives the project direction and meaning. The communication potential offered by video is an important element. Both product and process are interrelated and the important question is what sort of process best supports

the project aims. In this kind of project there are three main processes:

- The development process that facilitates the expression of participants opinions
- The transfer of video production skills to the participants
- The transfer of participants' knowledge about the subject under research into video material

Alongside this is a gradual transfer of responsibility for the project to the participants.

Facilitators have to balance these different processes and this generates some of the complexity. There are also time limitations. All projects are committed to producing a particular product and it is part of the facilitators' job to ensure that the group completes within the project timeframe. This creates the biggest tension for Participatory Video workers:

> 'You have to put you own creative process to one side – because there are different processes to get a good creative outcome through working with a group a people – particularly if you want the group to own it.' [2]

This can be particularly difficult for those who come from a production background rather than from community development, as they have more pre-conceived ideas about how a video should be made:

> 'As a worker you need to understand you have your own agenda. You want a product that can reflect well on you as well [...] and that might conflict with what they group want to do.'

The video worker is there to facilitate the group to produce something they can be proud of, but

> 'There's always a tightrope to be walked between ensuring the groups feels good enough about its results [...] but you can push them to get better results and they'll never feel good because they don't own the video.'

In addition projects of this kind can sometimes compromise the process of empowering a group in the work of facilitating them to make their own video. For instance, if the topic of the video is pre-determined, then the group cannot decide on what they are most interested in communicating.

This may be particularly relevant for youth projects, where sense of ownership is a key potential benefit for participants. However funders often decide what it would be useful for them to make a video about, which may be of no interest to the group concerned. This can result in a conflict between what the group wants to say or do and what funders or youth workers want them to address. Stakeholders need to face up to this tension if they genuinely want to include previously excluded young

voices.

In all of the project examples the topic of the video was tightly specified except Video Views. The purpose of this project was to get young people to explore their experience of supplementary schools, and a compilation tape was produced to promote them. However the brief was quite loose in terms of how the young people tackled the assignment, what they discussed and what they showed. The compilation allowed the experience, creativity and diversity of supplementary education reflected more obliquely through the very different products produced. This allowed the process to give more ownership to the groups concerned, although the final product did not tackle the issue the funders wanted addressed directly.

The brief in Stoke was very specifically to explore issues of access to education for looked-after young people. It was therefore of the utmost importance to be very clear with the young people concerned about the agenda, so that they understood from the beginning that the topic was prescribed. Within this the group were free to interpret the topic in their own way. Generally the process was felt to successfully combine a positive experience for participants with a successful end product.

The Dee Park project encountered some specific problems with the final product. The funders wanted the process to involve young people in the regeneration but different sections of the council had different understandings of how that might affect what was produced. The group of young people articulated views that did not fit with the housing department's expectations. One regeneration officer was not happy with the video as it did not provide the specific evidence required. It seemed that a promotional video had been envisaged. This illustrates the importance of all stakeholders understanding that if they genuinely want to empower young people to express their own views, what they say cannot be predicted or controlled.

5) Editing

The editing stage is another point at which ownership can be taken away from the group. There is rarely enough funding for a group to do all the hands on editing themselves. However it misses the point to think that ownership cannot be maintained by the group if they do not edit themselves. In addition greater involvement in the editing process may be inappropriate for projects of this kind. Young people may not have the time or inclination needed to edit this kind of final product themselves, especially if the brief is defined by the product commissioners.

This means that particular care is needed in thinking about how participants can be involved enough in the editing decisions to maintain their control over the final product. Facilitation of the participatory process has

ideally enabled participants to have their say on tape. It can be wholly appropriate in these kinds of collaborations for video professionals to edit the tape in a way that reflects participants' views, as part of their contribution to collaborative knowledge-making.

> 'An important element in ensuring the edit reflects the young people effectively is the trust and open working relationship between the group and the workers. In fact the editing process can empower because the young peoples' views are explicitly taken on board by a professional and represented effectively.'

In all the projects discussed participants did some hands on editing and were also consulted at various points in the editing process. What is important is that editors are aware of their power to subvert and change the message that they group want to convey. In addition funders need to understand that there needs to be enough time in the project for participants to develop some understanding of the edit process and be involved in the editing planning and macro decision-making, if they are committed to an empowering process.

6) Distribution
Video can provide a vertical channel of communication between socially excluded groups and with those with decision-making power. The action within this kind of action research project partially comes from the process of empowerment that participants go through, but it also comes from the potential action that can result from the distribution of the tape. One of the great strengths of projects like these is that the audience for, and use

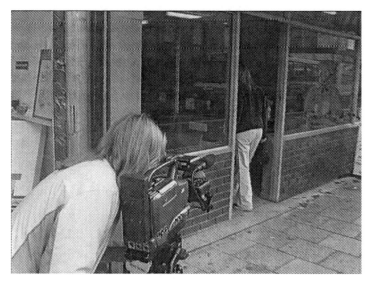

Time To Listen
project (Real Time)

189

of the tape is pre-defined.

The Stoke project included funding for a work pack to go with the tape so that it could be used as a discussion starter. It has since been used extensively to raise awareness amongst education supporters and providers about the needs of looked-after young people.

Video Views was screened at a number of nationwide CfBT conferences promoting the value of supplementary education, including some where the young people were involved in presenting the work. It has also been used to help establish a network of supplementary schools. Distributing it to all schools in the country enabled those in differing schools to get a sense of the wider provision and the experiences and approach of a variety of services.

Conclusion

Participatory Video can be a good means of including the voices of socially excluded groups. However this chapter has suggested that all stakeholders in projects including practitioners, project support workers, and funders need to think carefully about the process they are engaged in.

Work that aims to be empowering by its very nature intervenes in established power relationships. Encountering conflicting agendas and the resultant tensions and difficulties does not indicate a poor project. Rather it reflects the reality of attempting to tackle social exclusion. Participatory Video can contribute to changing the balance of power both within a group and between the group and wider society; it can give space for groups to generate their own knowledge and to facilitate communication with other groups and institutions. To achieve this potential, facilitators and other project workers need to consider how this transfer of power is managed, and how their own power in the situation can affect the process so that inclusion of socially excluded participants is truly transformative, rather than superficial. All stakeholders need to think about how a project can be manipulated to support vested interests and agendas that control rather than empower, as well as about the approach that is needed if they are genuinely committed to hearing from socially excluded groups.

Endnotes

[1] Real Time is an educational NGO specialising in the use of video as a participatory tool with disadvantaged and socially excluded groups. Real Time has 22 years of organising and running projects, training other facilitators, and offering consultation in this field of work, both in the UK and overseas, and has developed a comprehensive methodology aimed at creating opportunities through projects with a diverse range of groups. See Shaw, J. and C. Robertson (1997) *Participatory Video: a practical guide to using video creatively in group development work* (available from www.ebookmall.com/ebook/72602-ebook.htm. Contact: info@real-time.org.uk).

[2] This and the following quotes are from reflective interviews recorded with Real Time personnel from October–December 2006 as part of an action research project.

Chapter 13
Young Men, New Media and Life Politics

Victor Jeleniewski Seidler

With the development of global media and the reach of the Internet as well as new technologies of play, young people with access to new media are growing up into a different virtual world.[1] They can shape relationships with each other and keep in contact on a regular basis, so that it is easy for them to create their own world with their friends that their families are largely excluded from. They can move into and out of virtual spaces that they know an older generation has little access too. They have access to sources of information and identification through which they can explore their own feelings, desires and aspirations in networks they can search out for themselves. Of course these are mediated through layers of class, gender, 'race' and ethnic relations that also make a difference to the access people have to these new technologies and the familiarities they can develop with them. Young people from diverse backgrounds in multicultural and multi-faith environments can talk about aspects of their lives and explore possible identities for themselves within virtual spaces that offer them a certain freedom.[2] The Internet can help produce spaces of experimentation where they can explore desires that they might not be able to talk about in face to face contact. They can find ways of escaping from inhibitions to explore themes they might otherwise repress and silence.

These virtual spaces are gendered, though it can be difficult to explore the different ways in which young women and young men make use of them. Though these technologies have a global reach, research shows that it tends to intensify local communications, with friends being more engaged and connected to each other.[3] In a rapidly changing virtual world that is partly shaped through the dominance of corporate interests, young

people are exploring different ways of being, and complex identities that they are coming to terms with.

In this new media world how might different media be deployed in ways that can help young men in particular through a process of growth and transformation? How might young men learn to take certain risks with themselves and open up aspects of their experience to explore what could potentially help them learn *how to feel easier* with their embodied selves and inherited masculinities? How might young men be able to use the media in ways that allow them to explore and give shape to new masculinities that allow them to come to a different relationship with themselves? Too often within the frameworks of traditional anti-sexist politics young men have been left feeling bad about themselves because of the responsibilities they carry for the oppression and subordination of women. But this worked often to tacitly reproduce the general messages conveyed within a Protestant moral culture that 'boys are bad' and that 'boys are animals' that need to be disciplined and controlled because they cannot be expected to control their 'animal natures'.[4]

In different settings young men often learn to shape different 'fronts' for themselves so that they seek to present images to others they wish to sustain. If 'fronts' have traditionally helped to shape white working-class masculinities, there are notions of 'cool' that seem to spread across diverse class, racial and ethnic differences. For young men this is often associated with maintaining a sense of self-control, for there is a widespread identification between masculinity and self-control that is shaped differently across time. Young people now might be able to express more physical contact with each other with, for instance, hugging becoming more of an established mode of communication in schools and colleges. Some young men from diverse class and ethnic backgrounds also seem to be much more adept at relationships, sharing themselves more easily in intimate relations than in previous generations. They might maintain a front towards those they do not know but at the same time value being able to express more of themselves with their friends. But if there has been a softening in relation to homosexualities there is still a widespread homophobia in many communities that can help structure conventional heterosexual masculinities through an unspoken fear of the feminine. There is a fear of 'weakness' that is often associated with emotions, particularly with feelings of vulnerability and tenderness.[5]

Young men are supposed to be able to cope with whatever comes up for them emotionally and it can still be experienced as threatening to male identities to need help even from close friends. To acknowledge that you need help is a sign of weakness and so a threat to male identities. Sometimes men feel hurt by what they have heard spoken to them in their families and even though it might be part of a joking relationship, a com-

ment can hit home in ways young men can find difficult to deal with. They might feel obliged to carry silently a painful feeling of rejection. Boys are less likely to share these hurts with their friends or to look for support to understand what these remarks might mean in terms of the emotional life of the family. Rather they might carry a feeling of rejection that cannot be shown or revealed for it can only seem to prove what has been said, namely that you are 'good for nothing'. If you admit to a hurt you might suffer further rejection by being told not to 'be such a woos – it was only a joke.' Young men often have to learn to deal with banter and them have to become attuned to discerning the intent that might be behind it. They learn not to take offence, but sometimes they can feel obliged to carry the hurt silently. They do not want to demean themselves in their own eyes too. They do not want to admit that some remark has got through to them or that they are feeling hurt because this can also threaten their masculine identities.

Experiences

There is so much that can be learnt from men who have been involved in working with men sharing their own experiences. Often this is difficult, if rewarding work, partly because it can be so hard to get behind the 'fronts' men are so used to framing and earning the trust that allows for dialogue. Often young men will test you to discover what is behind your own talk, before enough trust can be established that allows them to reveal different aspects of themselves. I was excited to meet Dave Tomalin because I knew about some of the media projects he had developed with young people in East Leeds as part of Hi8us North. Initially I was introduced to Dave by a friend Tony Dowmunt who also teaches at Goldsmiths and who has worked with Dave within the Hi8us network.[6]

Tony knew that we were both interested in talking about his work with young men and the ways this has developed over time. We met at a café and Dave had so much to share about how different projects had developed over time. He was very generous in his sharing and helped me grasp the complex processes through which projects were developed. There was a feeling of warmth almost immediately and a mutual sense of excitement in his talking and my learning about his work. He had so much understanding and experience and was willing to explore some of the personal sources that helped shape professional projects. Often these remain unexplored and hidden from view in the ways projects are written about, even though they remain a primary source for developing a professional practice that can engage in *real ways* with young people. Often they are the very experiences that need to be learnt from, though they can often be discounted within unhelpful conceptions of professionalism that see it as impersonal and detached. But this too often encodes a limited vision

of objectivity. Dave was helping to articulate a vision of professionalism that involved really listening to and engaging with what young people had to say, and so could serve as an important model for the professional practice of others.

I was willing to listen and to learn as well as share some of my own experiences from working with men in different contexts. After the meeting and Tony had left to go his own way, Dave and I walked together to Holborn station. We talked more personally to each other about our lives and were happy to be in each other's company. He said he would send me some DVDs of his work and watching them made me aware of seeing and hearing voices that are not often heard. There was a directness and trust in their expression that can be very difficult to establish. There were young men talking about what boxing meant to them and young women from Bangladeshi backgrounds sharing the need to have their own spaces and keep something of their identities separate from their mothers. Somehow Dave showed the importance of the quality of trust and relationship that allowed people to find their own voices. He had been able to reach people from different communities and allowed them to explore their own thoughts and feelings about how life had been changing in East Leeds and how this is experienced differently by different generations. The conflicts that young people had to deal with in their everyday lives and the difficulties of somehow making a break from your mates to explore a life that was separate from drugs and gangs on the estates were made visible. Using drama he had discovered ways of exploring issues around domestic violence. There was also something complete in the meeting we had that day and I found myself wanting to sit quietly and write up what had already come up. I was struck by the resonance that Dave could set up, partly because he had shared a similar background and knew where people were coming from. This added, rather than compromised the professionalism of his work. He had discovered ways of working *with* young people so that they felt a sense of project ownership.

Dreams

Sometimes working-class boys will have their dreams but they cannot really believe – given the areas they are growing up in and the material circumstances of their lives – that these dreams can ever be realised. This is why a culture of aspiration has to be carefully grounded through the details of everyday life. They have their dreams but they do not imagine that their dreams can ever be realised – a dream remains just that, a dream. In conversation with Dave, I was struck by his saying that he asked young men and women he was working with in a working-class district in Leeds what their dreams were when they were children in *When I Was a Kid I Used to Dream* (**DVD clip / section 3 / 13.1**). Through dreams he had found

access to a particular quality of experience. Though we might talk about them as 'working class' they are really part of a white underclass, whose whiteness is significant to them given the ways they define themselves in a rapidly changing community. They have often grown up in families where adults are not employed because of the scarcity of traditional jobs.

Dave points out that their lives and attitudes began to change about six months before the project, during which time about a third of the population changed within an influx of people seeking asylum. The estate is one of the most deprived within the UK. The impact of regeneration may have provided new flats for the middle classes and infrastructure for business, but the estate continues to have a lack of infrastructure, decent living conditions, education and job opportunities. This was the context in which he asked young people about their dreams. The changing context of the estate is explored in the documentary *Over to the East* in which different generations of people share their very different responses to these rapid changes. Some people point out how schools and shops had been taken away and vacant areas left in the area so that the authorities had taken away their community. There was anger about this, it also a sense of resignation.

But there was also an awareness of how young people from different communities had married and had children together and even if they had divorced, there was a sense of an acceptance of partners and new families. There were voices of young men who expressed their anger through a hatred of people who had invaded 'their' territory and a sense of how territorial identities remain very significant, particularly with young men in a changing environment. Even though they might deny they are racists because they had mates who were mixed race, you got a sense of what was motivating support for the British National Party in some Northern towns and cities. It was as if young men felt some kind of obligation to carry the anger for the larger community. But there were other, more hopeful voices, where younger people talked more positively about experiences of diversity and difference. It seemed as if language remained a significant barrier for many and they expected new migrants to make an effort to learn English.

Talking about dreams was a way of getting through to young people. It was a question, as he explained, that was surprising to them too because it touched something so often safely hidden away. They would often talk about when they were younger, say 8, 10, 12 or 14, as if this was the time when they still had dreams though it feels like a long time back. Some explained how their dreams had been knocked out of them, others how they were obliged to give up dreams that proved impossible. Some dreamed of being footballers and some made attempts in this direction. Some felt that they could have made it if they had stuck with it but the pull of their mates

Still from When I Was a Kid I Used to Dream

on the estate and the life of drugs and petty crime proved too strong. Some were left with 'what could have been' if they had persisted.

It seemed as if setbacks were difficult to deal with, as if they are particularly threatening to these young men who have few opportunities for regular employment that would have traditionally sustained their male identities. There is something very precarious in their masculinities that remain important because there are few other sources of respect and self-worth. It can feel just too threatening to try again and risk further failure. It seems much easier not to try at all because at least you cannot fail. One young man who wanted to be a boxer and gave up after losing a fight acknowledged that he should have gone on and could have 'made it'. Others had been obliged to test their dreams against reality and had to realise that they did not have the skills they needed and had to make compromises. Dave mentioned that one boy admitted that he always dreams of being a fireman but that this was an impossible dream from his background, or at least was felt to be. But it was a dream that he could still remember and in some ways it had lived with him, even though he had never really talked about it.

197

What he mostly ended up doing was stealing cars. He would set light to cars that he had stolen and the firemen would often come to put down the blaze. At least he could witness what they were doing and so in some way, participate in his longstanding dream. A film in which people could witness themselves sharing their dreams has a particular intimacy and sets down a marker for others who could 'see' what they dreamed of doing on the screen. In this way they could gain a sense of self-recognition and a sense that at least they *mattered* in that moment. They could see representations of the estate and they could see themselves on the screen. They could see that they 'had made a splash' and that people were forced 'to take notice.' As the cars were burnt and went up in flames, he could see himself – and others could imagine him – standing with the firemen, almost as if he had somehow become one of them. It was as if his dream had been realised at least in that moment and what he had talked about on the film as his dream had, after all, become a kind of reality. It was living testimony that at least in some sense, dreams can become true. Even if this is not shown on screen these kinds of connections can be made in imagination.

It was as if time had stopped for a moment and he could watch his dream in action. It was a moment when others were forced to stop and 'take notice' before the recriminations, blaming and shamings came into play. At least for a moment he was allowed to stand in the warm glow of the fire. He could see himself on the screen, as could others on the estate. It was a moment of fame within a celebrity culture. They could see themselves on the screen as others would also see them. They had been part of their own project and they had staged the scene for the film. In a life in which they so often felt powerless, it was a moment when they could help shape the present of the film. Visual images have become so significant within contemporary culture and they provide a language through which young people learn to relate to each other. This makes new media a powerful source for creating dialogues across differences and so creating bridges not only between different communities and generations but that also show the transcultural, complex inheritances of many young people as they shape new hybrid everyday identities that draw on a diversity of cultural resources.[7]

Dave as the filmmaker was concerned to enlist them and *work with them* in defining the project. Of course it took time for him to get their agreement to collaborate with him, and they would initially test him to prove that he was not a fake or was not just out to use them for his own purposes. The fact that he lived locally and knew the area well had made a difference. But as Dave readily acknowledges these young men are often powerful in themselves and there is a shine that is also theirs. They are known in the community and they have a point of attraction that has

earned them the respect of others in their world – a world in which there are clear rules about how you earn the respect of others and how you become a 'big man' in the area. Of course these young men are not often asked about their dreams and they do not expect to be listened too. It might be the first time in their lives that they felt, as they did with Dave, that he was genuinely interested in what they had to say. It was quite a new experience for them to feel listened to. They appreciated that he was concerned to discover what they felt, thought and dreamt. This reflects a particular kind of hunger for recognition and respect that needs to be acknowledged if people are to work effectively with new media.[8]

Drama

Dave also talked about how in the past, he had worked extensively in male prisons in the North, creating drama through which issues related to men and masculinities were explored. In a more recent film he worked on, he drew upon his own memory of sharing experiences with a prisoner when a new recruit joined this prisoner in his cell (**DVD clip / section 3 / 13.2**). He ordered him to lie down on the floor. 'Why?... Because I told you.' It was an assertion of power and control. 'Lie on the floor and do it now or else.' This use of violence as a way of affirming a particular classed masculinity had become second nature for Dave in his early life, as it had done with the majority of men he had worked with. He knew this from the inside so that it was an embodied history that he could draw upon when he made a film that included a scene of a young man being told what to do to show who was the boss in the cell. There was only one man who could be in control and this exercise proved who it was going to be. This was a ritualised expression of the ways masculinities can be framed hierarchically. The drama opened up a *space of reflection* about a particular male experience and the masculinities men tacitly conform to.

Dave talked about the sharing that went on his early drama work with prison groups and the time that it took for men to establish trust and open up emotionally with each other and to him. So often histories of violence were revealed and physical abuse particularly in relationships with fathers. It seemed as if fathers felt particularly challenged by the behaviours of their sons and expected themselves to act as figures of authority who had a duty to impose discipline. But in the background there seemed to be little experience of communication across generations so that fathers would find themselves resorting to physical violence, as if this was the only way they felt they could 'get through' to their sons. There were also narratives of sexual abuse that was going on in families. Often men were carrying silently these traumatic histories of abuse they could not talk about without feeling further shamed. They felt they could not ask for help without losing face in front of their mates.

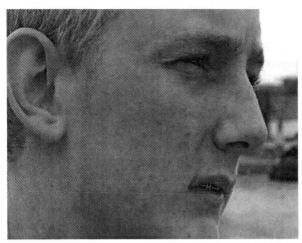
Still from When I Was a Kid I Used to Dream

The atmosphere deepened as men find the courage to talk about some of these events in the drama. People paid attention to each other and there was often mutual recognition as people found words to talk about events and situations that had seemed unspeakable for so long. It was as if a burden was being lifted as people talked and felt listened too. Somehow men felt less lonely and isolated as they were no longer obliged to carry these painful personal histories on their own. Somehow telling the stories to each other was a way of 'letting go' of what had been carried for so long. They felt lighter and somehow more able to communicate more of themselves. The bond created through the sharing was tangible and the pride that people could take in the drama was a source of self-respect.

Weight
What does it mean to be weighed down by a shamed history of physical and sexual abuse that you have never felt able to talk about? This is something that many men from diverse class, 'race' and ethnic backgrounds know about from their own experience. Young men often learn that these experiences are to remain unspoken since they threaten to bring further shame. They become interpreted as signs of weakness that can so easily be used as weapons against you. It can be hard enough to maintain your position in relation to other men so that you often learn to maintain tight boundaries around what can be spoken. It is difficult to not feel at some level that it must have been your fault so that you carry responsibility as a kind of stain that cannot easily be removed. There is a sense that 'real men' do not allow themselves to be abused or touched up and that at some level you must have 'asked for it.' So this become a shame that men try to forget about, but as Freud recognises it takes considerable libidinal energy to

maintain such forgettings.[9] Men can chose to place these memories in a past that is over and they can learn to 'put the past behind them' so that at some level, they cease to exist in the present. But they have a tendency to haunt the present and men can feel a tension about keeping what is past firmly enclosed in ways that do not allow painful memories to leak into the present.

Men learn to carry experiences of abuse and violence as if they have not really happened or in any case cannot really be talked about with others. It is part of what can turn men inwards towards themselves and make them inaccessible emotionally to others. They carry these silent burdens that seem to weigh them down emotionally and they refuse to talk about them because they threaten to disturb the 'front' that they seek to maintain in front of others. The past becomes firmly closed off as best it can and it can seem to become inaccessible to people themselves who can feel speechless, as if unable to connect to histories and experiences that have been split off to exist in tight realm of their own. As people learn to keep these painful histories to themselves they do not think of them as even potentially shareable with others. Rather it is as if these abusive experiences never happened at all even if at some level there is a fear that they might be 'found out' so exposing a man to ridicule and being put down. As silenced histories they can help to tighten the front men learn to present to the world. There is often an aura of violence that seems to surround them that can work to keep others at a distance and make it difficult to ask questions that might not be welcomed. It blocks the possibility of 'going there' even if people want to think they are willing to speak more openly about the emotional histories they carry.

Freud talks about the 'emotional work' that people have to do in order to gain more access to themselves. He draws on special metaphors that have paradoxically become part of everyday discourse when people talk about 'not wanting to go there' when they do not want to open up certain topics of conversation. For men there is often a particular fear of 'weakness' that can be linked to humiliation and so losing face in front of others. This is framed differently depending upon class, 'race' and ethnic backgrounds but there are anxieties in relation to sustaining masculinities that can flow across these differences. It is partly because masculinities cannot be taken for granted but have to be constantly proved that men can be left feeling vulnerable in ways they often want to deny. They can be heavily invested in thinking that they are 'in control' of their experience and so thereby in control of their lives. This can also connect to a tendency to 'make light' of these painful experiences as if they did not really hurt and as if 'it was nothing really'. In minimising the hidden injuries men can often feel they can sustain a sense of self-respect. Men can be so trained to blocking out painful memories of the past and splitting the past from life

as it is being lived in the present that they block access to their own lived experience.[10]

Through working together in a group setting and listening to what other young men have to say around a project of preparing a drama that might be used in a video they are making together, there is a certain distance that is allowed by the idea of a 'project' that makes the situation less threatening. The task they are planning for allows this distance, while the sharing in the group allows for identifications that can help young men open up to their own painful histories of abuse and violence. It allows young men to realise that they are not alone and that others have been carrying similar experiences. In first listening to what others have to say they can given themselves permission to share experiences that would otherwise be safely locked away.[11]

Rather than feeling shamed and so withdrawn they can begin to make connections with some of the experiences they have been carrying in silence. Reflecting a generational shift within working class masculinities they can also acknowledge, in a way that their fathers might have found it hard to do, that it is harmful 'to bottle things up' and that it can be helpful 'to get something off your chest.' They can allow themselves to feel less burdened and they can allow themselves to offload some of the weight they are carrying. Often the fact that they are working towards a video project that allows them to value the different skills and contributions they can individually make also shows them that their painful experiences can be used towards a positive purpose.

Recognising their own experience in what other young men are saying about themselves also breaks a feeling of isolation and loneliness. They might hold themselves less tightly and learn to take less refuge in their 'front' that they customarily use to block others out. They might learn to identify different levels of their experience and to acknowledge emotions that they would otherwise experience as signs of weakness. As they find the courage to share more of themselves so they also feel more connected to other young men they are working together with on the project. Making a video together and outlining the drama allows them to feel that their personal histories can be drawn on impersonally to produce something of value. In this way they learn to value their own experienced as a resource and can feel less burdened by the emotional weight they carry from their pasts. As long as relationships with other men are potentially framed as a conflict between 'you' and 'them' as to who can prove themselves to have 'more bottle' you will constantly have to be 'on guard' to prove your masculinity. Nobody will be allowed to 'take the piss and get away with it.' Often this adds a tension to relationships between young men especially if they are not mates or part of the same gang. The world comes to be divided between 'them' and 'us' often on the basis of shared local territory.

It is through claims to territory that esteem and value are established.

As young men find there are fewer opportunities for work that has traditionally sustained working class masculinities they seem more reliant on control over territory to affirm potentially threatened masculinities. This makes the marking of urban multicultures harder to produce and we discover that different ethnic groups can feel obliged to live in segregated communities.

Sometimes working on a video project can be a way of crossing boundaries of territory and encouraging young men to create spaces of reflection in which they can explore difficult emotions that they have been silently carrying as a burden. Rather than being 'weighed down' by a past that is closed off and sealed away, there is a movement between reflections around the past and scenes that are being planned for videos in the present. Not does the video provide an impersonal space for reflection but it allows young men to explore a relationship with their inner emotional resources. It can produce a spaces of safety in which young men can feel less threatened in their emotional expressions because there is an impersonal task at hand.

Transformative moments

Within a neo-liberal appraisal culture that is organised around academic qualifications it can difficult to value the skills that youth workers need to work effectively with young people.[12] This is working to exclude people with vital class experience from careers, for example as drug consellors, psychotherapists, youth workers because they might not have relevant paper qualifications. Often we underestimate the emotional work and intelligence required for youth workers to develop capacities within themselves for them to be able to work well. Unless you can be honest and open with yourself you cannot be honest with others. This is much more easily said than done and involves people in these fields learning *how* to work on themselves. Young people are often exceptionally attuned to recognising falsity and untruth. They will just 'turn off'. Often they do not want to be told what to do, but if a relationship of trust is to be created, they need to know that people are clear about where they are coming from. There is no substitute for youth workers doing the emotional work themselves for *only* then can they have a sense of where the young people are 'coming from emotionally'. Through video they can help to create an impersonal space for reflection in which young people can begin to trust in their own abilities and skills that might not be valued within traditional educational systems.

Often it can be difficult for young people to recognise they are being listened to, because this can be a completely new experience as it is for them to recognise that they have something of value to contribute. If they

have had abusive family histories it can be hard for them to make themselves vulnerable or to believe that they might have something to offer to a media project. Because people can be involved in different ways and because so many different kinds of skills are needed, there are spaces for different degrees of involvement and for young people to contribute in different ways. As they learn to work together so they begin to believe in themselves and learn that they can trust others to do what they have promised. In this way they can learn important life skills and ways of communicating more openly and honestly with others. They can say when they feel led down or when others have disappointed them without feelings so personally threatened themselves.

With the breakdown of traditional working class communities young people often learn to think of themselves in more individualistic terms. This can foster a recognition of individual differences and a sense that people can want very different things out of life. But this can make young men also particularly dependent on their mates and the gang cultures that are territorially based within inner city urban areas. People are less likely to assume that 'others' are very much like themselves and they can be curious to explore differences of culture, class, 'race' and ethnicities. Within the multicultural communities many young people are growing up in they learn to tolerate differences and can use video and new media in order to explore cultural and ethnic differences. This can help people to move across the boundaries of their own communities and to explore both what is shared and what is different in the ways that people live.

However, within a consumer culture of 'cool' it can be difficult for young men to explore different aspects of their experience or be open to their diverse sexual feelings. They can feel pressured to 'close down' as a means of self-protection so that their feelings and desires are not allowed to leak out beyond their control. But this can make them illegible to themselves as they find it difficult to name their own feelings or to relate in ways they would prefer to relate. Sometimes it is through dramatic constructions that people allow themselves to explore different aspects of self. They can identify with different positions and feel the possibility of different outcomes. They can get to know themselves in different ways. In the Hi8us North drama project 'The Bad Penny' young people are able to explore the dynamics of intimate relationships of 'boyfriend' and 'girlfriend' and issues of trust and betrayal between young men in a context where they feel under constant surveillance by the police on the estate.

Similarly in virtual spaces, young women for instance, explore their own experiences of being controlled physically and emotionally in their relationships with men and the domestic violence that follows. Even though the young men hardly appear in the video 'Under the Thumb,' their power is made visible and they can be made aware of their impact

through watching the drama young women have produced. As with self-harming they might find it impossible to talk about this directly with people they know, but the complex issues around it can be explored at one remove through new media. Within the impartial spaces of the Internet in chat rooms that bring together young men who self-harm they often find themselves capable of communicating in the ways they could not allow themselves in everyday life. In this way virtual spaces are not to be treated as 'unreal' spaces in which people can pretend to assume different identities, rather they are often provide spaces of reflection and exploration in which people can allow themselves to feel 'more themselves' than they can ordinarily. This is also true in relation to sexual identities in which, for example, gay men who might feel obliged to perform heteronormative masculinities in their everyday lives at work, might experience a sense of freedom and expression they cannot allow themselves in their work lives.

As young men allow themselves to explore different aspects of their experience through new media so they can sometimes begin to feel more at ease in their own skins. They can begin to identify what they might want for themselves as they explore different possibilities in a mediated form, say through video dramas. They might discover a language in which they can express more of what they want for themselves as they also clarify relationships and ways of being that they feel ready to reject or feel they have outgrown. As they become more accepting of themselves as men so they might question dominant masculinities and frame alternative visions of manhood. They might feel more open in straight and gay relationships as they feel more accepting of their sexualities and emotional lives. Dave was aware of just how much he had learnt as a heterosexual man working for a year with the theatre group Gay Sweatshop as they toured the country. It was an education into diverse masculinities and the possibilities of learning across sexual boundaries. It is still an experience that he finds himself drawing upon in his work with young men and gives him confidence in working around issues of sexuality.

As he is more in touch with his own experience and clearer about his emotional needs and desires, Dave feels more confident to bring different groups of men together with different class, 'racial' and ethnic backgrounds to explore concerns to do with their inherited masculinities and tensions this sets out for the ways they want to live and relate. Through drama and video he can explore places that young men might otherwise 'fear to go' directly but as trust is developed within the group they find that they can share more easily with each other. Not only does this help young men to live creatively with differences but it also can develop a curiosity about different ways of living. Young men come to value their own experience and feel less inclined to disown or rubbish what they

have lived through.

As they can begin to externalise some of these painful experiences and make use of them as sources of drama, film or video, so they can begin to feel more easily and accepting of themselves. If this is part of learning to live with differences it also helps to shape possibilities for future communities as a younger generation begin to take everyday multiculture for granted. Rather than feel threatened by difference/s they can learn to feel enriched by them as it seems to extent future possibilities available to them. As fear can give way to an appreciation of differences so young people no longer feel so fixed in given identities but can feel a sense of appreciation for the different skills and abilities that people bring into their collective projects.

Endnotes

[1] These reflections were stimulated by a really interesting discussion that I had with Dave Tomalin about the professional work that he is doing with Hi8us North in Leeds and is dedicated both to him and to all the young people he has worked with. Though I have regrets that I was never able to visit the projects in person as I had planned to do, I learnt so much from the detailed discussions that I had with Dave and the openness with which he shared some of his professional experience, that along with viewing the films he had produced with others he was working with, I felt that already many critical questions had been highlighted that others could really learn from.

[2] For some helpful reflections upon the changing multicultural shapings of diverse urban communities and the ways they suggest different ways of thinking about identity, history, community and diversity see for instance, Bhikhu Parekh *Rethinking Multiculturalism: Cultural Diversity and Political Theory* (Basingstoke, Palgrave, 2000); Paul Gilroy *There Ain't no Black in the Union Jack* (London: Unwin Hyman, 1987) and *After Empire: Multiculture or Postcolonial Melancholia* (London: Routledge, 2004) and Victor J. Seidler *Urban Fears and Global Terrors: Citizenship, Multiculture and Belongings* (London: Routledge, 2007).

[3] For some interesting reflections upon the ways in which generational relationships are shaped through the Internet and the kind of social networks that it allows young people to establish, see for instance, D. Coupland *Generation X: Tales for an Accelerated Culture* (London: Abacus,1992): H.P. Blossfeld, E. Klijzing, M.Mills and K. Kurz eds *Globalisation, Uncertainty and Youth in Society* (London: Routledge, 2005); A. Melucci *The Playing Self: Person and Meaning in the Planetary Society* (Cambridge: Cambridge University Press, 1996) and K. McDonald *Struggles For Subjectivity: Identity, Action and Youth Experience* (Cambridge: Cambridge University Press, 1999).

[4] I have explored the ways in which boys and young men are often left feeling bad about themselves so that they can feel they have to constantly prove that they are *not* 'good for nothing' and *so not* a 'waste of space' as features within a dominant Protestant culture that produces a culture of self-denial in *Recreating Sexual Politics: Men, Feminism and Politics* (London: Routledge, 1991) and more recently as a theme that is framed differently within diverse cultural and reli-

gious settings in *Young Men and Masculinities: Global Cultures and Intimate Lives*. (London: Zed Press, 2006).

[5] I have explored ways in which a fear of intimacy for young men is often associated with a fear of emotions that are deemed to be threatening to heterosexual masculinities in *Rediscovering Masculinity: Reason, Language and Sexuality* (London: Routledge, 1987) and more recently in *Man Enough: Embodying Masculinities* (London: Sage, 1999).

[6] Dave Tomalin has developed the Hi8us North project in Leeds that has worked over many years with developing media projects with young people in different communities and institutions. He works both through interviews and dramatic works that are developed with young people themselves. He works across different race and ethnic communities and across different genders.

[7] For some reflections upon the spatial dimensions of everyday life and on the negotiation of complex identities see, for instance, Les Back *New Ethnicities and Urban Culture* (London: UCL Press, 1996) and *The Art of Listening* (Oxford: Berg, 2007); M. de Certeau *The Practice of Everyday Life* (Berkeley:University of California Press, 1984); J. Bynner, E. Ferri and P. Shepherd eds *Twenty-Something in the 1990s: Getting On, Getting By, Getting Nowhere* (Aldershot: Ashgate, 1997); b.hooks *Yearnings: Race, Gender and Cultural Politics* (Boston: South End Press, 1991); N. Puwar *Space Invaders: Race, Gender and Bodies Out of Place* (Oxford: Berg, 2004); T. Modood and P. Werbner eds *The Politics of Multiculturalism in the New Europe: Racism, Identity and Community* (London: Zed Press, 1997).

[8] An interesting discussion that works from sources within the United States but which still has a lot to offer discussions of respect and inequality in Britain is offered in Richard Sennett *Respect: The Formation of Character in an Age of Inequality* (London: Penguin, 2004).

[9] For some helpful discussion on the ways that young men can often feel obliged to repress feelings and emotions that might be deemed to be threatening to their male identities and ways this is illuminated by Freud's work see, for instance, Stephen Frosh *Sexual Difference: Masculinity and Psychoanalysis* (London: Routledge,1994).

[10] For some discussion of how men often carry a depression that has been 'passed on' from their fathers and the emotional work that some men learn to do to release themselves from these unspoken family histories see, for instance, Terrence Real *I Don't Want to Talk About It: Overcoming the Secret Legacy of Male Depression* (New York: Random House, 1997) and his more recent *How Can I Get Through to You: Reconnecting Men and Women* (New York: Scribners, 2002).

[11] For some helpful work that is focused upon working with young men in different urban contexts see for instance, Niobe Way *Everyday Courage: The Lives and Stories of Urban Teenagers* (New York: NYU Press, 1998) and S.Frosh, A Phoenix and R. Pattman *Young Masculinities* (Basingstoke: Palgrave 2002) and Victor J. Seidler *Young Men and Masculinities* (London: Zed Books, 2006).

[12] For some reflections on appraisal culture and ways that it has developed in relation the entrepreneurial culture since the 1980s see, for instance, R. Keat and N. Abercrombie eds *Enterprise Culture* (London: Routledge, 1991) and P. Kelly 'The Entrepreneurial Self and 'Youth at-risk': Exploring the Horizons of Identity in the Twentieth Century.' Journal of Youth Studies, 9, 2006, 1, 17-32.

Section 4
Regeneration

Section 4: Regeneration

This section looks at the increasingly important relationship between regeneration and creativity. The creative industries are one of the fastest growing sectors of the economy and policy makers with responsibility for regeneration often look to the creative industries as a key economic driver. In the past two decades the UK has seen a multitude of different initiatives designed to stimulate growth in the creative industries. Colin Pons reflects on his personal experience as part of a team of people behind the development of the Cultural Industries Quarter in Sheffield, South Yorkshire.

Denzil Monk charts the economic decline of Cornwall and looks at the way regeneration funding has been used in the past five years. He contrasts earlier investment in prestigious capital projects intended to attract inward investment with the need to support production work by young people in their local communities. Finally, Tom Fleming draws on his considerable experience as a consultant and practitioner to chart the development of UK Creative Regeneration initiatives over the last ten years. He focuses on initiatives that have positioned the Creative Industries at their heart and the increasing significance of digitalisation within place-bound regeneration.

Chapter 14
Five Screens Short of a Load

Colin Pons

Introduction

Sheffield Independent Film (SIF) was established by a group of gradu-
ates from Sheffield City Polytechnic[1] in 1976 and operated from Walkley,
a residential district about four miles from the City Centre. It relocated to
central Sheffield in 1988 and moved into its current home in Brown Street
a year later. Throughout this time, SIF operated as a membership based
Company Limited by Guarantee and provided resources and business
support to filmmakers.

The 1990s saw the rapid growth a cultural quarter[2] in Sheffield and
in many ways SIF acted as a lynchpin for the development of one of the
strongest media economies outside London. Success was based on the
impetus provided by an entrepreneurial ability to use regeneration funds
and Lottery cash to draw in private sector investment to support produc-
tion. This was accompanied by the development of larger capital projects
such as the Showroom Cinema, the National Museum for Popular Music
and Live Arts.

In this period, SIF established a wholly owned subsidiary called the
Yorkshire Media Production Agency as a tool to finance production. This
grew rapidly to the point where it became the most important regional
production fund in England, financing a number of high-profile feature
films.

The two other major media beneficiaries were:

1) The Workstation, opened in 1993 to provide managed workspace for companies operating in the cultural and media industries.
2) The Showroom Cinema, opened in 1995 as a two-screen operation but extended into a four-screen operation in 1998.

In 1999 the newly established Film Council sought to bring a greater strategic coherence to regional support for film across England in line with the emerging Regional Development Agency agenda. Screen Yorkshire was established as the media development agency for Yorkshire and a number of plans for Sheffield were reconceived, principally ambitions for a 'Studio of the North'. One consequence of this realignment was that SIF was forced to retrench and restructure. YMPA/IMI is now an independent entity operating as an executive producer and SIF is focusing on the activity which originally bought it into being.

The original group of graduates behind SIF bought a pool of communally owned film equipment to create a resource for local filmmakers. This notion of access to provision remains central to SIF's ethos and the company works to meet needs across the filmmaking spectrum from professional work through support for new entrant to social inclusion based training. SIF has undergone many changes in the past 29 years but the fundamental sense of purpose behind the company remains in place and is simply captured in the Mission Statement. SIF works to

> provide professional support and services to practitioners and audiences of the moving image.

Colin Pons has worked with SIF since 1983 and this chapter is a personal reflection on the establishment of an important resource for filmmakers operating in a deprived area of England.

Sheffield in the '80s: Five Screens Short of a Load?

Its 1983 there are the beginnings of stirrings in a funny northern city that thinks it should have a piece of the UK media pie. The city and the sub region were trying to come to terms with the bleak out look of its post industrial future following the decimation of the coal and steel industries. In that year I was lucky enough to be booked as a camera assistant for two days so I travelled to that city, the city of Sheffield, and have been there ever since. The equipment I was assisting on came from an organisation called Sheffield Independent Film (SIF). By 1984 I was working as a technician for SIF and we were starting to cook our first deals with Alan Fountain and Caroline Spry at Channel 4. We were based in a crumbling two up two down in Walkley on the outskirts of Sheffield. After our first positive meeting with Channel 4 we (me and Hattie Coppard SIF's only other employee) went out and bought Filofaxes... we had made it as

212

media execs! One has to remember we did not know what we were doing and this was 1984!

As our relationship with Channel 4 built it was clear that part of our charm was we were a collectively owned organisation and our crumbling rented building still had an outside toilet. I remember prior to one winter meeting pouring hot water down the toilet so that it was not frozen for our visiting Channel 4 dignitaries. What we really had as part of SIF was a strong filmmaking community that included the groupings that became the two ACTT franchised workshops, Sheffield (women's) Film Co-op and Steel Bank Films each committed to producing an hour's worth of Television per year. Support from the two workshops and Channel 4 were the seeds of a systemic change for SIF.

At some point in the mid 1980s Channel 4 gave us an edit suite. We had to position it on the second floor safely away from the rising damp and from the leaking attic roof. We had to do something about our premises. After a temporary reprieve brought about by literally knocking a hole through into the next-door flat one Sunday morning, the problem became pressing again. I remember being really struck by one of the SIF members (yes members not customers or clients) commenting that the organisation had a 'poverty mentality'. Slowly we started to focus the membership and management committee on pulling the organisation forward at the same time as trying to keep the 'touchy feely' edges. I remember SIF bought its first Amstrad computer, to me this was a revelation and unleashed on our poor unsuspecting members waves of position and policy papers all suggesting the need for rather large-scale changes.

Thankfully all agreed that something had to change. God forbid but perhaps we were riding on the back of some of the ideological changes that were to lead up to New Labour thinking. We were, after all operating in the socialist republic of South Yorkshire. In tandem with all of this Sheffield City Council were starting to develop the notion of a Cultural Industries Quarter (CIQ) for the city. Some of my friends in theatre commented, 'what has happened to the other three quarters?' but generally the concept was well received by the cultural community in Sheffield. I also remember a lot of work lead by Sylvia Harvey being put into defining exactly what was meant by this new term 'Cultural Industries'. The CIQ was based around the newly established Red Tape recording studios, the only municipal recording studio in the country. The anti council headlines rang with 'Rock on the Rates' etc. etc. but the council through their Department of Employment and Economic Development (DEED) were determined to push on with the concept.

Red Tape was the first tenant of AVEC (the Audio-Visual Enterprise Centre). This was in the middle of a rundown area of the city close to both the Leadmill music venue and the main railway station. For our purposes

it was an attractive area of the city close to local and regional transport links etc. Initially we looked at a building at 77 Sydney St, which was then just outside a rather tightly focused CIQ. The contracting cutlery manufacturer Joseph Tyzak and Sons owned it but we got caught up in a restructuring of the company that resulted in all of its assets being frozen. Had the purchase gone ahead SIF would now have considerable equity in the building. That equity could have gone a long way towards building the organisation in future years but it was not to be.

What the bid to buy the premises had done however was to put the organisation firmly on the city councils radar. In 1987 we started negotiating with them on renting a 4,500 sq foot footprint within the AVEC building. We negotiated on an 'unimproved storage space basis' on a high section of the building that would allow us to build a second floor creating valuable extra space that we could rent out on an 'office space' basis. We planned two large offices for the franchised workshops and three start up or incubator spaces. All of this was new to us, land lording, start up spaces etc. There seemed to be no precedents in the rest of the country, no rules to go by, so we just made them up as we went along. It seemed to us that land lording was a good business to be in and that we could cross subsidise the rents on the start up units from the rents gained from the franchised workshops. Slowly SIF was moving in its thinking from a bunch of well intentioned filmmakers into forming itself into a business. We also appointed two co-ordinators, Hattie Coppard and Colin Pons! Later Hattie left and Suzanne Phillips joined me as co co-ordinator. At the time it was a big move for the organisation to have people who were more management than workers. In reality it was a false distinction as we only employed four people in total. The real power of SIF was and still is its membership. This membership volunteered to do everything from producing newsletters, to helping with accounts and projections, to eventually helping us to paint the building.

As we negotiated for the 4,500 sq. ft. footprint that would deliver nearly 9,000 sq. ft. of usable space it become clear that we needed to raise a considerable amount of cash to convert the building. This was the down side of renting 'unimproved storage space,' it was just that a roof and a floor and lots of empty space in between. Working with long suffering architects Tatlow Stancer we came up with a plan that gave us the studio space, edit suites and office space that we needed and a building firm that was prepared to build it within a tight budget. The question now was could we raise enough money? As I remember it the major assistance we got was from the British Film Institute (BFI), Sheffield City Council, Channel 4, a central government Industrial Improvement Area grant scheme and Yorkshire Arts. However even with pushing all of these organisations to the limits of their fiscal prowess we still did not have enough money.

Above: Opening of AVEC building site in 1988
Below: Colin Pons (left) with Michael Grade at SIF offices in summer 1989

Previously our bank had shown a willingness to lend on the 77 Sydney St building and so we approached them. The key difference this time was that we were not acquiring such an easily defined asset. We returned to our negotiations with Sheffield City Council and managed to extend the term of the lease, this gave the bank some comfort but not enough to lend us the all money that we needed. We knew it all stacked up and that it was a pretty safe bet and told the bank and all our funders so at every possible opportunity. To the bank we still looked like a 'friendly society' that was trying to make a change. I think to our funders we looked pretty ambitious. Alan Fountain once said, 'What you are trying to do here is to create a little bit of Soho in Sheffield'. I realised that if the bank wanted equity I had equity and it was in my house. I have always been blessed with a mouth the size of the Mersey Tunnel and had used it repeatedly to tell people how the plan could not fail and I believed it. I therefore had very few reservations about offering up a second charge on my house to secure the bank loan we needed.

Building work started in late 1988, cash flow was still a problem so we returned to our funders and played the 'if we can put our houses up you can cash flow us' line. The key problem was the requirement with some of the funding to put down hard cash prior to claiming that expenditure back. While I would not recommend that anyone put their house up to support an organisation like SIF, at that time it was certainly a good stunt to pull. All of our funders seemed very impressed by our determination and commitment. In particular through our main contact Irene White-head, Wilf Stevenson the then head of the BFI took an interest in what we were doing. Irene was about to leave the BFI and hand over to Carol Comley. With Wilf, Irene and Carol we came up with a scheme for Carol to loan, on a cash flow basis, almost her entire budget for the year to us. It was to be repaid in two tranches. We were very conscious of the damage we would do to other organisations if we messed up. We had no intention of messing up and made both repayments in full and on the agreed dates. The BFI had, at no extra cost to them, allowed us to go ahead. Sadly today I think it is unlikely that one would find a funder able to act in such an entrepreneurial way. Sheffield Independent Film opened the doors to its new building in February 1989.

Over the past few years we had become closer and closer with the people at DEED and became very linked to them in terms of progressing ideas for the development of the CIQ.

The next big idea for the CIQ was to develop the former Kennings car showroom but by this time the council was severely limited in what it was allowed to do and it was not able to develop the building in the way that it had developed AVEC. I returned from holiday later in 1989 to find that I had been appointed chair of a charity call SMEC (Sheffield Media and

Exhibition Centre). The Sheffield Star ran a front-page headline 'Arts Centre Scheme Mad Cap'. SMEC's ambitions encompassed the conversion of the Kennings building into a five screen cinema (The Showroom) and the building of some managed workspace for cultural industries companies (The Workstation). Given that I worked for a company called SIF chairing a company call SMEC seemed to make total sense! In reality much of what we had learned in the AVEC building was going to be applied to the development of SMEC and all its functions. I like to think I was appointed to chair of SMEC because I had a suit, brush up well and could be plonked convincingly in front of a bank manager. The reality was that the labour controlled City Council was increasingly being striped of its power by central government through rate capping and other such mechanisms. What SMEC needed to succeed was a profile that could gain cross party support. In a sense it was almost an anti political appointment.

Despite central government action one of the key drivers of all this activity continued to be DEED who together with a small group of 'believers' understood the project and stuck with it right the way through. To my recollection these were people like Ian Wild (now director of the Showroom), Matthew Conduit (one time director of both the Site Gallery and the Workstation and now a freelance consultant), Paul Skelton (key officer at DEED), Sylvia Harvey (academic at Sheffield Hallam University seconded to DEED), Chandran Owen (then voluntary finance director at SIF) and Phil Khorissandjian (Architect). Initially we talked the estates part of the Council into giving us a 115 year lease on the old Kennings building. In the old days that would have been offered at a peppercorn rent but that really was not possible at this time. We agreed to pay market rent for the unimproved building with a premium to secure the build of £500,000. The premium was deferred over a ten year period. In this way the council was able to help us but also to get the market value for the building that they were required to. Eventually what the city would get was one of the best creative industries centres in the country. Yet at this point the project was dependent on people like those listed above to deliver it.

Sylvia Harvey wrote copious papers that we presented to the city council about how Sheffield was disadvantaged by not having a broadcaster based in the city unlike its near neighbours Manchester, Nottingham and Leeds. Via presenting these papers I started to understand how the council worked and in 1991 accepted a years secondment to DEED to head up its Channel Five campaign. The point of the campaign was to attract the newly proposed Channel Five to locate in the city. Bradford and Liverpool also ran campaigns. In reality the key gain in Sheffield was to provide us with a Trojan Horse that could go deep into the council and gather support for a larger pallet of media development work like that surrounding the development of the Media and Exhibition Centre.

During my time at Sheffield City Council Sylvia Harvey and myself established within Sheffield City Council a media development unit leading to the establishment of a media development fund. Sylvia Harvey and Sue Lathan also did the development work to establish Yorkshire Screen Commission leading to Sue Lathan's appointment as the region's first screen commissioner and establishing England's second screen commission outside of London. Both were initiatives that were ground breaking on a national scale. At about this time, through working with the city council, I started to understand some of the levers that needed to be pulled to get new streams of money into the media development work. We needed to describe our work in industrial/widget terms, to talk about people as soft infrastructure and machines as hard infrastructure. This gave rise to the writing of yet more papers and applications, again lead by the indefatigable towering intellect of Sylvia Harvey. This process started to give us the beginnings of an understanding of the alchemy needed to interpret structural funding schemes such as ERDF (European Regional Development Fund) for media development benefit. Together with Roger Shannon over in Liverpool we were the pioneers in the country of unlocking ERDF for this purpose. ERDF has formed the bedrock of the funding for some of the Film Councils larger Regional Screen Agencies. By 1993 and back at SIF we had established the Sheffield and South Yorkshire Production Fund, with the magnificent sum of £70,000 to spend and surgeries every Wednesday afternoon to help people spend it!

After much planning in late 1989 SMEC finally launched itself. What we really did was to launch our fundraising activities. Our audience for the launch sat in the vast empty derelict cavern that was the Kennings car show room. At one end of this we had nine pieces of chipboard painted white behind a makeshift stage. Richard Attenbrough said what a 'wonderful, wonderful, wonderful' thing it was, Wilf Stevenson gave us a cheque for £150,000 from the BFI, I stood there smiling in a suit and Ian Wild, Matthew Conduit and the rest of the band of 'believers' rushed around keeping other potential funders warm (almost literally). The BFI support was key at a critical time and British Telecom and others soon followed them.

With the money raised we did not build a cinema, we built managed workspace. We used the 115 year lease we had from the council on the Kennings building to secure a £750,000 loan from the NatWest bank. We started fitting out the Workstation with lovely beech wood corridors that lead into unimproved workspace. Tenants came in and through a grant scheme that we had arranged got 50% of their fit out costs and a low rent. SIF expanded by building a suite of twelve offices to house production companies clustered around its 'development and production fund' that was now called Yorkshire Media Production Agency (YMPA). As tenants

moved on Paternoster (the subsidiary of the SMEC company that runs the Workstation) inherited a fully fitted building. Again we sought to use cross subsidy from land lording to support cultural activity. People were starting to understand the concept Wilf certainly did. It could at times however, be disappointing to realise that we had been working away for five years and still not delivered a cinema. It took a lot of nerve from people like the BFI to understand, support and trust our bigger plans. Eventually in March 1995 we opened the Showroom Cinema with just two screens. We were not to add the further three screens and café bar until the 26th March 1998. This was largely made possible by a grant from the newly formed National Lottery.

When the cinema opened screen one was equipped as a fully functioning preview theatre. Many of YMPA's productions have screened their rushes there. Other tenants of the workstation and users of the cinema and bar included Yorkshire Screen Commission, Sheffield International Documentary Festival, film production companies, photographers and designers. Perhaps, in addition to Alan Fountain's bit of Soho in Sheffield we have also created a cultural industries focused 'Bauhaus' in Sheffield. Certainly what we have managed to do over the last twenty years is to establish a cultural and creative nexus where previously one did not exist. The building represents a physical manifestation of much of the structural change that the Film Council is trying to implement through policy and through the Regional Screen Agency network. The housing and promotion of the vertically and laterally integrated elements needed to succeed in the Cultural Industries from Development through to Design and Production and into Exhibition has gained international recognition for the CIQ. To us it represents the aspiration not only to have a 'Bauhaus' of integrated practice in the north but also to have a 'power house' in the North!

Endnotes

[1] Now Sheffield Hallam University.

[2] Sheffield's Cultural Industries Quarter covers around three quarters of a mile in central Sheffield. It is now a partnership between the private and public sector and one of the largest cultural regeneration projects in Europe.

Chapter 15
Rural Revolution Through Digital Media
Joining the dots between geographically isolated communities: how digital media can empower young and marginalised people to have an equal voice in local and global communities

Denzil Monk

My chapter explores the upsurge of interest and investment in digital media in Cornwall over the last five years paying particular focus to the expansion of collaborative work between creative practitioners and young people. It is contextualised by the current framework of economic and community regeneration priorities at regional, national and European levels.

It examines the role digital media can (does) play in the regeneration of rural economies, depleted by the degeneration of traditional industries, and in understanding and improving community cohesion (high on UK and EU agendas).

As the technology needed to create media content becomes ever more accessible, with young people at the cutting edge of democratising content generation and consumption – it looks beyond the current cycle of short term funded projects, at how effective practices in developing more equal accessibility to the global media stage can be successfully and sustainably embedded in the delivery of community services in Cornwall, and how the best rural and urban models can be shared.

Roots
As a major producer of tin and important trading centre for thousands of years, Kernow (Cornwall) has been an outward looking, innovative and for much of its history an economically wealthy land, with strong traditional industries of farming, fishing and particularly mining. The significance of Cornish Mining has recently been recognised by UNESCO's designation in 2006 of World Heritage Site status to the Cornwall and West Devon mining landscape.

220

Cornwall pioneered the transfer of the British industrial revolution overseas and thus played a key role in the growth of a global capitalist economy.

Not only did the region dominate the world's output of copper, tin and arsenic, but the overall technological, social and economic contribution made by Cornish mining was crucial to the development of modern industrial society. The Cornish mining industry also played a leading role in the diffusion of both metal mining and steam technology around the globe. (Cornwall & Scilly HES 2006)

Metal ore production suffered from global market forces at the end of the nineteenth century, resulting in mass emigration, with nearly a fifth of the working population leaving Cornwall, many going overseas to escape the poverty that ensued, sending money to sustain their families back home.

Then in the twentieth century, fishing, agriculture and the dwindling extraction industries have suffered. In 1998 South Crofty, the last Cornish tin mine, closed.

New manufacturing industry has been attracted and this has helped to diversify the economy, although the manufacturing sector remains much smaller than in England and Wales. As a result, the range of job opportunities is generally more limited than in many other parts of

Kernow speaks its frustration

221

the country. The service sector has shown particularly strong growth in recent years and accounted for 75% of employees in 1998. (Cornwall County Council 2001)

Recently (2006) Cornwall's largest private sector employer, the China Clay firm Imerys announced 700 job cuts – a devastating blow to the St Austell area.

A blind faith in tourism over shadowed any sensible economic transition from these traditional industries and has left a Cornwall struggling to keep its head above the waves of second homers, folk retiring or relocating, and an aging population.

The reality is that Cornwall currently has the lowest Gross Value Added[1] in the UK (GVA per head £10,400 compared with UK average of £16,500) indicating a low level of economic activity. Cornwall has recorded the biggest house price rises over the past ten years with a 268% gain in the average price from £53,081 in 1996 to £195,388 in 2006 (£232,624 in Penwith – compared with the average wage of £19,760). 13,500 of these are second homes (nearly six per cent of homes, collectively worth about £3 billion.)

The lack of opportunities for young people presented by this situation creates a climate of low expectation, resentment and a steady migration of talent and entrepreneurialism out of Cornwall.

The frustration is expressed through graffiti on defunct shop windows, bridges and signs the length of Cornwall, calling for 'Proper Jobs, not Tourist Jobs' and 'Cornish Homes not Second Homes'.

With such a dynamic, prolific and profitable history, one can't help but wonder how things have got so bad and where Cornwall's wealth has gone?

- A capitalisation of profit from the efforts of many into the hands of a few;
- a heavy burden of taxation, disproportionate to inward investment in services;
- a historic debt to the monarchic system of perpetual inequality.

The Prince of Wales' 'investment income' from the Duchy of Cornwall in 2006-07 was £15 million, making him one of the UK's highest earners. The Duchy of Cornwall's assets, from which the Prince of Wales derives his 'investment income' has been provided over the centuries (since 1337) by the blood and sweat of Cornish communities, particularly Miners, who until the mid 19th century, being considered 'foreigners' paid double tax.

It would be a fitting tribute to the demise of this great traditional industry of the Cornish, that the birth of a new one – Cornwall's Creative Industries – could be supported by such an investment income: £15 million in 2006-07.

Compared to the slice of Convergence[2] pie likely to be invested in the

sector, this would provide a significant investment: stimulating innovation, sowing seeds of creative social entrepreneurialism to help achieve a more stable economic balance.

The Duchy could continue to manage the estate, as a social enterprise, with profits invested in the *most deprived communities*, rather the *single most privileged man*. Whilst politically this may be contentious territory, economically (and ethically) the argument is infallible.

Objective One and digital media

The Creative Industries are acknowledged as a rapid growth sector in Cornwall where film, video and digital media, a key sub-sector, has been the focus of some investment from the pre-cursor to Convergence, Objective One.

When a proposal was put forward for the creation of a South West Film Studios, Cornwall County Council's Objective One programme director Bill Bawden said:

> This project has real potential to position Cornwall as a centre for filmmaking excellence, and will reinforce the opportunities being presented by another Objective One project, the Cornwall Film Fund, which is supporting film production in the county. This is all part and parcel of growing the arts sector in Cornwall.

Unfortunately for everyone, it was a scam. The man behind it, Alex Swan, fraudulently obtained nearly £2 million of Objective One funding to set up the ill-fated South West Film Studios, quickly dubbed 'Aggiewood' at St. Agnes in Cornwall.

It's not like it wasn't anticipated though. Whilst an incompetent decision was made 'for the good of Cornwall,' many Cornish filmmakers predicted the fate of the Studios, as did the Cornwall Film Fund itself plus an Objective One panel set up by the County Council to advise on creative industry projects, (neither of which were consulted until after an offer of the grant was made) not least because of allegations, widely known in the industry, against Alex Swan's previous exploits.

Government Office South West (GOSW), which administered the Objective One grant said, 'some members of the panel were consulted'.

> An investigation by BBC Inside Out programme has revealed Mr Swan's previous film Spider Republic was abandoned with the crew and suppliers owed more than £300,000. Director of photography Sean Bobbitt said: "It's fair to say that he misled the crew about the true financial state of the production."
> Mr Swan was later cleared by the Department for Trade and Industry of wrongful trading and no action was taken. (BBC Inside Out 2005)

In a statement issued by GOSW, they were obviously still under the

charms of the conman when stating that, 'Concerns about Spider Republic's collapse *were not considered sufficient to withhold the grant.'*

Cornwall Film Fund's Chair, Charles Denton, former BBC TV Head of Drama and Chair of independent producers' association PACT, who had just finished his term of office as Chair of the Arts Council of England Film Panel and a board member of its successor, the UK Film Council, personally appealed to GOSW not to grant the money on the basis that the project was not viable.

> GOSW were clearly minded to withdraw the offer but the threat of legal action by Swan to reclaim costs incurred since the offer was made caused them to stick with the grant despite knowing it was, in the opinion of industry experts, flawed. (Rogers 2007)

Does this reflect the inefficacy of Government consultation, or just evidence that quiet words behind closed doors with selected individuals does not constitute a legitimate advisory panel? Who is speaking on behalf of whose interests?

Fast forward to Truro Crown Court, Spring 2007. Alex Swan, 44, of Kensington Mall, London, admits to four charges of forgery and seven of obtaining money by deception.

> Mr Thomas Kark, defending, said: "My client was not trying to line his own pockets but was motivated by a passion for film and a passion for this project."
> But Judge Philip Wassall: "You must have realised you would have to embark upon a sophisticated and deliberate fraud and you took that route from the start and everything that has stemmed from it was entirely foreseeable."

Whilst £2 million was wasted on a big idea with a rotten core, only half a million was actually invested in developing the Cornish Media Industry, through the Cornwall Film Fund (2002-04). A further £1.9 million investment of public and private funding in Cornwall's media industry has been stimulated since 2005, by the Cornwall Film AVIS-D project (the second phase of the Film Fund), but this falls far short of the potential for production development and industry growth anticipated. Several other media development projects never got Objective One funding simply because the lion's share had been given to the film studios. The Aggiewood legacy haunts the Cornish media sector.

Convergence & the knowledge based economy
Cornwall is in the unenviable position of receiving a programme of economic adjustment through targeted investments intended to bring it up to the level of its European peers. These ESF and ERDF structural funds constitute Convergence.

With 'Aggiewood' down the swanny, how does the future look for support from Convergence for media developments in Cornwall, and what opportunities will any such investments generate for young people?

The South West Regional Development Agency (RDA) are heading the management of Cornwall and the Isles of Scilly's Convergence Programme, worth in the region of £440 million. Though Convergence only equates to seven per cent Cornwall's annual GVA over seven years (or approximately one per cent per year) it represents a significant opportunity for investment in activity to provide catalytic change. Thoughtful, strategic, visionary decisions will need to be made.

With the Lisbon Agenda, the EU set itself the goal of becoming 'the most competitive and dynamic knowledge based economy (KBE) in the world'. On this 'fantasy island'[3] Her Majesty's Government dreams of Britain becoming KBE central and at the RDA, the Lisbon rhetoric permeates draft Convergence Operational Programmes (a target has been set that at least 60% of investments must contribute to fulfilling the Lisbon Agenda). Accordingly, strategic plans to develop an exemplar KBE in Cornwall abound.

Past plans for securing Cornwall's bright future from tourism have matured into an economy over-dependent on a low-skilled, low-waged, low-prospects service industry. The Objective One Partnership concludes that 'we do not have a skills profile of a modern and more competitive economy and this is a major constraint on economic growth' (Kelemen 2007: 1).

> "In the future skills will be a key route to prosperity and jobs," explains Geoff Hale, Chair of the ESF Implementation Group. "The Convergence ESF programme will play a vital role in supporting the economic transformation agenda by helping people to change their lives through learning."
> This means that there will be considerable investment, over and above the mainstream in the inter-linked skills themes of:
> - Moving the economically inactive of working age, whatever their challenges, into work; the voluntary and community sector should have an important role to play in helping people make the transition to work;
> - Young people – focusing both on young people not in education, employment or training and the promotion of enterprise and entrepreneurship in the 14-19 year age group;
> - Skills development in the workforce – raising workforce and business skills across all sectors – engaging with employers and employees in learning and training;
> - Higher education and skills – ensuring that the innovation agenda for the Cornish economy is driven from within the Combined Universities in Cornwall. (Objective One Partnership 2006: 2)

All well and good, but how does the rhetoric translate into reality? As far as developing the Cornish Media Industry is concerned, with decisions being made by an executive bitten by the Film Studios fiasco, the outlook is hazy, necessitating strong representation if the sector is to receive the support it needs to fulfil its growth potential. The RDA mentioned the word 'film' only once in their 144-page 2004 annual report ('Inward productions & film friendliness').

The entire agenda is driven by economic productivity mechanistically measured by short-term outputs hitting annual targets.

- Is this an effective measure of growth for a knowledge economy?
- Is it really possible to record creativity on a timesheet?
- Or measure innovation in increased turnover?

At the moment the call on local industry for work experience, placements, and eventually jobs, far outweighs the opportunities available. It is a case of selection or rejection – some people get through the door, others don't. This is currently what happens. In Cornwall the options are mostly either move 'up the line' or enter the badly paid, low job security, subsistence economy of the service industry, which underpins the Tourist Trade.

Cornwall County (*sic*) Council has recently been successful in its bid to become a Unitary Authority, creating a new system of local government which replaces the current one County, six Districts pattern. The idea of 'One Cornwall' reflects the old Cornish motto 'Onen Hag Oll' meaning 'One and All,' and may hearken the inevitable Cornish Assembly to a closer future. One and All certainly hope that the changes will rationalise the archaic systems that create unnecessary bureaucracy, and echoing the innovation of earlier centuries, create in its place a more efficient, dynamic, responsive and confident governance, rooted in the land and communities it serves.

So what opportunities can digital media offer young people entering the Cornish job market, trying to build themselves a life?

Shoots

The digital revolution has made media production accessible to children, young people and others who are economically disadvantaged. And there are a plenty of people who want their voices to be heard. Despite the loss of tin and copper, one commodity Cornwall still harbours is a rich seam of inspiration. Over the last five years there has been an exponential upsurge of digital media activity: shorts, features, youth media projects, artists, moving image, documenting and archiving, for big screens and small, festivals, broadcast, installations and web distribution.

This is by no means unique to Cornwall, however what is pertinent to this damaged rural economy is that the Cornish media community is growing significantly into a Cornish media *industry* with a huge potential

influence on its current trajectory for further growth. As the definition of media broadens and the potential of dispersed workplaces make Cornwall's geography a positive factor in establishing a new model of industrial growth (rather than being a barrier due to transport issues) the shape of this new industry is forming.

A feeling pervades the sector that retaining the sense of *community* is essential. Having a strong community foundation is paramount for Cornwall to create a distinctive and sustainable industry, a vibrant and dynamic knowledge economy. It's about supporting an environment, a climate in which creativity can flourish.

Collaboration or competition: Networking the networks
If government, business and communities work together, we can open up increasing opportunities for young people to communicate directly with each other, sharing ideas and experiences globally, celebrating local distinctiveness and dreaming together of the world they will co-create.

Digital media has an opportunity to play a major role in transforming the economic decline of Cornwall's traditional industries, echoing the innovation and dynamism of earlier centuries when mining was at its peak.

An integrated approach is necessary between media, youth arts and the intersecting youth media organisations – a 'convergence' to remove overlaps and plug gaps, to speak with a united and representative voice, to manage support and investments in the sector. I believe this can only work if we take a holistic approach, removing the socially conditioned barriers between the planning and delivery of youth media, community media and commercial media. Shifting from an economic to ecosophic[4] paradigm.

If Cornwall is to grow a sustainable media sector, an essential element in the proposed knowledge economy, then coherent, informed and substantial investments are required, based on the identified needs articulated from the ground up, not, as is traditionally the case, perceived needs informed by political agendas from the top down.

Youth media provision in Cornwall
Digital Media is being used to tell stories, explore ideas, engage young people and their communities, document projects, give voice to campaigns and share experiences across a wide range of settings in Cornwall.

Supported variously by Creative Partnerships[5], First Light[6], Neighbourhood Renewal and other community regeneration, youth engagement, arts and heritage funds, the majority of this work has taken place with disaffected groups who for a variety of reasons are being failed by mainstream education. There is a strong social agenda driving this princi-

ple of 'inclusion', or 'reducing risk of exclusion' through media.

Recent surveys and mapping have shown an exponential growth in interest from young people in exploring their creativity through digital media. Accordingly, those whose remit is to provide services for young people have found media an immensely productive tool for engagement, for skills development and pathways to education and employment as well as to document and evaluate other provision in this and other sectors.

Two major pieces of regional youth arts provision research have recently been undertaken, in Cornwall by KEAP (Kernow Education Arts Partnership) on behalf of Cornwall Arts Partnership and a report commissioned by the Arts Council looking at provision across the South West for young people 'at risk'.

> Media is a new artform and there is a great surge in interest but there is a lack of organisational support except for the film festival. It is very splintered. There are developments now with Hi8us making an appointment in Cornwall and also Awen an emerging organisation which runs media projects with young people. (KEAP 2006)

The Arts and Young People at Risk Of Offending and/or Anti Social Behaviour report (Arts Council England 2005) highlights a shift in Arts Council's focus towards support for arts provision concentrating on re-inclusion and cites many examples of digital media projects as a means of engaging young people and helping them grow in confidence and skills and providing signposting into education or employment, or at least to take steps in that direction.

Film Clubs are springing up in Extended Schools and youth clubs and more and more young people everywhere are making their own media and sharing it online with friends.

Between the social inclusion agenda, investment in the sector and passionate enthusiasm, there is a growing sense that Digital Media is an integral part of Cornish culture and of growing importance to Cornwall's economic expansion. Nowhere is this cultural development more evident than in the emergence of Cornwall Film Festival – supporting and stimulating the Media Sector in an annual celebration of Cornish films.

Screen Actions
Since its inception in 2002, the Cornwall Film Festival has supported young people's involvement in the growing media industry, and over the last five years has progressively handed ownership of the young people's events to young people to organise and manage themselves, with support from Festival staff and specialist mentors.

In 2005, young people from three schools (Falmouth, Newquay Tretherras and Mullion) organised, programmed, marketed, stage man-

aged, presented, and evaluated the Young People's Film Festival. In 2006, young people from schools, youth groups and motivated young entrepreneurs from across Cornwall, inspired by the previous year's event, formed a steering committee to take the idea of the YPFF being 'by and for young people' to the next level. They branded the festival as Screen Actions (SA06) and took control, led by a very talented young film-maker – 17 year old Luke Martin.

> 'The Young People's Film Festival has returned for another year, and it's going to be bigger and better than ever before!
> Since 2003, the first day of the festival has traditionally been the Young People's Film Festival working in co-operation with young people – however – this year the young people have taken full control!
> We're revamping and improving on previous festivals, spreading the event over two days and will include a full feature length film, guest speakers, hands-on workshops (previous workshops have included – bluescreening, stop-frame animation, post-production digital effects, creating sound effects and making movies on mobile phones – this year's workshops are yet to be confirmed), an award ceremony and party. The festival becomes a buzzing venue for – learning, creativity, networking, sharing ideas, film discussions, meeting new people interested in film, workshops, training, career research, new opportunities and experiences... phew! All this and films made by you!' (Luke Martin, Director, Screen Actions 2006)

Screen Actions 07 (**DVD clip / section 4 / 15.1**) is being organised by an even wider collective of young people, and as it becomes a stronger, more stable organisation, is branching out to meet other young people's media groups that are growing across the South West, like Club Flix (supported by Suited & Booted in Bath) the Young People's Film Council (supported by the Engine Room, Somerset) and Chew TV (supported by RiO, SW Screen, Cornwall Film, TwoFour and Hi8us).

Together, this Youth Media Collective is working to raise aspirations, self esteem, a positive cultural presence, economic sustainability, community engagement; raising the holistic quality bar of digital media projects – expounding a sensitive, process led approach to production, distribution and marketing of youth media content.

Chew TV – a communication channel for a connected generation

Chew TV is a pioneering youth broadband channel run by and for young people. This cutting edge project aims not only to provide exciting entertainment and communication possibilities for young people via the Web, but also to enable further networking between young people, their peers and the media industry.

Chew TV is an Internet TV channel for young people that is relevant (run by young people), quality (programmed and moderated) and has a

conscience (socially responsible and proactive). It shares a lot in common with the UK Sound TV broadband channel in East London which developed and operated as part of the Inclusion Through Media programme.

Rights Bytes

Rights Bytes is an ambitious project, with the simple aim of creating a cultural dialogue between young people across the world, using digital media to share perceptions and interpretations of their rights as enshrined in the International Convention of the Rights of the Child (CRC).

Children and young people work over four days of workshops with a specific article from CRC to explore how their rights are protected in their local community, region or country and what the article means to them. Filmmakers, digital artists and other creative practitioners support the young people to find creative ways to communicate these thoughts and feelings using moving image and sound.

Cornwall Children's Services are a key partner in the Rights Bytes pilot project, ensuring a dynamic and practical embedding of the convention in the services provided to children and young people in Cornwall. We hope to work with similar partnerships between local government, creative media organisations, and community workers in other parts of the world to make sure children's voices are articulated – the adult world communicating *with*, not *at* young people (**DVD clip / section 4 / 15.2**).

FilmSchool

FilmSchool is an acclaimed annual project running at Cornwall College with first year students on the BTEC National Diploma in Media Studies. It gives students an opportunity to work with and be part of a professional production team. This unique project runs for ten days in which students are challenged to their limits. Each student has to create an original idea to pitch to the group. The most popular (and achievable) idea is developed by the group into a step outline and then script. Once the script is written the group designate roles and move into production. Post begins after the first day of shooting, one team logging and capturing, whilst others shoot remaining scenes. A rough assembly is cut on a bank of computers reading from a server and compiled onto one timeline for completion. Music students create a soundtrack and sound effects, and journalism students put a write up in the local paper as the production is happening. The completed film, supported by a range of marketing tools, is then screened and pitched to a panel of media professionals. This project is invaluable in providing students with a realistic experience of working on set, in a team and to deadline (**DVD clip / section 4 / 15.3**).

These are just a few of the many examples of projects, which have been running over recent years. What began as disconnected single film projects

FilmSchool, 2007

has grown into thematic series, linking schools through intergenerational projects, exploring interactive and live performance digital expressions as well as music videos, documentary and dramatic forms.

> Creative Partnerships is exploring the potential of young people led activity especially in the medium of film and digital arts. This is raising expectations and opportunities, which would have been unheard of ten years ago. However, Creative Partnerships as a government research programme is unlikely to be funded in Cornwall after 2008 and yet their legacy needs to be sustained and the learning disseminated to a wider audience. (KEAP 2006)

RiO is a Community Interest Company[7] (CIC) which has grown out of Creative Partnerships, who are investing in creativity and change in communities and schools; Hi8us Cornwall is providing expertise and connectivity between young people and industry, local and global, engaging and supporting young people, through creative and entrepreneurial media projects; M-MAD in North Cornwall and Awen productions in the West (both also CICs) are working on the ground with communities, using digital media to promote social change – empowering marginalised

voices and widening participation in media.

Young people's expectations heighten with each experience, and the emerging professionals of a decade from now will have been making films and animations, and sharing them online since they were five years old.

There are many fantastic opportunities in education, from Penpol Primary School, where the Year Sixes learn Final Cut Pro and Flash, green screening, stop-frame animation, storytelling and performance skills – to University College Falmouth offering esteemed undergraduate and post-graduate courses in broadcasting and production.

It is essential that provision is also provided for those who are not fortunate enough to be in the right place or at the right time in their lives to benefit from these exemplars and to have a coordination of opportunities outside of mainstream education as well as better signposting within.

Hi8us Cornwall and Media Centre for Cornwall supported fifteen trainee placements on two micro-budget features funded through Cornwall Film's Target Talent scheme in early 2007. These combined opportunities raise the profile and the skills level of the local industry, helping nurture new talent and future entrepreneurs (**DVD clip / section 4 / 15.4**).

What is needed now is an integrated youth media service offering op-

Target Talent Trainees shooting on location

portunities for young people to engage in media projects, learn new skills, express creativity and explore pathways into the media industry through work placements, signposting to education and training and through individual mentoring support. If this service can be closely tied to industry, this will vastly increase opportunities for progression into work.

Digital seeds

It is an exciting time and an expressive time, a time for change and a time for reflection. It's also a long movement. Short-term mechanistic valued targets not only fail to see the bigger picture, they destroy it even before it's begun to form.

Gordon Brown is 'trying his utmost' to provide meaningful Education for All, so if the offer to our youth is to connect with and grow into enterprising industry, if these learning opportunities are to turn into jobs, if the creative stimulation is to bring about real economic transformation, then substantial, timely and accurate investments will need to be made. This will require decision makers to 'think out of the (media) box'.

Phil McVey, Head of European Programmes, in the 'Towards Convergence Newsletter 19' outlines the RDA's priorities as

> a focus on making those investments that will bring about real economic transformation across Cornwall and the Isles of Scilly. In this prioritisation process the key question for us all will not be "Is it eligible?" but "Is it good enough?"

But what does investing in 'real economic transformation' really mean? And what criteria are being used to determine what is 'good enough'? Time will tell, and history will no doubt judge with the benefit of hindsight.

Trading on its eco-lifestyle brand, Cornwall should become a leader in sustainable media production – and young people's media is where the future lies. I would like to see brave, risky ideas supported – innovation that breaks the mould of investment models based on extending airports, widening roads and erecting big buildings; experimentation that surprises the world and makes it a better place for everyone to live; communication networks which strengthen communities.

Cornwall suffers from geographical isolation because of its distance from centres of economic power, which control models of investment that were designed to fit an urban model of regeneration. In Cornwall, as with other rurally dispersed regions, you cannot point to a singular place, building, city or village and say, 'this is the heart of our industry, the centre or hub from which spokes of activity radiate'. Rather, threads of communities dispersed across the whole region, connecting like an invisible mycelium,[8] weave a tapestry of activity, which amounts to a far greater

whole than the sum of its parts.

In an urban-centric digital world, it is imperative that young people growing up in rural communities are given the same opportunities as their city dwelling peers to express themselves and participate in the shrinking cultural e-scape and to bridge the rural/urban divide.

I believe it is time for the approach to communication between 'those identified as in need of support and 'those who find themselves in a position to administer this help' to evolve to a more directly organised approach. The current hierarchy of administrative systems which attend first to self-preservation, then to meticulous examination of auditable systems, and eventually after a long list of priorities, to analysing distant data which has been accumulated along the way is no longer relevant to the world we want to live in.

On another planet, real people are trying to help other real people fulfil their dreams and contribute to the life of their community, whether that community is local or global or any defined region in-between.

'Cultivate' is a grass roots change programme being piloted by RiO in East Cornwall with the aim to

> demonstrate how meaningful cultural infrastructure can be created from the ground up, increase recognition of the importance of creative and cultural value and develop new models of governance and resources for this activity [to] develop stronger, more connected and better quality creative and cultural opportunities for young people. (Smith 2007)

Self-determined young people, supported by equally determined professionals, are already organising their own film festivals and other events, opening doors to progression paths, making contacts with industry operating locally and globally, they are running a web TV channel (www. chewtv.com) making and sharing content, hosting workshops, marketing themselves and networking with a global community/marketplace (depending on your perspective). These exciting developments have struggled into existence through a fragmented, disingenuous and practically un-navigable system of funding. We owe it to the efforts of future generations to wise-up to what is working and support it whilst the opportunities are there. Our future's history will be a collaboratively authored wiki, originated by its users – we are writing it now.

Remember the Lisbon Agenda, to become '…the most competitive and dynamic KBE in the world.' What about, 'the most *cooperative* and dynamic KBE in the world'? Well, 'most cooperative' is by definition an oxymoron. So maybe we could aim to become simply 'a globally cooperative and dynamic KBE'? This is surely moving towards *'an inclusive and environmentally smart business model'* (Kelemen 2007: 2).

A wisdom-based ecology

And if we are to integrate the traditionally antagonistic economic and ecological priorities into a sustainable carbon neutral strategy, then eco-sophically thinking through the economic concerns must be subsumed as an essential element of our social ecology. And if this paradigm shift happens, then knowledge can be applied with wisdom and we could truly begin to live in a wisdom-based ecology.

Digital media certainly has an important role to play in communicating this future shift through peer-to-peer synaptic pathways, unrestrained by the congestion of centralised filtering, a neural network connecting like-minded people, on-line or off-grid around the world. The intelligent network learns from itself and grows accordingly.

Maybe it's a revolution, maybe just devolution. As generations grow up in a global community, asking questions, demanding equality, co-creating balance, communicating effectively beyond a restricted mainstream media paradigm, there grows a natural, anarchic awakening, a mycelial movement of cultural change, evolution.

Endnotes

[1] Gross Value Added (GVA) is an indicator of economic prosperity.

[2] Cornwall and the Isles of Scilly are eligible for Convergence funding as 'a region with less than 75% of the EU average GVA (Gross Value Added). According to Eurostat Statistics published in January 2005 for the 3 years 2000-02, Cornwall and the Isles of Scilly was at 70% of the EU average GVA' (Objective One Partnership 2006).

[3] *Fantasy Island*, by Larry Elliott and Dan Atkinson, published by Constable UK.

[4] Arne Naess, who coined the term, described Ecosophy as a philosophy of ecological harmony or equilibrium.

[5] Creative Partnerships, active since 2002, is managed by Arts Council England and funded by DCMS and DfES.

[6] First Light Movies funds and inspires film projects with five to 18-year-olds throughout the UK (see www.firstlightmovies.com).

[7] Community Interest Companies (CICs) are limited companies, which conduct a business or other activity for community benefit, and not purely for private advantage. This is achieved by a 'community interest test' and 'asset lock,' which ensure that the CIC is established for community purposes and the assets and profits are dedicated to these purposes. Registration of a company as a CIC has to be approved by the Regulator who also has a continuing monitoring and enforcement role (see http://www.cicregulator.gov.uk).

[8] Mycelium is the vegetative part of a fungus, consisting of a loose network of branching, thread-like hyphae.

Chapter 16
Re-tooling the Creative Economy
New directions in creative regeneration

Tom Fleming

Place is the main driver of creativity in the UK. It is through the connectivity of specific infrastructural conditions in specific places that the creative industries gains its stimulation, inspiration, ideas and confidence; and it is through a direct engagement with combinations of infrastructure in place that the sector accesses opportunities for convergence, innovative partnership, and ultimately, competitive advantage. (CEP 2007: 5)

Introduction
This short chapter charts the development of UK Creative Regeneration initiatives over the last ten years. It focuses on initiatives that have positioned the Creative Industries at their heart to attend to those social, cultural and economic agendas that populate the overarching term 're-generation'. Building on recent work for the DCMS Creative Economy Programme, the chapter focuses on the increasing significance of digitalisation for creative production and consumption and explores the significance of this for place-bound Creative Regeneration where, in theory, digitalisation diminishes the significance of face-to-face relationships and bricks and mortar infrastructure. The chapter counters this widely held assumption. It shows how it is important to appreciate the distinctive role Creative Regeneration initiatives are playing in wider processes of 'creative place-making'. By this I refer to the significance (and potential increased significance) of initiatives in connecting otherwise divergent networks of individuals, organisations, businesses and institutions, thereby enabling new types of collaboration, conflating processes of production

and consumption, and brokering common purpose approaches to 'value' (for example with a corporate company and a community organisation able to extract value from the same process/intervention). A central theme here is the way(s) Creative Regeneration initiatives can establish innovative and progressive roles in an increasingly digitalised creative economy. The chapter focuses, for instance, on initiatives that explicitly embrace digitalisation as part of a fabric of place-focused creative infrastructure – such as through the Watershed in Bristol and the Lighthouse in Glasgow. Finally, the chapter will indicate the ways new sector trends are likely to place new demands on Creative Regeneration initiatives, and forecasts how such initiatives can establish themselves as digital innovators – creating new spaces and places for convergence, collaboration and innovation.

Critical here is understanding Creative Regeneration as a holistic concept, where a fabric of different approaches are required across a range of priorities – ranging from social cohesion to accelerating creative business growth. This understanding underpins the newly established 'Ten Infrastructural Conditions for a Competitive Creative Economy' introduced by the DCMS through their Creative Economy Programme. The vital units for this are communities and place: where it is important to establish a clear and navigable landscape of high quality, connected infrastructural conditions for a successful and sustainable Creative Economy.

Creative Regeneration – the Creative Ecology and Creative Economy
For successful and sustainable Creative Regeneration, it is vital that the breadth and depth of creative activity is both understood and supported: this requires an approach that recognises the relationship between the Creative Economy and Creative Ecology. This is important for economic growth considerations and to maximise the value-adding role of creative activities. Places with a high growth Creative Industries sector are also places with a distinctive mix of creative activities – ranging from community arts to a strong live music scene. Indeed, it is argued that without a lively and vibrant range of creative activities, a place lacks the cultural offer and creative dynamism required for higher-growth Creative Industries (and other knowledge economy) businesses to settle and grow (Florida 2002). Furthermore, other progressive relationships between different types of creative activity are also vital for sector growth – such as artists working with higher-growth animation firms in a direct supply chain relationship, or a strong local creative 'scene' offering the inspiration and motivation for individuals to set up creative businesses.

Correspondingly, it is argued throughout this chapter that for successful and sustainable Creative Regeneration, there must be an attendance to understanding, engaging with and supporting both the *Creative Economy* and

Creative Ecology, where each is configured as dependent on the other for their success and sustainability. This is particularly important in places where the sector is best described as 'emergent' rather than 'established'. For many creative businesses, the prime objective is developing products and services that have scalability, which in turn enables growth and profit. Such businesses are disproportionately positioned within certain sub-sectors (such as advertising, media and a range of digital content activities). These are the main contributors to the high growth, globally orientated *Creative Economy*. The *Creative Ecology* refers to the broad fabric of creative activities that spreads across sub-sectors and locations and encapsulates organisations and practices as diverse as arts centres, galleries, individual practitioners, education institutions, public art programmes, events and festivals, cafes and bookshops. The Creative Ecology provides the lifeblood of the Creative Economy by providing the ideas, energy and career opportunities upon which a successful, growth-orientated Creative Economy depends. It also provides opportunities for otherwise marginalised individuals and communities to actively produce and consume culture and creativity and helps to motivate social enterprise activities[1]. It provides vital energy in establishing a strong Creative Economy with major social benefits, it provides elements of inspiration – indeed 'R&D' – for commercial creative activities, it can play a major role in attracting creative businesses to a place, and many activities have the potential to provide direct economic value through the injection of entrepreneurial and commercial practice. This relationship between 'Economy and Ecology solutions' is not always fully understood by many policy-makers and intermediaries, hence the jarring of agendas, lack of focus, and difficulty in interpreting 'success'. This is particularly complex and difficult when the ecology is increasingly digitalised.

Why the Creative Industries? A reminder
The last decade has seen the rapid rise of the Cultural and Creative Industries[2] in the UK and other parts of the Northern Hemisphere[3]: as a recognised major growth sector with enormous significance for employment, productivity and the balance of trade (DCMS 1998 & 2001); as a construct for redefining and re-visioning places and even nations (Pine and Gilmore 1998); as a progressive sector with huge scope for advancing social agendas (PAT 10 1999); and as a tool for regeneration and renewal, where 'creative places' are the most successful in attracting and retaining highly skilled, ambitious and entrepreneurial workers (Landry and Bianchini 1995; Verwijnen 1999). This embrace with the 'creativity agenda' is thus in part a direct response to economic development opportunities, configured through interventions that focus on supporting businesses to maximise their growth potential; and in part a recognition of the broader

value of creativity (or at least the perception and presentation of creativity), where palpably 'creative places' are more likely to be inclusive, innovative, forward-thinking, and thus attractive locations in which to invest, live and work (Landry 2000; Florida 2002; Pratt 2002).

Over the past twenty years, the disappearance of local manufacturing industries, periodic crises in government and finance, and an increasing realisation that the convergence of technology and content provide high growth and distinctively competitive market positions, have made culture and creativity an increasingly key focus for UK and other Northern Hemisphere regions and cities: providing the leading edge for their tourist industries, offering a 'creative brand' to attract inward investment, and providing new skills and identities that are hoped will bring with them a unique, competitive edge (Boyle 1997; Evans and Foord 2000). This creative focus accelerated during the 1990s, as the 'network society,' 'experience economy,' 'creative cities' and 'globalisation' were used to define new modes of production and consumption within the 'new economy' (Kelly 1998; Saxenian 2000; Yusef and Nabeshima 2003). A new emphasis was put on the interplay between the economy and culture, as well as on creating crossovers between content generation and new media technologies (Amin and Thrift 2002; CIM 2004). The outcome for urban and some rural policies was that, rather than selling just goods or services, even very small places have the potential to mobilise cultural tourism, a diverse retail offer, distinctive architecture, and new synergies in cultural and creative production and consumption where small-scale, independent creative businesses and practitioners lead the way in building a strong 'creative economy' and transforming the image, confidence and experience of places that might otherwise be languishing at the margins of global flows (Crewe and Forster 1993; O'Connor and Wynne 1996).

This broad conceptual and practical engagement with what might be termed a 'creativity agenda', was given a high profile and strategic legitimacy in the UK by the new Labour Government in 1998 – less than a year after coming to power. The government effectively raised the stakes by seeking to directly measure the size and economic impact of a newly defined complex of creative activities or 'sub-sectors': the Creative Industries Sector. The significance (both real and potential) of the Creative Industries was heralded in 1998 by the Government's Department of Culture, Media and Sport (DCMS) through the publication of a high profile Creative Industries Mapping Document, which provided estimations of the size and growth potential of the sector and its sub-sectors. This was accompanied by the launch of the specialist Creative Industries Task Force[4], and an ongoing mix of national initiatives that have focused most intensively on advancing intelligence and sector mapping tools[5], promoting the nation's creative identity[6], targeting ideas generation and innovation[7], resourcing

specialist sub-sector development programmes[8], and advocating to other government departments – notably the Department of Trade and Industry – the significance of the sector and thus the need to develop specialist interventions to maximise its potential.

However, it is on a regional and local level (using national policy to legitimise intervention) that the Creative Industries has been prioritised most emphatically as a 'key driver' in the economic, social and definitional transformation of specific spaces and places. The DCMS – through its mapping and advocacy approach – helped to inform a wider audience of policy-makers of the significance, value and potential of the sector. In response, regional and local level decision-makers have been keen to attract Creative Industries activity and to add value to existing creative assets. Newly established English Regional Development Agencies (RDAs) offered for the first time clearly accessible resources for economic development that could be drawn-down with a level of regional autonomy. This allowed for the introduction of dedicated regional and local mapping studies to test the size and potential of the sector; followed by multiple initiatives determined to maximise the potential of a sector that offers employment opportunities alongside innovative approaches to physical gentrification; and new identities alongside alternative ways of (re)imagining places after decades of economic restructuring and cultural change (Comedia 1992; Scott 1997). Today, in the UK and much further a field, many regions and places are re-focusing their economic development policies through a 'creativity lens', many of which are directly embracing Creative Industries development programmes (Evans 2001; Ash 2003; Hesmondalgh 2002), often through innovative approaches.

However, though the importance of creativity as a generator of prosperity is acknowledged at the heart of government, across many areas of regional and local government, and increasingly by vital partners such as in the Education Sector, the growth potential of parts of the Creative Industries are being questioned by some private and public sector interests, with cross-sub-sector approaches to sector development seen by some as lacking in sophistication given the uneven growth patterns of different parts of the sector. For example, it is argued that intervention to support high growth digital content industries should differ from approaches to support more traditional and lower-growth visual arts activity (FSE 2003), though it is acknowledged that relationships do exist between these 'creative disciplines'. The essential limitations of the Creative Industries, as a policy construct, are being uncovered.

Moreover, some policy-makers and analysts rightfully question how intervention can simultaneously satisfy social, growth and cultural agendas, and point to the need for a clear rationale for each intervention, with interventions positioned to complement each other within a broader

240

strategy capable of traversing different policy areas. For example, the RDAs in England[9] often at first adopted 'catch-all' approaches that seek to maximise the potential of the Creative Industries across a range of strategic agenda – such as 'social inclusion', cultural tourism, regeneration and economic development. Such differing agendas require in most cases divergent approaches to support and development. This made coherent and effective delivery through catch-all approaches a very difficult task, which in turn affected the quality and impact of intervention. However, progress has been made by the RDAs and other partners. Here, the establishment of a *coherent landscape of intervention* is key: linking agendas and different part of the sector to support a complex local, regional or national *creative ecology*: where value chains are efficient, interactive and allow for multiple processes of innovation across different creative activities; where new talent and ideas are given the space to grow and cross-fertilise; and where places and communities are able to support this transforming sector and in turn be transformed by it.

Creative Regeneration: A Physical Dimension

[T]he conscious creation or nourishment of cultural sites, clusters or "milieus," is rapidly becoming something of an archetypal cultural planning instrument in the cultural planning tool box. (Mommaas 2004)

Creative businesses and practitioners like to cluster. They are knowledge-reliant, gaining their strength (often their intellectual property) through creative and practical exchange with other creatives; and enhancing their visibility, voice and spending power by collectivising – towards the costs of workspace, for showcasing and events (such as 'open studios'), to share a range of platforms, and to make the case for support. The need to cluster, and the need to cluster *affordably*, has contributed to the transformation of the urban landscape in many towns and cities in the UK and beyond, with creatives often acting as the 'pioneers', developing clusters of activity in old industrial (or other) buildings, attracted by the affordability, flexibility and ambiance of these 'unlikely' locations.

Historically, visionary property developers and landlords have responded to (and in many cases driven) the demand for proximity and affordability by creatives – at first through the provision of affordable studio complexes for artists (capitalising innovatively in disused, underused, even condemned space); and more recently through the provision of studios and managed workspaces developed with the specific space and support needs of the local sector in mind (such the increasing need for high bandwidth provision, specialist training and business support, or differently layered renting systems to encourage growth through lad-

241

dered approaches to affordability that encourage different types of creative activity to congregate)[10]. Companies such as ACME and ACAVA in London, Wasps in Scotland, Urban Splash in Manchester, are employing diverse models of public/private sector partnership to develop properties concentrated with Creative Industries activity. Such companies are increasingly recognised as supporting agents of both the creative economy and the beneficiaries of a strong local Creative Industries sector – local communities, businesses and (if managed appropriately) those seeking to invest in an area: the private developers and the public sector managers of space.

What is clear is that studio complexes, creative managed workspaces, formal and informal physical clusters of creative practitioners and businesses, can lead the transformation of an area, giving it credibility, a new sense of life by creatively utilising the spaces others – uncreatively – have left behind. Developers are moving ever deeper into the slip stream of creatives, recognising areas that creatives invest in as having commercial development potential. This presents a significant challenge, with the familiar pattern of creative practitioners and businesses being displaced by property prices inflated by the very presence of creatives a common concern. However, new approaches to planning are being developed that recognise the need for depth and breadth in the urban landscape, and that the increased sustainability and long-term vivacity of communities is often dependent upon the presence of creative businesses and practitioners.

In addition to the impact of the Creative Industries sector on re-utilising buildings or in some rare cases levering the development of new buildings[11], the sector is now widely acknowledged as making a significant contribution to the regeneration of the physical environment through design quality and innovative approaches to planning and visioning where creative production and consumption activities offer depth and breadth to a landscape and milieu. At a regional level, different RDAs are responding to this agenda. For example, the London Development Agency, through its Creative London[12] Programme, has placed securing accessible and affordable property as a prerequisite for a sustainable Creative Industries sector. This is based on the recognition that many creative businesses are relatively small and thus unable to pay the high property costs that in many cases have become so high because of the inflationary influence of creative businesses on an otherwise 'unlikely' area. Securing property is the only guaranteed way of sustaining creative activity and avoiding the disruption and ultimate decimation of the sensitive creative ecology due to the displacing influence of incoming businesses capable of paying much more for property.

242

Creative regeneration: A digital dimension

> The Internet has allowed us to replace a public sphere made up of finished statements, with one that invites us to a conversation. New mechanisms, from the simple mailing list and static webpages, to the emergence of writable web capabilities have enabled people to express themselves in combinations, on subjects and in styles that could not pass the filter of marketability in the mass media environment.
> (Rosemary Bechler 2006: 17)[13]

Technological developments over the last ten years have had a major influence on the lives and practice of creative businesses, not least those small and early stage businesses that public policy has most targeted. Critical here is digitalisation, which has brought into question the role of physical-led Creative Regeneration and forced new ways of conceptualising of the infrastructure appropriate to meet the needs of a changing Creative Industries sector. There are three main areas where digitalisation impacts upon the Creative Regeneration agendas:

1. Digital production

Creative businesses utilising digital technology to develop work, including appropriation and the establishment of recombinant and syncretic work. This establishes creative work as a more mobile phenomenon and can reduce the relevance of physical phenomenon such as clustering, thus reducing the impression on place. While the origins of creatively driven digital production can be traced back sixty years, it is since the 1980s that digital creative work has become increasingly accessible and mainstreamed, which in turn has opened-up new possibilities for appropriation, new forms of referencing, and for extending opportunities for what might crudely be termed 'ripping'. The terrain of digital production contains two broad categories: creatives who use digital technology as a tool for the creation of traditional art objects (such as photography, print, sculpture and music); and creative forms which uses digital technology as its medium, making full use of interactive or participatory features. Digital production throws up a considerable number of challenges to the established model of creative production in terms of distribution, the role of the creative 'artist', storage and exhibition. For example, interactivity and participation, two of the key themes of digital production, are becoming ever more complex and evolved as the Internet continues to open up more opportunities for artists to engage with audiences, with processes such as 'mash-up' now a major feature of creative consumption and production. Co-production between the creative practitioner and audience has reached a point where the practitioner and audience are blurring to a degree that challenges concepts of creation and ownership, which in turn places new demands on existing legal interpretations of intellectual pro-

perty rights and challenging policy-makers to find new ways of fostering spaces and places that allow creatives to produce new work in a confident and value-adding way.

Inclusion Through Media: Projecting Stoke
Projecting Stoke gave a voice to communities based in Stoke-on-Trent through the media of film, and maybe spot filmmaking talent along the way. Participants developed their ideas with the help of local filmmakers, and learned how to storyboard their ideas, direct, film and edit their stories. The first phase of this scheme focused on the Meir district and ten films were made with over 50 participants. The second phase in the Tunstall district finished in early 2007 and consisted of eleven films. The project also supported local people to re-vision and re-imagine their district and city, building new, distinctive senses of ownership and projecting them through film. Here, a dual agenda of creative place-building and sector development is pursued.

2. Digital consumption

New ways of consuming and reproducing creative products and services, which in turn includes processes of production (consumption is conceptualised here as a negotiated, transformative process where the boundaries between producer and consumer are increasingly porous). This has implications for the ways creative works are performed and sold, right down to the types of infrastructure required for audiences/markets to reach the products/services. As Culture Minister David Lammy in the *Digitalisation Action Plan for Europe*:

> In today's digital world of broadband, blogs and mobile devices, the citizens of Europe are no longer the passive recipients of information, but creators and publishers of content in their own right.

Webcasts, blogs, podcasts, and interactive performances are now no longer just an add-on for creative practitioners trying to reach out to the 'iPod generation', but a core part of organisational missions and objectives. The growth of digital consumption is intertwined with the 'consumer choice agenda', which is playing out in the creative world as much as in any other sphere. Young people used to being able to construct their own 'play list' or used to being at the centre of their own video game, are demanding and being given new ways to access a range of creative products across the value chain[14]; and consumers are increasingly 'digital travellers', traversing the globe (and time – for example to view and possibly appropriate content produced many years ago) with the click of a button, which in turn introduces an array of business support issues – such as legal issues relating to copyright.

There are numerous examples of this in practice through changes in exhibition and consumption models, with galleries and museums opening themselves up to new audiences through new digital technologies. In 2006, the ICA pioneered the use of new mediums to reach an audience through creating 'ICA: The Show'. This was a ten minute show which could be downloaded onto a Playstation Portable (PSP), containing highlights of exhibitions, music, features and design. It was applauded by Arts Council England as a way 'to develop a new and lasting relationship with a community of visually aware young opinion formers'.[15]

Inclusion Through Media: DigiTales
DigiTales is an international digital storytelling project involving people from across Europe making short films about their lives. Our European partners all share a common goal: to increase diversity in the media to improve quality and better represent Europe's increasingly diverse population.

Participants learned how to write a script, edit photos and drawings, and make them into a two minute film, which was posted onto the DigiTales website: personal stories across nations were exhibited and exchanged and, as the site grew, a patchwork-quilt of personal moments was built to create an evolving picture of contemporary Europe. Our Storytellers included Roma communities in Eastern Slovakia, Muslim women living in Amsterdam through to young visually impaired music students in London.

In the UK, Hi8us worked on the Lansbury Estate in East London. Through workshops and intensive support, local young people were given the opportunity to gain experience of innovative media production, and a chance to tell their stories. These were then shared with young people across Europe, creating new intercultural dialogue and a collaborative approach to exploring identity and developing creative skills through digital media.

3. Digital convergence
Where content crosses domains (such as design, film and music), creating new hybrid forms and processes and blurring senses of ownership. This heightens the growth potential and innovation levels of creative products and services, but introduces major challenges for the public sector as it seeks to keep pace, forecast and in turn support creative businesses to grow and grow in ways that have a wider value (such as social). From gaming and telephony through to social software and database creation, convergence has seen artists creating, collaborating, and questioning across a wide range of domains previously unexplored or neglected by

artists. The 2005 Arts Council conference, 'Ways of Working'[17], discussed at length the new 'eclectic methods' being adopted by artists working with convergent media and content. This involves an engagement with the multiplication of new mediums – such as mobile ring tones, film by broadband, voice over Internet protocol (VOIP) telephone – which has created new markets and opportunities for creative practitioners to explore. Mongrel, the leading British digital arts collective, has explored a number of these through groundbreaking work such as 'Telephone Trottoir', which exploits the possibilities of mobile telephony and Internet radio.

The major impact of digital convergence and wider processes of digitalisation on Creative Regeneration, has been that it has unsettled public policy makers more used to supporting 'bricks and mortar' infrastructure and/or supporting a sectoral approach – such as through a music scheme or a visual arts programme. Processes of digitally-enabled convergence and collaboration have repositioned the role and support needs of creative businesses across the value chain. Fostered by technology but also driven by an increasing recognition of the role of creativity in society and business and the mainstreaming of arts in regeneration, collaboration and convergence is now a cornerstone of professional practice. This has prompted the public sector (such as the Arts Council) to explore opportunities in collaboration and convergence across a range of economic and social spaces. The 2005 DTI-commissioned Cox Review into Creativity in Business has raised the stakes yet further, pointing to the essential role the Creative Industries has to play for UK competitiveness across all sectors and particularly through design in the arts. Thus the role of creative businesses as collaborators and generators in complex, often inchoate and legally intricate processes of convergence, requires attention as a key driver of change with social and economic consequences.

Maximising the UK's Creative Infrastructure:
Fit-for-purpose Creative Regeneration

Digitalisation of the creative economy offers a range of opportunities for Creative Regeneration. Cultural organisations and creative businesses can benefit from the opportunities such as reaching new audiences and widening access, as has been successfully demonstrated by Culture Online and the 24-Hour Museum. Sectorally, regions are benefiting from the cost reductions and possibilities that digital production and presentation have brought to film. Regional Screen Agencies are funding mobile digital screens which can breathe new life into village halls while the funding of digital screens in multiplex cinemas will bring non-mainstream productions to new audiences. Ultimately, as broadband is already proving, digitalisation can help alleviate the barriers previously imposed by geo-

graphy in rural areas, allowing a range of new services and businesses to prosper via virtual and real linkages to major cities and beyond. And yet, it is clear that Creative Regeneration remains preoccupied by approaches that pre-date wide-spread digitalisation, with too many initiatives failing to connect different businesses in creative sub-sectors, let alone creative businesses to other sectors. In addition, models such as in creative work-space do not provide the technology infrastructure and the social connectivity required by convergence-hungry creatives.

The DCMS Creative Economy Programme Infrastructure Working Group Paper responds to the increasing digitalisation of the Creative Industries to emphasise how existing Creative Regeneration approaches can be improved and new approaches introduced. It shows, for example, how cultural infrastructure in the UK is not fulfilling its potential as a driver of the UK creative economy. This is because, while there are many examples of high quality infrastructure making a huge positive impact on agendas such as innovation, diversity, learning and skills and the visitor economy; agendas are not effectively connected, and the infrastructure offer is too fragmented, and much of it is not fit for purpose in a digitalised environment. Creative businesses in a digital age require connected, accessible, flexible infrastructure that provides them with stimulation, inspiration, practical skills, sector intelligence, trading opportunities and partnerships. This requires the concentration of infrastructure through place and the embedding of this infrastructure so that it starts to transform places into creative hubs. Currently, infrastructure is under-connected and 'pieces of infrastructure' are too often placed in isolation across the urban landscape.

Watershed, Bristol
Watershed (www.watershed.co.uk) is a prime example of a highly connected, flexible, porous piece of cultural and creative infrastructure, of which there are too few examples. Watershed is more than just an arts cinema. It is at once a cultural centre, a business broker, a social networker, a research and innovation facility, a café/bar, and a cultural tourist attraction. This is because it has developed organically over the years to become totally embedded in place, operating as a shining light on Bristol's culturally rich harbourside, connected as part of the wider cultural offer of this distinct milieu (which includes Arnolfini gallery, Bristol Industrial Museum, @Bristol, Bristol Cathedral, the City Library, and a real mix of retail and other consumption spaces). Watershed, as part of this milieu, has become the cultural space of choice for many of Bristol's creative practitioners and businesses. This is because they have been able to make it their own and imprint their distinctive senses of identity and place upon the flexible and accessible spaces such as the bar with wi-fi. In turn, it has

become a key broker for innovation in creative businesses, building convergence through partnership projects with HP Labs, while at the same time providing new network opportunities for cultural organisations and social enterprises. This works because Watershed *constitutes place*, offering connections in the immediate milieu, across the wider city, and into the city region, through a mixed profile of proactive initiatives (from training to screenings), underpinned by the distinctive ambiance of the building. This ambiance is hard to plan for and cannot be guaranteed, but a culture for openness and connectedness, an embrace with place, and a willingness to let the creatives lead, establishes Watershed and other facilities such as Broadway in Nottingham and Lighthouse in Glasgow, as pieces of cultural infrastructure that truly drive creativity and competitiveness.

As outlined in the 2005 Cox Report, much of the growth associated with the creative industries occurs outside of the sector, where a creative business has advanced the competitiveness of a client business operating in another sector. Much creative industries innovation also comes through convergence – from the role of a museum providing resources and ideas to a creative practitioner, to cross-departmental partnership within a university. Each of these types of convergence is under-explored and thus under-exploited in the UK, with the role of major cities as the most potent catalysts of convergence neglected. This is because cultural infrastructure – from a museum to a university – has not been effectively tasked with the role of convergence catalyst, and when they have, the spaces of convergence provided have too often been inappropriate because they have not been effectively embedded within the creative networks, processes and senses of place.

The Infrastructure paper shows that infrastructure does not mix opportunities for production and consumption. Too often, cultural infrastructure in the UK has been conceptualised and positioned as focusing either on cultural production or cultural consumption. Rarely both. For example, museums and galleries are traditionally conceptualised as units of cultural consumption; whereas a Creative Industries workspace facility provides spaces for production. However, the most successful cultural infrastructure – whether this is measured in audience figures, visitor numbers or business growth – is that based on an understanding of the porousness of 'institutional walls' and the inseparability of processes of production and consumption. This can be recognised on a number of levels. For example, the DCMS Data Evidence Toolkit (DET) is based in an understanding that to measure creative Industries activity requires an appreciation of the connected and overlapping domains of content origination, manufacture, distribution, and exchange. Effective infrastructure – or the landscape of infrastructure – must support the connection of these

domains, especially because it is often the same business or a network of businesses that occupies each of them. A further and related example is the role of a museum or gallery. These are not just spaces for visitors to consume culture and creativity; they are producers of cultural resources that provide information, intelligence and inspiration for consumers who in turn are creative producers. It is therefore important that such infrastructure is effectively connected to the wider landscape of production and consumption-orientated infrastructure to accelerate and improve the transfer of their resources into the commercially-driven creative industries sector.

Back to place

As has been shown, place provides the means of connecting consumption and production processes through the formation of rich creative milieu. Through the co-location and connectedness of spaces of consumption and production – the galleries, bars, theatres, workspaces, support services, shops, arts centres, cinemas, universities – genuine creative city districts are established which have the ambiance and attitude required for genuine competitiveness. Places such as the Lace Market in Nottingham, North Lanes in Brighton, the Northern Quarter in Manchester and Hoxton/Shoreditch in London are oft-given examples of production and consumption working side-by-side towards the effects of regeneration and sector growth. Individual pieces of infrastructure such as The Design Museum in London or the Lighthouse in Glasgow, effectively mix consumption and production through space and programming, and are outward-facing to connect with the digital and physical infrastructure landscapes of the districts and cities in which they are based. Here, place, creativity and competitiveness, are perhaps most compellingly evoked.

The DCMS, in their ongoing Creative Economy Programme, emphasise the significance of establishing a fabric of creative infrastructure that connects the Creative Ecology and Economy and mainstreams creativity as a core constituent of 'place'. It states that:

> Cultural and creative infrastructure – from a gallery to a university incubation project; from a museum to a specialist network initiative – contributes meaningfully to the combination of factors that comprise a Creative sense of place. It is the fabric of infrastructure available to Creative businesses that informs their Creative sense of place, which in turn affects their ability to innovate and grow. It is also the ways that infrastructure is connected together (through networks, co-location, a high quality public realm) as a single "infrastructure offer" that influences the confidence and capacity of Creative businesses. (CEP 2007: 7)

This chapter has indicated that Creative Regeneration initiatives in the

Broadway, Nottingham:
Anchoring the transformation
of the Lace Market area

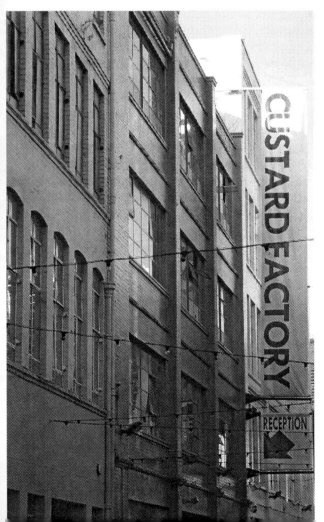

Custard Factory, Birmingham:
An early stage 'mini-cluster' of
creative workspace and activity
space

UK are under-connected, inflexible and too often negligent of the ways digitalisation can reinforce the significance of place for an innovative, growth-orientated and value-adding Creative Economy. The DCMS Creative Economy Programme introduces a set of guidelines for developing a successful competitive fast-growing Core Creative Place. It does this by outlining *Ten Infrastructural Conditions* and asks that regional and local partners consider ways of establishing these Conditions as a basis for Creative Industries competitiveness. Critically, these Conditions make the connection between Creative Ecology and Creative Economy, recognising that without one, the other will suffer. These range from '[A] world class, high profile cultural infrastructure – such as galleries, museums, concert halls and events programmes'; to '[D]iversity advantage – where complexly diverse communities are supported to project themselves as a major feature of the creative asset base of a place'. They also include '[A]n innovative further and school education sector, plus a strong informal learning sector'; and '[S]paces of convergence and connectivity, where creative workers can meet, exchange and build relationships that can help with ideas generation and trade'. It is this mix of larger-scale and capital-intensive interventions with people-facing, capacity-driven and confidence-building; that is so critical for a healthy, dynamic and inclusive creative economy and ecology. Inclusion Through Media is an example of a people-centred, engaging approach to creative development, working to enable otherwise marginal creative talent to connect to a wider set of infrastructural conditions which in turn might provide opportunities to build whole creative careers.

Endnotes

[1] For example, the 2002 Department for Trade and Industry document, 'Social Enterprise: A Strategy for Success', highlights the linkages between the Creative Industries and Social Enterprise sectors by profiling a number of social enterprises working in areas including design and the performing arts.

[2] Referred to in this chapter as the 'Creative Industries' for reasons of continuity. The Creative Industries sector is an aggregation of a complex collection of industrial and creative sectors and sub-sectors, and its 'boundaries' are thus often contested. The term used here is based on the definition employed by DCMS Creative Industries Task Force (1998):
'Those activities which have their origin in individual creativity skill and talent, and which have their potential for wealth and job creation through the generation and exploitation of intellectual property. These have been taken to include the following key sectors: advertising, architecture, art and antiques, crafts, design, designer fashion, film, interactive leisure software, music, the performing arts, publishing, software and television and radio.'

[3] Plus considerable policy activity in Australasia and South Africa.

Hoxton Square, London: Cultural consumption and production
co-located to establish a 'creative place'

[4] The Task Force was composed of leading industry figures and charged with an advisory and advocacy remit. One of its key recommendations was for the production of a document that provided an initial overview of the sector: the Creative Industries Mapping Document.

[5] The Creative Industries sector is to an extent being reconceptualised – especially in terms of how it is measured and how intervention should be targeted. The DCMS Data Evidence Toolkit (2004) focuses on an understanding of the Creative Industries value chain as the first step towards a more rigorous approach to measurement, including the measurement of growth. This is based on a 'Creative Industries Production System' approach, as introduced by London School of Economics. This approach offers a departure from segmenting the sector into specific sub-sectors, instead laying emphasis on the significance of 'activity type' in terms of position on the production chain – from ideas generation to distribution and retail.

[6] Such as through the activities of the British Council Creative Industries Team: highlighting the strength and quality of the UK's Creative Industries to project a forward-thinking, innovative, and rich identity for a nation often understood as anachronistic and dependent on 'old culture' (see British Council 2004).

[7] Led by the launch of the National Endowment of Science, Technology and the Arts (NESTA). NESTA's purpose, as set out in the National Lottery Act (1998), is

252

'to support and promote talent, innovation and creativity in the fields of science, technology and the arts'. See www.nesta.org.uk for an overview of the range of activities it undertakes to encourage and support innovation and creative practice.

[8] Such as through the activities of the Film Council (www.ukfilmcouncil.org.uk) or Design Council (www.designcouncil.org.uk).

[9] RDAs are not active in Scotland, Wales and Northern Ireland – although similar economic development bodies exist, such as Scottish Enterprise (see www.scottish-enterprise.com).

[10] See ACE 2003a and Hadley 2004, for a detailed introduction to the roles of different studio providers (encompassing many different models, approaches and ethics) as key pioneers in urban regeneration.

[11] This is most common in sub-sectors such as media, film and design (with media centres and incubator spaces increasingly widespread in the 'urban landscape'). However some examples of new build do exist in other sub-sectors – notably Yorkshire Artspace, a major new studios complex in Sheffield supported by a range of funds that included a large contribution from the National Lottery. This funding resource is unlikely to be available for future creative workspace developments.

[12] See www.creativelondon.org.uk.

[13] See: www.unboundedfreedom.wordpress.com.

[14] For more on the rise of consumer choice on the arts, see John Knell, 'Whose art is it anyway?', Arts Council England 2006.

[15] Sarah Weir, 2006 (BBC website).

[16] Organised by Arts Council England and the Centre for Arts Research, Technology and Education (CARTE).

Media and Democracy
Some missing links

Nick Couldry

> I call our system a system of despair, and I find all the correction, all
> the revolution that is needed [...] in one word, in Hope. (Emerson
> 1977: 256)

Emerson was writing about education in 1840s America in a fast-chang-
ing society that had a long way to go towards an effective representative
democracy. This, after all, was before the US Civil War and the abolition of
slavery, before the struggles to create trade unions, before the civil rights
struggle for excluded black citizens in the 1960s – and before America's
current crisis over corporate and military influence on the federal admini-
stration of George W. Bush. But Emerson's basic idea – seeing, for what
it is, the *despair* written into the world around us, and imagining 'that
something else is possible'[1] – is still relevant to today's USA and to today's
Britain. It is still relevant to ask what might be the links between how we
treat young people and address, or ignore, their hopes, and the type of
society we can expect in the future; it is still worth asking what resources
might make a positive difference to those young people's hopes and the
society that for all of us emerges.

In fact, for those who want to build hope, this may be a particularly
important moment, in Britain at least. For young citizens' despair at the
workings of British democracy is starting to come to the surface, where
it can no longer be ignored. In the two most recent general elections in
2001 and 2005, voter turnout among 18-34 year olds – that is, among those
who are in or have recently left full-time education – was *below* 50% (Elec-
toral Commission 2005). This is hardly surprising when in a recent sur-
vey *only* 27% of the UK adult population agreed with the statement: 'I
have a say in how the country is run' (Electoral Commission 2007). And
the British government is beginning to get worried: quite rightly, because
unless those who were 18-34 earlier in the decade start voting in greater
numbers, Britain will cease to be a working democracy in the next decade
or two. 2001 was the first modern peacetime election in Britain when less
than 60% of voters turned out to vote. So British governments need to lis-
ten to their young citizens better, or risk losing their legitimacy.

If governments need to listen, what should they be told, or perhaps

reminded of? For one thing, in case we forget it, they should be reminded that Britain has become more, not less, unequal over the past two decades; for another, that local government in Britain has lost, not gained, power and resources over the same period, which means, inevitably, that the experience of effective democracy is much more distant from people than before. This is the essential background to any new initiatives for 'devolving power' to local people by the new Gordon Brown government,[2] welcome as they may be. It is important to be clear that the issue is not voter apathy: as the Power Report published in February 2006 argued, drawing on a lot of recent evidence and picking up a growing trend in the literature on political engagement, people in Britain are not uninterested in politics in principle; but they don't have, or find, places where they can go to be listened to and have their views and ideas taken into account when government policy gets made and implemented (Power 2006). Or, as we put it in a study at London School of Economics completed last year, the problem with British democracy is not a lack of public engagement on the part of its citizens but a lack of *recognition of* that engagement *by governments* (Couldry, Livingstone and Markham 2007: 189).

I'll be drawing on the Public Connection study[3] later but this chapter is not mainly about political engagement, or even as we put it there about 'public connection', the basic level of *orientation* to a world of public issues on which any potential interest in politics depends. I want to focus instead on a problem within British democracy, and a dimension of social injustice, that even more rarely sees the light: I mean the undemocratic nature of the *media*, not the political, process.

No one would deny the importance of the freedoms which British media generally enjoy: the freedom to publish that once was severely restricted by government in various ways. No one would deny that these freedoms are important to the very possibility of democracy. But that is not the same as saying that media institutions themselves are democratic, in the sense of taking account of the views of the citizens affected by what they publish or broadcast. Yet if media – vital institutions of democracy as they are – themselves operate in a way that is not open to democratic

challenge, this is a democratic deficit too.

There are two ways of thinking about remedying that deficit. First, by making the process of media production more open to citizen intervention or, as the political philosopher James Bohman has put it, 'widen[ing] the circuit of influence over the means of communication' (2000: 60): discussing this leads into media ethics and media regulation, and would take me too far afield. Second, by making fairer the distribution of the resources on which media rely – the resources to make media or, more simply, to tell stories *and be listened to*. It is this second route – challenging the injustice in how society's storytelling resources are distributed – that I want to discuss here, because all the projects in this book, directly or indirectly, are practical challenges to that injustice.

I am not a media practitioner; I am a media and social theorist. But my work in researching and thinking about media, and media's relationship to democracy – the conditions of democracy – has focused from the start on the unjust distribution of society's resources for storytelling: or, more technically, the unequal distribution of 'symbolic power'.[4] Because I'm not a practitioner, I don't claim expertise in putting that injustice right; instead, I will try to explain why, and how, I think this injustice matters, and in that way I hope to contribute something to the debate on why we need more projects like Inclusion Through Media and what it would mean for such projects to succeed.

Hidden injuries

Others will have other stories, but my first real understanding of these issues started with reading the American sociologist Richard Sennett's book *The Hidden Injuries of Class* (Sennett and Cobb 1972). Countless books have been written before and since on the economic and status injustices linked to class in the USA, Britain and elsewhere, but until then few if any writers had focused on how class differences 'feel': the psychic pain they cause, and the difficult routes people take in dealing with that pain. Sennett had done interviews with working class people in Boston, USA and his book brings out how people internalised their low position in the society, as a way of coping with it, until they came to feel in subtle ways that they deserved it – that those who were better off or had higher status deserved those greater rewards because they had qualities those 'below' them didn't. An unequal class system, in other words, in addition to inflicting material injuries through poor housing, poor wages and long working hours, inflicted also 'hidden injuries' on its victims, injuries to self-esteem and self-recognition. In this way, the justice of the class system seemed natural even to those who had most to gain from challenging it; as a result, it was almost immune to change, until at least those hidden injuries were grasped more clearly.

Over the next three decades, similar and just as powerful studies of 'hidden injuries' were told by writers investigating other dimensions of inequality. So Carol Gilligan and many other feminist writers wrote about the damage to women's self-esteem cased by the internalisation of gender hierarchies in the education system; Stuart Hall, David Theo Goldberg and others, drawing on the classic early work of W. E. DuBois and Frantz Fanon, wrote of the psychic damage done by racism and race-based social systems; and more recently, Michael Warner, Judith Butler and others have written about the hidden injuries inflicted by societies where one norm, and one norm only, of sexuality – heterosexuality – is imposed as a grid to regulate men and women's much greater range of sexual orientations and practices.

In all those different ways, we have come to see how so-called 'material' inequalities – in money, physical assets, legal rights – are matched by 'symbolic' inequalities. These symbolic inequalities amount to more than being represented unfairly by others, crucially important though that is. These hidden injuries eat away also at individuals' own symbolic resources, their ability to represent themselves, to tell their stories effectively and with confidence. In the controversial context of the current 'war on terror', new forms of hidden injury and symbolic inequality are emerging, linked with intercultural differences; some replay older forms of racism, others are directly linked to the unequal treatment of, and respect for, different religions. The problem of 'hidden injuries' is, in other words, a large and ever-changing one.

Correcting these symbolic inequalities might seem to be a matter simply of giving greater respect to individuals in our interactions with them. But *in mediated societies* – societies where media institutions have a dominant role and most, if not all, of our information about what's going on beyond our immediate locality comes from media – it is impossible to separate the recognition individuals get from each other and the way that media resources are distributed. Another American sociologist Todd Gitlin expressed this beautifully when he wrote: 'what makes the world beyond direct experience look natural is a media frame' (1980: 6). Yet not everyone has access to the resources of media institutions that build that frame. This means that *who* has access to media resources affects whether *my* experience can make sense, or seem interesting and important, *to you*. Media, Raymond Williams (1976) once wrote, provide 'images of what living is now like' – or not, as the case may be. If your life is the type of life that is *not* regularly represented in media, it is liable to be cast into the shadows, making it harder for you to get others to listen to your story of what life is like for you. This is where we can see the hidden injuries of media power working (Couldry 2001), shaping our expectations of whether others would even be interested if we were to tell them our story.

It is not surprising then that, as a number of chapters in this book mention, just getting your hands on media resources – a digital camcorder, for example – can be a 'hook' to get people involved in a community project. *That* this is such a hook is part of the wider problem, since it is the flipside of people *not* normally having such access to media tools. The 'glamour' of media – useful attraction though it is – is the other side of an injustice. So projects that try to correct that injustice, by giving effective access to media tools, are of enormous importance: I'll come back to what counts as effective access later.

Often those projects involve technical training: media skills are now inseparable from web skills, because the dispersed nature of the Web makes it a colossal resource for telling stories and sharing information. However technical the issues of digital technology skills become, it is vital not to lose sight of the basic point, and the basic injustice being addressed, which always comes down to our ability to exchange with others our accounts of what we feel, remember, think and propose. Storytelling feeds back to the ways in which we recognise and respect each other as individuals, as the founder of the Center for Digital Storytelling, Joe Lambert, explains:

> We all pre-judge, and label, and disregard folks before we know that much about them. Story sharing and listening creates compassion, and other a huge does of humility. While opinions may not change, certainly a deeper civility can be engendered, a kind of civility that is rapidly disappearing from our culture. (Lambert 2006: xxi).

Or, as the leader of another much less well-known collective storytelling project in Chile has put it: 'it is necessary that all voices are heard in the concert of life' (Ysern 2003).

There are of course many forms of injustice: fundamental are failure to sustain a fair distribution of food, housing, basic amenities, health and education. Amongst these huge lacks, 'civility' and mutual respect might seem rather incidental, but, as the development economist Amartya Sen points out, being able to participate in how things that affect you are decided is part of living a life that is worthwhile and worthy of a human being, and democracy in this broad sense contributes both to development and to freedom (Sen 1999). We are gradually coming to realise that there is no rigid boundary between 'hard' questions of economic resources and 'soft' questions of recognition.

As the US political philosopher Nancy Fraser has pointed out, each of us needs resources – not just a basic standard of living, but the tools to make ourselves heard – if we are to be recognised: injustice of 'resources' and injustice of recognition are part of the same larger story (Fraser 2000). Which means, to recap, that in mediated societies, the fair distribution of media's narrative resources – remember we call them 'media' resources because, for so long, they have been concentrated in media *institutions*,

but it could be otherwise – is part of a wider social justice.

The implications of this insight continue to grow as more and more people cross national borders looking for work or fleeing war, yet often fail to get recognition – politically or socially – in their new host countries, and as growing economic inequalities within nations are forgotten by affluent elites beneath a story of economic success and market flexibility. This is why the projects of Inclusion Through Media have much wider implications than for the particular communities they directly affect. They are challenges to a wider and usually hidden injustice: the injustice of access to the 'medium' through which we see the social world around us.

General principles, however, only take us so far. In the rest of my chapter, I want to think more specifically about how such projects can work, drawing first on a few insights from the Public Connection project mentioned earlier.

Some implications of the public connection project [5]

Our aim in this project was, in a way, very simple: to test out, by listening to people's voices and accounts whether the bottom line of most political science and media research is true. That bottom line is the assumption that, whatever their dissatisfaction from the details of politics and whatever the growing debates about the exact stuff of politics should be about, nonetheless citizens in a complex democracy such as the UK are *oriented to*, potentially attentive to, a world of public issues and public affairs where, in principle, politics goes on and political issues are decided. We call that basic orientation 'public connection'. A linked assumption is that people's uses of media, their media consumption, sustains that public connection, so people's 'public connection' is mediated. But what if that were not the case? Then all the efforts of politicians and other public commentators would be wasted because people would already be turned in another direction.

We had a special reason for asking this question in 2004 and 2005 because of growing uncertainties about what politics should now be about, and what exactly – beyond turning up to vote – citizens should do. This uncertainty is common among academics, but our hunch was that it would be shared by citizens more generally, and that we could tap into it by giving people the space to reflect over time on what they had followed each week in the public world, and how media had helped them follow it. We left it up to our diarists to define what they counted as of 'public' concern. We obtained fascinating reflections from 37 diarists aged 18-69 across Britain in 2004, interviewed them before and after their diary, and then in mid 2005 commissioned from ICM a nationwide survey on the issues raised from the diary research.

You can read our wider findings elsewhere (Couldry, Livingstone and

Markham 2007). Here I just want to pick out some points that seem relevant to Inclusion Through Media. Our general finding was that most people in the UK *do* have public connection, and that media help sustain it. But this was only the start of a much more complex story.

First, when we looked at our survey results – which get closer to the average population (inevitably, since if you ask someone to produce a diary, you are weighting things a little towards those who are already engaged in some sense, although not necessarily towards politics) – we found a significant minority for whom media did not work to engage them. You were more likely to be disengaged if your socioeconomic status was lower, as well as more likely to lack a sense that you can affect things locally. Turning to media, disengagement was predicted both by an interest in celebrity and by a sense that media are often irrelevant to one's life: in other words, by a paradoxical disengagement from media as well. If you were manual working class (where levels of disengagement are much higher in any case), then the more television hours you watched, the more likely you were to be disengaged, although this was not true for other social groups. This illustrates that media consumption in itself is not a route to engagement: watching large amounts of television may be a feature of disengagement, and strikingly disengagement from media as much as from politics. If media contribute to engagement – and by and large they do – it is only as part of a broader balance of consumption and activity within people's lives.

Second, we found amongst our diarists, that even those who are most engaged – people who both followed the news closely, and were civically active – had few, if any, outlets for taking action on public issues. Indeed, although people generally had plenty of places where they could talk about public issues, it was rare to find anyone report a link between talking about an issue and taking action on it: this is symptomatic we believe of what political scientists have called a weak 'deliberative culture' in Britain (Pattie et al. 2004: 274). This is exactly the gap between engagement and recognition that I noted earlier. This suggests a larger issue: that the lack of opportunities for citizens and media consumers to participate effectively in political decisions or policy generation is not something that better media or better engagement in media can remedy by itself. As one of our diarists, a 47 year-old senior health protection nurse from the rural Midlands, put it: 'It's all right having a duty and following things but is there a point if there's nothing at the end of it?'

This links to a final and broader point which emerged in many forms in our study: that to assess the wider consequences and meanings of particular habits or activities (watching a TV news bulletin, reading the paper, going online – or indeed picking up a camcorder) it is not enough to study them in isolation; it is essential to find out how those habits are

connected up with other habits, as part of wider practices – or perhaps are *not* connected up with anything else in a person's life. In fact, it was the wider, 'joined-up' practice of citizenship that, ironically, was *missing* in New Labour Britain as reviewed in our study. This suggests that it is the *articulations* of what young people do in particular projects with wider contexts *to durable habits and practices* in daily life that we need above all to review in assessing the effectiveness of projects where media resources are, temporarily, passed into their hands.

Media and social justice in action

The earlier chapters in this book illustrate many inspiring ways in which the basic inequality in the distribution of symbolic resources – the resources for giving an account of one's life – can be addressed. Inevitably there are many solutions, because, if the aim is to redress a lack of recognition, we must realise that 'recognition' comes in many forms and from many directions. Holding a camcorder in your hand is one way; posting a diary on a social networking site may be another, providing people have the time to read it attentively; so with learning how to edit a mass of footage of yourself and your friends into a well-shaped narrative or having the story of lives like yours represented with sensitivity for the first time by others through mainstream cinema or television. Outcomes will, and should be, variable.

There is also an inevitable conflict about 'audit'. Audits are accounting processes that measure 'value'. Audits at some level are necessary as a way of sustaining basic trust in those who distribute funds. But, as the leading sociologist of audit culture Michael Power has pointed out, there is a danger in audit culture that it ends up measuring only what it wants to measure, while being blind to the distortions that audit tools introduce into the practices it claims to regulate:

> The audit process requires trust in experts and is not a basis for rational pubic deliberation. It is a dead end in the claim of accountability [...] more accounting and auditing does not necessarily mean more and better accountability [...] and [yet] *it expresses the promise of accountability* [...] *but this promise is at best ambiguous*: the fact of being audited deters public curiosity and inquiry [...]. Audit is in this respect a substitute for democracy rather than its aid. (Power 1997, 127, added emphasis)

More bluntly, 'value for money' – accounting value – is not the same as value for life; economic measurement and moral/ethical norms intersect in the one word 'value' without any clear resolution, since they face in opposite directions. Yet projects that address injustices in the distribution of symbolic resources are, in the end, defined not by accounting ends but by their aim to make society more just and so more livable.

At the same time, it is reasonable and fair that projects who use scarce resources are held to account for the likely consequences of how they spend that money. Whatever the wider doubts about the overextension of audit culture in contemporary Britain, the more important issue in the short term may be how we introduce into the evaluation process a more nuanced 'account' of how, over time, the skills in which projects involve their participants are plausibly linked with enduring habits and practices in those participants daily lives. Why not use narrative – the tools of narrative placed in the hands of participants by projects – as a means to encourage them to tell their evaluation story at a later date, by telling how, looking back, they see the projects as having affected, or not affected, their daily lives? In this, and many other respects, the huge expansion of online resources and sills provide new opportunities for recording and exchanging reflections and diaries, for creating discussion fora, and for channeling participants' proposals for new projects and new uses for the skills they have learned. Indeed that longer term process of social archiving may *itself* be an important form of self-respect, given the much wider democratic deficit in Britain that I noted earlier. I leave open the question of how we can rethink the purpose of 'evaluation' in such a way that time becomes available for former participants and former project leaders to reflect, and have policymakers register those reflections, in an effective way.

This leads me to my final point. The aim of projects within or similar to Inclusion Through Media, as I understand it, is to redress injustices and in that way alter lives. As Clodagh Miskelly points out in her chapter, skills that are tied to the specific and limited context of a project are probably not enough in themselves – what matters is the enduring skill 'to make informed choices'; while as Jackie Shaw points out, the term 'participation' is potentially a slippery one – not just, I would add, in the context of 'Participatory Video', but in the whole history of democratic politics.

So, along with building broader and more sensitive ways of evaluating whether participatory media projects effectively redress the injustices they identify, we need to be realistic. For all the potential of new media and digital tools of media production, distribution and social networking, what is at stake, in the end, is democracy – an effective democracy. Changing through media tools young people's possibilities to be recognised and be heard will only succeed on a wider scale, if, from the other direction, government and other formal authorities act as if young people, and young people's accounts of their lives, mattered. In this respect, I suspect, our thinking and practice about what democracy might mean has still a long way to go.

Endnotes

[1] Badiou (1998: 116).

[2] Guardian 5 July 2007, p. 1, quoting Hazel Blears, MP, the newly appointed Secretary of State for Communities.

[3] See www.publicconnection.org.

[4] See Couldry (2000, 2003).

[5] Funded under the ESRC/AHRC Cultures of Consumption programme (project number RES-143-25-0011),whose financial support is gratefully acknowledged. I would emphasise that the particular 'cultural studies' interpretation which I give to the project here is mine, rather than necessarily a collective view.

Contributors

Jacqueline Clifton studied harpsichord and organ at the Royal College of Music. She has worked as a musical director in theatre, film and television as well as teaching music and music technology at all levels. When her sight was damaged she founded Musicians in Focus. She has won a number of awards including an Hon. RCM, selection as one of the Women of the Year 2002 by Good Housekeeping Magazine and was a finalist in the Women of the Year Frink Award 1999.

Nick Couldry is Professor of Media and Communications at Goldsmiths, University of London. He is the author of five books on media power and media consumption including most recently *Media Consumption and Public Engagement* (Palgrave, 2007, co-authors Sonia Livingstone and Tim Markham).

Kulwant Dhaliwal is Director of Hi8us Midlands Ltd, a company she established in 2003 having successfully set up and run the Midlands department of Hi8us in 1999. She has nearly 15 years experience of working in arts & media production and training with young people having started her career at the Depot, Coventry's Youth Arts & Media Centre (now known as Herbert Media). Kulwant originally trained as a Graphic Designer, later completing an MA in Media Cultures; both disciplines have been important to the work developed at Hi8us Midlands.

Tony Dowmunt has practised, taught and written about alternative video and television for the last 30 years, and is currently the Course Tutor on the MA in Screen Documentary at Goldsmiths, University of London. His publications include *Video with Young People* (InterAction 1980, reissued by Cassell 1987) and *Channels of Resistance: Global Television and Local Empowerment* (British Film Institute 1993), which accompanied the TV series of the same name. He is co-editor of *The Alternative Media Handbook* (Routledge, 2007).

Mark Dunford is Executive Director of Hi8us Projects, a charity specialising in collaborative media work and the lead partner in Inclusion Through Media (ITM) an Equal funded development partnership operating in the UK and Europe. He also is also a Director of DS Media Consulting and previously worked at the BBC, BFI, Arts Council England and City University.

Juliette Dyke is a freelance journalist and a regular contributor to Broadcast magazine. She was educated at Warwick University and pre-

viously worked in TV production before switching careers. She lives in London.

Dr Tom Fleming is Director of Tom Fleming Creative Consultancy, and is a consultant and academic specialising in research and support for the creative economy and cultural sector. Based in London, he works internationally to undertake research and devise strategy. Clients include local, regional and national government and sector support bodies.

Alan Fountain has been involved in various aspects of media since the 1970s. He is currently Chief Executive of European Audiovisual Entrepreneurs (EAVE), a professional development programme for European film and television producers, Chair of the Hi8us Projects Board and Professor Emeritus, Middlesex University. He was one of the founding commissioning editors at Channel 4 Television 1981-94. He is co-editor of *The Alternative Media Handbook* (Routledge, 2007).

Ben Gidley is a research fellow at the Centre for Urban and Community Research at Goldsmiths, University of London. He has been involved in several evaluation projects, including Positive Futures, the Knowledge East Creative Impact project and Beyond The Numbers Game.

Rick Hall was Director of Roundabout Theatre in Education Company at Nottingham Playhouse from 1986 to 1990. Since 2003 Rick has led the Ignite! Project for young people, designed to support creativity in learning, first as part of NESTA and since October 2006 as an independent organisation. Rick is also a writer and consultant on matters relating to creativity and young people and founder of Rehearsal – a space for improvisation and experiment.

Nicole van Hemert works for Hi8us Projects and is the Communications Manager for the Inclusion Through Media programme. Before moving to the UK, Nicole was a management consultant in the Netherlands at &Samhoud Consultancy, where she worked with government bodies including the Ministry of Transport and Dutch Railways.

Sally Hibbin has a long established track record as both a producer and an executive producer. She produced numerous films under the Parallax Pictures umbrella and collaborated for several years with Ken Loach, producing such highly acclaimed and award winning films as *Carla's Song* and *Ladybird Ladybird*. Sally recently completed principal photography on Parallax East's film, *Almost Adult*, written by Rona Munro and directed by

Yousaf Ali Khan. *Yasmin* had its UK television premiere on Channel 4 and *Almost Adult* will do the same.

Victor Jeleniewski Seidler is Professor of Social Theory in the Department of Sociology, Goldsmiths, University of London. He has written widely in social and cultural theory with a particular interest in gender. His recent work includes *Transforming Masculinities: Men, Cultures, Bodies, Power, Sex and Love* (Routledge, 2006); *Young Men and Masculinities: Global Culture and Intimate Lives* (Zed, 2006); *Urban Fears and Global Terrors: Citizenship, Multicultures and Belongings* (Routledge, 2007) and the forthcoming *Jewish Philosophy and Western Culture* (I.B. Tauris, 2007).

Tricia Jenkins has over 25 years experience in the creative industries and is currently Development Associate of Hi8us Projects Ltd. She started out as a lecturer in media education and video production in FE colleges in London, and developed some of the first qualifications for 16-19 year olds in media. She has since worked in grants management and has developed international projects in the field of community media and learning, through European funding programmes, and with partners across Europe since 1996.

Clodagh Miskelly is a facilitator of participatory media projects and an independent researcher. She was evaluator for the *L8R* project while working as a postdoctoral researcher at the University of the West of England. She is now part of the *L8R* web production team overseeing content development.

Denzil Monk writes, produces and makes films with communities and young people. He is Founder-Director of the media production social enterprise Awen Productions CIC, Chair of Cornwall Film Festival and is the Hi8us Cornwall Development Director.

Colin Pons is presently Managing Director of Studio of the North (the successor to YMPA) and joint Managing Director of FearFactory Films. For FearFactory he is currently co-producing the feature film *Hush* with Workstation based WarpX and London based Shona Films.

Andy Porter trained as a community and youth worker before becoming a filmmaker. His working life has been spent in exploring ways of combining these two activities and making a living. He was a founder member of Hi8us and currently works with Hi8us South in East London. He set up and teaches the Digital Media and Social Change Module on

the Cross Sectoral and Community Arts MA at Goldsmiths, University of London.

Jackie Shaw is Founder-Director of Real Time Video, specialising in participatory video since 1984. She is author of *Participatory Video – A practical guide to using video creatively in group development work* (Routledge, 1997). As well as facilitating participatory media projects and offering training to professional in the approach she is currently researching video use as a tool for inclusion.

Imogen Slater grew up in South East London where she became involved in youth and community development. This has led into research in related areas, fuelled by the belief that solutions can be found 'on the ground,' and that links need to be made between grass roots practice, and the strategies of policy makers and purse holders.

Robert Smith is a producer, director and media consultant with extensive knowledge of directing film, scriptwriting, production and current media trends. A respected teacher of film and television drama in several key universities, he currently leads a postgraduate course in feature film at Goldsmiths, University of London.

List of Inclusion Through Media Projects

This appendix describes the various projects, which took place across Inclusion Through Media. More detail is included in the individual chapters and the intention here is to give a sense of the quality, range and amount of work, which took place over three years.

For a detailed overview of our projects, please visit our website: www.inclusionthroughmedia.org

ITM Project	Partners
Almost Adult *Production of a feature film.* The film tells the story of seventeen year old Mamie who has fled from the Democratic Republic of Congo in the hope of finding a safer life. She has lost her sister and doesn't know what has become of her parents. Passport less, Mamie finds herself being sent to Birmingham where she looses her papers and ends up on the streets. *Almost Adult* is a subjective film about what it means to be frightened in an alien world. The audience sees our society through an outsider's eyes. A film like this cannot obliterate prejudice, but it can help us understand our duty of protection towards those who find their way to our shores. Seven talented young people, from hard to reach groups in the West Midlands (6) and London (1), were recruited to work as part of the production team on a unique training programme. All the trainees had some limited experience of working in small-scale productions such as; short films, television and promos. This training opportunity allowed them to work directly on a feature film and gain experience in a structured way. Website address: www.almostadult.co.uk	Parallax East Hi8us Projects Hi8us Midlands Beyond Films Channel 4 Euro Arts Screen West Midlands
Be Roma or Die Tryin' *A collaborative documentary produced with a group of young Roma people.* The film is a journey through their heritage and across London, examining Britain's ignorance of Roma culture and celebrating the new life they are making for themselves. Website address: www.beromadvd.net	Hi8us South Roma Support Group

Beatz! Camera! Action! (BCA)

An artist development programme which enabled young musicians to learn how to create their own music video promos, and gain valuable advice on negotiating the music industry through a series of seminars and one-to-one workshops. Topics covered included marketing, distribution and the digital music market.

Participants pitched their music video idea to a panel of music industry professionals. Three were selected to work with an experienced music video director to make their own promos.

Website address: www.beatzcameraaction.com

Partners: Hi8us South, Raw Skillz, CIDA, Film London

Beyond The Numbers Game

This research project looked at the efficacy of existing performance measures for participatory media work. It developed an alternative approach to making the case for the value of creativity in general, and participatory media in particular, as a tool for engagement and social inclusion, especially with young people. The Centre for Urban and Community Research (CUCR) worked with Hi8us Midlands to develop an interactive evaluation toolkit for Inclusion Through Media.

Partners: Goldsmiths, University of London, Hi8us Projects, Hi8us Midlands

Converge

Converge created new opportunities for young people to exhibit and distribute moving image productions.

The project:
• Developed a website and published information, about existing sites where young people can upload their digital videos.
• Run a series of 'How To' hands-on workshops across a number of the partner groups, to enable young people to fully utilise both existing offers and build their own open source based channels.

Website address: www.converge.org.uk

Partners: Goldsmiths, University of London

Creative Clusters

Creative Clusters is the leading global event on policy for the creative economy and on culture-led regeneration. Hi8us and Creative Clusters worked together to highlight relevant issues through the conference.

Inclusion Through Media has been a partner with Creative Clusters conferences from 2005-2007.

Partners: Creative Clusters, Hi8us Projects

ITM Project	Partners
Psychosis Awareness DVD Hi8us Midlands, Community Service Volunteers and the Early Intervention Service worked with a group of young men with experience of mental health issues, to develop a film-training programme. This resulted in a DVD that tries to combat common misconceptions and educate the general public about the effects of mental health issues.	Hi8us Midlands CSV Media Department of Health
Deaf Media Resource The Deaf Media Resource is a website produced in partnership between Hi8us Midlands Ltd and Zebra Uno. The site aims to provide information and inspiration for deaf people who are interested in a career in the Media. The site includes clips from workshops, tips, advice, and information for deaf people to support their career development in the media. Website address: www.deafmediaresource.org	Hi8us Midlands Zebra Uno Screen West Midlands
Boost Hi8us Midlands developed and ran a unique business support scheme in the West Midlands. All support given was bespoke, tailored to the needs highlighted by the 40 participating individuals or companies. Boost consisted of business workshops, mentoring, networking events, marketing, industry placements and an office base with resources. Participants were able to choose their own mentors, suggest workshops that were needed and receive marketing and design services suitable for their business. The aim was to help participants to successfully develop their businesses or business ideas to a point where they could among other things, start trading, increase sales or fundraise. Website address: www.boostwm.co.uk	Hi8us Midlands University of Central England's Digital Central Programme
Digital Features *Digital Features aimed to take participatory filmmaking to a wider audience by making feature films.* *Heavy Load* – Production of a feature documentary following a punk band including people with learning difficulties as they try to break into the mainstream. *Yarco* – Reveals the dramas behind a thriving seaside front in East Anglia, a divided community. Development of script through workshops. *Crew* – Development of script and to point production. Crew stars an East London Garage/Grime crew taking their music out of the bedroom and onto the street. It flows from work through BCA and UK Sound TV.	Hi8us Projects Hi8us South APT Parallax East

ITM Project	Partners
Digital Media for Social Change MA Module	Hi8us South
Goldsmiths collaborated with Hi8us South to deliver a Digital Media for Social Change module as part of the MA in Cross Sectoral and Community Arts, within Goldsmiths' department of Professional and Community Education (PACE).	Goldsmiths, University of London
The module introduces digital production in a variety of social/community settings, using participatory and collaborative techniques, relating practical work to the histories and current theories of alternative, participatory and radical media.	

DigiTales	Hi8us Projects
DigiTales is an international digital storytelling project involving people from across Europe making short films about their lives. Our European partners all share a common goal: to increase diversity in the media to improve quality and better represent Europe's increasingly diverse population.	Hi8us Midlands YLE – Finnish Broadcasting Co. Ltd, (Helsinki), working with immigrants and ethnic minorities living in Finland.
Participants learned how to write a script, edit photos and drawings, and make them into a two minute film, which was posted onto the DigiTales website: personal stories across nations were exhibited and exchanged and, as the site grew, a patchwork-quilt of personal moments was built to create an evolving picture of contemporary Europe. Our Storytellers included Roma communities in Eastern Slovakia, Muslim women living in Amsterdam through to young visually impaired music students in London.	BGZ – Berliner Gesellschaft für internationale Zusammenarbeit (Berlin), working with immigrants, including groups from Roma and Russian backgrounds.
Website address: www.digi-tales.org	Dimitra – Institute for Training and Development (Athens and Larissa), working with unemployed re-patriate journalists from Albanian and Pakistani backgrounds.
	Miramedia – the Dutch national organisation for media and minorities (Utrecht), also running a project with young people from diverse backgrounds.
	Politiek Cultureel Centrum De Balie (Amsterdam) – working with Muslim women.

DigiTales (continued)

ACEC, Association for Culture, Education and Communication, Slovakia – working with Romany people in Slovakian society.

Department of Youth Affairs above Ministry of Social Affairs and Labour, Vilnius, Lithuania – working with young people who are disengaged or at risk of social exclusion, especially young women who are single parents, or who are victims of human trafficking.

The Culture Centre, Partnership of Initiatives for Nowa Huta, Krakow, Poland – working with young people and families, using cultural activity as a means of creating employment and regeneration in this former steel-based economy.

ITM Project	Partners

EDRAMA

An innovative online multi-user role-playing tool that can be used in a variety of learning situations, in a safe and controlled environment, and for virtually any subject.
Website address: www.edrama.co.uk

Hi8us Midlands

ITM Cornwall

Hi8us Cornwall was established in August 2006. It has since been developing collaborative media projects with young people and communities across Cornwall, to open progression routes into the media industry and enable young people to create and build their own enterprises.

Advocating support for 'youth media' as integral to Cornwall's Media Sector development it has set a strategic course for growth in this area of work. A particular focus is on maximising opportunities from EU Convergence funds and the recently successful bid from Cornwall County Council to become a Unitary Authority.

Over the first year Hi8us Cornwall has developed successful partnership projects with arts organisations, local councils, schools and colleges, youth groups and festivals. It has provided hundreds of young people with their first experience of creative digital media production, raising aspirations, signposting further training for those with specific areas of interest, and offering work experience placements to emerging professionals.

Hi8us Cornwall
RiO
Chew TV
Cornwall Film
Cornwall College
Camborne
South West
Screen
Cornwall Film
Festival
Children's,
Young People
and Family
Services
Cornwall Youth
Service
National Trust
Cornwall Mines
and Engines

ITM Leeds

Collaborative film making project in East Leeds, which made a series of films as part of the In Full View and Health Matters and In One City, strands of ITM Leeds. It engaged young people to think creatively and gain technical skills. ITM Leeds has produced social films, which are relevant to young people and their communities.

Hi8us North
East Leeds
Neighbourhood
Renewal, Leeds
City Council
Youth Services,
Leeds City Council
Re'new East Bank
Archway
Tonic
Screen Yorkshire
University of
Leeds
Park Lane College
Lippy Films Ltd.
BBC

L8R	Hi8us South
L8R is a powerful, award-winning interactive youth drama series on TV (BBC Learning Zone and Teachers' TV), DVD and the Web, used in secondary schools and informal youth education settings. It engages young people in addressing key issues relating to:	Actorshop BBC Teachers' TV Personal Power UK

- Sex and relationships, sexual health.
- Teenage pregnancy and early parenthood.
- Alcohol, drugs use, bullying, peer pressure, friendships.
- Values, attitudes and decision-making
- Identifying sources of information and support.

The *L8R* website allows young people to interact with the six teenage characters the drama revolves around. They advise them and debate issues, as well as influence future episodes by voting on the outcome of a dilemma at the end of each of the ten-minute episodes. Young people can also talk to trained online peer mentors (aged 16-25) about issues related to the drama, and, find links to national support organisations that offer expert information and advice.

The ITM project has enabled *L8R* to develop the following strands of work:

- Online Peer Mentors – 16-25 year-olds trained to host online chat on the *L8R* website around sensitive issues such as sex and relationships, and signpost young people to other links and sources of advice and information.
- Virtual Cast – two groups of 16-25 year-olds trained to understudy the six main *L8R* cast members on the website forums.
- New *L8R* website – redesigned and re-built in order to incorporate these new activities, make it easier to navigate and use, and more relevant for both young people and practitioners.

Extending *L8R*'s reach by increasing the overall capacity has allowed the resource to reach a much wider area of the UK. The result is the development of 17 new partnerships – since 2005 – with local authorities, primary care trusts and other key organisations and bodies, who in turn work with *L8R* across both formal and informal education settings. This helps extend *L8R*'s reach to crucial target groups, including vulnerable and disadvantaged young people.

Website address: www.l8r.uk.net

ITM Project	Partners

Mental Health Media Awards

The Mental Health Media Awards recognise and celebrate the best portrayals of mental distress and reporting of mental health issues in the broadcast media and print. All the winning programmes and articles successfully challenge the misinformation and stereotypes that surround mental health. Most importantly this includes the voices of people who have experienced mental health problems. ITM sponsored the 'Making a Difference' Award at the 2005, 2006 and 2007 Ceremony.

Website address: www.mhmawards.org

Partner: Mental Health Media

Music for Screen and Drama
Research into existing Music Education and employment paths for visually impaired people, particularly in the audiovisual sector.

Activities included:
- Research social status of visually impaired musicians.
- Sound / music library.
- Get your Hands on an Orchestra (workshop).
- Composition for screen and drama.
- Digital Stories contribution.
- Research, development and production new teaching materials.
- Research accessibility hardware and software.
- Training for teachers, support workers, parents and others.

Website address: www.musiciansinfocus.org

Partners: Musicians in Focus
London Symphony Orchestra
Royal College of Music

Open Up
Discrimination and prejudice hit people with mental health problems hard and can have a devastating effect.

Open Up brought people with experience of mental distress together to lead the way in taking action on discrimination. The work will continue after ITM.

Challenging this takes concerted action, from shifting the ways people think and act, to campaigns for changes to law and policy. To make a lasting difference, people with experience of mental health must be at the heart of this work.

Website address: www.openuptoolkit.net

Partner: Mental Health Media

Breastfeeding Awareness DVD

Hi8us Midlands has worked with a group of young mums to develop a learning resource DVD focusing on breastfeeding for expectant mothers 'The Breast Intention'. Although the DVD was created to promote breastfeeding, it was developed to offer a balanced argument in conjunction with the real life experiences of the young mothers involved.

Partners: Hi8us Midlands
Department of Health

Breastfeeding Awareness DVD (continued)
The tool includes the following sections:
- Personal Stories, Including Father's Story.
- Advice from Health Professionals (Interviews).
- Group Discussion.
- Breast Feeding Demonstration.

Projecting Stoke

Projecting Stoke gave a voice to communities based in Stoke-on-Trent through the media of film, and maybe spot filmmaking talent along the way. Participants developed their ideas with the help of local filmmakers, and learned how to storyboard their ideas, direct, film and edit their stories. The first phase of this scheme focused on the Meir district and ten films were made with over 50 participants. The second phase in the Tunstall district finished in early 2007 and consisted of eleven films.

Website address: www.projectingstoke.com

Partners: Hi8us Midlands, Stoke-on-Trent City Council, Staffordshire University, Screen West Midlands

Brick Lane Training Scheme

Brick Lane is a feature film based on the novel of the same name by Monica Ali. ITM operated a training scheme to provide opportunities for seven trainees to work in their chosen department in the production of a feature film. It followed on from earlier work on Almost Adult, a film made by the ITM partnership. The training scheme extended the earlier work outside ITM and provided mainstream opportunities for those who could be otherwise marginalised by the media industries.

Trainees worked under the supervision of their Head of Department. The Departments were Costume, Make-Up, Assistant Directors and Casting, Production, Camera, Art Department and Lighting.

Partners: Hi8us South, Hi8us Projects, Ruby Films, CIDA

StripSearchers

StripSearchers aimed to support and nurture amateur talented comic illustrators via a professional led vocational training scheme, culminating in the production of their own comic books. The scheme also involved creating an online content managed gallery site to promote West Midlands based artists, a touring exhibition of their work and VIP trip to the UK's largest comic convention. The success of this and two other comic illustration schemes delivered by Hi8us Midlands, has led to an ITM supported feasibility study looking into the establishment of a national Comic School.

Website addresses: www.stripsearch.org.uk
www.artpeeps.co.uk

Partners: Hi8us Midlands, Arts Council West Midlands

ITM Project	Partners
Ten 4 Hi8us Midlands, together with Maverick TV ran a practical training and industry support scheme for talented amateur journalists. Participants took part in a series of industry-focused workshops and worked together to produce a high quality magazine for national distribution. The magazine was written, photographed and designed by the participants. Website address: www.channel4.com/ten4	Hi8us Midlands Maverick TV
UK Sound TV UK Sound TV is a youth-run broadband channel focusing on British underground music, emergent technology and local/global issues. UK Sound TV is the first broadband channel produced and directed by a team of youth producers from Bow, East London. UK Sound TV is both a youth entertainment channel and a launch pad for new young talent, where young people can learn skills in production, sound, video, content development, design, and marketing. Website address: www.UK Sound TV.com	Hi8us South Space Old Ford Housing Association

Bibliography

Amin, A. and Thrift, N (2002) *Cities: Reimagining the Urban*, Cambridge: Polity Press

Aronson, L. (2000) *Screenwriting Updated*, St Leonards: Silman-James Press.

Arts Council England (2005) *The arts and young people at risk of offending*. Available from http://www.artscouncil.org.uk/publications/publication_detail. php?sid=21&id=493, accessed 6/11 2007

Ash, C. (2003) 'Inner City Inspiration', Arts Professional, Issue 42 p.5.

Aufderheide, P. (1993) *Forum Report: Media Literacy: A Report of the National Leadership Conference on Media Literacy*, Washington DC: The Aspen Institute

Auchard, E. (2007) 'Participation on Web 2.0 sites remains weak', San Francisco: Reuters. Available from http://www.reuters.com/article/internetNews/id-USN1743638820070418, (accessed 5/7/07)

Badiou, A. (1998) *Ethics: An Essay on the Understanding of Evil*. London: Verso.

Ball, S. (1993) 'Theatre in Health Education' In Jackson, T. (ed.), *Learning through theatre: new perspectives on Theatre in Education*, New York and London: Routledge, pp 227-238.

Bechler, R. (2006) *Unbound Freedom: A Guide to Creative Commons for Cultural Organisations*, British Council.

Belfiore, E. & Bennett, O. (2006) *Rethinking the Social Impact of the Arts: a critical/historical review*, Warwick: Centre for Cultural Policy Studies, University of Warwick.

Boal, A. (1979). *Theater of the Oppressed*, London: Pluto Press.

Bohman, J. (2000) 'The Division of Labour in Democratic Discourse' in Chambers, S. & Costain, A. (eds) *Deliberation, Democracy and the Media*, Lanham, Maryland: Rowman and Littlefield, pp 47-64.

Boyle, M. (1997) 'Civic boosterism in the politics of local economic development: "institutional positions" and "strategic outcomes" in the consumption of hallmark events', *Environment and Planning* A 29.11, pp.1975-98.

Braden, S. (1999). 'Using Video for Research and Representation: basic human needs and critical pedagogy.' *Journal of education media* 24(2).

Buckingham, D. (2001). 'Media Education: A Global Strategy for Development'. Prepared for UNESCO, Sector of Communication and Information. Available from http://www.childrenyouthandmediacentre.co.uk/Pics/unesco_policy_paper.pdf (accessed 12/10/07).

Buckingham, D. (forthcoming) 'Skate perception: self-representation, identity and visual style in a youth subculture' – unpublished paper.

Buckingham, D., Grahame, J. & Sefton-Green, J. (1995) *Making Media: Practical*

Production in Media Education, London: English and Media Centre.

Burman, E. (1999) 'Appealing and Appalling Children', *Psychoanalytic Studies*, Vol 1, No 3.

Canetti, E. (1973) *Crowds and Power*, London: Penguin

Centre for Urban and Community Research and Crime Concern Trust UK (2006) *Youth Volunteering: Kickstart's Good Practice Model: A Report for the Russell Commission*, London: Goldsmiths. Available from http://www.goldsmiths.ac.uk/cucr/pdf/finaldraft06.pdf (accessed 12/10/07).

CEP (2007) DCMS Creative Economy Programme. Available from http://www.cep.culture.gov.uk (accessed 12/10/07).

Chambers, R. (2005). Notes for participants in PRA-PLA familiarisation workshops in 2005. P. r. C. a. IDS. Brighton: Institute of Development Studies.

Chappell, K. (2007a) 'The dilemmas of teaching for creativity: Insights from expert specialist dance teachers', *Thinking Skills and Creativity* Volume 2, No.1 April 2007.

Chappell, K. (2007b) 'Creativity in primary level dance education: moving beyond assumption', *Research in Dance Education* Vol 8 No 1 April 2007.

Clarence House (2007) 'Finance'. Available at http://www.princeofwales.gov.uk/finances/index.html, accessed (24/6/07)

Claude, G. (2007) 'Copyright: The Politics of Owning Culture' in Coyer, K., Dowmunt, T. & Fountain, A., *The Alternative Media Handbook*, London: Routledge.

Coalter, Fred (2001) *Realising the Value of Cultural Services: the case for sport*. London: LGA.

Cohen, Phil (1997) 'Rules of Territoriality and Discourse', *Rethinking the Youth Question: Education, Labour and Cultural Studies*, Basingstoke: Macmillan.

Comedia (1992) *The importance of culture for urban economic development*, Stroud: Comedia.

Cooke, B. and U. Kothari (2001). *Participation: the New Tyranny?* London: Zed Books.

Cornwall & Scilly Historic Environment Service (2006) Available as http://www.cornish mining.org.uk/status/significance.htm (accessed 14/6/07).

Cornwall County Council (2001) *Employment and Industry*, Available as http://www.cornwall.gov.uk/index.cfm?articleid=2001 (accessed 1/8/07).

Couldry, N. (2000) *The Place of Media Power: Pilgrims and Witnesses of the Media Age*. London: Routledge.

Couldry, N. (2001) 'The Hidden Injuries of Media Power', *Journal of Consumer Culture*, 1(2): 155-178.

Couldry, N. (2003) *Media Rituals: A Critical Approach*. London: Routledge.

Couldry, N., Livingstone, S. & Markham, T. (2007) *Media Consumption and Public Engagement: Beyond the Presumption of Attention*. Basingstoke: Palgrave Macmillan

Crabbe, T. et al (2006) *'Going the distance': Impact, journeys and distance traveled*, (Third Interim National Positive Futures Case Study Research Report), London: Home Office.

Craft, A .(2000) *Framing and developing practice*, London: Routledge.

Creative Industries Management (2001) *Content – Europe's New Growth Engine*, Finland: CIM.

Crewe, L. and Forster, Z. (1993) 'Markets, design and local agglomeration: the role of small independent retailers in the workings of the fashion system', *Environment and Planning D: Society and Space* 11: 213-29.

Davis, J.M., and Hill, M. (2006) 'Introduction' in Tisdall, E.K.M., Davis, J.M., Prout, A. & Hill, M. *Children, Young People & Social Inclusion: participation for what?* Bristol: Policy Press.

Deleuze, G. and Guattari, F. (1988) *A Thousand Plateaus*, London: Athlone.

Department for Media, Culture and Sport (DCMS; 1998) *Creative Industries Mapping Document*. London: Department for Culture, Media and Sport.

Department for Media, Culture and Sport (DCMS; 1999) *Policy Action Team 10: Arts and Sport, A Report to the Social Inclusion Unit*. London: Department of Culture, Media and Sport.

Department for Media, Culture and Sport (DCMS; 2001) *Creative Industries Mapping Document*. London: Department for Culture, Media and Sport.

Department for Media, Culture and Sport (DCMS; 2004) *Culture at the Heart of Regeneration*. London: Department of Culture, Media and Sport.

Department for Education and Skills (2006) *Teenage Pregnancy:, Accelerating the Strategy to 2010*, London: HMSO. Available as http://www.everychildmatters.gov.uk/_files/94C1FA2E9D4C9717E5D0AF1413A329A4.pdf, (accessed 21/6/07).

Department for Trade and Industry (2005) *Cox Review of Creativity in Business: Building on the UK's Strengths*

Dewson, S., Eccles, J., Tackey, N.D. and Jackson, A. (2000) *Measuring Soft Outcomes and Distance Travelled: A Review of Current Practice*, London: Department for Education and Employment Research Report RR219.

Dwoskin S (1976) *Film Is*, London: Peter Owen

Electoral Commission (2005) 'Election 2005: Turnout. How Many, Who and Why?' Available from http://www.electoralcommission.org.uk (Accessed 12/10/07)

Electoral Commission, (2007) 'An Audit of Political Engagement 4'. Available from http://www.electoralcommission.org.uk (Accessed 12/10/07).

Elliot, L. and Atkinson, D. (2006) *Fantasy Island*, London: Constable

Elwes, C. (2005) *Video Art, A Guided Tour*, London: IB Tauris.

Emerson, R. (1977, originally published 1844) 'Education' in *The Portable Emerson*, edited by M. Van Doren, New York: Penguin.

Evans, G. (2001) *Cultural Planning: an Urban Renaissance?* London: Routledge.

Evans, G. & Foord, J (2000) 'Landscapes of Cultural Production and Regeneration', in Benson, J. and Rose, M. (eds.) *Urban Lifestyles: Spaces, Places, People*, Rotterdam: A.T. Balkema, pp. 349-256

Evans, G. & Shaw, P. (2004) *The Contribution of Culture to Regeneration in the UK: A Review of Evidence*, London: Department for Culture Media and Sport

Fals Borda, O. (2001). 'Participatory (Action) Research in Social Theory: origins and challenges', in P. Reason and H. Bradbury (eds) *Handbook of action research: participative inquiry and practice*, London: Sage.

Fawzi El-Solh, C. & Mabro, J. (eds.) (1994) *Muslim Women's Choices: Religious Belief and Social Reality*, Oxford: Berg.

Feldman, Csikszentmihalyi & Gardner (2004) *Changing the World: A Framework for the Study of Creativity*, Westport: Praeger.

Finance South-East (2005) *Creative Industries Fund for the South-East*, Crowthorne:

FSE.

Flint, W. (2005) *Recording Young People's Progress and Accreditation in Youth Work,* Leicester: National Youth Agency. Available from http://www.nya.org.uk/Templates/internal.asp?NodeID=92441, (Accessed 14/9/07)

Florida, R. (2002) *The Rise of the Creative Class,* New York: Basic Books.

Florida, R. and Tinagli, I. (2004) *Europe in the Creative Age,* Demos

Fraser, N. (2000) 'Rethinking Recognition', *New Left Review* (new series) 3: 107-120.

Fraser, H. (2005). 'Four different approaches to community participation', *Community development journal* 40(3): 286-300.

Freire, P. (1972). *Pedagogy of the oppressed.* London, Penguin.

Gale Jr, H. F.; Wojan, T.R.; Olmsted, J. C. (2002) 'Skills, Flexible Manufacturing Technology, and Work Organization', *Industrial Relations* 41 (1) January 2002

Gidley, B. (2007) 'Youth Culture and Ethnicity: Emerging Youth Multiculture in South London' in Deicke, W. & Hodkinson, P. (eds) *Youth Cultures: Scenes, Subcultures and Tribes,* London: Routledge

Gitlin, Todd (1980) *The Whole World is Watching,* Berkeley: University of California Press.

Goodman, S. (2003) *Teaching Youth Media: A Critical Guide to Literacy, Video Production & Social Change.* New York: Teacher's College Press – Columbia University.

El Guindi, F. (1999) *Veil: Modesty, Privacy and Resistance.* Oxford: Berg.

Hackett, K., Ramsden, P., Sattar, D., Guene, C. (2000) *Banking on Culture – New Financial Instruments for expanding the cultural sector in Europe,* European Commission

Halsey, K. et al (2006). 'What Works in Stimulating Creativity amongst Socially Excluded Young People'. Available from http://www.nfer.ac.uk (Accessed 10/08/07).

Harvey, I. et al (2002). *Being Seen, Being Heard: young people and moving image production.* Leicester: The National Youth Agency in partnership with The British Film Institute.

Health Development Agency, (1999) 'Reducing the rate of teenage conceptions: An international review of the evidence (summary bulletin)'. Available as http://www.nice.org.uk/page.aspx?o=501917 (Accessed 21/6/07)

Hesmondhalgh, D. (2002) *The Cultural Industries,* London: Sage.

Hickey, S. and G. Mohan (2004). 'Towards participation as transformation: critical themes and challenges' in Hickey S. and Mohan, G., *Participation: from tyranny to transformation,* London: Zed Books, 3-24.

Hill R. and Moriarty G. (2001) *As Broadcast in Beijing: Merseyside ACME: A Social Impact Study.* Merseyside: ACME.

Hopkins, J. (ed.) (1973) *Video in Community Development,* London: Centre for Advanced Television Studies / Ovum.

Humphreys, P., Lorac, C. and Ramella, M. (2001). 'Creative support for innovative decisions', *Journal of decision systems* 10: 241-264.

Jackson, T. (ed.) (1993). *Learning through theatre: new perspectives on Theatre in Education.* Second Edition. New York and London: Routledge.

Jagodzinski, P., Rogers T. & Turley, S. (1999) 'Paradigms for the Design of Interactive Drama', *Personal Technologies* 3, 141-152.

Jenkins, H. (2006) *Convergence Culture: Where Old and New Media Collide*, London & New York: New York University Press

Jermyn, H. (2001) 'The Arts and Social Exclusion: a review prepared for the Arts Council of England', London: Arts Council of England. Available as http://www.sca.unimelb.edu.au/riskybusiness/Images/ArtsandSocialExclusion.doc (Accessed 12/10/07)

Jermyn, H. (2004) 'The Art of Inclusion'. Research Report 35. London: Arts Council of England. Available from http://www.artscouncil.org.uk/publications (Accessed 12/10/07).

Jowell, T. (2004) *Government and the Value of Culture*, London: DCMS.

KEAP (2006) *Youth Arts Mapping*. Available from http://www.keap.org.uk/programmes_network/youth_arts_mapping.html, accessed 6/11 2007

Kelemen, C. (2007) 'Towards Convergence Newsletter 16', Cornwall: Objective One Partnership.

Kelly, K. (1998) *New Rules for the New Economy: 10 Radical Strategies for a Connected World*, London: Fourth Estate.

Kemmis, S. and R. McTaggart (2003). 'Participatory Action Research', in Denzin, N. K. L. & California, Y.S. *Strategies of Qualitative Inquiry*. London: Sage, 336-96.

Kindon, S. (2003). 'Participatory video in geographic research: a feminist practice of looking', *Area* 35(2): 142-153.

Kinsella, S. (1997) 'Japanization of European Youth', Available from http://ebasic.easily.co.uk/04F022/036051/Japanization.html (Accessed 12/10/07).

Krogh, K. (2001). *Video action research: possibilities as an emancipatory research methodology and reflections on a health policy study for people with disabilities.* Democracy, diversity and disability Conference of the society for disability studies, Winnipeg, Canada.

Lambert, Joe (2006) *Digital Storytelling: capturing lives, creating community*, 2nd edition. Berkeley: Digital Diner Press.

Landry, C. (2000) *The Creative City: a Toolkit for Urban Innovators*, London: Earthscan

Landry, C. and Bianchini, F. (1995) *The Creative City*, London: Demos.

Laney, M. L. (1997). 'Video: a tool for participation'. *PLA Notes*. London, IIED: 63-64.

Lord, P. et al (2002) *Making Connections: informal media education projects for young people*, Leicester: The National Youth Agency.

Madzey-Akale, J. (2005). 'Phillips Community Television Evaluation Report 2004-2005', Youth Development Program Planning & Evaluation Services. Available as http://www.phillipscommunitytv.org/pcteval04-05.pdf (Accessed 20/2 2007).

Manzoor, Sarfraz 'Britain should integrate into Muslim Values', 2007. Available from http://www.therevival.co.uk (Accessed 12/10/07)

Martin, L. (2006) 'Screen Actions'. Available as http://www.cornwallfilmfestival.com/Sections-article15-p1.htm (Accessed 14/6/07)

Matarasso, F. (1997) *"Use or Ornament": The Social Impact of Participation in the Arts,* COMEDIA. Available from http://www.comedia.org.uk/pages/pub_download_pp.php (Accessed 12/10/07)

Mayer (2000). 'Capturing cultural identity / creating community', *International*

Journal of Cultural Studies 3(1): 57-78.

McCarthy, H. (1993) *Anime! A Beginners Guide to Japanese Animation*, London: Titan Books

Mckee R (1997) *Story*, New York: Harper Collins.

Miskelly, C. (2004) *Report on the evaluation of L8R 2004*, University of the West of England, unpublished report.

Miskelly, C. (2006) *L8R Evaluation Report 2006*, unpublished report.

Mohammed, A. & Ahsan, H. (2002) *Globalisation or Recolonisation? The Muslim World in the 21st Century*, London: Ta-Ha Publishers.

Mommaas, H. (2004) 'Cultural Clusters and the Post-industrial City: Towards the Remapping of Urban Cultural Policy'. *Urban Studies* 41.3: 507-532.

Mosse, D. (2001). "People's Knowledge' - Participation and patronage: operations and representation in rural development', in Cooke, B. and Kothari, U., *Participation: The New Tyranny?* London: Zed Books.

Murray, JH., (1997) *Hamlet on the Holodeck*, Cambridge, MA.: MIT Press.

NACCE (1999), *All Our Futures: Creativity, Culture and Education*, London: National Advisory Committee on Creative and Cultural Education/Department for Education and Skills

NAMAC (2003) 'Voice, Self and Community Through Video Production: An Evaluation of the Long-Term Impact of the Educational Video Center's Youth Documentary Programs'. Available as http://www.evc.org/pdf/NAMAC_Final_Report_EVC.pdf (Accessed 12/10/07)

National Youth Agency (2007) *National Framework for Awards in Non-Formal Educational Settings*, Leicester: National Youth Agency. Available from http://www.nya.org.uk/Templates/internal.asp?NodeID=90205 (Accessed 14/9/07)

Newton, B. et al (2005) *What employers looks for when recruiting the unemployed and inactive*, DWP Research Report No.295

Objective One Partnership (2006) Available from http://www.objectiveone.com/01htm/01-convergence/post2006_faq.htm, (Accessed 1/8/07)

O'Connell, J (2002). 'The Fine Art of Youth Programs: Award-winners take neophytes to new heights', *Youth Today*, May 2002. Available from http://www.evc.org/pdf/Youth_Today_May02.pdf (Accessed 12/10/07).

O'Connor, J. and Wynne, D. (eds.) (1996) *From the Margins to the Centre: Cultural Production and Consumption in the Post-industrial City*, Aldershot: Ashgate Publishing.

O'Connor, J. (2004) *"A Special Kind of City Knowledge": Innovative Clusters, Tacit Knowledge and the 'Creative City'*, Manchester: MIPC.

Parker, P. (1998) *The Art and Science of Screenwriting*, Exeter: Intellect Books.

Pattie, C., Seyd, P. & P. Whiteley (2004). *Citizenship in Britain: Values, participation and democracy.* Cambridge: Cambridge University Press.

Penwith District Council. (2006) 'Affordable Housing' Leaflet. Available from http://www.penwith.gov.uk/media/adobe/9/p/Affordable_Housing_Leaflet.pdf (Accessed 1/8/07).

Pine, J. & Gilmore, J. H. (1999) *The Experience Economy: Work is Theatre and Every Business a Stage*, Boston: Harvard Business School Press.

Potter, W. J. (2005) *Media Literacy*, London: Sage.

Powell, D. (2003) *Creative and Cultural Industries – An Economic Impact Study*, Arts Council England

Power, M. (1997) *The Audit Society*. Oxford: Oxford University Press.

Power (2006) The Power Inquiry, *The Report of Power: An independent Inquiry into Britain's Democracy*. Available from http://www.powerinquiry.org/report/index.php (Accessed 5/5/07)

Pratt, A. (2002) 'Hot jobs in Cool Places. The material cultures of new media product spaces: The case of South of the market, San Francisco', *Information, Communication Society* 5 (1): 27-50.

Protz, M. (2004). 'Watching for the unspoken, listening for the unseen', International and Rural Development Department. Reading: University of Reading.

Ramella, M. & Olmos, G. (2005) 'Participant Authored Audiovisual Stories (PAAS): Giving the camera away or giving the camera a way?', London: Multimedia Lab, London School of Economics and Political Science.

Reach Group (2007) *Reach: an independent report to Government on raising the aspirations and attainment of Black boys and young Black men*, London: Department for Communities and Local Government

Reeves, Michelle (2002) *Measuring the economic and social impact of the arts: a review* London: Arts Council of England. Available from http://www.artscouncil.org.uk/documents/publications/340.pdf (Accessed 12/10/07)

Regional Studies Association (2001) *Labour's New Regional Policy: An Assessment*, Regional Studies Association

Rodriguez, C. (2003) 'The Bishop and his Star: citizens' communication in southern Chile' in N. Couldry and J. Curran (eds.) *Contesting Media Power: Alternative Media in a Networked World*, Boulder, CO: Rowman and Littlefield, 177-194.

Rogers, C. (2007) 'RE: Aggiewood' (e-mail communication 2/8/07)

Sawney, F., Sykes, S., Keene, M., Swinden, L. & McCormick, G. (2003). *It Opened My Eyes: Using Theatre in Education to Deliver Sex and Relationship Education. A Good Practice Guide*. London: Health Development Agency.

Saxenian, A. (2000) 'The Bangalore Boom: From Brain Drain to Brain Circulation?' In Kenniston, K. & Kumar, D. (eds.) *Bridging the Digital Divide: Lessons from India*, Bangalore: National Institute of Advanced Study.

Scott, A. J. (1997) 'The cultural economy of cities', *International Journal of Urban and Regional Research* 21.2: 323-39.

Sennett, R. & Cobb, J. (1972) *The Hidden Injuries of Class*. New York: Alfred A. Knopf

Shaw, J. & Robertson, C. (1997). *Participatory Video: A practical approach to using video creatively in group development work*. London: Routledge.

Shaw, P. (2003). 'What's Art Got to do with it?' Briefing Paper on the Role of Arts in Neighbourhood Renewal. London: Arts Council of England. Available from http://www.artscouncil.org.uk/publications (Accessed 12/10/07)

Simmons, A. (2001) *The Story Factors*, Cambridge MA.: Perseus Books.

Smith, T. (2007) 'Cultivate – Championing Culture & Community Innovation', unpublished report, RiO.

Staricoff, R. L. (2004) *Arts in Health: A Review of the Medical Literature*. Research Report 36. London: Arts Council England.

Tierno, M. (ed.) (2002) *Aristotle Poetics for Screenwriters*, New York: Hyperion Books.

HM Treasury & Department for Children, Schools and Families (2007) *Aiming*

High for Young People: a ten year strategy for positive activities London: HM Treasury.

Tusa, J. (2000) *Art Matters: Reflecting on Culture*, London: Methuen

Tyner, K. (2003) 'Introduction: Mapping the Field of Youth Media', in Tyner, K. (ed.) *A Closer Look: Media Arts 2003 (Case Studies from NAMAC's Youth Media Initiative)*, San Francisco: National Alliance for Media Arts and Culture, 5-6.

Tyner, K. & Mokund, R. (2003) 'Mapping the Field: A Survey of Youth Media Organizations in the United States with Discussion of Results', in Tyner, K. (ed.) *A Closer Look: Media Arts 2003 (Case Studies from NAMAC's Youth Media Initiative)*. San Francisco: National Alliance for Media Arts and Culture, 61-83.

Verwijen, J. (1999) 'The creative city as a field condition: can urban innovation and creativity overcome bureaucracy and technocracy?', *Built Environment 24* Nos. 2/3: 142-54.

Vine, C. (1993) 'TIE and the Theatre of the Oppressed', in Jackson, T. (ed.), *Learning through theatre: new perspectives on Theatre in Education*, Second Edition. New York and London: Routledge, 109-130.

Wavell, C., Baxter G., Johnson, I.M., Williams, D.A. (2002) *Impact Evaluation of Museums, Archives and Libraries: Available Evidence Project*. Aberdeen, The Robert Gordon University

Wight, D., Raab, G., Henderson, M., Abraham, C., Buston, K., Hart, G. and Scott, S. (2002) *The limits of teacher-delivered sex and relationships education: interim behavioural outcomes from a randomised trial*, London: Sex Education Forum Research Briefing/National Children's Bureau.

Willett, R. (forthcoming) 'Consumption, Production and Online Identities: Amateur spoofs on YouTube.' in Marsh J., Willett, R. and Robinson, M. (eds.) *Play, Creativity and Digital Cultures*. London: Routledge

Williams, R. (1976) *Drama in a Dramatised Society*. Cambridge: Cambridge University Press.

The Work Foundation (2007) *Staying Ahead: The Economic Performance of the UK's Creative Industries*. The Work Foundation, July 2007

Ysern de Arce, J. L. (2003) 'Presentación' in *Enciclopedia Cultural de Chiloé*. Chile: Fundación Radio Estrella del Mar.

Yusuf, S. and Nabeshima, K. (2003) *Urban Development Needs Creativity: How Creative Industries Can Affect Urban Areas*, World Bank

Printed in the United Kingdom
by Lightning Source UK Ltd.
124499UK00002B/55-999/A

9 781906 496005